Steampunk

Library of Gender and Popular Culture

From *Mad Men* to gaming culture, performance art to steampunk fashion, the presentation and representation of gender continues to saturate popular media. This new series seeks to explore the intersection of gender and popular culture, engaging with a variety of texts – drawn primarily from Art, Fashion, TV, Cinema, Cultural Studies and Media Studies – as a way of considering various models for understanding the complementary relationship between 'gender identities' and 'popular culture'. By considering race, ethnicity, class and sexual identities across a range of cultural forms, each book in the series will adopt a critical stance towards issues surrounding the development of gender identities and popular and mass cultural 'products'.

For further information or enquiries,
please contact the library series editors:
Claire Nally: claire.nally@northumbria.ac.uk
Angela Smith: angela.smith@sunderland.ac.uk

Library of Gender
& Popular Culture

Steampunk

Gender, Subculture and the Neo-Victorian

Claire Nally

BLOOMSBURY ACADEMIC
LONDON • NEW YORK • OXFORD • NEW DELHI • SYDNEY

BLOOMSBURY ACADEMIC
Bloomsbury Publishing Plc
50 Bedford Square, London, WC1B 3DP, UK
1385 Broadway, New York, NY 10018, USA

BLOOMSBURY, BLOOMSBURY ACADEMIC and the Diana logo
are trademarks of Bloomsbury Publishing Plc

First published in Great Britain 2019

Cover design by Arianna Osti
Cover image © Doctor Geof (Geof Banyard)

ISBN: HB: 978-1-3501-1318-3
ePDF: 978-1-3501-1320-6
eBook: 978-1-3501-1319-0

Series: Library of Gender and Popular Culture

Typeset by Integra Software Services Pvt. Ltd.
Printed and bound in Great Britain

To find out more about our authors and books visit www.bloomsbury.com
and sign up for our newsletters.

Contents

List of Figures

Acknowledgements

This book is for Hector Eunan Richard Wingate Burns – a wee soul growing up in the best tradition, with 'no gods, no masters'.

I have a debt of gratitude to a number of people who supported me in the writing of this book. Doctor Geof is foremost among these, as he has provided much intelligent discussion and wit during the course of this project. Also Sara Hawthorn, his wrangler (every artist needs one). I would like to thank Nick Simpson for his immense kindness and generosity when I asked him numerous questions about his work. Margaret Killjoy and Miriam Roček (Steampunk Emma Goldman) were also incredibly charitable with their time. I also spent far too much time hounding Andy Heintz and The Men That Will Not Be Blamed for Nothing, as well as Bryan Talbot, so thank you to them for their patience.

There are a number of colleagues who have supported me during the writing and reviewing process: Catherine Spooner, Xavier Aldana-Reyes, Martin Danahay, Angela Smith, Ann-Marie Einhaus, Matt Worley, Julian Wright, Mel Gibson. I would also acknowledge my third-year students at Northumbria University, who studied various steampunk texts on my Neo-Victorian module, and their insights provided inspiration for some of this material.

This book is underpinned by an exhibition hosted at Discovery Museum, Newcastle upon Tyne, UK entitled 'Fabricating Histories: An Alternative 19th Century', which I co-curated with Tyne and Wear Archives and Museums, funded by Arts Council England. I would especially like to thank Karen Sturgeon-Dodsworth and Shona Thomas for their support during this project: without them, this book would have been very different.

A personal thank you to Joel Heyes for information on the Steampunk Bar in Prague; Stephen Turner and Anne Burns for unwavering friendship; my parents for their unfailing support; Anna Coatman, Lisa Goodrum and my reviewers for all the manuscript support, and Tim most of all.

Series Editors' Introduction

As many books in this series explore, popular culture often develops or derives inspiration from subcultures. In this book, Claire Nally explores one such subculture as it has evolved in the twenty-first century. Although not limited to the period of Queen Victoria's reign, steampunk re-evaluates the historical impact of the industrial revolution in the nineteenth century, rendering this aspect of Victorian period relevant to the present. Nally traces steampunk from the 1980s, in a political context where Margaret Thatcher was espousing 'Victorian values' as foundational to her policies in that decade. Whilst steampunk embraces Victoriana, the conservative values attached to politics in the 1980s remain a context against which the steampunk texts investigated here can be measured.

As Nally explores in this book, one of the problems with steampunk's obsession with Victorian aesthetics is that of the gendered politics that underlie such an historical period. For example, the steampunk aesthetic for women's costume is based around the corset, a garment that carries with it the conservative connotations of social as well as physical containment of women, but in steampunk culture it can also be viewed as something akin to a warrior's breastplate. Thus the rearticulation of Victorian aesthetics in steampunk is not a straight forward copy. However, the inherent gender politics of steampunk are not without their wider political problems, and Nally's study here investigates this in the twenty-first century context, where she examines its Janus-faced nature in terms of nineteenth-century values and twenty-first century neo-liberalism.

Unlike other subcultures in this Library which emerge from film, music and social movements, steampunk began as a literary form. However, as with other emergent cultures, it has spread across a range

of genres and thus can be found lurking in other studies within this Library. The influence of steampunk can be seen on popular culture texts such as the long-running television series Doctor Who (where the set design of the Tardis under David Tennant's Doctor was heavily influenced by steampunk aesthetics), and crops up in music videos across a wide range of musical genres.

Nally's discussion of steampunk practice consequently includes representations in subcultural zines, music, and art, as well as the more mainstream popular cultural uses in film, television, graphic novels, and neo-Victorian literature. As Nally argues, steampunk manages to be found thriving in both popular culture and in subculture. Such crossovers can be found in many of books in this Library, particularly those that are dealing with subject matter that has emerged from subcultural contexts.

Introduction

Defining steampunk

In 2011, I attended the 'Empire' Ball at the Asylum, one of the foremost UK steampunk festivals in Lincoln. A man, in frock coat and top hat, approached me and asked me whether I was accompanied by a gentleman. He then proceeded to ask me about my sexual predilections. It is worth addressing at the outset that steampunk is playful, taking an ironic and critical approach to historical and cultural material from the Victorian period, with especial focus on the technology and science of the Industrial Revolution. But was this man's retrogressive comment, and the imperialist connotations of the event, as playful, ironic and critical as I was supposed to think?

In many of the texts addressed in the following pages, the notion that steampunk is a radical counterculture embedded in aesthetic resistance to modern mass production is questioned. Thus, this book not only posits an uncertainty about the depth of steampunk's irony but also reaches far beyond the limitations of the subculture in order to explore the ways in which gender politics function in the twenty-first century, as well as the unique contribution steampunk makes to such debates.

Steampunk is both a genre in art and literature, and a subculture within contemporary popular culture as a whole. The literary genre emerged in the 1980s, evolving from cyberpunk, and the subculture has followed with its affiliations to the goth, punk and DIY subcultures. Participants heavily invested in the scene include

musicians, artists, writers and subcultural aficionados, whose work harks back to the science, technology and aesthetics of the Victorian steam era.[1] Steampunk re-evaluates the historical impact of industry in the nineteenth century, rendering the Victorian period relevant to the present. Understanding the complicated relationship between the story (literature, art, film, etc.) and the spectacle (subculture) is essential to understanding the potentially uncertain claims of steampunk to be participating in contemporary counterculture. Contemporary subcultures are often supposed to be radical, but we need to interrogate this position and steampunk needs to have this perspective challenged. This is a genre that has its complexities and its problems, but it needs to be properly, academically problematized. To evaluate the contradictions and complexities of steampunk, this monograph attempts a rare feat: it pursues a conversation between steampunk as literary and artistic genre and steampunk as subculture. Sometimes, as we will see, that conversation unfolds within the tangled life stories of individuals such as novelist and subcultural icon, Emilie Autumn. The subculture's claim to subversion can cause friction and tension between different elements. One of the distinctive features of steampunk is that it has found a unique way of turning the story or the artwork of steampunk *as genre* into the lived spectacle of steampunk *as subculture*. Steampunk develops latently conservative strands, woven into the complex and often radical countercultural statements it offers at first sight. In this analysis, we need to think about the role of Empire, specifically in relation to masculinity, as this book will explore at length.

It is also the case that steampunk is deeply self-referential and ironic, with the potential for that irony subverting as well as reinforcing classic models of masculine and feminine, sexuality and performance. As a movement that looks backwards even as it looks forwards, it is worthwhile thinking about Imelda Whelehan's caveat about nostalgia:

It is my belief that we have passed into an era of 'retrosexism' – nostalgia for a lost, uncomplicated past peopled by 'real' women and humorously cheeky chappies, where the battle of the sexes is mostly fondly remembered as being played out as if in a situation comedy … Such retrospective envisioning offers a dialogue between the past and the present and is symptomatic of a real fear about a future where male hegemony might be more comprehensively and effectively attacked than has so far been the case.[2]

This dialogue between the past and the present can be identified with some of the more conservative models of steampunk gender, a reimagined time when men were men and women were women. However, no subculture is monolithic, and it is clear from the analysis in the following pages that a thread of contestation regarding gender stereotypes also runs through much steampunk practice.

The material covered in this book is not intended as a comprehensive analysis of steampunk. Rather, it takes key aspects from literature and various forms of media (film, music, art, popular culture) in order to provide a foundation for the critical study of steampunk. Foundational texts such as those by authors like K. W. Jeter (*Infernal Devices, Morlock Night*) William Gibson and Bruce Sterling (*The Difference Engine*) and a host of others (China Miéville, Neil Stephenson, Robert Rankin) have started to attract critical discussion, so my focus here is on work which might resist the privileging of 'hardcore' steampunk and science fiction texts. This is one of the justifications behind the discussion of graphic novels, 'zines, popular music and romances, rather than the traditional sci-fi novel. Whilst this may suggest a diminution of the 'purity' of the subculture, it is important to think about how popular culture intersects with steampunk and how ideas of authenticity are questioned and interrogated. As there have been so few book-length studies of the form, and even less engagement with how gender and sexuality intersect with steampunk, this book represents one of the first of its kind, and hopefully, not the last, in

addressing steampunk from the theoretical perspective of gender. Notable academic studies of steampunk include Roger Whitson's *Steampunk and Nineteenth-Century Digital Humanities: Literary Retrofuturisms, Media Archaeologies, Alternative Histories* (2017), which addresses the material and digital aspects of steampunk culture, with the broader objective of thinking about the rise in nineteenth-century online resources. There have been several edited collections relating to steampunk, as well as coverage in journal articles. For instance, Rachel A. Bowser and Brian Croxall's *Like Clockwork: Steampunk Pasts, Presents and Futures* (2016) covers a number of topics, including steampunk and disability, race and national identity, and different genres such as the graphic novel form, as well as more conventional literary texts. Julie Anne Taddeo and Cynthia J. Miller's *Steaming into a Victorian Future: A Steampunk Anthology* (2013) addresses fashion, romance and erotica, consumerism and subculture, art and design and the role of exhibition. However, none of these texts represent a concerted attempt to engage with the issue of gender representation in the steampunk subculture. Notably this book is also not a sociological study of the steampunk community, though it does consider steampunk iconography and textual/visual practice as manifested within the subculture. The study of steampunk conventions and online forums would be a worthy study in its own right, but this is beyond the remit of the current book. Rather, textual and visual manifestations of the subculture are addressed in this study. For instance, *The Steampunk Magazine* is a publication which can be evaluated as a text written by the community, speaking to (and for) the subculture. In its reviews, articles and illustrations, it offers one definition of the subculture. Alternative definitions or contestations, as well as modes of critique from within the subculture, such as those by artists (Doctor Geof), ultimately point to the problem of demarcation. The nuances of defining steampunk, or what particular texts might be considered steampunk (especially in

addressing figures which participate in several subcultures, such as Emilie Autumn or the Neo-Victorian artwork of Nick Simpson), are therefore multifarious and highly contested. As with all subcultures, it is not an uncomplicated site, and any definition, including in this book, is by necessity partial and provisional.

As with all subcultures, one of the major issues is that of authenticity. Such debates can relate closely to Sarah Thornton's theory of subcultural capital, which can be *objectified* or *embodied*.[3] Being 'in the know' and owning the 'right' books, music or clothing indicate membership of a particular subculture, and for Thornton, is closely correlated with media consumption. She notes that the media is 'a network crucial to the definition and distribution of cultural knowledge. In other words, the difference between being *in* or *out of* fashion, high or low in subcultural capital, correlates in complex ways with degrees of media coverage, creation and exposure.'[4] It is for this reason that the current study has selected material from popular culture, from within the subculture and from the margins of that culture in order to understand better the various definitions of steampunk.

Steampunk texts and motifs

The major objective of steampunk is rewriting history from the vantage point of today (so steam power is an everyday part of society, and the internal combustion engine has never been made), and time is anachronistic or characters are chronologically displaced, whilst science fiction motifs are common. Often (but not always), writers are influenced by early science fiction and gothic writers, such as H. G. Wells, Bram Stoker, Mary Shelley and Jules Verne. In imagining alternative worlds, practitioners often employ intertextuality, self-conscious referentiality and parody: for instance, the trope of the

mad inventor, derived from Mary Shelley's *Frankenstein* (1818) and developed by others such as H. G. Wells in *The Time Machine* (1895), is referenced extensively throughout the genre.[5] Steampunk as a subculture is therefore unusual, as it originated as a literary form, whereas many others, such as goth or punk, emerged as music styles.[6] The author K. W. Jeter is credited with coining the word: in a 1987 letter to science fiction magazine *Locus*, Jeter described his novel *Morlock Night* (1979) as 'gonzo-historical' and suggested the genre, which he suspected would be the next big thing, might be called something like 'steampunk' – as a comedic reference to a variant on 'cyberpunk'. From this, there has been an explosion of novels broadly situated within the steampunk aesthetic: K. W. Jeter's *Infernal Devices* (1987), William Gibson and Bruce Sterling's *The Difference Engine* (1990), James P. Blaylock's *Langdon St. Ives* book series (1986–2015), Tim Power's *The Anubis Gates* (1983) as well as a wealth of other fiction too numerous to be listed here.[7] Crucially, Mike Perschon has observed that the genealogies of steampunk are somewhat flexible and that the message in these early works are not necessarily always countercultural.[8] Whilst I struggle to subscribe to his distinctions between 'political' and 'pulp' (popular fiction also has a political message, however implied or submerged), his complication of the steampunk's literary lineage is a useful starting point.

In steampunk, classic images and narratives include dirigibles, clockwork, mad scientists, Victorian technology developed to an anachronistic degree, adventure narratives and stereotypes of nineteenth-century behavioural codes, including such oddities as tea drinking and duelling. These are fetishized, interrogated and celebrated. Literary characters, like Sherlock Holmes and Mina Harker, as well as historical figures, are borrowed, reconfigured and rewritten. For instance, the mathematician Ada Lovelace, whose father was Lord Byron and whose work with Charles Babbage on calculating machines has only recently gained popular currency, features in

much steampunk literature and cosplay or character performances, as does Queen Victoria, and more broadly, the character of the female adventurer.

In thinking about the links between steampunk, gender and related topics like Neo-Victorianism, we might note that in many instances in the popular imagination at least, Victorian society is seen to be a time of manners, civility and elegance. Neo-Victorian commentators frequently register some caution in the popular appropriation of the Victorian, suggesting our immersion in the nineteenth century is not without idealization or simplification, and this is why the current book uses a Neo-Victorian lens to read these cultural texts. Kate Mitchell observes there is

> the issue of what is involved in this re-creation of history, what it means to fashion the past for consumption in the present. The issue turns on upon the question of whether history is equated, in fiction, with superficial detail; an accumulation of references to clothing, furniture, décor and the like, that produces the past in terms of its objects, as a series of clichés.[9]

Nostalgic desire, the attempt to replicate a prior period of history, is quite plainly a problem in replicating the popular idea of the Victorian period as a time when men were men and women were women. Ideologically and historically, this is a fiction, but there is also the security and stability that such (invented) paradigms invoke, carefully disregarding the many social problems of the period. Women of course did not have the vote and could not own property until the Married Woman's Property Act in 1870 (widows and single women could own property). England in such discourses is constructed as a place of stable values: the Empire and scramble for colonies signified great power across the globe, and the class system ensured everyone had a designated place in the economy. It was also a time of large-scale industrial development (Brunel and the

development of the modern steam train is but one example). During
the Industrial Revolution, steam gradually replaced water or man to
power engines and enabled travel as well as greater and more efficient
industrialization. It also meant the rise of capitalism and commodity
culture, and exploitation on a scale never seen before. Following
the Great Exhibition of 1851, scientific and engineering inventions
promised a quality of life hitherto unimaginable. However, how does
such an account accurately represent the darker side of Victorian
culture (Empire, suppression of women, class dynamics, poverty)?
These issues are central to the material in this book: steampunk
frequently faces charges of replicating colonial paradigms without
any sense of critique: 'The visual vocabulary of imperialism that
dominates steampunk texts and culture (modified pith helmets,
military uniforms and weaponry, maps, the gear and trappings of
space and terrestrial exploration, Asian(-inspired) materials and
costuming) and a certain position toward the Victorian that leaves
in place orientalist structures and understandings of "the East" has
prompted a re-examination of the steampunk archive.'[10] Part of the
problem is the potentially conservative nature of any process which
relates to nostalgia. Ryan Trimm notes that '*heritage* can operate in
post-war Britain as cultural gatekeeping, a selective nostalgia editing
out contemporary multiculturalism'.[11] Steampunk has addressed
this concern at several junctures: Diana M. Pho's and Jaymee Goh's
writing on this subject represents an important critical intervention,
and there are many subgenres devoted to this area, such as silkpunk
and afrofuturism.[12] There are various instances in steampunk where
artists and practitioners attempt to challenge or deconstruct an
imperial narrative (as well as other related hegemonic discourses
such as patriarchy). We can point to the ways in which contemporary
writers have taken all the trappings and trimmings of the nineteenth
century (manners, social mores, fashions, sensibilities), but also added
to these suppressed or devalued narratives. Whether the objective

to rethink Victorian social conventions (of gender, Empire, science, technology) is always successful is quite another matter.

Steampunk and the political context

The 1980s as the evolutionary moment for steampunk is crucial, as recovering 'Victorian values' was foundational to Margaret Thatcher's policies in that decade and was directly referenced in the run-up to the 1983 election.[13] However, as Raphael Samuel has commented, Thatcher's '"Victorian" seems to have been an interchangeable term for the traditional and the old-fashioned, though when the occasion demanded she was not averse to using it in a pejorative sense'.[14] Thatcher railed against a nostalgia for the Industrial Revolution and was entirely unsentimental about some of the great benefits of the period: whilst she cited Adam Smith and John Stuart Mill and consistently voted to restore hanging, she also celebrated high-tech advancement in industry, whilst at the same time rejecting other Victorian ideas, such as paternalism (in central government at least) and philanthropy. This celebration of the sleek high-tech is very much in opposition to much of steampunk's rusty aesthetic. Martin Danahay asserts steampunk encapsulates the fear 'that in a post-industrial society essential human values are threatened by digital technologies and the intensification of commodification in all aspects of life thanks to computer-mediated networks and virtual worlds'.[15] Thatcher's version of the Victorian invoked 'the Puritan work ethic', and others in her party, such as Rhodes Boyson, interpreted her rallying cry as a 'return to strictness'.[16] Part of this context was related to moral anxiety and the notion that 'Britain was becoming ungovernable, in Mrs Thatcher's words, "a decadent, undisciplined society"'.[17] The agitation of feminist protests, the AIDS epidemic, the increase in workers' rights, unionization, multiculturalism, the visibility of

sexual minorities and a fear of welfare claimants as a financial liability contributed to the idea of moral panic, and relatedly, the need for 'Victorian values'. It is worth noting that a related trajectory was discernible in the United States and the Reagan administration, with which Thatcher's government enjoyed a special relationship: 'Like the small town America of Mr Reagan's rhetoric – God-fearing, paternalistic, patriotic – Mrs. Thatcher's Victorian Britain is inhabited by a people living in a state of innocent simplicity ... small businesses and family firms. Work is accorded dignity, achievement rewarded rather than taxed.'[18] Thatcher's Victorian values were based in conventional morality: puritan, old-fashioned, celebrating self-made economic success and personal accountability. Despite being Britain's first female Prime Minister, her reflection on the past is grounded in mythology, or at the very least, a partial version of what the Victorians represented.

I am not saying steampunk and political Conservatism can be conflated: in many instances, political resistance to this model is part of steampunk activity, whilst at the same time emerging in the same chronological moment. Steampunk can be satirized to deflate these very conservative values. For instance, *The Daily Mash* ran a short piece in January 2018 which satirized Jacob Rees-Mogg's pro-Brexit, right-wing values as a steampunk rebellion:

> Rees-Mogg has outlined plans for a post-Brexit Britain of brass automatons, clockwork cars and steam-powered internet.
>
> He said: 'With myself at the helm, we will forge a brave new nation of valves and pumps, of smoked-glass goggles and Tesla coils, of transatlantic tunnels and invincible British airships darkening European skies.
>
> 'Somewhere around 1900, our birthright as a nation was snatched from us. I propose to reset the calendar and do the last hundred years or so properly, with parliament returned to its advisory role and the monarch in absolute power.

'Don't you want your sons to be the first to wear top hats on Mars? Your daughters waited on by a house-robot named Stevens who contains a fully-functioning pipe organ capable of playing eight different hymns?'

Political commentator Eleanor Shaw said: 'This is easily the most coherent vision of post-Brexit Britain we've heard so far.'[19]

Brexit and right-wing rhetoric is certainly a source of steampunk satire, as we will see in Chapter 2. More generally, steampunk's political ambiguity, which looks to the past as well as the future, can speak to today's political concerns, reflecting on the Victorian moment as a period of manners which need to be recovered. This seems part of the more general cultural landscape out of which both steampunk and Thatcher's 'Victorian values' emerged: 'Victorian Britain was constituted as a kind of reverse image of the present, exemplifying by its stability and strength everything that we are not. The past here occupies an allegorical rather than temporal space. It is a testimony to the decline in manners and morals, a mirror to our failings, a measure of absence.'[20] That steampunk design revisits the nineteenth century might also find a reflection in the 1980s, which revived 'period' interiors: Laura Ashley might be a prime example here, whilst Victorian heritage and museums of industry gained greater prominence. It seems possible that the vested interest in the nineteenth century which Thatcher vocalized is part of a great historical moment reflecting upon the Victorians in social life, politics, art and culture, and that steampunk is a part of this process.

A Neo-Victorian subculture?

Steampunk has a number of affinities with the critical practice of Neo-Victorianism, but it is important to acknowledge it has a very different literary lineage and they are not synonymous. As we unlock

the complex way in which steampunk can subvert but sometimes reinforce cultural norms and the nostalgia for older cultures, the relationship between steampunk and Neo-Victorianism needs to be analysed more deeply. Steampunk locates itself, on one level, within some of the tropes outlined within the Neo-Victorian project; in other ways it challenges those tropes. Neo-Victorianism allows for a liminal space in which the Victorian and the contemporary are in constant dialogue, and it is this relationship, founded on continuities, (in) consistencies, tensions and influences, which informs the approach to steampunk found in this book. The best way of approaching steampunk and its relationship to Neo-Victorianism is to use the Neo-Victorian critical lens as a means of reading steampunk material. Elizabeth Ho comments that 'many steampunk authors and participants express their belonging to steampunk through technology ... To forget the "technology level" and focus only on "the Victorian" ... is to do violence to the genre.'[21] It is not simply the recovery of the Victorian but rather a playful approach to historical science and technology. It is entirely possible for a cultural product to be Neo-Victorian, but not steampunk. Despite this, Neo-Victorianism provides a useful critical framework with which to approach this material. The standard definition of Neo-Victorianism often vaunted by critics is from Ann Heilmann and Mark Llewellyn's 2010 study *Neo-Victorianism: The Victorians in the Twenty-First Century*: 'Texts (literary, filmic, audio/visual) must in some respect be *self-consciously engaged with the act of (re)interpretation, (re)discovery and (re)vision concerning the Victorians.*'[22] This definition seems to privilege a particular type of research into culture (they detail the importance of metafiction, postmodernism and metahistoricism), and several critics, including Heilmann and Llewellyn themselves, have widened this definition: 'We have become increasingly alert to the international and global spheres in which the term "neo-Victorianism" is now deployed, or locations and moments in which, to us, there may be trace elements

of potential engagement with the concepts behind neo-Victorianism as a larger global framework for discourses around nostalgia, heritage and cultural memory.[23] Helen Davies has remarked that 'it is worth acknowledging that the temporal and geographical reach of "neo-Victorianism" is neither fixed nor self-evident'.[24] She argues that we have constructed these historical categories and that there is much more fluidity in historical boundaries than we might acknowledge. Perhaps for this reason, many steampunks have a flexible approach to Victorianism. They might borrow from the early twentieth century (as in the case of Doctor Geof and the First World War) or from early nineteenth-century narratives which predate Queen Victoria's accession to the throne in 1837 (Ada Lovelace was born in 1815, for instance). Cora Kaplan's definition of the Neo-Victorian is also more open-ended (though she prefers the term 'Victoriana'). She has noted that '"Victoriana" might have narrowly meant the collectible remnants of material culture in the corner antique shop, but by the late 1970s its reference had widened to embrace a complementary miscellany of evocations and recyclings of the nineteenth-century, a constellation of images which became markers for particular moments of contemporary style and culture'.[25] In many ways, with its focus on material culture, and its understanding of cultural borrowing as a 'miscellany', this might be the most useful definition of Neo-Victorianism to apply to steampunk. Steampunk garners influences from the Victorian period in fashion: top hats, bustles, corsets, frock coats, but subjects these to modern interpretation – the skirts, for instance, are often too short for historical costume. It employs literary parodies and postmodern pastiches, whilst celebrating or offering a critique of the Victorian moment and the present day. The steampunk approach to the nineteenth century is therefore self-conscious in its anachronism and ahistoricism (or combination of different historical themes and tropes), with subgenres such as dieselpunk marking a more twentieth-century aesthetic, whilst others may deploy motifs

from the long nineteenth century, rather than focusing exclusively on Queen Victoria's reign (1837–1901). Whilst Queen Victoria's iconic status in steampunk is noteworthy, equally important is the acknowledgement that her prominence is very much an Anglo-centric experience of history, and other cultures, even in Europe, will have different historical touchstones: many international steampunks, in the United States, Europe or Asia, will present their material differently.

Subculture or pop culture?

Steampunk is also a subculture which is demonstrable in a number of ways: music (bands such as The Men That Will Not Be Blamed for Nothing, Professor Elemental and Ghostfire in the UK, Abney Park, Steam Powered Giraffe, or SPG, and Unwoman in the United States); magazine culture (*The Steampunk Magazine, The Steampunk Literary Review*); films (*Steamboy, Hugo, Adele Blanc Sec*); art (Datamancer, James Richardson Brown, Doctor Geof) and fashion (where we might think about the ubiquity of the corset). In recent years, several exhibitions either have been dedicated to steampunk or have included steampunk elements alongside a broader Neo-Victorian brief: the first of these was held at the Museum of the History of Science, Oxford (2009–2010), whilst a smaller exhibition was hosted by Kew Bridge Steam Museum, London (2011). The Guildhall Art Gallery, London, exhibited 'Victoriana, The Art of Revival' (2013), and 'Longitude Punk'd' was held at the Royal Observatory, Greenwich (April 2014–January 2015). Further north, Discovery Museum, Newcastle upon Tyne, showcased 'Fabricating Histories: An Alternative 19th Century' in 2016–2017. Each of these examples suggests not only the emergence of steampunk in terms of arts and craft but the ways in which the form blurs distinctions between high art, science and the craft movement:

'The "punk" is an important reference to an outsider attitude. In steampunk, this attitude manifests itself in the form of the lone wolf artist, the Do-It-Yourself (DIY) craftsman, and the amateur engineer, who are not beholden to any contemporary style or ideology.'[26] In many ways, this notion of punk coincides with Hebdige's notion of subculture as *bricolage:* 'Basic elements can be used in a variety of improvised combinations to generate new meanings within them.'[27] As a caveat, Hebdige is addressing working-class subcultures and theorizing *bricolage* through Levi-Strauss's argument in *The Savage Mind* (1962). Whilst beyond the scope of this book, it is worth noting that steampunk is often (not always) a middle-class phenomenon. It requires disposable income and leisure time for participation. That said, *bricolage* as a 'theft' or adaptation of prior discourses and sartorial styles is a hallmark of steampunk production.

Steampunk artists often take something from our modern-day culture, such as the computer, and retrofit it or imagine its aesthetic value when invested with nineteenth-century images. A steampunk computer may be fitted with an old typewriter keyboard for an antiquated look. Perhaps the most important example of this work is Datamancer (Richard Nagy), whose website explains: 'The idea was to build a full computer station from every significant artistic decade in history. From Art Deco, to Victorian, and even back to Gothic design. It started with a Victorian style brass keyboard ... which pioneered the idea of typewriter key caps on a modern keyboard.'[28] This combination of modern utility with historical style is a hallmark of steampunk design. Items such as USB sticks are souped up to reflect a Victorian sensibility. These are practical everyday objects, converted to a steampunk aesthetic: wood, brass, cogs, the inner working of machines. Relatedly, Linda Hutcheon has noted that 'as we approach the millennium, nostalgia may be particularly appealing as a possible escape from what Lee Quinby calls "technological apocalypse." If the future is cyberspace, then what better way to

soothe the techno-peasant anxieties than to yearn for a Mont Blanc fountain pen?'[29] What is particularly noteworthy about steampunk is how far it complicates this opposition between progress and reactionary nostalgia. Whilst the aesthetics of steampunk look to an (idealized) science fiction past as well as an alternative future, more broadly, the marketing of arts and crafts in steampunk is dependent upon modern technology, as is the way in which the subculture has evolved as an online network. Many steampunked items are custom-made and marketed through the possibilities allowed by Web 2.0 sites such as Etsy's craft community, promoting as it does an international network of small businesses and collective engagement:

> Web 2.0, as an approach to the web, is about harnessing the collective abilities of the members of an online network, to make an especially powerful resource or service. But, thinking beyond the Web, it may also be valuable to consider Web 2.0 as a metaphor, for any collective activity which is enabled by people's passions and becomes something greater than the sum of its parts.[30]

Thus part of the idea of collectivity and subculture in steampunk is communicated via very modern technology, whereas prior subcultures, such as punk or goth, originally had to rely on analogue methods. Steampunk imagery and photography are visible on sites such as Instagram, Pinterest and Tumblr, whilst eBay represents one example of steampunk shopping online. However, such a neat binary between analogue and digital is complicated by such developments as the detective drama/comedy *Victoriocity* (2017), a podcast set in an alternative 'Greater London'.[31] Whilst the show explores typical issues as the emancipation of women (in the first episode, our heroine, Clara, has an argument with her mother about undertaking remunerative employment), clockwork invention, the industrial cityscape and its inherent social problems, the show is also noteworthy because podcasts involve listening – typically associated with analogue

technologies like radio. At the same time, however, podcasts are emphatically modern, being launched on platforms like iTunes and available for listening via mobile phone.

The emphasis on art and craft has also prompted a number of publications influenced by the community's DIY ethos. Sarah Skeate and Nicola Tedman's *Steampunk Softies* (2011) is one such example among many: plush toy designs (with individual narratives) are provided for readers to make for themselves: 'Each has his or her part to play in the past-that-never-was that is the essence of steampunk.'[32] These include 'Charity Storm', an aviatrix, and 'Minerva Dupine', a detective, each revealing the possibilities for female characters in the steampunk craft movement. The revival of retro baking and groups affiliated to the Women's Institute such as 'Buns and Roses' have also influenced steampunk in the emergence of recipe books.[33] For instance, *Steampunk Tea Party* has a wide range of jams, cakes and decorative food themed around the subculture. However, and perhaps surprisingly, the recipe book features vintage-style photography in which men and women (of different ethnicities) delight in the ceremony of afternoon tea, although the stories accompanying the menu are gendered in more traditional terms.[34]

The notion of 'punk' is also one of the most discernible ways that steampunk emerges as a subculture. Dick Hebdige, writing in the 1970s, has identified subcultural style as 'intentional communication'. He explains, '[i]t stands apart – a visible construction, a loaded choice. It directs attention to itself; it gives itself to be read. This is what distinguishes the visual ensembles of spectacular subcultures from those favoured in the surrounding culture(s). They are *obviously* fabricated ... They *display* their own codes.'[35] Whilst Hebdige has been heavily revised among subcultural theorists, his idea of a 'spectacular subculture' is relevant to any discussion of steampunk. There is a focus on visual signifiers, especially in the sartorial style which comprises steampunk subculture. This notion of display is central to steampunk

ideas of belonging: whether it is expressed through top hats, bustles, corsets, military weaponry or many other examples of the aesthetic, the steampunk participant registers their affiliation to the subculture through style. This model has been rendered more complex by various theories of postmodern elective identities in subcultures, and this will be discussed in more detail with reference to Emilie Autumn, who constructs her persona through several different subcultural styles (see Chapter 3).

The idea of spectacle also influences many steampunk gatherings and festivals. These are international, ranging from Steamathon in Las Vegas, the Steampunk World's Fair in New Jersey (United States), markets in Leeds and Haworth (UK), steampunk fringe events and bands at Goth festivals such as Wave Gotick Treffen in Leipzig (Germany), Whitby Goth Weekend (UK) with a steampunk weekend in Whitby in July, 'A Splendid Day Out' in the seaside town of Morecambe, usually in October, and perhaps most notably, the Asylum Steampunk Festival in Lincoln (UK) which began in 2009. As referenced earlier, in 2011, the Asylum featured an Empire Ball, and also included a costume parade, with the objective in terms of sartorial style gesturing towards inclusivity, combined with quite clear distinctions between the festival and everyday society:

> We would suggest that people do try to be as steampunk as they feel happy with however since 'normal' may feel distinctly out of place … If someone is new to steampunk and only has regular street clothes this is not a problem at all. (Jeans and t-shirts are usually very very noticeable in their absence however.) If you are not going to dress 'steampunk' may we gently suggest that Friday night and Saturday day you wear whatever you do normally and for the Ball think of it as if you were invited to your eccentric cousin's wedding.[36]

Indeed, in January 2013, Margi Murphy in *The Independent* heralded steampunk as 'Britain's latest fashion craze'.[37] There is a steampunk bar

in Prague, with browns and burnished orange décor, whilst menus are in sepia tones, and cogs feature everywhere, including on the napkins and sugar packets.[38] Certainly Justin Bieber's music video for 'Santa Claus is Coming to Town' (2011) shows all the staples of steampunk culture – a clockwork, corseted woman, hooped skirt, waistcoats, brass and machinery, and steampunk makers were involved in the production of props.[39] This co-option of the imagery of steampunk has resulted in a resistance from the subculture. Robert Brown ('Captain Robert'), lead singer with the steampunk band Abney Park, has sought to distinguish the 'authentic' steampunk community from perceived commodification: 'I'm fairly annoyed by people dressing Steampunk, then making music with zero vintage in the sound, and calling themselves Steampunk music makers […]. There are also a ton more clones these days. Cosplayers playacting they are Steampunks in a hotel lobby. People, instead of being their own original interpretation on Steampunk, show up looking almost identical to everyone else.'[40] Indeed, the YouTube video phenomenon of 'Just Glue Some Gears On It (And Call It Steampunk)' castigates how it has become a 'trendy fashion' dissociated from its 'correct' definition of 'retrofuturism', or science fiction in an alternative past often set in Victorian England.[41] This tension is all fairly standard fare in terms of subcultural studies, which frequently address participants' ideas of belonging, demarcation and the policing of boundaries. However, in her recent study *Post-Millennial Gothic*, Catherine Spooner notes that 'one of the things that interests me most about the relationship between Goth subculture and Gothic culture is what happens when Goth images or aesthetics enter the mainstream, or are appropriated by cultural producers and audiences who are not current participants in the subculture'.[42] This book follows a similar trajectory in addressing the images or cultural products associated with steampunk, informed by their origins in the subculture. It seems that the popularization of steampunk motifs complicates any strict

distinction between subculture and the mainstream. Therefore, this argument hinges on the ways in which the iconography and themes of the (steampunk) subculture have been employed and play out in wider popular culture.

It is this popular cultural interest in the steampunk form which is most visible in TV coverage, such as the reality TV show *Steampunk'd* (2015), produced by Pink Sneaker Productions and initially premiered on the Game Show Network. The show featured judges such as the model Kato and the burlesque artist Dita von Teese, as well as makers from the community, who each week designed a room from junkyard salvage. Whilst the show was hardly a runaway success, the marketing of the show accords with the sensationalism of many aspects of contemporary culture. Several tweets from the *Steampunk'd* account identify how women are aligned with some fairly stereotypical ideas of femininity: the subject of many tweets featuring women (including the presenter Jeannie Mai) include makeup tips, fashion and 'steamy' outfits. One exception, a tweet about Kato's steampunk gun, nonetheless reveals a very feminine midriff, representing the limitations of women's representation in the subculture, in that sexual appeal is at the forefront of marketing strategy. Conversely, Ralph Lauren's 2008 Spring Ready-to-Wear Collection shows the influence of Neo-Victorian and steampunk aesthetics and some complication of gendered signifiers: one female model sports a bowler hat and skirt, whilst others wear riding costumes, top hats and dandy pinstripes, all of which borrow from 'masculine' historical wear. Thus, steampunk and its popularization doesn't always mean a recourse to traditional gendered values. As observed later in this book, models of steampunk character and performance seem to allow for free play in terms of gender: women might be inventors, for instance, but there is much that is still very conventional. The navigation of this ambiguity might be best articulated through one particular staple of the steampunk wardrobe: the corset. As a number of commentators have noted, the

corset is a particularly ambiguous and elusive sartorial item, imbued
with a number of potentially contradictory and ideologically complex
cultural codes. Leigh Summers notes, 'there has been no sustained
feminist criticism of the corset's role in constructing and enforcing
the private realm of womanhood. The corset remains profoundly
under-theorized, though it is potentially the most illuminating icon
of the Victorian era, heavily pregnant with feminine metaphors and
associations, unavoidably steeped in and expressive of Victorian
female sexuality and its subordination'.[43] Historically, the corset's
chief aim was to constrict the female body in order that it may
correspond to the Victorian ideal of feminine decency and decorum:
the female body was unruly and needed careful regulation by
sartorial intervention. By contrast, whilst the corset provided such
control, it also accentuated the sexual characteristics of the female
form: the breasts, the waist, the hips and the buttocks. In this way, it
is a garment of conflicting ideological codes which mirrors the social
containment of women: it enforces submissiveness to patriarchal
discourses of medicine, but also offers a way to resist such oppression
through the public (rather than private) spectacle of underwear
as outerwear. Corsets were, as commodities which were a form of
underclothing, permeated with female sexuality and thus skirt the
parameters of public decency.[44] By representing an invitation to
observe the most intimate scene of the boudoir and of female dress,
conventionally reserved for the marriage bed, corsets present an
immensely private experience in public, one which was traditionally
reserved for the eyes of one's husband. Similarly in contemporary
subcultural fashion, the corset is somewhat unstable. Whilst feminist
commentators have worried the co-option of the corset signifies a
backlash against feminism and a recourse to traditional femininity,
Valerie Steele identifies the problem of viewing the corset 'in terms
of oppression versus liberation, and fashion versus comfort and
health. Corsetry was not one monolithic, unchanging experience

that all unfortunate women experienced before being liberated by feminism. It was a situated practice that meant different things to different people at different times'.[45] In her book *Fetish*, Steele remarks that wearers of the corset are diverse. Some people associate the item with femininity, whilst others are invested in an aesthetic ideal, and still others correlate corsets with erotic pleasure and BDSM practice. The notion of submissive femininity is thereby complicated by the association of the corset with the dominatrix.[46]

If we approach the performance of steampunk in this light, the corset becomes a commentary on the gendering of fashion. The steampunk corset, whilst often made of leather and metal, with brass accoutrements testifies to the persona of a female adventurer: a representation of the breastplated, armoured body, rather than the wispy satins and silks of traditional feminine historical attire. The distinctly more practical, but for Victorian sensibilities, eminently disreputable, short skirts and big boots in steampunk signify the combination of the modern punk with the historical, or 'the Victorian period gone wrong'.[47] Indeed, as Steele continues, 'once the punks adopted fetish corsets as a defiantly perverse statement, it became increasingly possible to interpret at least some corsets as an ironic, postmodern manipulation of sexual stereotypes'.[48]

The popularization of steampunk, and its uneasy relationship with consumerism and commodity, also testifies to much research already undertaken into other subcultures. Paul Hodkinson's landmark study on goth maintains that festivals are a key source of consumerism: he suggests that non-local sites of consumption indicate 'a significant degree of self-generation for the goth scene, [but] such internal consumption, far from being anti-commercial, was also enabled by the diverse free-market economy within which the subculture operated'.[49] A similar function may be established for steampunk, with maker markets, festivals and fairs all contributing to a subcultural economy and circulation of capital. David Muggleton has argued

that 'it is precisely through the desire to give free reign to creative self-expression and promote the values of play and pleasure that the counterculture is highly complicit with the central capitalist values of entrepreneurial individualism and consumer creativity'.[50] With an emphasis on individuality and DIY maker culture, it is possible that subcultures such as steampunk may be co-opted by the mainstream or at least become complicit with mainstream values. This is of course very much at odds with the declared 'punk' ethos of some steampunks. Margaret Killjoy, the editor of *The Steampunk Magazine* and steampunk anarchist, has elaborated on the way in which popularization of the subculture has also meant depoliticization:

> So … with the increased popularity of steampunk came the increased isolation of the radical theoretical/political/social themes within steampunk. Mainstream society has a tendency to pick up on the surface level aspects of an aesthetic and ignore the theory and practice which lead to those surface level choices. Keep the goggles, ditch the anti-imperialism and certainly the anarchy. That didn't sit well with me. Personally, I stuck it out for awhile, because there are and always will be interesting corners within steampunk, and I wanted to help expand those corners and make sure they continued to exert an influence over the culture at large. But it burned me out and I stepped away. Especially once things are reduced to their surface-level aesthetics, they become stifling to creativity and cannot allow for the full breadth of life.[51]

Steampunk: Gender, Subculture and the Neo-Victorian seeks to navigate these issues: the ways in which the subculture can be popularized or overlaps with other forms (such as goth or the anti-establishment message of punk); how far gender and sexuality can remain radical in such a climate; in what ways steampunk is complicit with, or a challenge to, Empire and its associated gendered dynamics; and how far the movement constitutes a self-conscious revision of the Victorians themselves. In doing so, it does not aim to

provide an exhaustive account but rather facilitate discussion about steampunk, its antecedents and its future.

Chapters in this book

Whilst each of these chapters function as stand-alone essays on a particular aspect of steampunk culture, they are nonetheless united by the use of steampunk to provide an analysis of the performance of gender, a critique of imperialist discourses and a space in which to interrogate sexuality. Chapter 1 addresses the role of *The Steampunk Magazine* in constructing the notion that the subculture is a radical space of progressive politics. As a collective enterprise, the magazine not only represents some of the key ideas in steampunk practice but also intersects with gender at various points. Similarly, the chapter looks at the steampunk band The Men That Will Not Be Blamed for Nothing, and argues that their song lyrics, as well as their iconography, is at least partly able to solidify one strand of steampunk as a resistant culture. Through interviews with key participants in the US steampunk community (Margaret Killjoy and Steampunk Emma Goldman), this chapter also evaluates the ways in which intersectionality is represented, whilst drawing on theories from zine culture to elaborate how far politics of the movement can be considered radical. Chapter 2 takes one of the UK's most prominent artists on the steampunk scene, Doctor Geof, as well as the Neo-Victorian photographer and artist Nick Simpson and explores their artwork in relation to gender. Doctor Geof's work is a challenge to the idea of a jingoistic and imperialistic masculinity. His frequent parodies of First World War propaganda registers a critical intervention in the rhetoric of war as inherently heroic, whilst his concept of the 'Tea Referendum' provides a critique of nationalistic and hypermasculine British politics during the European Referendum in 2016. At the same time, his scientific and maritime

pieces frequently revise the invisibility of women in such disciplines, whilst his parody of pornography satirizes the gender relations of the contemporary moment, as well as historical and specifically Victorian moral codes. Following on from this analysis, Chapter 3 looks at the musician Emilie Autumn, in terms of the relationship between goth and steampunk, and interrogates how far the use of spectacle and sensationalism in her burlesque stage shows, lyrics and novel shore up the stereotypical notion of female madness and alternative sexualities as inherently deviant. Chapter 4 looks at the ways in which the graphic novel as a visual medium has also provided a number of challenges to conventional gender dynamics, and relatedly, the hypermasculinity of English imperialism. Alan Moore's and Kevin O'Neill's *The League of Extraordinary Gentlemen* (1999) is an obvious choice here, given the visibility of Mina Murray as the leader of this band of (anti)heroes. Moore's dissatisfaction with the film adaptations of his work is well established, as are his anarchist sympathies. Thus the chapter will also address the film version of *The League of Extraordinary Gentlemen* (2003) and look at the ways in which the gender dynamics of the film differ in adaptation from the graphic novel. The chapter will also consider Bryan Talbot's graphic novel series *Grandville* (2009–2017). Presenting an anthropomorphic badger hero in the role of Inspector LeBrock (derived in part from Sherlock Holmes), Talbot represents and interrogates our ideas of Neo-Victorian masculinities through parody, satire and intertexuality. Chapter 5 takes the conventionally 'feminine' genre of the romance novel and looks at how such popular fiction has provided a platform for steampunk themes and tropes. Gail Carriger's series 'The Parasol Protectorate' (2009–2012) and Katie MacAlister's *Steamed* (2010) provide the case studies here, ultimately suggesting that whilst romance fiction provides a fantasy space for women readers, the tropes and narrative arc of romance fiction inhibit the potential for more radical interventions in gender and sexuality, as well as diminishing real-world concerns, such as

women in science. This is perhaps one of the most troubling aspects of the material selected here: it seems that these retrograde texts are also those which are more commercial and often aimed at a female audience. The tendency in steampunk seems to be that men find more opportunity for innovation in terms of gender stereotypes, and part of this phenomenon may relate to the fact that steampunk is a relatively young subculture, and role models for women are still emerging. The overall aim of the book is therefore to consider the ways in which steampunk has materialized in subcultural and popular cultural forms and how different genres navigate the issues of gender and sexuality.

Notes

1 For a useful discussion of the history of technology from the Industrial Revolution, see David Edgerton, *The Shock of the Old: Technology and Global History since 1900* (London: Profile, 2006), pp. 2ff.

2 Imelda Whelehan, *Overloaded: Popular Culture and the Future of Feminism* (London: The Women's Press, 2000), p. 11.

3 Sarah Thornton, *Club Cultures: Music, Media and Subcultural Capital* (Cambridge: Polity, 1995), p. 11.

4 Thornton, *Club Cultures*, 14.

5 For discussion of how the gothic intersects with steampunk, see Gail Ashurst and Anna Powell, 'Under Their Own Steam: Magic, Science and Steampunk', in *The Gothic in Contemporary Literature and Popular Culture*, ed. Justin Edwards and Agnieszka Monnet Soltysik (Abingdon: Taylor and Francis, 2013), pp. 148–164. For an exploration of science fiction and utopia, see Fredric Jameson, *Archaeologies of the Future: The Desire Called Utopia and Other Science Fictions* (London: Verso, 2007).

6 See Dick Hebdige, *Subculture: The Meaning of Style* (London: Routledge, 1979).

7 More contemporary steampunk authors would include, but not limited to, the following: Cherie Priest, China Miéville, Paolo Bacigalupi,

G. W. Dahlquist, Neal Stephenson, Robert Rankin, Scott Westerfeld and a host of others.

8 See 'Seminal Steampunk: Proper and True', from *Like Clockwork: Steampunk Pasts, Presents and Futures,* ed. Rachel A. Bowser and Brian Croxall (Minneapolis: University of Minnesota Press, 2016), p. 156. See also Rebecca Onion, 'Reclaiming the Machine: A Look at Steampunk in Everyday Practice', *Neo-Victorian Studies* 1:1 (2008), 138–163, 139–141.

9 Kate Mitchell, *History and Cultural Memory in Neo-Victorian Fiction: Victorian Afterimages* (London: Palgrave, 2010), p. 3. See also 'Nostalgia and Material Culture', by Anne Enderwitz and Doris Feldmann in *Neo-Victorian Literature and Culture: Immersions and Revisitations* ed. Nadine Boehm-Schnitker and Susanne Gruss (Abingdon: Routledge, 2014), pp. 51–63.

10 Elizabeth Ho, *Neo-Victorianism and the Memory of Empire* (London: Bloomsbury, 2012), p. 148.

11 Ryan Trimm, *Heritage and the Legacy of the Past in Contemporary Britain* (New York: Routledge, 2018), p. 20.

12 See Diana M. Pho's blog, https://beyondvictoriana.com/, and Jaymee Goh's http://silver-goggles.blogspot.com/ [accessed 18 September 2018] as an introduction to multicultural steampunk.

13 Raphael Samuel, 'Mrs. Thatcher's Return to Victorian Values', *Proceedings of the British Academy*, 78 (1992), 9–29, 9. See also Trimm, *Heritage and the Legacy of the Past in Contemporary Britain*, especially Chapter 6, which discusses the ways in which Thatcher's government employed a 'politics of heritage', p. 156.

14 Samuel, Mrs. Thatcher's Return to Victorian Values, 9.

15 Martin Danahay, 'Steampunk as a Postindustrial Aesthetic: "All That Is Solid Melts in Air"', *Neo-Victorian Studies* 8:2 (2016), 29.

16 See Samuel, Mrs. Thatcher's Return to Victorian Values, 12.

17 Samuel, Mrs. Thatcher's Return to Victorian Values, 15.

18 Samuel, Mrs. Thatcher's Return to Victorian Values, 18.

19 Anon, 'Rhys-Mogg launches steampunk revolution', http://www. thedailymash.co.uk/politics/politics-headlines/rees-mogg-launches-

steampunk-revolution-20180126143249, 26 January 2018 [accessed 26 January 2018].

20 Samuel, Mrs. Thatcher's Return to Victorian Values, 18.

21 Ho, *Neo-Victorianism and the Memory of Empire*, 145–146.

22 Ann Heilmann and Mark Llewellyn, *Neo-Victorianism: The Victorians in the Twenty-First Century* (Basingstoke: Palgrave, 2010), p. 4.

23 Mark Llewellyn and Ann Heilmann, 'The Victorians Now: Global Reflections on neo-Victorianism', *Critical Quarterly* 55:1 (2013), 24–42, 24.

24 Helen Davies, *Neo-Victorian Freakery* (Basingstoke: Palgrave, 2015), p. 4.

25 Cora Kaplan, *Victoriana: Histories, Fictions, Criticism* (Edinburgh: Edinburgh University Press, 2007), pp. 2–3.

26 Art Donovan, *The Art of Steampunk* (East Petersburg: Fox Chapel, 2011), p. 24. See also Sally-Anne Huxtable, '"Love the Machine, Hate the Factory": Steampunk Design and the Vision of a Victorian Future', in Taddeo and Miller, pp. 213–233, for a discussion of steampunk as correlated with the Arts and Crafts Movement of the nineteenth century.

27 Hebdige, *Subculture*, p. 103.

28 See https://datamancer.com/about/ [accessed 10 August 2017].

29 Linda Hutcheon, 'Irony, Nostalgia and the Postmodern', http://www.library.utoronto.ca/utel/criticism/hutchinp.html (1998) [accessed 18 September 2017], citing Lee Quinby, *Anti-Apocalypse: Exercises in Genealogical Criticism* (Minneapolis: University of Minnesota Press, 1994), p. xvi.

30 David Gauntlett, *Making Is Connecting: The Social Meaning of Creativity, from DIY and Knitting to YouTube and Web 2.0* (London: Polity, 2011), p. 7.

31 For further details, see the Victoriocity website: https://www.victoriocity.com/ [accessed 2 December 2017].

32 Sarah Skeate and Nicola Tedman, *Steampunk Softies: Scientifically-Minded Dolls From a Past that Never Was* (Lewes: Ivy Press, 2011), p. 4.

33 For 'Buns and Roses', see http://www.bunsandroses.co.uk/ [accessed 25 August 2017].

34 Jema 'Emily Ladybird' Hewitt, *Steampunk Tea Party* (Cincinnati: David and Charles, 2013). Perhaps predictably, the engineers, scientists and admirals are men, though on occasion, women feature as soldiers – see p. 74. Ada Lovelace and Mary Shelley also make an appearance – see p. 31.

35 Hebdige, *Subculture*, p. 101.

36 Weekend at the Asylum, 'Dress and Etiquette' Guide (2011).

37 http://www.independent.co.uk/life-style/fashion/news/steampunk-introducing-britains-latest-fashion-craze-8458861.html [accessed 9 August 2017].

38 My thanks to Joel Heyes for drawing my attention to this. See http://steampunkprague.cz/ for further information [accessed 10 August 2017].

39 Ian Finch-Field of SkinzNhydez made the steampunk gauntlet Bieber wears in the music video, released for the film *Arthur Christmas* (2011). See https://www.etsy.com/uk/shop/SkinzNhydez [accessed 9 August 2017].

40 Jeff Vandermeer and Desirina Boskovich, *The Steampunk User's Manual* (New York: Abrams, 2014), p. 202.

41 Reginald Pikedevant, 'Just Glue Some Gears On It (And Call It Steampunk)', https://www.youtube.com/watch?v=TFCuE5rHbPA (2011) [accessed 17 July 2018].

42 Catherine Spooner, *Post-Millennial Gothic: Comedy, Romance and the Rise of Happy Gothic* (London: Bloomsbury, 2017), p. 21.

43 Leigh Summers, *Bound to Please: A History of the Victorian Corset* (Oxford: Berg, 2001), p. 2. See also Jenny Sundén, 'Clockwork Corsets: Pressed against the Past', *International Journal of Cultural Studies* 18:3 (2015), 379–383.

44 See Garry Leonard, 'Joyce and Advertising: Advertising and Commodity Culture in Joyce's Fiction', in *James Joyce Quarterly* 30: 4–31 (1993), 1, 586.

45 Valerie Steele, *The Corset: A Cultural History* (New Haven, CT: Yale University Press, 2001), p. 1.

46 Valerie Steele, *Fetish: Fashion, Sex, and Power* (New York: Oxford University Press, 1996), p. 63.

47 James Richardson-Brown (Sydeian) first explained steampunk thus in a conversation in 2011 at the Asylum in Lincoln.

48 Steele, *The Corset*, 174.

49 Hodkinson, *Goth: Identity, Style and Subculture* (Oxford: Berg, 2002), p. 139.

50 David Muggleton, *Inside Subculture: The Postmodern Meaning of Style* (Oxford: Berg, 2000), p. 51.

51 Margaret Killjoy, Personal Interview (via email), 28 July 2017.

Steampunk: The Politics of Subversion?

Introduction

Steampunk is an equivocal discourse. Many practitioners maintain that the movement espouses an aesthetic radicalism which is inherently resistant to mainstream values and which expresses itself in a subculture through material objects, fashion, art, film, literature and other instantiations of popular culture.[1] In 'A Steampunk Manifesto', Jake von Slatt suggests that steampunk practice is a contestation of contemporary mainstream culture. He explains:

> The only future we are promised is the one in development in the corporate R&D labs of the world. We are shown glimpses of the next generation of cell phones, laptops, or MP3 players. Magazines that used to attempt to show us how we would be living in fifty or one hundred years, now only speculate over the new surround-sound standard for your home theater, or whether next year's luxury sedan will have Bluetooth as standard equipment.[2]

This focus on aesthetic resistance acknowledges the rejection of consumerism, alongside, as the manifesto explains later, 'the politically and environmentally aware Steampunk'.[3] However, whilst the declared resistance to commodity culture is self-evident here, it is difficult to discern how von Slatt's utopian vision of 'choosing to own a very few

fine things rather than closets of mass-produced goods' isn't also a party to privileged ideas of wealth, leisure time and indeed, a partial vision of the Victorian period.[4] Von Slatt references how steampunk's focus on 'disruptive technologies' can offer us lessons in the climate of the oil crisis and the evolution of labouring economies of China and India. What is less apparent, in this comparison, is how far the Victorian period was in itself foundational to mass-market production, but more importantly, how the Industrial Revolution and its associated technologies, valorized here as a solution to contemporary threats of apocalypse, were also responsible for grand-scale inequalities in terms of social class, gender and the rights of the worker. This steampunk fantasy of a-past-that-never-was seems curiously partial in its appraisal of the history upon which it draws.[5] It is also important to note that steampunk politics discussed in this section, whilst broadly left of centre, are not reflective of an organized political policy as such, and this is part of the indeterminacy of steampunk which this book seeks to explore. The steampunk semiotics of refusal, insofar as aesthetics are concerned, is less about the policymaking of government and more about what Hebdige refers to as a 'symbolic violation of the social order'.[6]

However, other steampunk manifestos seem quite emphatically embedded in challenging the romanticism of this vision, presenting a steampunk which maps an awareness of the inequalities of the past onto the present and contests both of these social problems. *The Steampunk Magazine* is a foundational publication in this respect. The opening article of the first issue, 'What, then, is steampunk?', articulates this most forcefully:

> Ours is not the culture of Neo-Victorianism and stupefying etiquette, not remotely an escape to gentlemen's clubs and classist rhetoric. It is the green fairy of delusion and passion unleashed from her bottle, stretched across the glimmering gears of rage.

We seek inspiration in the smog-choked alleys of Victoria's duskless Empire. We find solidarity and inspiration in the mad bombers with ink-stained cuffs, in whip-wielding women that yield to none, in coughing chimney sweeps who have escaped the rooftops and joined the circus, and in mutineers who have gone native and have handed the tools of their masters to those most ready to use them.[7]

This argument puts the injustices of Victoria's reign – women's rights, Empire, class distinctions, working children and poverty – at the forefront of steampunk practice and aligns steampunk with the outsider in the nineteenth century. The 'whip wielding women' (whilst being suggestively sexual) possibly refers to suffragette figures like Emily Wilding Davison, who famously attacked a vicar with a dog whip in 1913, mistaking him for the Prime Minister, Lloyd George.[8] Sympathy with 'mad bombers' is likely a gesture towards anarchist agitation in the period and perhaps specifically references the Greenwich Observatory bombing of 1894 (immortalized in Joseph Conrad's 1907 novel, *The Secret Agent*). The magazine presents itself as an activist publication, and this version of steampunk is aided by its publication context, its status as an online zine and its political content. Similarly, The Men That Will Not Be Blamed for Nothing (hereafter abbreviated to TMTWNBBFN) align themselves with the underdog of Victorian culture. This steampunk band not only addresses the histories of inventors, scientists and visionaries (Brunel, Stephenson, Darwin, Curie) but explores the steaming underbelly of Victorian society: the poverty stricken but morally bankrupt 'baby farmers': aberrant women who reject their traditional gendered role and who are in many ways monsters fostered by the insatiable greed of capitalism. Exploring this underground Victorian culture suggests a corrective to some of the more polite versions of steampunk which focus on aesthetic revolution to the detriment of activism.

'We stand with the traitors of the past as we hatch impossible treasons against our present.' *The Steampunk Magazine* (2007–2013)

One of the most compelling facts about steampunk is that despite its emphasis on material, tactile culture, its visibility online (through maker websites like Etsy, community forums such as 'Brass Goggles', online publications such as *The Steampunk Journal* and designated groups on Facebook, among many other sites and forums) mean that steampunk's digital footprint is extensive, as is now common to many subcultures. Indeed, in many ways, *The Steampunk Magazine* participates in constructing and maintaining the imagined subcultural community of steampunk. In his definitive statement on nationalism, Benedict Anderson maintains that '[the nation] is an imagined political community … because the members of even the smallest nation will never know most of their fellow-members, meet them, or ever hear of them, yet in the minds of each lives the image of their communion'.[9] These subcultural communities function in a similar way. Relatedly, Paul Hodkinson has discussed the role of online participation in relation to goth, stating that the web functions to

> reinforce the boundaries of the grouping. The key general point here is that regardless of the number of individuals online, the internet does not, in practice, function as a singular mass medium but rather as a facilitating network which connects together a diverse plurality of different media forms … resources and forums on the internet functioned to facilitate the subculture as a whole through providing specialist knowledge, constructing values, offering practical information and generating friendships.[10]

The tension between material, tactile culture and virtual community is foregrounded in how *The Steampunk Magazine* navigates virtual

and material cultures. It is a broadly anarchist publication which is available for free online or to purchase as a physical publication.

The Steampunk Magazine was initially published in 2007 and remains one of the best examples of politically resistant steampunk practice. It is closely aligned to anarchist politics, and more specifically, anarcho-feminism (as witnessed in material by Miriam Roček – otherwise known as Steampunk Emma Goldman). If *The Steampunk Magazine* explores an alternative future influenced by a fictional nineteenth-century past, then it also aligns itself with iconoclastic politics. This is foregrounded in the first issue of *The Steampunk Magazine*, in the article by The Catastrophone Orchestra and Arts Collective (discussed above). As a manifesto to steampunk practice, this article situates itself against an uncritical nostalgia which replicates the Victorian age without any political critique. The collective suggests that 'steampunk rejects the myopic, nostalgia-drenched politics so common among "alternative" cultures … Too much of what passes as steampunk denies the punk, in all its guises'.[11] This also summarizes the ethos of magazine very effectively. *The Steampunk Magazine* lasted for nine issues and delivered interviews with writers, such as Michael Moorcock and Alan Moore, as well as musicians and bands like Ghostfire, The Men That Will Not Be Blamed for Nothing, Dr Steel and Unwoman (some of whom will be discussed below). The magazine also published original fiction and poetry on steampunk themes, but a large part of the publication was comprised of non-fiction articles, including descriptions of the subculture, lifestyle advice, and hints and tips for makers and DIY practitioners (for instance, 'It Can't All Be Brass, Dear: Paper Maché in the Modern Home', 'Sew an Aviator's Cap', 'Sew Yourself a Lady's Artisan Apron'). At the heart of many articles is an incendiary plan to revolutionize society ('The Courage to Kill a King: Anarchists in a Time of Regicide', 'Nevermind the Morlocks: Here's Occupy Wall Street', 'On Race and Steampunk: A Quick Primer', 'Riot Grrls,

19th Century Style'). Notably, many of these articles give a feminist
perspective which is diametrically opposed to conventional ideas
of gender and sexuality. In 'The Steampunk's Guide to Body Hair',
the reader is enjoined that 'in regards of the growing or shaving of
body hair, people of all genders ought to feel free to do either', whilst
one article by Miriam Roček (aka Steampunk Emma Goldman)
contests 'the fascism in fashion'.[12] Part of this also reflects the ethos
of the publication more generally. Spearheaded by Margaret Killjoy
(a trans woman with anarchist sympathies), the magazine's DIY and
alternative credentials put it squarely in the zine tradition. As Michelle
Liptrot has argued in her discussion of British DIY punk, '[in] the Do-
It-Yourself (DIY) self-production ethic of 1970s punk … participants
followed in the DIY tradition of jazz, skiffle and the sixties counter-
culture to produce their own music, visual style and media (in the
form of fanzines)'.[13] DIY functions in punk, and in steampunk, as a
locus of autonomy, egalitarianism and self-definition from within the
community. Before moving on to the content of the magazine, this
chapter will explore the ways in which it shares many characteristics
with zines and the online equivalent, e-zines (electronic fanzines).

In his definitive guide to zine culture, *Notes from Underground*,
Stephen Duncombe describes the zine as follows: '[it] might start with
a highly personalized editorial, then move into a couple of opinionated
essays or rants criticizing, describing, or extolling something or other,
and then conclude with reviews of other zines, bands, books, and so
forth'.[14] At first glance, this doesn't seem to represent *The Steampunk
Magazine*. What distinguishes a zine from other publications,
Duncombe continues, is the pirating of material and 'unruly cut-and-
paste layout, barely legible type, and uneven reproduction'.[15] Given its
expert visual presentation and page layout, *The Steampunk Magazine*
seems, at least initially, to be quite far removed from this description.
However, zines are also 'independent and localized, coming out
of cities, suburbs and small towns across the US, assembled on

kitchen tables ... defining themselves against a society predicated on consumption, zinesters privilege the ethic of DIY, do-it-yourself: make your own culture and stop consuming that which is made for you'.[16] Duncombe notes that zines emerged as a medium from science fiction fandom in the 1930s and exploded in the mid-1970s: 'The only defining influence on modern-day zines began as fans of punk rock music, ignored by and critical of mainstream music press, started printing fanzines about their music and cultural scene.'[17] Dick Hebdige concurs with this assessment: 'Fanzines ... were journals edited by an individual or a group, consisting of reviews, editorials, and interviews with prominent punks, produced on a small scale as cheaply as possible, stapled together and distributed through a small number of sympathetic retail outlets.'[18] The graphics used coincided with punk ethos, being anarchic, cut-and-paste affairs, whilst the prose style was littered with billingsgate obscenities, mistakes and grammatical errors. Underground publications are defined here as anti-establishment and emphatically political, usually edited and produced by one individual or a small collective. These publications resist commercialization and commodity culture and are often given away rather than sold or offered to readers very cheaply. One of the first commentators on the medium, Fredric Wertham, suggests that zines have commonality with underground presses and little magazines, and he argues that despite possible differentiation, there is 'fluidity in the boundaries of these publications'.[19] It is within those interstices that I wish to situate *The Steampunk Magazine*.

Given the advent of the internet, zines now proliferate in a way hitherto unimagined and reach global audiences, rather than a localized readership. Duncombe explores this development by addressing how zinesters have always co-opted new technology for their own ends: 'Perhaps the only thing that separates a zine from all these new forms of computer-mediated communication is the medium. Zines have always been more than just words or images on

paper: they are the embodiment of an ethic of creativity that argues that anyone can be a creator.'[20] Whilst Duncombe also concedes that 'there's something missing from the blogs, the fan sites, and the social networking pages', other critics suggest that e-zines and online fanzines offer community and solidarity.[21] In his discussion of comic book communities, Matthew Smith notes that 'e-zines ... serve as noteworthy examples of how distance-transcending communities can be developed, grown and maintained on the Web ... Historically, zines have had small press runs, limiting the number of fans they could reach ... Choosing to publish a zine on the web instead of on paper means that fans have a potential audience of millions, an audience they could never reach given the limitations imposed by the cost of self-publishing on paper and distributing via traditional mail.'[22] E-zines are entirely immersed in their own (sub)culture and invite 'active participation of their readers. They encourage would-be contributors ... [and] demonstrate an orientation towards the needs of the audience.'[23] Alison Piepmeier also scrutinizes this aspect of zine culture, stating 'zines instigate intimate, affectionate connections between their creators and readers, not just communities but *embodied communities* that are made possible by the materiality of the zine medium.'[24]

Piepmeier highlights the materiality of a zine, explaining that e-zines do not function in the same way as their print counterparts.[25] However, Teal Triggs notes how the DIY tradition prompted 'a migration of print fanzines on to the web'.[26] The subject matter of e-zines tends to follow those of print media: science fiction and music being key examples, whilst other commentators on the form suggest many commonalities with paper zines: 'The difference ... is in the mode of distribution, since e-zines are "distributed partially or solely on electronic networks like the Internet." As technology moved forward, so too did the way in which zinesters used the medium.'[27] *The Steampunk Magazine* is interesting in this regard, because it

is published, for free, as a PDF file online. It is also available as a paper copy and is sold more commercially through sites such as Amazon.[28] However, the publisher of the paper edition is Combustion Books, a small press collectively managed by Margaret Killjoy and other figures behind *The Steampunk Magazine*. The press espouses subversive politics: 'We specialize in genre stories that confront, subvert, or rudely ignore the dominant paradigm and we're not afraid to get our hands dirty or our houses raided by the government. How many fiction publishers can promise you that?'[29] Whilst the subversive nature of the magazine is overt, it is also noteworthy that it functions as an imagined community of steampunk and is entirely immersed in the culture.[30] It has an emphatically DIY ethos, not only in terms of content (articles on 'how-to' feature throughout the magazine's publication history) but also in terms of its organizational management. It is a collectively run enterprise, supported by the principles of anarchism and social revolution. In common with the participatory element of e-zines, it eschews advertisements and press releases, but it enthusiastically invites contributions from readers.[31] Smith emphasizes that this engagement with the audience is central to the definition of e-zines:

> E-zine editors invite the active participation of their readers. They encourage would-be contributors with invitations such as 'Want to write for Alphascope? Got an article you'd like to contribute? Why not write us?' E-zines demonstrate an orientation towards the needs of the audience.[32]

Notably, *The Steampunk Magazine* invites similar contributions from its readership. From the first issue, the magazine enjoins the reader to 'Submit to no master! But submit to us' with details about how to write content for the publication.[33] However, it also effectively provides specialist knowledge and demarcation of boundaries, as in some ways it offers a 'gatekeeper' stance in relation to the subculture. Whilst it

is clearly a forum for discussion and debate, rather than consensus, it also helps to define what may be included within the definition of steampunk. The magazine is overt in its political positioning, clearly challenging conventional authority, and it makes a strong declaration for equality and diversity, whilst locating itself in opposition to a depoliticized steampunk:

> SteamPunk Magazine is a print-and-web periodical devoted to the genre and burgeoning subculture of steampunk. We pride ourselves on promoting a version of steampunk that does not forget the punk aspects of it – challenging authority, Do-It-Yourself attitudes, and creating our own culture in the face of an alienating and boring mainstream one. We publish fiction set in the Victorian era, set in the far future, and set in fantasy worlds. We have a fairly broad interpretation of what might be considered steampunk, resisting the urge to limit ourselves and create a 'pure' definition of the word. We also publish DIY how-to articles, essays on fashion, historical tracts, rants and manifestos ... anything we think will serve the greater steampunk community.
>
> We are also dedicated to a steampunk that is fiercely anti-colonial, anti-racist, and pro-gender-diversity. We've no interest in glorifying the rulers of our society any further.[34]

Whilst operating to subvert and refute mainstream media, the magazine (in common with zine culture more generally) also provides a forum for mediation within the community.[35] The magazine is an authority which can define what steampunk is and is not, even if it resists a 'pure definition' of steampunk: 'We remained an undercurrent in the larger steampunk landscape, the magazine and the scene that grew up around it was always an influence on steampunk at large. Basically, the scene started to explode in popularity and we were there at the beginning. We didn't cause the explosion in popularity, but we were around to help shape it.'[36] This is very much the case if we think about various articles in the magazine, such as 'Paint It Brass: The

Intersection of Goth and Steam' by Libby Bulloff, 'A Corset Manifesto' by Katherine Casey or 'You Can't Stay Neutral on a Moving Train (Even If It's Steam-Powered)' by Margaret Killjoy. The articles define steampunk, through theory and practice (or how-to articles), whilst offering examples of steampunk fiction and also pieces which explore the meaning and significance of steampunk practice – as maker culture, as fashion, as historical anachronism and political resistance.

In terms of zine production, it is worth noting that zines lack financial incentive: 'Zines are a print form not intended to curry market attention or garner financial profits for their creators.'[37] Relatedly, the origins of *The Steampunk Magazine* accord very closely with the conventions of zine production:

> Well, in 2004 I read the essay 'Colonizing the Past so We can Dream the Future' by the Catastrophone Orchestra and it introduced me to steampunk. It's an anti-colonial ode to a past that never was, and I loved it. For the next couple years I wrote some steampunk fiction. In 2006, I'd just moved back to the States from Amsterdam, where I'd helped design a squatter magazine, and I wanted to do a magazine. I talked to my friend Steven Archer from Ego Likeness about the idea of doing a steampunk magazine, and he said 'do it now.' I didn't realize there was a steampunk subculture about to explode. So I put out a call on Livejournal in a steampunk group. I got a lot of shit on that post from people who said things like 'how can you claim to be *anti*-colonial and be steampunk?' Those people are, of course, morons. I made the magazine anyway, attracted radicals and people-who-aren't-opposed-to-radicals to write for it, and the magazine had a pretty good run for a couple years. In the end we did I think 9 issues? I put together the first issue while living in a house without internet, and I had to go to a coffeeshop around the corner every couple of days to check my email. I printed I think 300 hard copies of the first issue and put the PDF up for free, and Boing Boing picked it up, and I sold out of that first print run within, I'm not sure, an hour or two? Overnight, I became a publisher.[38]

The circulation outside the capitalist economy, the amateur organization and production arrangements (published from a house without internet) all situate the magazine within zine and e-zine parameters. Killjoy is also emphatic that the steampunk radicalism espoused by the magazine is crucial to an intersectional understanding of gender:

> Gender has always been part of a radical/anarchist view of the world (certain of our forefathers had massive blindspots around gender, such as Proudhon, but other influential anarchists of all genders were quick to take Proudhon to task about his misogynist garbage). In my limited research, anarchist society in the western world in the beginning of the 20th century was far more open to queer and gendernonconforming individuals than the broader society was. Anarchists have been at the forefront of fights for birth control, gay rights (in my research, one of the first [if not the first] gay magazines was an anarchist magazine from Germany), and the emancipation of women. As radical steampunks, that carries right over. Our heroes weren't just thinkers, but also revolutionaries – including gender revolutionaries.
>
> Besides which, steampunk as a culture (not just the radical elements) is very welcoming of trans issues and of gender and sexuality. Homophobia and transphobia won't get you very far in the steampunk corner of the geek world.[39]

Readily apparent in this account of the magazine is the predominance of intersectionality. In its original coinage, intersectionality was intended to apply to the ways that systemic inequality may be experienced by an individual who occupies more than one subject position. So, for example, Kimberle Crenshaw's original argument addressed how women of colour experience rape and violence and how that might be different to the experiences of white women. Crenshaw claims that 'intersectionality might be more broadly useful as a way of mediating the tension between assertions of multiple

identity and the ongoing necessity of group politics'.[40] In this context, the anarchist challenge to systemic misrepresentations of race, gender, trans and sexual politics found in *The Steampunk Magazine* establishes how the publication is a subversive and collective voice from the margins.

Steampunk Emma Goldman

In addressing the importance of politics to the magazine, this chapter will focus on several articles related to Miriam Roček (Steampunk Emma Goldman). Roček is an article contributor to the magazine, but has also provided an interview in Issue 8, expounding on her contribution to steampunk politics. In her 'Steampunk GLBT Equality Rally', Roček marshals figures such as Oscar Wilde (also discussed in Chapter 5 of this book), Gertrude Stein and Lord Byron as a means to persuade potential participants to attend.[41] This biofictional co-option of historical figures in steampunk is well established, as various texts in this book will demonstrate. More importantly, perhaps, it also underscores the ways in which alternative narratives (including the successes of marginalized peoples) can be occluded in steampunk practice. In an interview with the Jewish Women's Archive, Roček notes:

> One of the problems with focusing on the oppression of the 19th century is that it actually removes from the conversation the accomplishments of countless women, immigrants, people of color, workers, and other marginalized groups … It's all well and good to admit that rich white men were at fault, but focusing on them as villains does a disservice to the people who fought against them. They deserve recognition. Emma Goldman deserves it more than most; she managed to be right about a lot of things that most of her contemporaries were wrong about.[42]

Miriam Roček's journalism, in *The Steampunk Magazine* and elsewhere, consistently addresses the role of social justice in the steampunk community. In an interview, Roček offered a useful critique of historical appropriation without political inflection in terms of steampunk's relationship to nostalgia:

> That's really why I conceived of Steampunk Emma Goldman; to remind people that the 19th century was as much a time of radicalism and change as any other, and that there were people alive then who were fighting against the inequality that characterized the era. I want to remind people who are nostalgic for that era that not only was it a horrible time for many of the people who lived through it, but that many of those people were actively trying to bring about radical change, and with good reason.[43]

This timely reminder also correlates with the broader objectives of Neo-Victorianism. Mark Llewellyn identifies that dialogue between the present and the past in Neo-Victorianism is meant to offer a critical lens up to the present day: 'The neo-Victorian text writes back to something in the nineteenth century, [but] it does so in a manner that often aims to re-fresh and re-vitalise the importance of that earlier text to the here and now … opening up aspects of our present to a relationship with the Victorian past in ways that offer new possibilities for simultaneously thinking through where we come from.'[44] Llewellyn also specifically situates this dialogue as a discussion on rights and freedoms:

> What has come to be known as steampunk fiction has the potential to illustrate quite directly the imagined and real linkages and similarities through difference that are negotiated in our own postmodernist, post-human landscape … while at the same time demonstrating the roots of ideas surrounding choice, difference, conflict and liberal idealism that can be found in the Victorian period. This idea intersects with the increasing attention Victorian

literary and cultural critics afford liberalism and its impact on social relationships from the mid- to late-Victorian period and its bearing on the fundamental concepts of freedom and choice that we now find under threat in a post-9/11 world.[45]

The context of post-9/11 rhetoric and its correlation with masculinity will be explored in Chapter 2. However, this is also a valuable point to make with reference to a dialogue between women's experiences in the present and those of the past. One of Roček's most visible endeavours has been her role in the Occupy Wall Street movement. Occupy's objective was 'to protest the dramatic and rapidly growing economic inequality and the equally dramatic increase in the political influence and impunity of corporations and financial institutions for which Wall Street is a metonym'.[46] The Occupy movement spread across the United States, as well as in Europe, attempting to reclaim public space and to offer a progressive politics which espouse a leftist notion of 'participatory democracy':

> The history of its various elements can, needless to say, be traced back into the 19th century and before, but Occupy draws most directly on forms within US social justice movements since World War Two ... the Black Panther Party's citizens' patrols and free breakfast programs, the Women's Liberation Movement's autonomous feminist health clinics and safe houses, and other similar projects in the 1960s and 1970s. Its insistence on total transformation rather than a list of demands echoes the Gay Liberation Front and the Women's Liberation Movement of the same period.[47]

The intersectionality of this approach was foundational:

> The specific histories of disenfranchisement associated with racism, sexism, class exploitation, and ethnic subordination that shape one another in specific social contexts are no longer understood as separate events but, rather, they are connected ... Intersectionality

helps politicize the initial catalyst … in that social protest becomes a rallying platform for differentially disenfranchised groups … Intersectionality enables these groups to see the interconnectedness of the issues that concern them, as well as their own placement within global power relations.[48]

The nature of disenfranchisement, be it based on gender, race, sexuality or economics, is here articulated as a social problem located in financial inequality and the overarching influence of capitalism and neoliberalism. This is very much in accord with Roček's address to Liberty Plaza in 2011, where she spoke as 'Steampunk Emma Goldman', a cosplay alter-ego, and recited Goldman's 'A New Declaration of Independence' (1909).[49] The Declaration is itself a revision of the American Declaration of Independence (1776) and maintains:

We hold these truths to be self-evident: that all human beings, irrespective of race, color, or sex, are born with the equal right to share at the table of life; that to secure this right, there must be established among men economic, social, and political freedom; we hold further that government exists but to maintain special privilege and property rights; that it coerces man into submission and therefore robs him of dignity, self-respect, and life.[50]

This is noteworthy, as Roček is rendering visible a political history which can be aligned to the early twenty-first century, collapsing distinctions in an intentionally ahistorical and anachronistic gesture. The avowed anachronism in steampunk allows us to reflect on the similarities between the historical and the present day: on the continuity, despite acknowledged historical specificity, of social injustice, where issues as varied as gender disparity, LGBTQ+ inequality, poverty and social class, and racial discrimination abound. Roček comments that science fiction and fantasy allow for reflection and that steampunk is especially useful because it has 'the added

benefit, of course, of being rooted in an historical era that was rife with those issues.'[51] Roček also explains that her reasoning behind taking 'Steampunk Emma Goldman' to Occupy Wall Street was as follows: 'When I brought my Steampunk Emma Goldman performance to Occupy Wall Street, I was trying to remind people of the roots of radicalism in America and in New York City, and I was trying to encourage them to learn from, and be inspired by, the movements that had come before.'[52] In this line of reasoning, history becomes a continuum, rather than discrete periods with distinct and unrelated social problems. This appropriation of history is expressed specifically through the science fiction trope of time travel. In her Occupy speech, Roček explains, 'I have travelled through time to be here with you, in 2011, in Liberty Plaza, because I love what you are doing here The New York Times said this Saturday that any attempt on the part of police to clear this plaza would result in the resurrection of Emma Goldman. Too late.'[53] This iconic 'resurrection' creates a dialogue between historical protest and contemporary agitation.

Roger Whitson notes that 'Steampunk Emma Goldman is a powerful example of how steampunk is able to appropriate historical images and events as tools to help people participate politically'.[54] As an anarcho-feminist who was vocal about issues such as birth control, free love and working conditions, Emma Goldman (1869–1940) is a powerful symbol for issues that still plague society today, also articulated in the recent popularity of the TV version (2017–) of Margaret Atwood's *The Handmaid's Tale* (1985) and the funding cuts to Planned Parenthood in the United States. Roček draws a direct correlation between the contemporary and the historical in her discussion of the Labour Rally at the Steampunk World's Fair (discussed in a different context in the conclusion to this book). Roček explains:

> I had been talking ... about Scott Walker, the decline of the unions
> in America, and the ridiculous anti-union rhetoric spouted by

conservative politicians. Somewhere along the line, we decided
that the big problem was that people had forgotten their history
… I encouraged people to come out in support of organized labor
past, present and future, real and fictional, and people responded
with delightful enthusiasm.[55]

This context is also crucial in terms of thinking about *The
Steampunk Magazine* and Roček's contribution to steampunk more
generally. The magazine's online editorial comments: 'This, from my
point of view, is cosplay done right. I'm really damn proud of her, and
proud that she's become a regular contributor to the magazine.'[56]

Roček's contributions to *The Steampunk Magazine* also reflect her
political credentials. In an article entitled 'A Healthy Alternative to
Fascism in Fashion', she offers a commentary on the role of military
uniforms (especially Nazi and fascist militaria) in steampunk. She
observes that this practice is mostly observable in men and that such
cosplay can be construed as offensive 'especially when it has roots in
recent, violent history'.[57] She then advocates instead the performance
of steampunk characters which have their roots in anti-fascist protest.
Her reasoning is as follows: 'One thing I love about anti-fascist fighters
as a source for costume and character inspiration is the number of
options they offer for female-presenting people and characters.'[58] She
then offers potential sources of such inspiration: a woman and child
wearing costumes drawing on Spanish Republican Militia; a man with
influences from Italian, French and Spanish anti-fascist partisans; a
woman from the French Resistance; a working-class Londoner from
the Battle of Cable Street, protesting Oswald Mosley's march of the
British Union of Fascists through the East End in 1936; and a cosplay
version of Salaria Kea, a black nurse from Ohio who fought with the
Republicans in Spain. Roček foregrounds the contribution of women
in this article, which highlights the ways in which steampunk is a site
of contestation: the aesthetic revival of the nineteenth century may
necessitate a more politicized or activist-based revival which thinks

carefully about overlooked historical personae. Roček confirms this in an interview with *The Steampunk Magazine*:

> The reason I picked Emma Goldman ... was that I had noticed that while steampunk spends a lot of time, as a culture, admiring and remembering great artists, writers, and scientists, we don't talk much about the activists of the nineteenth century ... Roleplaying her allows me to put a little bit of her revolutionary fire into steampunk, and into the world. It seemed like a good tool to help me politicise steampunk.[59]

A good example of this politicized steampunk might be found in Roček's article 'A Brief History of Birth Control' (2012), published by the same stable as *The Steampunk Magazine* in *The Steampunk Guide to Sex* (incidentally, this also relates to the later discussion in this chapter on Amelia Dyer). Here, Roček references her historical predecessor, Emma Goldman, explaining that 'the famously fearless anarchist, Emma Goldman was sent to jail for educating people about birth control, an incident that she, as was her habit, took in stride, but many advocate lives were dominated and ruined by the consequences of their commitment to birth control'.[60] As per the steampunk parameters of anachronism, however, the article directly links contemporary and historical experiences of contraception and thereby articulates very effectively Mark Llewellyn's observation that 'even as we move further away from the Victorian, the ideas of the period come to haunt us more deeply and in unexpected ways ... it is perhaps unsurprising that we ... [are] in search of an epistemological reference point, which might explain, or help to explain, who we are and how the choices made in the past have led to the *now*'.[61] Similarly, Goldman's activism haunts Roček's steampunk practice, and relatedly, this anarchist and activist tradition haunts *The Steampunk Magazine*.

Roček contextualizes her argument by placing her reader in a dialogue with the past: 'The next time you find yourself speaking to

those who find artificial contraception distasteful or immoral, ask that they examine, for a moment, their history.'[62] Whilst she acknowledges the longevity of this history of birth control (going back to ancient times), it is clear that her focus is the nineteenth century: 'The 19th century saw great advances in both the effectiveness and availability of contraception, as well as (with the growing understanding of sepsis and the effective use of anaesthetics) advances in the safety with which abortions could be practiced.'[63] She then takes great pains to situate this history alongside the present-day U.S. alliance between church and state: 'Those in power sought to restrict access to birth control by declaring any discussion or education on the matter indecent, inappropriate, and legally "obscene." A parallel to this technique might be detectable, by an alert observer, in the current movement for "abstinence-only-sex-ed" in American public schools.'[64] She goes on to discuss the Comstock Act from 1873: by articulating a historical politics of resistance which address economic and gendered inequality and linking this to the current debates surrounding abortion rights in America, Roček situates Goldman and other campaigners firmly in the present. This means of protest rejects the linearity of historical progress, in favour of a dialogue with nineteenth-century history, with the effect that the modern day does not seem to have moved forward from that historical period at all. Indeed, Goldman's autobiography notes that her lecture on contraception delivered to an elite audience of medical professionals proceeded entirely without incident. It was not until her bid to speak in New York to 'women on the East Side [who] needed the information most' that the authorities intervened and Goldman was arrested.[65] Social class, poverty and gender intersect then (as now) with a politics of the left. It is noteworthy that *The Steampunk Magazine*, Miram Roček and this version of steampunk more generally foster a version of a self-conscious and politically invested subculture, which embraces aesthetics as part of its activism. This trajectory is also discernible in other politically

inflected manifestations of steampunk, including The Men That Will Not Be Blamed for Nothing.

Putting the punk in *steampunk*

In 2011, Dave Ashworth interviewed The Men That Will Not Be Blamed for Nothing, for *Pure Rawk,* and asked the question, 'So what would happen if the Victorians had rock bands? They might sound a bit like The Men That Will Not Be Blamed for Nothing, a bunch of mad hatters writing songs about Isambard Kingdom Brunel, The Empire, and Queen Victoria, who may or may not have been bemused.'[66] The band's name is derived from the infamous graffiti scrawled on the wall at Goulston Street in London in 1888, purported evidence in the Jack the Ripper case.[67] In terms of sound, the band combine thrash, metal, punk and the musical hall tradition (Figure 1), as well as the more

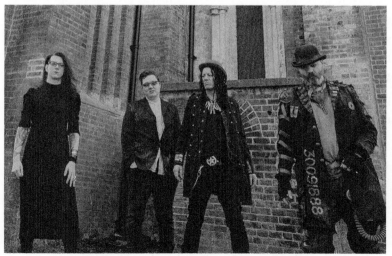

Figure 1 The Men That Will Not Be Blamed for Nothing [photo credit: Kim Burrows].

melodic aspects of goth, and like some other steampunk musicians (such as Unwoman), their political alignment emphasizes the highly politicized '-punk' aspect of the genre, castigating the inequalities of the Victorian age in songs like 'Third Class Coffin' and 'Miner'. That the band combine these different genres is relatively unusual in subcultural music circles, but this is perhaps the consequence of the band members' individual influences, who all have 'quite varied tastes' in music.[68] Indeed, Jeff Vandermeer describes the band as 'one interesting musical act currently exploring the far edges of subversion'.[69] Andy Heintz of TMTWNBBFN explains, 'We decided to take the "punk" part of Steampunk literally and imagine what a punk band would be singing about if they were from 1880 instead of 1980'.[70] Andrew O'Neill's vocals and guitar accompany Heintz's vocals (and musical saw!), alongside Jez Mills on drums (who replaced Ben Dawson in May 2010) and Marc Burrows on bass guitar. The frontmen in particular present a striking subcultural spectacle onstage: O'Neill's cross-dressing and Heintz's garishly dyed pink beard and post-apocalyptic punk style match their uncompromising sound.[71] If we think about Hebdige's discussion of sartorial style and symbolic resistance, the visual spectacle of the band becomes part of their political intent. Heintz describes the band as 'filthy Victorian Whitechapel punk underclass', which usefully articulates the class politics inflecting most of their material.[72] Similarly, Andrew O'Neill remarks:

> We're all very averse to the class-roleplay element of steampunk. We're not pretending that we're anything other than middle class, but Ben and I [former drummer] have played in punk bands for years and to do a gig where, when the lights come up, people shout 'Huzzah!' just dicks me right off. We're not particularly politically motivated, but to me personally that stuff really rankles. I've always been a big fan of Victoriana, but the part that interests me is the nasty underside of it. Proper throwing-bombs-at-monarchs

anarchism came out of the Victorian era, and that's far far more interesting to me than regimental insignia.[73]

There are several issues worthy of note here. O'Neill's tricksiness (where he explains the band aren't political, but then invokes Victorian protest) is paired with a resistance to *some types* of steampunk practice (the militaria, a naïve or celebratory approach to Empire) and thus reveals some of the tensions in the movement. He continues: 'It's not Neo-Victorianism, there should be some sort of subversion there.'[74] If we are understanding Neo-Victorianism to mean an uncritical revival of the nineteenth century (rather than the academic genre and mode of criticism), then this is entirely apposite. However, Neo-Victorianism as critical practice can elucidate the band's ethos: the recovery of the submerged narratives of the marginalized urban populace, and the poverty and degradation which the band explores (not without humour) in their lyrics, suggests a challenge to the polite and decorous heritage film industry version of Victorianism.

Despite O'Neill's caution registered here about steampunk, the band clearly espouses much of the punk-aligned politics of the movement: 'There are elements of the steampunk subculture that are completely punk. The DIY ethic, the fact that people are getting out of the house and doing stuff is just fucking brilliant.'[75] Related to this DIY steampunk ethic, the band have playfully released songs on limited-edition wax cylinders. The song 'Sewer' was released in 2010, limited to forty copies, with the proviso that 'anyone buying one of the 40 copies of the track on wax will also get instructions for building a phonograph to play the cylinder.'[76]

TMTWNBBFN's steampunk credentials therefore find a home alongside other symbolic modes of resistance, such as *The Steampunk Magazine*, and Steampunk Emma Goldman's anarcho-feminism, and this contestation is at the forefront of their performances. For instance, 'Doing it for the Whigs' (from the 2012 album *This May Be the Reason*

Why The Men That Will Not Be Blamed for Nothing Cannot Be Killed by Conventional Weapons) includes a chorus 'No future in Tory politics', whilst their band logo carries the circle-A of anarchism. This political agenda is not just a fictional performance: Andrew O'Neill's gender bending is accompanied by veganism and the espousal of a polyamorous lifestyle with his wife Stephanie Munro, whilst Andy Heintz's membership of Creaming Jesus (a UK hardcore/metal band with goth undertones and laden with satire, formed in 1987) testifies to the underground legacy and subcultural lifestyle that informs TMTWNBBFN.[77] Andy Heintz explains that 'politically I'm as far left as I can get, but I do feel nowadays that you have to vote tactically to keep the ring-wing scum out' and Andrew O'Neill confirms, 'We're all pretty much left-wing. It's fairly clear when you look at the Victorian era that there were things that were right and things that were wrong. It's not hard to write a political song, all you've got to do is put some of your opinions into a song as opposed to your feelings.'[78] Given this perspective it is not surprising that the 2010 album *Now That's What I Call Steampunk Volume 1* (subsequently renamed in 2012 as *The Steampunk Album That Cannot Be Named for Legal Reasons*, due to EMI's threat of legal action) provides an antidote to steampunk's articulation of gender normativity which we find elsewhere in the subculture (see Chapter 3 on Emilie Autumn). If Autumn articulates a model of femininity which is aligned to the conventional gendered trope of irrationality, 'Goggles' confronts both contemporary and historical norms related to femininity and appearance. Goggles themselves are multifarious signifiers: they emerged in steampunk via the cybergoth and cyberpunk aesthetics, but they also suggest comic book icons such as *Tank Girl* (1991) by Jamie Hewlett and Alan Martin. They are also a sartorial staple of the eccentric but eminently capable scientist, Dr Jillian Holzmann, in *Ghostbusters* (2016). The song takes that ubiquitous steampunk accessory and unfastens it from the gentleman inventor hero (see Chapter 2), preferring instead

to identify goggles with a capable woman. The song features a male speaker implicitly addressing other men, articulating a paean to womanhood in the line 'Most men like … '. This perspective suggests the female subject is held in the male gaze, but the woman to whom the song refers is a direct challenge to Victorian models of gender. She is not 'deferential and polite' like the Victorian Angel in the House, but rather, she is 'the type of girl who looks like she could win a fight'.[79] The album cover relates to this subject directly, picturing two women engaged in bare-knuckle boxing. Rather than being a stereotype, it is apparent the model of steampunk womanhood in 'Goggles' enjoys the materiality of the machine, the dirtiness of the engine room. She can 'fix your stuff' and 'can strip an engine / Glistening with sweat and with oil'. What the lyrics of the song underscore is the inadequacy of historical and contemporary femininity and how the correlation between sexual appeal, attractiveness ('pretty girls') and women's diminutiveness ('dainty girls') is fundamentally flawed. Of course this buys into much of what feminist critics like Naomi Wolf have been arguing about women and appearance: in the service of patriarchy, 'women's identity must be premised upon our "beauty" so that we will remain vulnerable to outside approval, carrying the vital sensitive organ of self-esteem exposed to the air'.[80] 'Goggles' is interesting because it invests beauty in unconventional images: 'There's spirits, smarts and wit. / If you just want an ornament then you sir/Are a tit.'[81] The ambiguity of the band's approach to gender might be flagged up here, as the mild obscenity used in these lines ('tit') obviously invokes (usually) female anatomy as an insult. However, the rallying cry of the final verse directly addresses the contemporary male listener: 'It's time that we as men reject this view of woman folk / And embrace the type that sing and dance and / Fart and fuck and smoke.'[82] This summarizes patterns of behaviour which are deemed unseemly not only in history but also in the present moment. The attractiveness of women who 'fuck' is important, as Wolf notes that virginity was correlated with

beauty until very recently, and even in our sex-positive age, there is still a great deal of prudery about women's agency in sexual pleasure.[83] Whilst women who dance might not be judged especially harshly today, women farting still has a 'laddish' quality associated with it and might be linked more generally to the shamefulness still attached to the processes of women's bodies.[84] Whilst there is clearly a critical ambiguity in a male speaker according this woman sexual desirability due to her contestation of gender, 'Goggles' also offers a way to defy stereotypes.

A similar trajectory is discernible in 'Free Spirit', from the band's 2012 album, in which a figure called Elsie 'slept her way through London in an opiate haze', apparently influenced by the role models of Lord Byron, Shelley and his wife Mary.[85] Shelley celebrated the concept of free love in his poem *Epipsychidion* (1821) and of course Byron's licentiousness was legendary. Thus Elsie is pitted against the moral censure of the Victorians, whilst being not unproblematically embedded in a scopophilic logic which aligns women and sexuality: 'Though society tut-tutted, she could not care less. / Elsie's never happier than when she was undressed.'[86] The most noteworthy aspect of these lyrics is the issue of agency, and the comic bawdiness of her indecent nakedness in the afterlife emphasizes this: 'She takes great delight exposing herself at séances to give the crowd a fright.'[87] Elsie is seen to escape the restrictive edicts of society: there is a consistent emphasis on freedom from restraints in the images of the corset, the grave and heaven. The song articulates Victorian prudery ('There's things polite society just won't allow but she's going to do them anyhow'[88]), but simultaneously rejects this, and thereby challenges our contemporary notion of the prim and strait-laced nineteenth century. In Antonija Primorac's discussion, '"sexing up" the proverbially prudish Victorians' has numerous problems, not least sensationalism and voyeurism, but it is also clear through Elsie's rebellious behaviour that we are meant to rethink the narrowness of

our contemporary perspective on nineteenth-century womanhood and women's needs and desires.[89] This revision of the nineteenth century also implicates the present and the absence of articulating women's sexual desires: 'Where are most girls to go for a feminist vision of their erotic life? … The next phase of feminism must be about saying a sexual yes as well as a sexual no … I want female sexuality to accompany, rather than undermine, female political power.'[90] Natasha Walter also discusses the idea of women's emancipation as related to sexuality: 'One of the primary goals of the second-wave women's movement of the 1970s was to enable women to feel free to enjoy sex without being held back by traditional social expectations.'[91] Part of this freedom invokes sexual promiscuity and a rejection of monogamous relationships, as Germaine Greer's *The Female Eunuch* has identified: 'Spiritually a woman is better off if she cannot be taken for granted … Adultery would hold no threat if women were sure that the relationships they enjoyed were truly rewarding and not merely preserved by censorship of other possibilities.'[92] Thereby Elsie is also delightfully anachronistic, occupying two time frames at once and is very much a feminized symbol of steampunk identity. Her freedom is chronological and geographical, as well as sexual, and her defiance of boundaries is what makes 'Free Spirit' potentially liberating. However, this is tempered by the fact that Elsie is constructed entirely through the lens of a male speaker (a problem which all these songs share) at a distance of some centuries. Indeed, this knowing, chronological distance can result in an assumption of contemporary superiority in matters of sex, as Marie-Luise Kohlke has noted: 'By projecting illicit and unmentionable desires onto the past, we conveniently reassert our supposedly enlightened stance towards sexuality and social progress.'[93] In our supposedly enlightened contemporary moment (as various campaigns such as the #MeToo movement testified), sexualized women are still not equal to men, and their experiences might include sexual violence, exploitation, slut-shaming and victim-

blaming as much as the liberation described here. In some ways, Elsie is a fantasy of empowerment rather than an articulation of what has been achieved for and by women.

Relatedly, other material from TMTWNBBFN, including 'Etiquette' (with a chorus expounding the virtues of 'a stiff upper lip and etiquette' and a refrain exclaiming 'manners … maketh the man'), poke gentle fun at the Victorian gentleman and his model of masculinity. This point is confirmed by the ironic juxtaposition of these lyrics with heavy guitars, and loud, aggressive vocals, as well as another song from the same album, 'A Traditional Victorian Gentlemen's Boasting Song', which is more overt in its satire.[94] The optimism of 'Free Spirit' is countered by other songs, such as 'Blood Red', which articulates a brutal vision of British imperialism. The subsequent album, *Not Your Typical Victorians* (2015), offers a bleak vision in 'Third Class Coffin' (taking as its subject the class distinctions aboard the Necropolis Railway) whilst 'Turned Out Nice Again' features overt references to Jack the Ripper; 'Miner' and 'A Clean Sweep' both give voice to the narrative of the nineteenth-century underclass; and 'I'm in Love with Marie Lloyd' quickly descends from the admiration of a music hall singer to the alarming obsessiveness of a stalker. This is a London of disease, crime and poverty, with little hope beyond a gallows humour and the stultifying effects of cheap alcohol ('The Gin Song').[95] However, the title song on this album also asserts a revisionist strategy associated with the band, suggesting how competing voices about Victorian history can be represented. The speaker is 'not your typical Victorian', rejecting misogyny ('his wife's his equal in every way'), imperialism ('He hates empire and monarchy') and even contests some of the major tropes of steampunk itself: 'He can't stand engines, cogs or gears … H. G. Wells bores him to tears' and the song concludes with 'I'd happily blow up the Queen / I'm not even that keen on steam.'[96] This critique is especially useful as it comes from within the movement

and highlights some of the major disjunctions between subversive steampunk and the more conservative aspects of the genre.

One of the band's most iconic songs, 'Brunel', is seemingly a celebration of the swaggering achievement of Isambard Kingdom Brunel (1806–1859), who is an icon of steampunk subculture due to his status as an engineering genius operating at the time of the Industrial Revolution. His works included the Great Western Railway (which opened in 1838) and the designs for the Clifton Suspension Bridge, which links Bristol to North Somerset (1864). The song lyrics of 'Brunel' provide snapshots of these key highlights in the engineer's career. Brunel is represented here as an exceptional genius: 'Haven't you heard? I'm not a lot of men!' which accords with the gendered portrayal of the inventor genius (stereotypically male), a steampunk figure which features and is contested in many narratives of this type. However, the repeated emphasis (with slight variation) on the refrain, 'A lot of men tried, a lot of men died!', is important – it suggests the cost of the Industrial Revolution in terms of human life, rather than an unambiguous celebration of engineering and men of genius.[97] Of course, Brunel is one of the period's greatest successes and treated his workers comparatively well for the time, but it also registers more generally how such insistent and overarching ambition is powered by hundreds of fatalities, nameless individuals who have the status of an ordinary worker. Indeed, the Thames Tunnel (built using Marc Isambard Brunel's technological advances, the father of the illustrious Isambard) was the scene of one such tragedy: on 12 January 1828, six men died working on the tunnel, and Isambard Kingdom Brunel was fortunate to escape with his life. The song clearly celebrates Brunel's achievements, but it is ambivalent too, underpinned by a reiteration of anxiety about the human cost in nineteenth-century working conditions. This is part of the broader thematic concerns of TMTWNBBFN and Neo-Victorian critical practice, 'which desire to re-write the historical

narrative of that period by representing marginalised voices, new histories of sexuality, post-colonial viewpoints and other generally "different" versions of the Victorian'.[98]

Perverse maternity: Women, contraception and the rejection of motherhood

Women in the lyrics of TMTWNBBFN are not always ambiguous gestures towards emancipation, as in the case of Elsie in 'Free Spirit'. In two instances, 'Inheritor's Powder' (2015) and 'Baby Farmer' (2018), the lyrics are indicative of the ways in which historical women have circumvented the traditional role of wife, mother, nursemaid and helpmeet to patriarchy. However, their status as murderers also means we need to evaluate how far Neo-Victorian sensationalism features as part of this steampunk spectacle. Certainly Andrew O'Neill's investment in Jack the Ripper – he conducts comedic tours of the Whitechapel murder sites in order to unpick the commodification of the Ripper narrative – articulates this problem very effectively. It is a double bind in terms of how far and in what ways we need to recover lost histories. Helen Davies notes that 'neo-Victorian representations – traumatic or otherwise – are not always motivated by the "best of intentions": fictional reimaginings of the nineteenth century can also be sensationalist, cynical, trivialising, coarse'.[99] However, the lyrics from these two songs, whilst seemingly cynical and trivializing, also offer a mediation on gendered identity in the period. What ultimately emerges is how far these monstrous women are also born of capitalism and patriarchy.

In thinking about these representations by TMTWNBBFN, it is noteworthy that these women (Mary Ann Cotton in 'Inheritor's Powder' and Amelia Dyer in 'Baby Farmer') represent a perverse

maternity, rejecting feminine traditionalism in favour of murder. What these song lyrics achieve is a critical space in which the contemporary moment can hold a mirror up to contemporary gendered issues, including abortion and contraceptive rights, especially in terms of their relationship to conventional faith in the United States and Ireland. This contemporary context has become more imperative with the pro-choice Repeal the Eighth movement in the Republic of Ireland and the slow but persistent erosion of women's rights in some areas of right-wing America.[100] 'Inheritor's Powder' opens with a scream (Heintz) and is followed by two voices in dialogue which repeat the phrase 'they say' emphasizing the media speculation surrounding Mary Ann Cotton's case.[101] In some ways, this is a testimony to the impossibility of uncovering 'historical truth' in such cases. The only possibility is a partial and reconstructed fabrication, suggesting that history itself is contingent (indeed this is very much a part of steampunk more generally, given its proximity to alternative histories and potential narratives). David Wilson, in a somewhat idiosyncratic account of Cotton's life and crimes, notes that 'in the days after execution various newspapers speculated about how many people Mary Ann might have killed'.[102] Whilst Judith Flanders notes that Cotton's case was reported in subdued fashion when compared to other cases in the preceding decades, she does highlight how 'wild rumours' were prevalent in newspaper coverage.[103] These rumours, which suggested Cotton murdered somewhere in-between four and twenty-five people (including husbands, her children, stepchildren, her mother and lover), did not compare to the circus of panic surrounding other murderers in the latter half of the nineteenth century, such as Jack the Ripper, but nonetheless, this does testify to how contemporary print culture constructed multiple versions of Cotton. Cotton allegedly poisoned her victims with arsenic in the tea, despite the fact that no arsenic was recovered from her home. Accidental death was dismissed as a possibility at Cotton's trial,

though Judith Flanders expresses some doubt as to the wisdom of this decision. She explains that there was no evidence of intentional poisoning, given that arsenic was present in all manner of household items, including wallpaper: 'How this was deduced is not clear: today's tests, which measure appearance of arsenic along the nail or hair shaft, were not then possible.'[104]

TMTWNBBFN's lyrics expand upon media speculation, exclaiming that 'they say her mother's her sister / Her brother's her dad' whilst also providing a litany of her life history:

> They say she moved across country
> Upped sticks and fled
> They say wherever she lived
> Someone ended up dead.

Cotton moved from her home in the North East of England to Cornwall with her first husband, William Mowbray, but returned to the County Durham area, where Cotton's other crimes were reputedly committed, resulting in the death of two other husbands and several others. The song then reveals that one of the voices is in fact one of Cotton's husbands, who finds himself in a rather perilous position: 'Why did no-one say nothing / Til she was my wife?' Not only does this put the male speaker in a position of vulnerability (very much counter to stereotypical understandings of Victorian masculinity), but it also identifies how far Cotton was seen to be a parody of a dutiful wife and mother. Her attention to the sick and the dying, her role as nurse and Sunday school teacher, her reasoning that her use of arsenic was to clean the beds all simultaneously challenge (but also reinforce) gender norms:

> A grotesque, sadistic travesty of intimacy and love: from spooning poisoned medicine into the mouth of a trusting patient, for example, or smothering a sleeping child in its bed. In short,

from tenderly turning a friend, family member, or dependant into a corpse.[105]

Her actions are repeatedly attributed in the song to financial motivation: 'She took a policy on me / Just to be safe.'[106] Historically, Cotton took out life insurance policies on family members, who then mysteriously died, sometimes only days after she entered the home. 'Inheritor's Powder' is thus related to economic necessity and outlines the ways in which lower-class women were often only offered very narrow choices. The lyrics refute women's status as patriarchal victim and destabilize the logic of women as patient sufferers – indeed, it is the male speaker who is in the position of extreme vulnerability here. However, Cotton's economic precariousness also makes a point about class inequality. Judith Knelman shares this view of Cotton, explaining 'when there were too many responsibilities, or when she had too little money to live on, she eliminated one of the responsibilities or poisoned for profit, or both'.[107] The song also articulates one of the most challenging aspects of Cotton's case:

They say she worked as a governess
Married her boss
They say she hated his children
Bumped them all off.[108]

This seems to be a reference to James Robinson, the only one of Cotton's husbands who outlived her. But these lyrics also point to one of the dilemmas in Cotton's media identity: how could a woman, by the standards of the day a maternal and caregiving figure, also commit murder? This double bind was also articulated in Cotton's appearance in the dock. Her final child, a baby girl, was born 10 January 1873. She was charged with one murder, that of Charles Edward Cotton, convicted on 7 March and executed on 24 March 1873. Protesting her innocence until the end, she was represented in the press as 'placidly

nursing a baby' from her cell in Durham prison.[109] Broadsides dating
to just after her execution reveal how part of the anxiety surrounding
Cotton relates to her travesty of maternity:

> She never has acted a good woman's part;
> With dark deeds of murder she perill'd her soul
> And her children destroyed for possession of gold.[110]

In the same ballad, she is pictured as 'an unfeeling mother unworthy
the name', whilst the broadside then extols the values of normative
femininity:

> How happy it is that seldom we hear
> Of women poisoning their children so dear;
> In this world below or the bright world above
> A heavenly gift is a true mother's love.[111]

Contemporary broadsides provide a useful comparison to 'Inheritor's
Powder', as the focus here is on Cotton's aberrance, her marked
departure from conventional gendered behaviour. Her deviant
maternity, alongside her pose as a caregiver, also challenges every
notion about gendered determinism and makes her uncomfortable
for nineteenth-century audiences. Indeed, as Knelman has identified,
Cotton's newborn baby prompted a 'change of feeling against the
"monster murderess"', as it was difficult to reconcile this vision of
motherhood with murder, especially for base economic benefit.[112]

It is also worth noting that Mary Ann Cotton is one of history's
forgotten figures. The late nineteenth century marked a high point in
the 'celebrity' of figures like Jack the Ripper, but Cotton and Amelia
Dyer have much less currency in the modern day (despite the fact
that waxwork figures of both Cotton and Dyer featured in Madame
Tussaud's Chamber of Horrors). More recently, Cotton was the subject
of a recent ITV drama, *Dark Angel* (2016), and her letters, along with
what purports to be the arsenic teapot, were exhibited at Beamish

Museum in County Durham. But she has not the same notoriety as someone like Jack the Ripper. Various commentators have remarked how the Ripper has (perversely) achieved heroic status, fascinating amateur detectives, writers and artists for decades. Judith Walkowitz remarks that '[the Ripper story's persistence] has continued to provide a common vocabulary of male violence against women, a vocabulary now a hundred years old. Its persistence owes much to mass media's exploitation of Ripper iconography – depictions of female mutilation in mainstream cinema, celebrations of the Ripper as a "hero" of crime – that intensify the dangers of male violence and convince women that they are helpless victims'.[113] The problem with Cotton (as expounded by the speaker in 'Inheritor's Powder') is that she doesn't play the victim, quite the opposite: men are included among her supposed victims, whilst her method of dispatch, poison, doesn't subscribe to our notions of bloody criminal spectacle. Quite literally a woman on top, she physically restrains one of her presumed victims, Joseph Nattrass, by holding him down during a fatal seizure.[114] By comparison to the Ripper, her methods are decidedly domestic, which both fixes her in the feminine private sphere and renders such spaces monstrous and threatening. Relatedly, TMTWNBBFN reflect upon this masculine vulnerability, with the male speaker rendered in distinctly plaintive but romantic and feminized terms: 'Dear God, I'm begging you, / I love this woman, / Don't let it be true.'[115]

'Baby Farmer' is the story of Amelia Dyer, a nurse, who was tried in 1896 for the murder of two children, Harry Symmonds and Doris Marmon, though she is suspected of killing a significantly larger proportion of children handed over to her care (the exact number is unconfirmed, possibly up to fifty babies). Dyer was a 'baby farmer', a term which belies the cruelty of her actions – she strangled children with dress maker's tape (she claimed that 'you'll know all mine by the tape around their necks') and threw their bodies in the Thames.[116] Akin to Cotton's legendary arsenic-laden teapot, this is a curiously

domestic and feminine murder weapon. Dyer placed advertisements
in Bristol newspapers to care for unwanted children: 'Couple with
no child, want care of or would adopt one: terms £10. Care of Ship
Exchange, Bristol.'[117] Ten pounds was a vast some of money at the
time (approximately a thousand pounds in today's currency), which
testifies to the desperation of many young women at the time.
Knelman suggests that 'it is unlikely, considering the publicity that
had been given to baby-farming in the previous twenty years, that
her prospective customers did not understand this was a code. At any
rate … many of the mothers asked her not to communicate further
with them'.[118] Dyer pleaded insanity (and indeed she had been in and
out of asylums for much of her life), but both judge and jury were
unconvinced.[119] Newspaper coverage, as with Mary Ann Cotton,
made much of her travesty of feminine attributes: 'A woman with no
love for little children is a blot on nature.'[120] But like Cotton, she is also
a monstrosity born of capitalism, as a contemporary broadside ballad
relates:

> To make a fine living in a way so inhuman
> Carousing in luxury on poor girls' downfall.
>
> Poor girls who fall from the straight path of virtue,
> What could they do with a child in their arms?
> The fault they committed they could not undo,
> So the baby was sent to the cruel baby farm.[121]

Whilst Dyer hardly lived 'in luxury' (though she did make her
money from the exploitation of young, often unmarried, and poor
women, who have fallen from 'the straight path of virtue'), the ballad
is noteworthy in exploring the gendered hypocrisy of nineteenth-
century sexual morality. The mother of one of Dyer's victims, Evelina
Edith Marmon (writing under the pseudonym Mrs Scott), was a
barmaid from a rural background, who wrote to Dyer as a respectable

widow rather than a 'fallen woman'. She did not return to her family, as 'she must have known deep down that in such a small community, where decency, hard work, and Christian morals were valued above all else, her fall from grace and her illegitimate child would only bring shame and sorrow to her family'.[122] Indeed, Dyer's suspected victims were frequently (but not exclusively) children of unmarried mothers, women who had been seduced by married men, the latter of whom were content to offload responsibility for a one-time fee.[123] In reflecting upon the effects of moral fervour (despite censure, these women had very few options open to them), this account also provides a startling comparison to the present day, specifically with reference to the contemporary pro-life movement and the consequences of religious morality cohering around women's bodies. In the UK, a small but visible contingent of right-wing MPs, including Jacob Rees-Mogg (Conservative MP for North East Somerset), vociferously oppose women's rights to abortion.[124] Out of this cultural climate, the recovery of some of these historical narratives, about the desperate and poor conditions for women prior to achieving abortion rights, provides a contestation of the move towards a far-right agenda. It is out of this climate, in early 2018, that TMTWNBBFN's new album, including the song 'Baby Farmer', emerges. The lyrics reflect upon these contexts by directly addressing the unmarried mother who finds herself pregnant:

> As soon as it shows, avoid scandal and shame
> Hide til its born, protect the family name
> Give Amelia a shout, she'll whisk it away
> Raise it herself, as long as you pay.[125]

The aggressive style of Heintz's vocals, along with guitar riffs and musical nods to 1980s punk, positions the song as a protest against these Victorian conditions: the religious and moral judgements implicit in 'avoid scandal and shame' coincide with the same

impetus to capitalist profit discernible in Mary Ann Cotton's case. As with other songs, such as 'Tesla Coil', temporal distance from the nineteenth century tends to produce the effect of ironic distance from the speaker. We are not invited to sympathize or agree with the sentiments expressed here, quite the opposite. This dark and troubled world of slums and baby farming seems a world away from our society, but media contexts such as the Tuam baby scandal, which erupted in 2014 (when the bodies of around 800 babies and children were discovered in Bon Secours Mother and Baby Home in Tuam, County Galway) along with global agitation from the pro-life movement (including from within the UK Parliament and the White House), mean that church morality and state policy remain uneasily aligned. Campaigns in Ireland, foremost being #RepealtheEighth, and concomitant agitation from Northern Ireland to allow women there to enjoy the same rights and freedoms as the rest of the UK mean that this is still a pertinent issue.[126] This is also an analogy that Miriam Roček draws in her discussion of birth control, suggesting how far this steampunk historical recovery is politicized:

> Do not, I pray, feel morally superior because you have no intention of resorting to infanticide or infant abandonment to deal with an unwanted pregnancy. You live in a world that has many more options, and as such you have been given the privilege of being more selective. Contraception, education, and medical abortion are all that separate us from those centuries when wolves, lions, and birds of prey fed on the flesh of unwanted infants.[127]

The message of this material seems to be that we are perilously close to this history.

It is noteworthy that 'Baby Farmer' features the character of Father Thames, an ancient deity of the river dating back to pre-Christian times, but one who is often associated with the trade and commerce brought to London via the Thames.[128] In the song, Father Thames is

more than a personification of the river: he accepts the bodies of these children as sacrificial offerings. He is constructed as a patriarchal father figure, demanding tributes from fallen women in order to expiate sins, but even he is appalled by the extent of Dyer's actions:

> Father Thames wants a word
> One or two souls is quite enough
> But this is quite absurd.[129]

This discussion of unwanted children in the nineteenth century is also explored in 'Tesla Coil' (2012), which offers the perspective of a husband whose wife has been fitted with an entirely fictional contraceptive device, the 'Tesla Coil' (a very anachronistic conflation of Tesla's experiments with electricity, themselves a staple of steampunk narratives, and the intrauterine coil, a contraceptive device developed in the early twentieth century). Whilst entirely comedic in intent, the song also carries a more serious message, and in common with 'Baby Farmer', our temporal distance results in an ironic distance from the (male) speaker. This character is outraged that his 'conjugal rights / Are spoiled'.[130] This nameless gentleman's wife insists 'giving birth once, / Is quite enough, thank you. / It's agony, and sometimes women die'.[131] In response, the male speaker is outraged by this denial of his 'conjugal rights', explaining 'it's a bloody disgrace' and blaming the inventor, Tesla, he resorts to violence, exclaiming 'Nikola! Get your arse back over here! / If you cannot explain yourself, / I'll smack you in the face!'[132] The insistence on a woman's body as a man's sexual property (as well as legal property) reflects upon patriarchal institutions in the period. Male threat is obvious in lines such as 'My wife protects herself from me' and 'She knew she couldn't trust me / To be chaste by will alone'.[133] Not just a contraceptive device, this is an invention to protect women from men, even their partners. In the Victorian period, a man's rights over his wife's body were unquestioned:

Allowances for normal impulses and youthful exuberance meant that sexual assaults were rarely perceived as criminal. The original Roman laws against rape had conceived it as a property crime against the male relatives of the victim. While the English laws had never completely accepted the Roman concept, the presumption that women were the possessions of men was still important. As late as 1890 Justice Stephen could still assert that 'the custody of a wife's person belongs to her husband'. (Stephen, *Mr. Sergeant*, p. 276)[134]

However, this song also has consequences for the contemporary moment. Whilst fictional steampunk technology is used here to castigate men's historical rights over women, the song also maps onto the present day. We need only think of figures like Roosh Valizadeh, who is the editor of 'The Return of Kings', a website which vocalizes a return to an ethos of masculine dominance: 'The site features such headlines as "The myth of date rape drink spiking", "How to turn a feminist into your sex slave" and "How to convince a girl to get an abortion."'[135] The song thereby occupies that interrogatory space between the present and the past, exploring fictional possibilities for women's rights through fictional technological advancement.

In all of these lyrics, women are represented as refusing their traditional lot (whether criminally, diabolically or more legitimately). They refuse maternity, through contraception, baby farming or murder, though paradoxically these women also perversely perform the role of mother, as in the case of Mary Ann Cotton and Amelia Dyer. The musical exploration of Victorian gender norms – through sexuality, ownership, domestic motifs and family life – also impart upon the contemporary context. The band also examine a horrific, dystopian past and project these experiences as a warning to the present, identifying how such warnings are still unheeded in the twenty-first century.

Conclusion

This chapter has demonstrated the ways in which political discourses have informed steampunk practice. It has also attempted to delineate how the tensions from within the subculture as to what steampunk means, and what its priorities are, have resulted in overt performative strategies related to cosplay (Miriam Roček) and music (TMTWNBBFN). Similarly, *The Steampunk Magazine*'s publishing ethos, which is emphatically co-operative and anti-establishment, being closely aligned to both anarchist publishing and the counter-cultural impetus of zines, suggests the ways in which steampunk practice can be inflected with a subversive agenda. This is not to say there is a clearly articulated policy or a political movement in any obvious way, but rather, a series of actions and sartorial gestures which seek to articulate a political attitude.

The steampunk participants and performers discussed here each deploy historical narratives in order to shed light upon the political milieu of the present day, often using these stories to present a critique of the contemporary climate. As with other genres to which it is closely related (such as sci-fi or satire), it acts as a warning to society in terms of where we might be headed. Many of these narratives are informed by theories of intersectionality, which have gained ground through globalized (though not always clearly delineated) protest such as the Occupy movement, addressing the ways in which race, gender, sexuality, social class and economic deprivation have become interlinked in popular culture. Conversely, in specifically gendered terms, it is obvious that incursions upon women's rights in the United States, and in Britain and Ireland, as well as the galvanization of the far right in America and Europe (including Poland, Hungary, the Netherlands and Greece), present an occasion for protest, as well as a reflection upon the history of marginalization and disenfranchisement. This trend of contestation continues in Doctor

Geof's work, which is the subject of the next chapter, along with the photographer/artist Nick Simpson.

Notes

1 For a useful discussion of the tensions inherent in steampunk representation, see Christine Ferguson, 'Surface Tensions: Steampunk, Subculture and the Ideology of Style', *Neo-Victorian Studies* 4:2 (2011), 66–90. Ferguson looks at TMTWNBBFN and the intersection of Neo-Victorianism and steampunk in their music practice.

2 Jake von Slatt, 'A Steampunk Manifesto', in *The Steampunk Bible*, ed. Jeff Vandermeer with S. J. Chambers (New York: Abrams, 2011), p. 216.

3 von Slatt, 'A Steampunk Manifesto', 218.

4 von Slatt, 'A Steampunk Manifesto', 218.

5 Jake von Slatt's introduction to the collected edition of *The Steampunk Magazine, Issues #1–7* (New York: Combustion Books, 2012), p. 3, provides a more nuanced approach to the politics of the subculture. Von Slatt states here that 'the steampunks that I met that influenced me so had taken ideas form the trash bins of history – thoughts on race, class, gender and social mores – and recontextualised them in a compelling way'. The earlier manifesto by the same author seems to lack this critique.

6 Dick Hebdige, *Subculture: The Meaning of Style* (London: Routledge, 1979), p. 19.

7 The Catastrophone Orchestra and Arts Collective (NYC): 'What, then, is steampunk? Colonizing the Past So We Can Dream the Future', *The Steampunk Magazine*, Issue 1 (n.d.), 5.

8 See June Purvis, 'Remembering Emily Wilding Davison (1872–1913)', *Women's History Review* 22:3 (2013), 353–362, 357. Although Davison's activities were outside Victoria's reign, as demonstrated in the Introduction, steampunk is somewhat flexible with historical demarcations.

9 Benedict Anderson, *Imagined Communities: Reflections on the Origin
 and Spread of Nationalism* (London: Verso, 1991, rev. ed.), 6. See also
 Andy Bennett, 'Virtual Subculture? Youth, Identity and the Internet',
 in *After Subculture: Critical Studies in Contemporary Youth Culture*, ed.
 Andy Bennett and Keith Kahn-Harris (Basingstoke: Palgrave, 2004),
 pp. 162–172. The issue here is that steampunk tends to revise the
 widely accepted theoretical model of subculture as a 'youth' culture,
 given that many of its participants are in a different demographic
 and tend towards middle age. Such sociological study is beyond the
 scope of this book, but hopefully more work in this area will emerge
 in future scholarship. Paul Hodkinson's revision of goth subculture as
 'youth' culture is also instructive here. See Paul Hodkinson, 'Ageing in
 a Spectacular "Youth Culture": Continuity, Change and Community
 Amongst Older Goths', *The British Journal of Sociology* 62:2 (2011),
 262–282.

10 Hodkinson, *Goth: Identity, Style and Subculture* (Oxford: Berg,
 2002), pp. 176–182. Elsewhere, Hodkinson refers to the internet as
 'subcultural consolidator'. See Paul Hodkinson, '"Net.Goth": Internet
 Communication and (Sub)cultural Boundaries', in *The Post-Subcultures
 Reader*, ed. David Muggleton and Rupert Weinzierl (London: Berg,
 2003), pp. 285–298.

11 *The Steampunk Magazine*, Issue 1, p. 5.

12 Anon, 'The Steampunk's Guide to Body Hair', *The Steampunk Magazine*,
 Issue 2 (n.d.), 48. Miriam Roček, 'A Healthy Alternative to Fascism in
 Fashion', *The Steampunk Magazine*, Issue 9, 96.

13 Michelle Liptrot, '"Punk belongs to the punx, not business men!":
 British DIY Punk as a Form of Cultural Resistance', in *Fight Back: Punk,
 Politics and Resistance*, ed. The Subcultures Network (Manchester:
 Manchester University Press, 2014), p. 233.

14 Stephen Duncombe, *Notes from Underground: Zines and the Politics
 of Alternative Culture* (Bloomington, IN: Microcosm, 2008), 2nd ed.,
 p. 14.

15 Duncombe, *Notes from Underground*, 14.

16 Duncombe, *Notes from Underground*, 7.

17　Duncombe, *Notes from Underground*, 11.

18　Hebdige, *Subculture*, 111.

19　Fredric Wertham, *The World of Fanzines* (Carbondale, IL: Illinois University Press, 1972), p. 76.

20　Duncombe, *Notes from Underground*, 210.

21　Duncombe, *Notes from Underground*, 211.

22　Matthew J. Smith, 'Strands in the Web: Community-Building Strategies in Online Fanzines', *Journal of Popular Culture* 33:2 (1999), 87–99, 89.

23　Smith, 'Strands in the Web', 90.

24　Alison Piepmeier, 'Why Zines Matter: Materiality and the Creation of Embodied Community', *American Periodicals: A Journal of History and Criticism* 18:2 (2008), 213–238, 214.

25　Piepmeier, 'Why Zines Matter', 220.

26　Teal Triggs, *Fanzines* (London: Thames & Hudson, 2010), p. 171.

27　Triggs, *Fanzines*, 172, citing John Labovitz.

28　Triggs, *Fanzines*, 172, notes that 'many contemporary zines have both a Web and a print presence'.

29　Combustion Books, http://www.combustionbooks.org/about/ [accessed 15 April 2018]. Their publications are distributed by AK Press, the anarchist publisher.

30　Smith, 'Strands in the Web', 90.

31　*The Steampunk Magazine*, http://www.steampunkmagazine.com/deadlines-submissions/ [accessed 15 April 2018].

32　Smith, 'Strands in the Web', 90.

33　*The Steampunk Magazine*, Issue 1, n.d., 72.

34　*The Steampunk Magazine*, http://www.steampunkmagazine.com/faq/ [accessed 15 April 2018].

35　See Sheila Liming, 'Of Anarchy and Amateurism: Zine Publication and Print Dissent', *The Journal of the Midwest Modern Language Association* 43:2 (2010), 121–45, 122.

36　Margaret Killjoy, Personal Interview, 31 July 2017.

37　Liming, 'Of Anarchy and Amateurism', 122.

38　Killjoy, Personal Interview, 31 July 2017.

39　Killjoy, Personal Interview, 31 July 2017.

40 Kimberlé Crenshaw, 'Mapping the Margins: Intersectionality, Identity Politics, and Violence against Women of Color', *Stanford Law Review*, 43:6 (1991), 1241–1299, 1296. See also 'Kimberlé Crenshaw on Intersectionality', http://www.law.columbia.edu/news/2017/06/kimberle-crenshaw-intersectionality [accessed 16 April 2018] and Kimberlè Crenshaw, 'Demarginalizing the Intersection of Race and Sex: A Black Feminist Critique of Antidiscrimination Doctrine, Feminist Theory and Antiracist Politics', *University of Chicago Legal Forum*, Issue 1, Article 8 (1989), http://chicagounbound.uchicago.edu/uclf/vol1989/iss1/8.

41 See the Jewish Women's Archive, https://jwa.org/media/steampunk-lgbt-equality-rally-flyer [accessed 23 April 2018].

42 Kate Rafey, 'JWA's Greatest Hits: Meet Steampunk Emma Goldman', *Jewish Women's Archive*, https://jwa.org/blog/meet-steampunk-emma-goldman, 3 October 2011 [accessed 23 April 2018].

43 Miriam Roček (Steampunk Emma Goldman), Personal Interview, 16 August 2012.

44 Mark Llewellyn, 'What Is Neo-Victorian Studies?', *Neo-Victorian Studies* 1:1 (2008), 164–185, 171.

45 Llewellyn, 'What Is Neo-Victorian Studies?', 172.

46 Amy Schrager Lang and Daniel Lang/Levitsky (eds), *Dreaming in Public: Building the Occupy Movement* (East Peoria, IL: Versa Press, 2012), p. 15, Introduction.

47 Schrager Lang and Lang/Levitsky, *Dreaming in Public*, 19. The editors also note the influence of the May 1968 Uprising in Paris and its related Situationist politics, No Borders collectives, environmentalist campaigns, urban squatting and ACT-UP-Philadelphia as models of influence.

48 Patricia Hill Collins and Sirma Bilge, *Intersectionality* (Cambridge: Polity, 2016), pp. 141–142.

49 *The Steampunk Magazine*, http://www.steampunkmagazine.com/2012/03/spm-contributor-miriam-rocek-arrested-agai/ [accessed 17 April 2018].

50 Emma Goldman, 'A New Declaration of Independence', *Mother Earth*, Vol IV, no. 5 (July 1909), available at The Anarchist Library,

https://theanarchistlibrary.org/library/emma-goldman-a-new-declaration-of-independence [accessed 17 April 2018].

51 Roček (Steampunk Emma Goldman), Personal Interview, 16 August 2012.

52 Roček (Steampunk Emma Goldman), Personal Interview, 16 August 2012.

53 *The Steampunk Magazine*, 'SPM Contributor Miriam Roček Arrested at #OWS Again', http://www.steampunkmagazine.com/2012/03/spm-contributor-miriam-rocek-arrested-agai/ [accessed 17 April 2018].

54 Roger Whitson, *Steampunk and Nineteenth-Century Digital Humanities: Literary Retrofuturisms, Media Archaeologies, Alternate Histories* (London: Routledge, 2017), p. 158.

55 'Cosplaying the Good Fight: Emma Goldman and Voltairine DeCleyre: Steampunk's Own Anarcho-Anarcho-Feminists', *The Steampunk Magazine*, Issue 8, n.d., pp. 75–77, p. 76. Relatedly, Bruce Sterling makes a similar point in his 'The User's Guide to Steampunk', where he states 'steampunk's key lessons are not about the past. They are about the instability and obsolescence of our own times'. See *The Steampunk Magazine*, Issue 5 (n.d.), 32–33, p. 33.

56 *The Steampunk Magazine*, 'SPM Contributor Miriam Roček Arrested at #OWS Again', http://www.steampunkmagazine.com/2012/03/spm-contributor-miriam-rocek-arrested-agai/ [accessed 17 April 2018].

57 Roček, 'A Healthy Alternative', 96.

58 Roček, 'A Healthy Alternative', 96.

59 'Cosplaying the Good Fight: Emma Goldman and Voltairine DeCleyre: Steampunk's Own Anarcho-Anarcho-Feminists', *The Steampunk Magazine*, Issue 8 (n.d.), 75–77, 75.

60 Miriam Roček, 'A Brief History of Birth Control', in *The Steampunk Guide to Sex* (New York: Combustion Books, 2012), pp. 125–126.

61 Llewellyn, 'What Is Neo-Victorian Studies?', 164–185, 174.

62 Roček, 'A Brief History of Birth Control', 123.

63 Roček, 'A Brief History of Birth Control', 124.

64 Roček, 'A Brief History of Birth Control', 124.

65 Emma Goldman, *Living My Life* (London: Penguin, 2006), p. 321.

66 Dave Ashworth, 'Anachronism in Context – The Men That
Will Not Be Blamed for Nothing', *Pure Rawk*, 22 October 2011,
http://www.purerawk.com/2011/10/anachronism-context-men-
blamed/#more-8010 [accessed 14 March 2018].

67 Anon, 'Less Brass Goggles, More Brass Knuckles: An Interview with
The Men That Will Not Be Blamed for Nothing', *The Steampunk
Magazine*, Issue 7, p. 421.

68 Anon, 'Less Brass Goggles, More Brass Knuckles: An Interview with
The Men That Will Not Be Blamed for Nothing', *The Steampunk
Magazine*, Issue 7, p. 423.

69 Jeff Vandermeer and Desirina Boskovich, *The Steampunk User's Manual*
(New York: Abrams, 2014), p. 203.

70 Vandermeer and Boskovich, *The Steampunk User's Manual*, 188.

71 Catherine Spooner has navigated Andrew O'Neill's persona as a stand-
up comedian in her *Post-Millennial Gothic*. See pp. 146–151.

72 Vandermeer and Boskovich, *The Steampunk User's Manual*, 203.

73 Anon, 'Less Brass Goggles, More Brass Knuckles: An Interview with
The Men That Will Not Be Blamed for Nothing', *The Steampunk
Magazine*, Issue 7, p. 422.

74 Anon, 'Less Brass Goggles, More Brass Knuckles: An Interview with
The Men That Will Not Be Blamed for Nothing', *The Steampunk
Magazine*, Issue 7, p. 422.

75 Anon, 'Less Brass Goggles, More Brass Knuckles: An Interview with
The Men That Will Not Be Blamed for Nothing', *The Steampunk
Magazine*, Issue 7, p. 423.

76 Anon, 'Tech Know: A Journey into Sound', 27 May 2010, http://www.
bbc.co.uk/news/10171206 [accessed 14 March 2018].

77 See Stephanie Munro, 'A Moment That Changed Me: Turning My Back
on Monogamy', https://www.theguardian.com/commentisfree/2017/
sep/15/moment-that-changed-me-monogamy-polyamory-jealousy
[accessed 14 March 2018].

78 Anon, 'Less Brass Goggles, More Brass Knuckles: An Interview with
The Men That Will Not Be Blamed for Nothing', *The Steampunk
Magazine*, Issue 7, p. 425.

79 TMTWNBBFN, *Now That's What I Call Steampunk Volume 1*, 'Goggles', Leather Apron (2010).

80 Naomi Wolf, *The Beauty Myth: How Images of Beauty Are Used against Women* (London: Vintage, 1991), p. 14.

81 TMTWNBBFN, 'Goggles'.

82 TMTWNBBFN, 'Goggles'.

83 Wolf, *The Beauty Myth*, 14.

84 As a comparison, see Chapter 2 on M. M. Bakhtin for the notion of the 'grotesque body' in Nick Simpson's work.

85 TMTWNBBFN, 'Free Spirit', *This May Be the Reason Why The Men That Will Not Be Blamed for Nothing Cannot Be Killed by Conventional Weapons*, Leather Apron Recordings (2012).

86 TMTWNBBFN, 'Free Spirit'.

87 TMTWNBBFN, 'Free Spirit'.

88 TMTWNBBFN, 'Free Spirit'.

89 Antonija Primorac, 'The Naked Truth: The Postfeminist Afterlives of Irene Adler', *Neo-Victorian Studies* 6:2 (2013) http://neovictorianstudies. com/89-113 [accessed 15 March 2018], 90. See also Steven Marcus, *The Other Victorians: A Study of Sexuality and Pornography in Mid-Nineteenth-Century England* (New Brunswick: Transaction Publishers, 2009, new edition), for a useful corrective to the desexualized Victorians.

90 Naomi Wolf, *Fire with Fire* (London: Vintage, 1994), p. 199.

91 Natasha Walter, *Living Dolls: The Return of Sexism* (London: Virago, 2010), p. 84.

92 Germaine Greer, *The Female Eunuch* (1970, repr. London: HarperCollins, 2006), pp. 274–275.

93 Marie-Luise Kohlke, 'The Neo-Victorian Sexsation: Literary Excursions into the Nineteenth Century Erotic', in *Probing the Problematics: Sex and Sexuality*, ed. Marie-Luise Kohlke and Luisa Orza (Oxford: Interdisciplinary Press, 2008), p. 356.

94 See TMTWNBBFN, *Now That's What I Call Steampunk Volume 1*, Leather Apron (2010).

95 For these songs, see TMTWNBBFN, *Not Your Typical Victorians*, Leather Apron (2015).

96 TMTWNBBFN, *Not Your Typical Victorians*, 'Not Your Typical Victorian', Leather Apron (2015).

97 See also Doctor Geof, 'Isambard Kingdom Brunel', which gestures towards 'the human cost of the industrial revolution, but the truth is IKB was actually one of the better engineers to work for with regards to worker mortality', http://shop2.islandofdoctorgeof.co.uk/index.php?route=product/product&product_id=182.

98 Llewellyn, 'What Is Neo-Victorian Studies?', 165.

99 Helen Davies, *Neo-Victorian Freakery* (Basingstoke: Palgrave, 2015), p. 8.

100 For a comprehensive history of abortion rights (and the erosion thereof) in the United States, see Carol Sanger's *about Abortion: Terminating Pregnancy in Twenty-First Century America* (Cambridge, MA: Harvard University Press, 2017).

101 TMTWNBBFN, 'Inheritor's Powder', *Not Your Typical Victorians*, Leather Apron Recordings (2015).

102 David Wilson, *Mary Ann Cotton: Britain's First Female Serial Killer* (Hampshire: Waterside Press, 2013), p. 157.

103 Judith Flanders, *The Invention of Murder: How the Victorians Revelled in Death and Detection, and Created Modern Crime* (London: HarperCollins, 2011), p. 390.

104 Flanders, *The Invention of Murder*, 391–392.

105 Harold Schechter, *Fatal: The Poisonous Life of a Female Serial Killer* (New York and London: Simon and Schuster, 2003), p. xviii. This fascination with female serial killers (such as Myra Hindley or Aileen Wuornos) continues in the present.

106 TMTWNBBFN, 'Inheritor's Powder' (2015).

107 Judith Knelman, *Twisting in the Wind: The Murderess and the English Press* (Toronto: University of Toronto Press, 1998), p. 74.

108 TMTWNBBFN, 'Inheritor's Powder' (2015).

109 TMTWNBBFN, 'Inheritor's Powder' (2015).

110 From the Broadside Ballad, 'The Trial, Sentence, & Condemnation of Mary Ann Cotton, The West Auckland Poisoner', Bodleian Library, Oxford, Harding B 12(184), http://ballads.bodleian.ox.ac.uk/view/sheet/18273 [accessed 21 March 2018].

111 Broadside, 'The Trial, Sentence, & Condemnation of Mary Ann Cotton'. See also 'The Execution of Mary Ann Cotton at Auckland county Durham who was accused of a long seiries [*sic*] of murders by poison', Bodleian Library, Oxford, Firth *c.* 17(98), http://ballads. bodleian.ox.ac.uk/view/sheet/12876 [accessed 21 March 2018].

112 Knelman, *Twisting in the Wind*, 75.

113 Judith R. Walkowitz, 'Jack the Ripper and the Myth of Male Violence', *Feminist Studies* 8:3 (Autumn, 1982), 542–574, 569.

114 One of Cotton's neighbours, Jane Hedley, gave this account under oath. See Wilson, *Mary Ann Cotton*, 90.

115 TMTWNBBFN, 'Inheritor's Powder' (2015).

116 Alison Rattle and Allison Vale, *The Woman Who Murdered Babies for Money* (London: Andre Deutsch, 2011), p. 231.

117 *Trial of Amelia Dyer*, May 1896, Old Bailey Proceedings Online, https://www.oldbaileyonline.org/print.jsp?div=t18960518-451 [accessed 9 March 2018]. See also 'The Reading Child Murders', *Morning Post* (London, England), 20 April 1896, p. 6.

118 Knelman, *Twisting in the Wind*, 175.

119 *Trial of Amelia Dyer*, May 1896, Old Bailey Proceedings Online, https://www.oldbaileyonline.org/print.jsp?div=t18960518-451 [accessed 9 March 2018]. See also Rattle and Vale, *The Woman Who Murdered Babies for Money*, 216.

120 *Evening News*, 27 April 1896, p. 3. Cited in Knelman, *Twisting in the Wind*, 179.

121 Cited in Knelman, *Twisting in the Wind*, 179.

122 Rattle and Vale, *The Woman Who Murdered Babies for Money*, 166.

123 See examples from Rattle and Vale, *The Woman Who Murdered Babies for Money*, 148.

124 Jessica Elgot, 'Jacob Rees-Mogg Opposed to Gay Marriage and Abortion – Even after Rape', *The Guardian*, 6 September 2017, https://www.theguardian.com/politics/2017/sep/06/jacob-rees-mogg-opposed-to-gay-marriage-and-abortion-even-after [accessed 10 November 2017].

125 TMTWNBBFN, 'Baby Farmer', from *Double Negative*, Leather Apron Recordings (2018).

126 For the Tuam baby scandal, see Elaine Edwards, 'Tuam Babies: "Significant" Quantities of Human Remains Found at Former Home', *Irish Times*, 3 March 2017. https://www.irishtimes.com/news/social-affairs/tuam-babies-significant-quantities-of-human-remains-found-at-former-home-1.2996599 [accessed 10 April 2018]. The death of Savita Halappanavar in Ireland in 2012 also galvanized support for the pro-choice campaign. See Alison O'Connor, 'How the Death of Savita Halappanavar Changed the Abortion Debate', *Irish Examiner*, 28 October 2017, https://www.irishexaminer.com/viewpoints/analysis/how-the-death-of-savita-halappanavar-changed-the-abortion-debate-461787.html [accessed 10 April 2018].

127 Roček, 'A Brief History of Birth Control', 123–124.

128 Peter Ackroyd, *Thames: Sacred River* (London: Chatto & Windus, 2007), pp. 24–25.

129 TMTWNBBFN, 'Baby Farmer' (2018).

130 TMTWNBBFN, *This May Be the Reason Why The Men That Will Not Be Blamed for Nothing Cannot Be Killed by Conventional Weapons*, Leather Apron Recordings, (2012).

131 TMTWNBBFN, 'Tesla Coil' (2012).

132 TMTWNBBFN, 'Tesla Coil' (2012).

133 TMTWNBBFN, 'Tesla Coil' (2012).

134 Carolyn A. Conley, 'Rape and Justice in Victorian England', *Victorian Studies* 29:4 (Summer 1986), 519–536, 533.

135 Shaun Davies & Milly Stilinovich, 'How Return of Kings Used Outrage to Sell Extreme Ideas', BBC News (Australia), 4 February 2016, http://www.bbc.co.uk/news/world-australia-35490223 [accessed 10 April 2018].

2

Doctor Geof and Nick Simpson: Sex, War and Masculinity

Introduction: Steampunk and art

In *The Art of Steampunk*, a publication which accompanied the first ever steampunk exhibition, hosted by the Museum of the History of Science in Oxford, UK (October 2009 to February 2010), Art Donovan explains that 'steampunk design is definitely not just a "boy's club" of enthusiasts. Its fans and creators are equally divided among women and men, young and old alike, from around the world'.[1] Interestingly, whilst some women feature within the pages of the catalogue, it is notable that overwhelmingly, the artists are men. Indeed, the current chapter is no exception in this regard, taking two male artists (Doctor Geof and Nick Simpson) as the subject of the study of steampunk art. Clearly, these two male artists are vocal supporters of gender equality and challenge the tradition of masculine dominance in their artwork. However, they are also navigating the problem that they are men attempting to fix the problem of hegemonic masculinity in and outside of steampunk culture on behalf of women (as well as on behalf of enlightened men). What is perhaps noteworthy here is the systemic valorization of male art at the expense of women vocalizing their own experiences. However, the reasoning behind this choice is important: in their range of media (photography, line drawing), both artists clearly reflect upon the intersection of gender, history, representation and steampunk: for Doctor Geof, this entails a frank and forthright discussion of historical and contemporary pornography, BDSM

subculture, Victorian advertising and our misapprehensions of the Victoria era whilst also exploring how science in the nineteenth century was coded masculine (several examples of Doctor Geof's work are influenced by his early academic career as a physicist). Additionally, Doctor Geof explores the nature of Empire and its links to masculinity through the model of jingoism and the rhetoric of war (particularly related to the First World War). Interestingly, Doctor Geof also employs this historical context to address political rhetoric in the present moment, specifically in relation to the European Union Referendum in the UK and the high-profile campaign associated with this historic vote, held 23 June 2016. Nick Simpson works in photography using nineteenth-century techniques and equipment in order to construct an imagined history of his fictitious great-grandfather, Samuel Heracles Gascoigne-Simpson, resident of the family seat, Bumforth Manor.[2] Thus, it is possible to perceive how postmodern notions of play feature strongly in such artwork, where reliability, intertextuality and the parodic use of literary themes and sources interrogate historical tropes of masculinity. As is apparent from much of his work using female nudes, Nick Simpson also carefully addresses the notion of body image, size and ageing in order to contest contemporary notions of beauty.

Both artists also reflect upon their subjects with wry humour and in a particularly Neo-Victorian fashion. In their introduction to *Neo-Victorian Humour*, Kohlke and Gutleben observe that 'neo-Victorian humour ... is doubly double: both temporally and ideologically. Accordingly, it lends itself to positive, liberating and ethical readings as well as negative, derogatory and unethical interpretations.'[3] Doctor Geof conflates time periods so that we look at his artwork mindful of historical dissonance as well as complementarity: we view pseudo-nineteenth-century material with a twenty-first-century perspective. This tension between two historical perspectives also means it is important such humour carries a caveat: an audience must

subscribe to and be aware of the ironizing gestures inherent in the art. As Kohlke and Gutleben suggest, 'by re-presenting period terminology, outmoded attitudes, and questionable ideological discourse in order to comically deconstruct them, neo-Victorian humour becomes implicated – even if only ironically – in their reproduction, inadvertently giving them new life and keeping them in cultural circulation'.[4]

The two artists in this chapter circumvent the problems of Victorian re-presentation through incongruity. Noël Carroll has noted that humour is 'a deviation from some presupposed norm – that is to say, an anomaly or an incongruity relative to some framework governing the ways in which we think the world is or should be'.[5] Certainly Doctor Geof explains that his use of powerful female figures relates to 'an inversion of norms (as opposed to subversion of norms)'.[6] Similarly, Nick Simpson suggests that his use of larger, middle-aged female models is a conscious choice: 'I find them far more interesting than the usual idealised beauty foisted on us by today's media. Whether it's the emaciated teen models of high fashion, the buffed and ripped male and female gym bunnies, or the tattooed pneumatic "suicide" girls of today's "alternative" modelling, I just find it all a little predictable.'[7] In both instances, the artists have developed notions of gender which are incongruous to cultural and social expectations. One example will suffice here. Doctor Geof's *Steampunk Literary Review* features numerous pages of spoof Victorian advertisements. One of these, 'B-B-Bottled Bees', clearly parodies the representational logic of modern-day sexual culture (which renders women's sexuality a male spectacle) whilst simultaneously offering a critique of nineteenth-century hypocrisy with reference to sex and gender.[8] The advertisement references the historical existence of numerous print advertisements for relief from hysteria in the late nineteenth century, 'in which the vibrator went from being a piece of specialist equipment in the hands of medical practitioners to being a domestic appliance

used by women to secure their own erotic satisfaction'.[9] However, the use of bees is an immediate and overt gesture towards incongruity, as is the image of a fairy riding a bottle of bees in erotic ecstasy. The use of a symbol exclaiming '100% bees' suggests modern commodity and its relationship with trademarks, approval marks, authenticity and ethical evaluation (repeated in the footer 'No bees were harmed in the making of this advert'). Most pertinent, however, is the substitution of a woman for a fairy (as this is a fantastical and childlike figure). The copy in the spoof advert states: 'Buy the thimble-sized creature in your life something special this xmas.' Intertextually, this relates to an earlier drawing in the *Steampunk Literary Review*, 'Fairy Folk', from a series entitled 'Inappropriate Etchings' where a male scientist scrutinizes the naked female form of a minute fairy. This drawing also references Conan Doyle's advocacy of the Cottingley Fairies in *The Strand Magazine* (1920), but it also clearly reveals how women feature as erotic spectacles for the consumption of the male viewer. The fairy in the 'B-B-Bees' advertisement is as incongruous as the bottle of bees, but she is also a substitute for the diminutive (in all senses) woman – she is hyperfeminine, small (and therefore unthreatening) and sexualized (she is tied to a bobbin of cotton, with her buttocks exposed to a riding crop).

In many instances, this idea of the diminutive is a legacy of eighteenth-century aesthetics. In his analysis of beauty, Edmund Burke reasons that 'beautiful objects are comparatively small'.[10] Indeed, as many commentators have later argued, Burke's notion of beauty is inflected by gender determinants.[11] The woman is spectacle and disempowered as a diminutive source of visual pleasure. The depiction of autoerotica in this small illustration highlights very specific historical gender stereotypes, whilst the humorous incongruity here (bees, fairies, vibrators, Victorian advertising) underscores Doctor Geof's critique of gender inequality. There is a category error here: we do not expect bees in bottles and fairies to be part of an advertisement

relating to sexual pleasure. Thus the humour here is also directly related to the subject matter – sex. Carroll suggests that 'sex and sexual behaviour are freighted with so many norms and stereotypes, they too are a natural breeding ground for humour'.[12] Whilst not expressly stated in the advertisement, the implied reader is a man, a husband buying a gift for his wife. Each of these meanings absurdly conflates into a robust critique of normative gender binaries, ultimately collapsing into nonsense and bearing out Carroll's observation that 'not only can concepts be problematized for the purpose of incongruity, but so can stereotypes. Our stereotypes can be distorted either through the exaggeration of stereotypical features or through their diminution'.[13] Another example, 'Mugs', uses the language of pornography ('hot, wet') juxtaposed with the ceremony of tea drinking (a steampunk staple). The small image accompanying this spoof advertisement reveals a pin-up in a highly incongruous pose, holding two mugs of (presumably) tea in front of her chest. Her figure, with narrow waist and implied oversized breasts, suggests an exaggeration of Victorian dress (the corset), but the masculine scopic logic of conventional pin-up images is fractured: instead of sensationalism which places women's sexuality in the service of the male gaze, we have a comedic and oddly *unexposed* image of pin-up womanhood.

As a caveat, in relation to steampunk art specifically, we need to think about how far these forms of Neo-Victorian humour conflate with notions of superiority. Kohlke and Gutleben note that superior humour is 'often linked with empowering and positive effects … or serving as a means of resistance and subversive socio-political critique'.[14] Following this train of thought, as contemporary viewers, we hold ourselves superior in this form of laughter, because we are supposedly so much more enlightened than the Victorians. However, by gesturing towards contemporary and historical limitations, and drawing analogies between these two perspectives, both artists avoid claiming that modern society is somehow superior to the Victorian

moment. In fact, both artists actually address our misapprehensions of the Victorian era, as well as considering contemporary ideas of beauty and conventional female behaviour. Nick Simpson's artwork, such as 'The Venus of Whissendine' (2015), circumnavigates such notions of 'superiority' by also challenging how contemporary society supports normative beauty ideals. Whilst not a humorous subject as such, this piece emphasizes a carnivalesque approach to portraiture. As is well established in theoretical models of the body, Bakhtin suggests one of carnivalesque's key features is the representation of the grotesque body, which is always in the process of living, dying, creating, existing:

> It is usually pointed out that in Rabelais' work the material bodily principle, that is, images of the human body with its food, drink, defecation, and sexual life, plays a predominant role. Images of the body are offered, moreover, in an extremely exaggerated form. In grotesque realism ... the bodily element is deeply positive.[15]

Simpson's 'Venus of Whissendine' challenges the smooth lines of classical aesthetics, which involved the completed body, one which is ready made and scourged of any process of birth, living, dying, without orifices. Ageing is also particularly important in this context: an older subject, as well as one whose body is excessive, larger than life, is a body in extreme, in rebellion against classical archetypes in which 'inner processes of absorbing and ejecting were not revealed'.[16]

Carnivalesque humour also provides an additional critical framework for Doctor Geof's pornographic artwork ('The Hindenboob Types I and II', 'A Series of Inappropriate Etchings'). This work often features the penetrated body (however implicit), the displacement of traditional masculine authority, the autoerotic, oversized members and ribald humour, which all coalesce in a challenge to traditional modes of representation. In the words of Bakhtin:

The stress is laid on those parts of the body that are open to the outside world, that is, the parts through which the world enters the body or emerges from it, or through which the body goes out to meet the world. This means that the emphasis is on apertures or the convexities, or on various ramifications and offshoots: the open mouth, the genital organs, the breasts, the phallus, the pot-belly, the nose.[17]

For Doctor Geof, this is a fantastical and speculative art related to 'the fake world that we wish to exist'.[18] It is a Victorian world upside down, where women are scientists and men are submissive sexual playthings. However, carnival art is also only partial in its challenge to authority, being a 'safety valve',[19] limited by official culture. The text becomes a partial, permitted space: one which is obscene, which synthesizes different forms and hierarchies of cultural production, reverses social roles and is 'a mediation between high and low forms of culture'.[20] In their respective discourses of the body, both artists explore the possibility of representation outside social convention.

Spoof histories – War and masculinity in the artwork of Doctor Geof

The Steampunk Literary Review introduces itself as 'a collection of humorous, anachronous, drawings and comics', which in some ways provides a useful introduction to the work of Doctor Geof as a whole.[21] It features a spoof editor, 'Count P. Von Plumbing-Supplies' (at intervals this character is also dubbed 'Major P. Von Plumbing-Supplies' of the First Tea Company First Inland Auxillary Reserve), whose pompous introductions, formal language and humble self-aggrandizement emulate the narrative voice of a nineteenth-century editor. Doctor Geof's work neatly combines steampunk satire, pastiche, parody, gentle humour and erotica, whilst emphatically

maintaining a critique of the more conservative elements of the
subculture, including unreconstructed nationalism, gender bias
in science, imperial motifs and celebration of British Empire. The
use of the British Empire is interesting in locating steampunk as a
contested site. Steampunk people of colour, both practitioners such as
Diana M. Pho and critics such as Elizabeth Ho, have challenged the
steampunk appropriation of Empire without any critical irony, and
Doctor Geof is situated in a similar rhetorical framework. In many
instances, Doctor Geof's work celebrates sexual progressiveness,
whilst at the same time offering a very Neo-Victorian understanding
of the nineteenth century. For instance, Doctor Geof maintains
that *The Steampunk Literary Review*, which will be a cornerstone of
discussion in this chapter, has a double chronological perspective:
the spoof adverts included in the magazine simultaneously address
contemporary issues, but also parody Victorian adverts, as well as
our understanding or indeed miscomprehensions of the historical
Victorian period.[22] As Eckhart Voights-Virchow has outlined in his
discussion of Neo-Victorian novels:

> Neo-Victorian texts invite … The emergence of the modern and
> the traditional at the same time (literally, the contemporaneousness
> of what is not contemporaneous or *Gleichzeitigkeit des
> Ungleichzeitigen*, a phrase coined by Ernst Bloch and art historian
> Wilhelm Pinder). This would propose neo-Victorianism as a kind
> of third space, not Victorian, not contemporary. The faux Victorian
> novel is a fascinating area of tension between the Victorian and
> the contemporary, a hybrid space of mimicry, camouflage and
> assertions of difference.[23]

This *Gleichzeitigkeit des Ungleichzeitigen* manifests itself in Doctor
Geof's work through a reflection on, and challenge to, jingoism:
'Jingo is the biggest problem. The path against jingo is to undermine
jingo.'[24] Historically, the jingoism of the latter half of the nineteenth
century is inflected with a paranoia related to the rivals for Empire

(America and Germany) and was combined with racist rhetoric and a curious religiosity.[25] It was also emphatically hypermasculine, in common with the themes of heroic manliness espoused by writers like Rudyard Kipling. John Tosh notes that 'empire was seen as a projection of masculinity ... both made much of struggle, duty, action, will and "character" ... [Empire's] acquisition and control depended disproportionately on the energy and ruthlessness of men; and its place in the popular imagination was mediated through literary and visual images which consistently emphasised positive male attributes'.[26] This is established quite clearly in *The Steampunk Literary Review* Vol. I, where Plumbing-Supplies situates the journal in a broader culture of masculinity and Empire: 'We all have our roles to play in an armed struggle. Some of us far away upon foreign shores, whilst others must toil nearby in comfy offices'.[27]

Whilst this clearly reflects the inequalities of war (the Tommy in the trenches versus the clerk at home), it also buys into (and satirizes) two models of masculinity which dominated First World War propaganda: the heroic, located on 'foreign shores' and the battlefront, whilst the second was domestic, empathising with men's roles at home as 'both protector and provider'.[28] These models of masculinity 'dominated the early years of the war when gendered propaganda was used to encourage men to enlist, evoking the associations made between participation in warfare and physically and morally virtuous masculinity'.[29] It is worth noting how the image of the soldier as hero was also informed by the nineteenth-century models:

> In the nineteenth century, the figure of the imperial soldier hero, alongside that of the imperial adventurer, was one of the most potent and widespread images of idealised masculinity in cultural circulation. In history, fiction, children's literature, on the lecture circuit and in the newspapers, the soldier was celebrated as the epitome of both the imperial ideal and appropriate masculinity.

The continued potency of this ideal in the early years of the First World War can be seen in the use of the image of the soldier hero in recruiting posters, particularly in the famous image of Kitchener, already heroic through his military exploits in Khartoum. This image was to remain iconic long after the war was over, not simply as an ironic symbol of military bluster, but as an icon of the purpose with which individuals in Britain had gone to war.[30]

The image of the soldier also becomes invested with images of nationhood and nationalism. Steve Attridge has noted that cenotaphs and the Tomb of the Unknown Soldier carry ideological freight far beyond their declared intention of honouring the war dead: 'The soldier is an archetype, symbolizing race and nation.'[31] Similarly, Benedict Anderson has noted that such anonymous, nameless icons contribute to his notion of an imagined community: 'Void as these tombs are of identifiable mortal remains or immortal souls, they are nonetheless saturated with ghostly *national* imaginings.'[32]

Kitchener's image represents a military force which is both nationalistic and imperialistic. Whilst he was the Secretary of State for War during the First World War, his fierce public image emerged with his policies in the Second Boer War 1899–1902, including his institution of concentration camps, and his Anglo-Egyptian campaign in the 1890s to recapture the Sudan for the British Empire. Doctor Geof's intervention in the rhetoric of war is perhaps best explored by reference to some of the tropes he uses in his illustrations. Indeed, we might first think about Doctor Geof's contribution to the plethora of imitations and parodies of the Lord Kitchener First World War Recruitment poster, 'Your Country Needs You' (Figure 2), which highlights how this historical image has become overburdened with meaning.

James Taylor has provided extensive evidence that the poster was originally drawn by Alfred Leete (1882–1933) as an advertorial magazine cover for *London Opinion* (1914) and was privately printed,

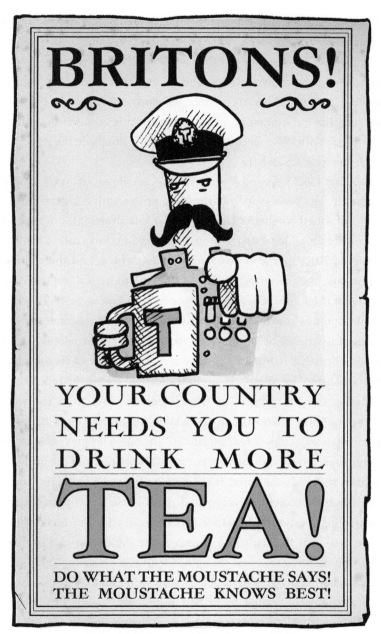

Figure 2 Doctor Geof, 'Britons, Your Country Needs You'.

rather than being a campaign by the Parliamentary Recruitment Committee (PRC).[33] As Rachael Teukolsky notes, such print culture gives readers 'the illusory sense of shared experience with innumerable unknown others' and is one of the ways in which national iconographies are established and maintained.[34] The fact remains that our contemporary appraisal of this poster is bound up with First World War recruitment campaigns, alongside the legacy of Kitchener as colonial hero.

Doctor Geof's parody renders the ideology of war utterly foolhardy. His version follows the 1914 poster with a central image of a uniformed Kitchener (rendered in a line drawing), pointing at the viewer and addressing 'Britons!' in a nationalistic call to arms.[35] However, Kitchener also bears a large mug of tea, and the caption below says 'Your country needs you to drink more tea!' followed by 'Do what the moustache says! The moustache knows best!' The first point of note is how this spoof recruitment poster participates in the incongruity theory of humour: the fact that the poster relates to that famous British pastime of tea-drinking (so beloved of steampunks and fetishized by them) is an unexpected, comic juxtaposition, following Beattie's proposition that 'laughter arises from the view of two or more inconsistent, unsuitable, or incongruous parts or circumstances, considered as united in one complex object or assemblage, or as acquiring a sort of mutual relation from the peculiar manner in which the mind takes notice of them'.[36] However, some theorists of humour have suggested that by itself, incongruity isn't funny. The question is 'whether it is necessary for the incongruity to be resolved; that is, to be shown to be logical, or at least less incongruous than was first thought'.[37] Whilst tea and the ceremony of tea drinking are rendered utterly absurd in Doctor Geof's world, it is also closely related to British imperialism, and thus, neatly correlates with Kitchener's imperial heroic image. Whilst tea and the military are clashing concepts, and ultimately contradictory, there

is also a common ground here: the Victorian era is noteworthy in Doctor Geof's work because for him, it reflects 'gun boat diplomacy … China buying opium from the British because we wanted tea … Tea is colonial. It's an icon of Englishness but it is also imperial'.[38] Provocatively, Kitchener is reduced to a comedically oversized moustache, with the imperative strapline 'do what the moustache says, the moustache knows best' neatly parodying masculine aggression and authority. In terms of his objectives in spoofing First World War propaganda, Doctor Geof explains that 'it feels violent to us … [it's] the language of a parent talking to a child'.[39] Certainly in the case of the Kitchener image, it is a bossy, authoritative voice, but one which is undercut by incongruous juxtaposition.

The satirical approach to the military relates to Doctor Geof's situated critique of steampunk from within the movement. He says that 'steampunk needs to be fake military, not real military' which is a distinction he also draws in *The Steampunk Literary Review*, in a short series of panels showing steampunk characters outraged by street protesters, summarized as 'Steampunk – You're Doing It Wrong'.[40] Angered by 'awful poor people protesting again', one steampunk character exclaims, 'Send in the cavalry I say, violence is the only thing these people understand.' There is a clear class distinction here (poor people versus a man who simply wants to enjoy 'his elevenses in peace') but more importantly, the idea that military control and violence is the answer is clearly contested: this is the wrong way to practise steampunk. The overall tension here from within the steampunk community is between a celebration of war and challenging war as a great evil. The nexus of hypermasculinity, imperialism, war and steampunk is interrogated and disputed in this satirical drawing. A similar objective is discernible in other posters from this issue of *The Steampunk Literary Review*. For instance, 'Be Ready Jam Sponge' (Figure 3) is a direct parody of the anonymous recruitment poster 'Be Ready! Join Now!' from 1915, with a mustard background and

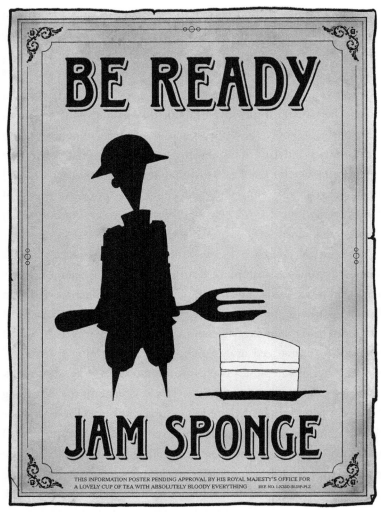

Figure 3 Doctor Geof, 'Be Ready, Jam Sponge'.

showing the silhouette of a First World War infantryman holding a
fixed rifle bayonet.

Doctor Geof's version, in a similar colour scheme with black
silhouette, substitutes the rifle for a cutlery fork and inserts a slice
of Victoria sponge into the foreground. This image destabilizes the

validation of war: the violence, aggression and brutality popularly expected of men on the front line become an innocuous and humorous tea-time treat. In terms of gender relations, if the masculine attributes of warfare established a power base in which men claimed gender privilege, then this hegemonic masculinity is humorously undercut by the Tommy and his sponge cake. Doctor Geof is careful to suggest that he isn't lampooning the soldiers who fought and died as participants in war. Rather, he is (a) constructing a fake version of the military which is far more innocuous and (b) identifying how a jingoistic ideology underpins many of these images: 'Jingo is the difference between a life on the line for a job, and "heroically" shooting people.'[41] The cover image of the spoof journal 'Tea and Country' (also in the same issue of the *Steampunk Literary Magazine*) achieves a similar critique of the intersection between masculinity, war and Empire. This image shows a Tommy in khaki, standing next to a small child who is offering the soldier a mug of tea. What is noteworthy about this image, however, is that the narrow waist and curved breasts suggest a female soldier. The lack of facial features allows a similar reading, so that the image conflates a soldier off to war, with a woman and child, unpicking all the conventions of masculinity military service and feminine domesticity. Other spoof posters, such as 'Who Do You Want To Be?', carrying the strapline 'Be the Best' (derived directly from the British Army's recruitment campaigns up to and including the time of writing), offer opportunities including train driving, baking, surfing, racing, car driving and playing music – in fact, any and all opportunities except fighting. The poster 'Enlist' explores similar themes asking, 'Do you love lovely love tea enough to lovely well defend it?' In all these spoof posters, the defence of the realm, notions of Englishness and national identity are rendered entirely absurd through comparison to that stereotypical English obsession with tea drinking.

The First Tea Company – Tea and Brexit

Each of the images discussed in the previous section also contributes to a bigger project, 'The First Tea Company', which is Doctor Geof's invention of a spoof military unit (including those he issues with an identity card) (Figure 4):

> This … probably has a lot to do with the popularity of the original 'enlist' poster. To date I've enlisted several hundred people, sketched a great many faces on to ID cards, made yet more posters and mugs, cast pewter medals and had an enlistment fair … I have been known to refer to the FTC as a fake re-enactment society. This idea tickles me: we'd have to organise meetings that we may or may not attend and then drink tea whilst quibbling over the lack of authenticity of everything and anything.[42]

His point is not to vilify the military, quite the opposite. These illustrations express a sympathy with the soldier and recognition that war and loss of life are terrible. 'The military' here identifies an institution rather than those who serve in it. By comparison, the serving soldier seems to be worthy of reverence, meaning there may

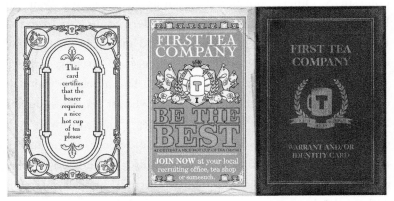

Figure 4 Doctor Geof, the First Tea Company recruitment card.

be some sense of the value of patriotic sacrifice.[43] What this artwork rejects is the heroic propaganda which surrounds war. Hence part of Doctor Geof's satirical target is nationalistic war propaganda. Doctor Geof's satire challenges the perception of hypermasculinity in the Victorian era (and aspects of steampunk), as well as in the present day, anachronistically shifting between contemporary army recruitment campaigns and those of the past. He emphasizes that steampunk military needs to wear its artifice overtly. It is a performance which reflects upon and challenges its historical predecessor, rather than providing a homage or simple re-enactment of events.

As a loose assembly of Doctor Geof's patrons, fellow steampunks and other interested parties, the First Tea Company is performative as well as a visual narrative. The name unites the idea of a 'company' not only as a military unit but also links to commodity-driven organizations such as the East India Company, which had its own armed militia. It encompasses Doctor Geof's artwork in *The Steampunk Literary Magazine*, fake military performance and a spoof referendum at the Lincoln Steampunk Festival (26–28 August 2016). Framed as a vote based on 'Milk First' or 'Milk Last' in the preparation of tea, this is deeply politicized, being a satirical intervention in the propaganda surrounding the European Referendum (23 June 2016), where the UK voted whether it should remain or leave the European Union. 51.89 per cent voted to Leave, whilst 48.11 per cent chose to Remain. However, he isn't the only satirist to draw correlations between an imagined nineteenth century and the post-Brexit crisis. *The Daily Mash* article 'Rees-Mogg Launches Steampunk Revolution' features Jacob Rees-Mogg (MP for North East Somerset and a reactionary right-wing conservative). The article lampoons him for his regressive social attitudes (monarchist, Eurosceptic, opposition to same-sex marriage and abortion) and suggests he will be marching on Downing Street accompanied by a steampunk army and ornate weaponry: 'Rees-Mogg has outlined plans for a post-Brexit Britain of brass automatons,

clockwork cars and steam-powered internet.'[44] Given how a 'return to Victorian values', first invoked by Margaret Thatcher in the 1983 election, was reiterated frequently in politics as a rallying cry for 'lost stabilities', it seems entirely appropriate that Rees-Mogg should be made fun of in this way.[45] It also highlights how martial imagery has become a cornerstone of discussions about Brexit. Indeed, it seems the current political climate enables this form of satire more generally. At the time of writing, the widespread currency of regressive nostalgia seems to have been triggered by fear of globalization that in a sense enabled the referendum (and its result).

The divisive debates between Leave/Remain campaigns and their use of martial metaphor are exemplified by the UK Independence Party (UKIP) exclaiming on Twitter that they are 'ready for war'.[46] Just after the referendum in October 2017, Phillip Hammond, the Conservative Party Chancellor of the Exchequer, described the EU as an 'enemy', resulting in newspaper coverage which characterized Hammond's statement as a 'war of words'.[47] War was also implicit in the EU referendum campaign in the run-up to the vote in June 2016, as analogies were drawn between the UKIP campaign (separate, at least formally, from the 'Vote Leave' camp) and Nazi propaganda, a trajectory which has continued ever since. In 2014, Nigel Farage, the leader of UKIP at the time, invited the public to join his 'People's Army', cementing the analogy between the language of war and the forthcoming European Referendum.[48] At the same time, right-wing journalists, politicians and commentators have compared the EU and particularly Angela Merkel to the Nazis.[49] UKIP focused on stirring anxiety in relation to immigration: one of their anti-migration posters pictured a long queue of migrants from the Croatia-Slovenia border in 2015, mimicking, however accidentally, Nazi propaganda footage and was reported to police as inciting racial hatred.[50] This fear of the foreign had a real impact on the voting intentions of people in 2016: 'People's attitudes towards immigration were closely linked to their

vote in the Referendum ... The catalyst for change was the decision to allow citizens of the states of Central and Eastern Europe unrestricted access to the UK following their entry into the EU ... As a result, Britain received a historically unique inflow of migrants from the EU accession countries.[51] This established a link in the public mind between negative opinions on immigration and its deleterious effects on British society and equally adverse attitudes towards the EU. Geoffrey Evans and Anand Menon have noted how the Leave vote was aligned with anti-immigration sentiments, whilst Ian Dunt has suggested that

> the twin crises – debt and refugees – created a surge of Euroscepticism on the Continent. More than ever before, people questioned the European project. It was a component, perhaps, of a broader global trend, finding its most grotesque expression in the election of Donald Trump as US President. Populists – typically of the right but occasionally of the left – proved adept at channelling anger over stagnating wages, economic insecurity and globalisation into an attack on the status quo and an affirmation of national, religious or cultural values.[52]

Relatedly, Clarke, Goodwin and Whiteley note 'the importance of feelings of "Englishness" for understanding UKIP's attraction.'[53] Unsurprisingly perhaps, given a variety of factors, including 'economic deprivation and growing inequality, cultural disruptions precipitated by mass immigration and a feeling of alienation from mainstream politics', it is statistically more likely that 'older individuals and men are consistently more likely to support the party [UKIP] than are younger voters and women'.[54] A direct correlation may be made between the rhetoric of war used by campaigners and their key demographic (older people who may remember the Second World War and especially men).[55] This is not to say women didn't support Vote Leave nor that an alignment can be drawn neatly between

voting patterns, age and military service. Rather, as we will see, the steampunk artwork under consideration here draws clear analogies between these related issues (immigration, national autonomy and national identity, masculinity and military discourses), cutting across historical contexts from the past and into the present (an anachronism that is entirely characteristic of steampunk).

The Tea Referendum was accompanied by a formal vote in Lincoln at the Steampunk Festival, a series of posters, voter registration cards (which notably present the vote as a 'Very Civil War') and an ongoing debate via online forums (Facebook, Twitter, Instagram). What is especially noteworthy is how the military imagery of Doctor Geof's previous work, especially in his parody of historical propaganda posters, is folded into political campaign rhetoric. 'Milk First' accuse their opponents of 'broken promises' (a fact widely covered in the media following a U-turn on 'the claim written on the side of the Vote Leave Battle Bus – that leaving the EU would release £350m a week that could be spent on the NHS').[56] By contrast, the 'Milk Last' campaign invokes a 'Vote for Truth' and a 'Vote for Justice' and interestingly, a discourse of blame: one poster, 'Blame Them', suggests, in comedically hyperbolic and alarmist fashion, that Milk First are responsible for 'Orphan Gruel-Fatigue Syndrome' (a delightfully nineteenth-century image, suggesting the ways in which this artwork seeks to represent different historical time periods, with the self-conscious anachronism so ubiquitous in steampunk), whilst Milk First are also presented as 'evil' and 'the Silent Killer'. Doctor Geof's bathetic parody of the EU referendum, a clear demonstration of the incongruity theory of comedy, makes sense in a steampunk context if we think about the iconography with which he is working: military motifs, tea, sepia tones, historical referents and anachronisms, whilst criticizing the divisive nature of the debate as a whole and emphasizing its futility, its nationalistic narrowmindedness and its foolhardy use of the rhetoric of war.

Fetish, filth and ankles: Steampunk illustration and pornography

Doctor Geof's exploration of gender and sexuality in his 'A Series of Inappropriate Etchings' is a corollary to his satire directed towards the hypermasculinity of historical warfare and our contemporary engagement with such material. One of the main objectives here seems to be 'refiguring the Victorian patriarchal in-group as the rejected neo-Victorian outgroup'.[57] In this way, the women of these pieces are presented as an alternative to the dominance of patriarchal hegemony. The series is composed of twenty illustrations, exhibited from March to April 2009 in Sh! Women's Erotic Emporium, London. Notably, this was the first sex shop in the UK which catered exclusively to women, and until October 2014, men were not permitted in the shop unless accompanied by a woman (they are now allowed in the lower floor, whilst the upper floor remains a women-only space). The name is an ironic take on how women's sexuality has been historically neglected: 'a playful comment on society's silencing of women's sexuality – with the exclamation mark sticking its tongue out to all that!'[58] The store stocks women's erotica, books on sexuality and soft-core pornography, but emphasizes it only supports women-friendly material. The Sh! store maintains that it has been 'on a mission since 1992 to create a safe, liberating place for women to explore and express their true sexuality away from pressure or stereotypes'.[59] In some ways, this is part of a broader trajectory in relation to commodified sexuality. In his analysis of sex and media in the twenty-first century, Brian McNair delineates what he calls the 'democratization of desire': that is, 'on the one hand, expanded popular access to all means of sexual expression, mediated and otherwise (the availability of hard core porn to anyone with access to the internet, for example), and on the other, the emergence of a more diverse and pluralistic sexual culture than has traditionally been accommodated within patriarchal capitalism.'[60] However, it is also worth thinking about

how far this is implicated in the post-feminist therapeutic culture, in which women are encouraged to maintain and manage body image, lifestyle, luxury goods as part of a regime in which women construct their femininities according to commodity and fashion. Or as Attwood suggests 'there is a perceivable shift towards the notion of sex as self-pleasure – as indulgence, treat, luxury and right'.[61] Part of this move means that sex becomes a commodity, in much the same way as Emilie Autumn (Chapter 3) offers a packaged and commercial version of subcultural femininity. At the same time, the issues of taste, decorum and value, which are each bound up in a class discourse, reconfigure the traditional view of 'pornography' as something legitimatized: linking sexuality to a range of other contemporary bourgeois concerns such as the development and display of style and taste and the pursuit of self-development and self-care. The resulting figure of the 'sex goddess' is one facet of a broader post-feminist middle-class ideal in which femininities and sexualities are understood as styles, and indeed, as style'.[62] This post-feminist legitimation of women's sexuality is echoed in the Sh! story (Ky Hoyle is the emporium's founder):

> [Ky's] a liberated young woman, and believes it's her right to explore and enjoy her sexuality. … What Ky experiences is alienating, intimidating and sleazy. Dark, dingy sex shops owned by porn barons, run by male staff and catering to male sexuality only (or at least their view on it!) Amidst the DVDs and scratchy panties, are the 'toys', each as phallic and graphically 'realistic' as the next, locked away in grubby glass cabinets. Fellow customers follow her around, often standing too close for comfort – clearly a female looking at sex toys is open game. The only other women around are the blow-up variety. Even the chain that appears more 'female-friendly' feels more about making women feel sexually attractive to men than about exploring their own pleasure.[63]

Thus, as a 'safe space', Sh! seems an ideal location to exhibit Doctor Geof's critical responses to both the Victorian and modern, gendered

values. The 'Inappropriate Etchings' series wrestles with the problem of how to represent sexuality and specifically pin-up culture, without being derogatory to women or offering a stereotype of their experiences from the perspective of a male artist. The Hindenboob (Type I) (Figure 5) presents this dilemma effectively. Given steampunk's

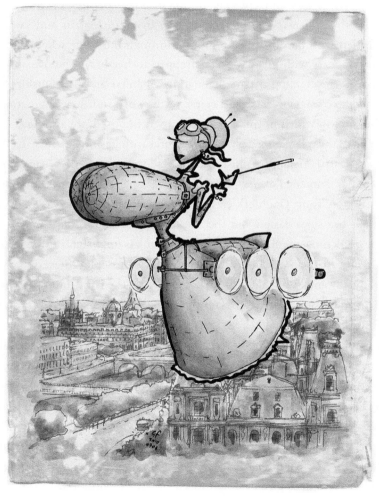

Figure 5 Doctor Geof, 'The Hindenboob – Type I'.

valorization of historical engineering and inventions, the Hindenburg disaster referenced here is especially noteworthy, as it combines both the end of airships as a feasible means of travel, whilst the dirigible itself is an icon of the steampunk imagination (in 1937, the German passenger airship Hindenburg caught fire at Air Station Lakehurst, United States, with a death toll of 36).

However, Doctor Geof's illustration marries iconographic imagery from the cult classic *Tank Girl* (1991) by Alan Martin and Jamie Hewlett with parodic pin-up motifs (through the scene where Tank Girl appears with giant rockets strapped to her bra). The oversized breasts (resembling a pair of floating airships) are also fetishized: whilst excessive breasts are a staple of the porn industry, suggesting the ways in which normative femininity is imposed, we also need to think of the related imagery of conical bras from fashion history: Lady Gaga's 2010 'Alejandro' music video; Madonna's bustier by Jean-Paul Gaultier, launched at her performance in Japan for the 1990 Blonde Ambition Tour; Gaultier's earlier designs from the 1980s; as well as 1950s brassiere design and the use of structured bras by women in the punk movement.[64] The reference to punk is important, as it relates directly to the ways in which steampunk can deploy these images ironically and knowingly. This is confirmed in The Hindenboob (Type II), which uses the airship as a substitute for an oversized penis. The absurdity of this image (a respectable Victorian gentleman flying over a cityscape propelled by his erection!) is only matched by the playful carnivalesque themes it identifies: the figure in Type I is a woman, and in Type II, the subject is a person of colour. The excessive body, one which is too large, is distended or gestures towards generation, sexuality, bodily fluids, is also one which seeks to challenge orthodoxy and give an alternative means of parodic communication to those who cannot speak in authorized discourse: 'Bakhtin sees the carnivalesque as functioning to give back to those who are not authorised to speak some kind of articulate solidarity … The body of the people translates

into speech of the body, and operates with particular vehemence in a culture where the body exists but does not speak.'[65] In Doctor Geof's work, the marginalized body is rendered visible.

In terms of gender-specific bodies, 'Steam-Tease' (No. 01 in the 'Inappropriate Etchings' series) uncovers the marginalized experience of women and their physicality. It also represents the dilemma of contemporary neo-burlesque and the way in which it has become implicated in some aspects of steampunk practice (see Chapter 3 on Emilie Autumn). There is a large body of work which addresses neo-burlesque from a variety of perspectives, but for the current argument, it suffices that neo-burlesque is an ambivalent and contradictory discourse.[66] 'Steam-Tease' encapsulates this dilemma: rather than a huge martini glass, for which burlesque stars like Dita von Teese are famous, the subject sits in an oversized tea cup, sporting a top hat (a common steampunk signifier, but conventionally, a Victorian *man's* attire), goggles, a riding crop and striped tights. Far from representing a conventional form of femininity, this image complicates any neat assumptions we may have: for all intents and purposes, the subject is clothed (or at least, her partial nakedness isn't visible for our consumption). At the same time as her tights suggest steampunk femininity, her stovepipe hat is curiously phallic (being suggestive of a chimney pipe). Her riding crop is a BDSM signifier, and her goggles actually serve to partially conceal (and therefore anonymize) her face. She might be titillating, but she also has a symbolic relationship with the costume of the dominatrix. Valerie Steele notes that the dominatrix is often masked, anonymous and therefore threatening: 'Masks are associated with torturers, executioners, or burglars.'[67] Steele also notes that a riding crop implies 'someone should be beaten … the common fantasy of corporal punishment, which is not only about beating because the action is also a metaphor for sex'.[68] If nudity suggests vulnerability, we do not have access to this subject's naked form. Indeed, most of the symbolism associated with her suggests an

aggressive and phallic version of femininity. And all of this is rendered faintly absurd, given that this steampunk woman is ostensibly sitting in a huge cup of tea. In many ways, this is part of a broader debate following the women's liberation movement of the 1960s and 1970s: Maria Elena Buszek notes that the pin-up was 'rediscovered and recontextualised' through figures like Diana Rigg (as Emma Peel in the TV show *The Avengers*) and in the light of feminist discourses, so that 'these pin-ups appeal to both sexes allowed such idealised images of the aggressive, sexually dominant woman in popular culture to once again cross over into the realm of female visibility and acceptance'.[69] This is noteworthy in the context of Doctor Geof's concerted engagement with fetishized female dominance. His 'Chaise Homme' (No. 04 in the series) shows two women seated on a chaise longue, which on closer inspection is a prone gentleman performing the role of a piece of furniture whilst one woman clearly sits on his face (a sexual practice which has since been prohibited representation in porn films as part of the Audiovisual Media Services Regulations 2014). Like Mary Ann Cotton from the previous chapter, these are quite literally women on top.

'Ms. Frankenstein's Monster' (No. 08 in the series) exemplifies the difficulties of the representation of women in a number of spheres including science, sex and art. As noted in the opening to this chapter, there is a dilemma for the male artist offering a critique of patriarchy, whilst by necessity being within that system. Doctor Geof notes that this illustration reflects upon much of his work for *Physics World* (*c.* 2000–2005): 'I drew lots of MALE scientists. This is a challenge to that. Drawing fewer male scientists – it's the fake world that we wish to exist.'[70] This is part of a well-documented issue relating to the dearth of women and girls in STEM subjects:

> In the UK, girls make up just over half of GCSE students studying science; yet this level of participation in science dramatically decreases as the academic level rises, particularly when compared

to their male counterparts. Today, women make up 12% of all employees in STEM occupations in the UK, and in academia only 9% of all full-time professors in STEM departments are women.[71]

In the light of these statistics, it is worthwhile establishing that parodies of male authority poke fun at, but cannot challenge, the hegemonic forces which instituted such myths and stereotypes. Whilst the series offers powerful female figures as an inversion of norms (rather than a subversion of them) the femme fatale is in many ways a patriarchal construct: the active female is as much a fantasy as the passive woman.[72] However, it is worth noting that some critics have attempted to recover the femme fatale:

> Feminism dismisses the femme fatale as a cartoon and libel. If she ever existed, she was simply a victim of society, resorting to her womanly wiles because of her lack of access to political power. The femme fatale was a career woman manqueé, her energies neurotically diverted into the boudoir. By such techniques of demystification, feminism has painted itself into a corner. Sexuality is a murky realm of contradiction and ambivalence.[73]

The notion of contradiction and ambivalence in the femme fatale is a cornerstone of Doctor Geof's work as a whole. The Frankenstein illustration is trapped in its own era: de facto, Dr Frankenstein means a man, so this is a representational problem in terms of how to signal quite clearly this version of the mad scientist is a woman. One way of going about this is dress, another is a lack of academic title (Ms. as opposed to Dr. – which carefully reflects on how historical women were denied academic qualifications). We might note that steampunk openly revisits Mary Shelley's 1818 novel *Frankenstein* at various points:

> The engineer/inventor as a powerful and threatening creator is a variation on the mad scientist theme, but it is a departure from the Faustian aspect of the mad scientist. The Faustian mad scientist,

best typified by Mary Shelley's Victor Frankenstein, is dangerous because he is not equipped to handle his new knowledge.[74]

Doctor Geof's mad scientist, however, is also a phallic woman – not just in her usurpation of the male bastion of science but also in her manufacture of oversized (and therefore ridiculous) genitalia for her creature (brought to her by a delightfully obsequious Igor, a character from the 1931 *Frankenstein* film with Boris Karloff and directed by James Whale). 'Ms. Frankenstein's Monster' clearly seeks to 'superimpose a sexual seditiousness onto steampunk's socio-political contestation, magnifying and ridiculing myths of femininity while playfully feminising, deconstructing, and carnivalising the traditionally masculine stereotype of the mad scientist'.[75] Incongruously, the Creature is a sex toy for Ms Frankenstein. But, far from suggesting submission to male authority, the illustration asks, 'Why would you want that?'[76] – there is something absurd about this snapshot of scientific creation, suggesting the monstrosity (and therefore manufactured, contingent and partial nature) of masculine authority, and also a curious circumvention of the feminine reproductive burden of labour pain and child rearing (Ms Frankenstein doesn't just give birth). This is also the flip side of 'Fairy Folk' (No. 6 in the series), as here we have a woman scientist objectifying a male subject. Ultimately, 'Ms. Frankenstein's Monster' plays with excessive phallic signifiers as a means to poke fun at masculinity. In a BDSM context (Doctor Geof's other comic *Fetishman* has explicit BDSM themes), 'Inappropriate Etchings' represents the wide array of sexual practices available for women. The artist has noted that 'I'd like BDSM to be more accepted by society. I'm not saying anyone has to do it, I'd just like consenting fetishists to be able to do their "thang" together without being criminalized'.[77] In this alternative world, women are agents of their own pleasure, be it steam-powered sex devices (No. 3), curious parodies of transportation (No. 11) or fracturing the polite

discourse of ladies at afternoon tea in a humorous performance of bondage, polygamy and bestiality (No. 16).

Nick Simpson – The alternative Charge of the Light Brigade

Nick Simpson's photography hovers somewhere in-between Neo-Victorianism and steampunk. Indeed, many of the themes that he addresses, such as scientific exploration ('Dr Crighton's Apparatus ... '), parodies of nineteenth-century war ('Blunderer of the Thirteenth Light') and alternative histories, retro-engineering and invention ('The Astonishing Steam Rhinomotive'), can be identified as steampunk. Nick Simpson has exhibited extensively, including at the Lincoln Steampunk Festival (UK) in 2017. However, much of his work ('Podiceps Cristatus', 'The Venus of Whissendine', 'The Elucidation') addresses broader Neo-Victorian themes of rethinking the Victorian age. Certainly Simpson is aware his work occupies multiple categories, which are in many ways a testament to the ongoing interactions of Neo-Victorianism and steampunk: 'Although some of the work I make could definitely be described as steampunk, it is not exclusively so, and as I am producing work with the underlying suggestion that it was created in the nineteenth century by an actual Victorian photographer, then for me it is perhaps more Neo-Victorian than steampunk.'[78] This Victorian photographer, Samuel Heracles Gascoigne-Simpson (1839–1910), is an alternative and fictional version of the artist's great-grandfather.

Part of this narrative is related to Simpson's fascination with Victorian technology and specifically the technical aspects of photography. This exploration of Victorian photographic practice is mirrored in the techniques that Simpson uses to create an aged or vintage effect in his work as well as the narratives which surround

the images. Simpson uses an 1867 Petzval lens alongside a full-plate mahogany view camera from the same period, and the resulting images are resonant of Victorian salon photography, with black/white and sepia tones. Additionally, 'hand painting, scratching and distressing add a patina to the plates, giving the illusion of historical provenance, adding further credibility to the suggestion that the picture really might be a nineteenth century artefact'.[79] Simpson's aesthetic has much in common with the American photographer Joel Peter Witkin (1939–): like Simpson, he employs the constructed and highly stylized convention of the tableau. Simpson's work also suggests the influence of Flemish/Dutch still life of the sixteenth and seventeenth centuries: each element or object in the photograph has a symbolic meaning, which forms a series of cues as to the wider narrative intention.

Simpson explains that the mid-century Victorian period is of especial importance to photography, given that whilst visual representation was once in the hands of painters and engravers, 'by the mid 1800s this was beginning to open up to almost anyone with the vision and a relatively modest amount of money to invest in the necessary equipment'.[80] Relatedly, Samuel Heracles Gascoigne-Simpson is credited with the (entirely fictional) development of the 'transient puff':

> [A] method of moving liquid light sensitive silver mercury emulsion via the use of a vacuum air blower onto the surfaces of electrically charged zirconium alloy plates. This often dangerous and explosive process actually received a patent in 1876 but it was later withdrawn after several technicians were said to have changed colour after handling the highly toxic and unstable materials.[81]

The spurious historical narrative participates in a number of steampunk themes: the use of dangerous technologies; the trope of the mad inventor; the use of electricity (which can be correlated more

broadly with Nikola Tesla's visibility in many steampunk narratives, as well as his increased visibility in Neo-Victorian culture through films such as *The Prestige* from 2006). Many of these themes may also be identified in Simpson's photography: 'Dr Crighton's Perambulation Device' and 'Dr Crighton's apparatus for the exploration of other worlds being without the benefit of a breathable atmosphere'. In many ways, the Gascoigne-Simpson narrative, which forms a scaffold over Simpson's work as a photographer, is an origin myth of the artist: the fictitious Bumforth Manor (even the name evokes the self-aggrandizing nineteenth-century gentleman, being oddly reminiscent of the word 'bumptious'), the ancestral seat of the family, is situated near the Lincolnshire village where Simpson was raised, and various (pseudo/auto)biographical details of the artist and family have been carefully inserted into the narrative.

In common with Doctor Geof, however, Nick Simpson's thematic concerns also focus on the nature of gender and sexuality. Like Doctor Geof, his engagement with military motifs and a concerted critique of war-like imperial masculinity are approached with parody and incongruous humour. Simpson's 'Blunderer of the Thirteenth Light' is a clear example of this, referencing as it does the Crimean War (1853–1856), and specifically, Alfred, Lord Tennyson's 'The Charge of the Light Brigade' (1854). The Crimean War is fascinating for a number of reasons. The allied forces of the English, French and Turks were pitted against the Russians, with fighting focused around Sebastopol in the Crimea (Ukraine). It was emphatically imperial, 'the outcome of competing Russian and English imperial interests in the Balkans and the Eastern Mediterranean … England's economic and political influence over its most valuable colony, India, would have been dramatically diminished if Russia had gained control of this territory'.[82] It was therefore heavily implicated in models of English imperial masculinity. Stefanie Markovits notes that Tennyson's poetic response to the war, 'The Charge of the Light Brigade', was responding

to (and playing with) ideas of chivalry, aristocratic warfare and military codes of honour, all of which were thrown into disarray: 'The war that was to have revitalized a threateningly mercantilized British manhood after a peace of forty years devolved into what was perceived by many to be farce.'[83] Similarly, Helen Groth suggests that 'the assumption underlying the poem is that the fusion of patriotic rhetoric with abstract imagery can transform a contemporary event into an eternal moment of chivalry, resonant with classical associations and universally legible in its epic yet simple delineation.'[84]

However, this epic moment was marred by 'blunder': on the morning of 25 October 1854, over six hundred soldiers were mistakenly ordered to ride in the wrong direction at Balaklava. Fewer than two hundred men returned to camp and the whole incident was attributed to a series of bungled orders. It was brought to the attention of the British public, in all its gruesome detail, through the development of modern media technologies: 'The invention of the electric telegraph in 1836 and Isaac Pittman's perfection of shorthand in the 1840s led to a new reportorial investment in immediacy, transcription, and the eyewitness account.'[85] The ensuing media coverage led to a revelation of gross mismanagement by officers, including most obviously the suicidal Charge of the Light Brigade. The technological developments are important, as Tennyson's poem, published in *The Examiner* on 9 December 1854, relied on the comparatively speedy coverage from the media (*The Times* reporter correspondence from which Tennyson read about the Charge was delivered to London via the electric telegraph). Coverage of the Charge therefore made it a very modern war, exploiting as it did the scientific advancements of the Victorian age.

In his bathetic homage to the Charge, entitled 'Blunderer of the Thirteenth Light' (Figure 6), Nick Simpson revisits 'The Charge of the Light Brigade', deriving his title from Tennyson's 1854 poem, which reads 'Someone had blundered.'[86]

Figure 6 Nick Simpson, 'Blunderer of the Thirteenth Light'.

Various critics have noted the unease with which Tennyson constructs this poetic memorial to the fallen soldiers, and Nick Simpson's tableau is similarly ambivalent, participating in both satirical deflation of the subject and genuine reverence.[87] Simpson explains that his youthful memories of the 17th Lancers (a regiment based in Belvoir Castle near the artist's childhood home) who were in the Light Brigade at the Battle of Balaklava were the source of his composition: 'I would spend hours studying the uniforms, weapons and paintings depicting the ill-fated "Charge of the Light Brigade" and was fascinated by the thought that throughout history, the notion of honour has often superseded "good old common sense" and rarely with the question of "why?" ever being asked.'[88] In common with Doctor Geof's satire, tempered by a reverence for individual soldiers and their sacrifice, Simpson's criticism of the military is moderated

by respect for the sacrifice of individual soldiers, which in both cases show the limitations of steampunk and Neo-Victorian critique. The fact that both artists are men means their evaluation of war is inevitably still determined by masculine subject positions.

In common with Doctor Geof's approach to the themes of Victorian combat so prevalent in steampunk practice (art and costume design being two notable examples), the rhetoric of warfare is deflated by Simpson's bathetic imagery. We have an aged soldier in a Hussars uniform, with his sabre held aloft in an aggressive gesture, apparently charging towards the battle field.[89] This warlike image is undercut by the fact that this soldier is riding a child's rocking horse and is quite clearly situated in the tableau of a Victorian drawing room. There is a hint of senility here and vulnerability, as well as a satire on the motifs of heroic masculinity which is often identified with the robustness of imperial governance.[90] The subject appears utterly foolhardy, a point strengthened by Simpson's own reflection on the composition:

My picture depicts the sitter reliving the moment of missed glory when perhaps thirty years earlier during the Crimean War, he was responsible for delivering the infamously vague order at the Battle of Balaklava for the British cavalry to charge the Russian guns …. Lord Lucan received the order and asked our eponymous hero as to which guns were meant, to which our 'hero' replied, 'There are your guns, sir!' and further added to the confusion by gesticulating vaguely in the direction of the bedded-in Russian artillery, which was most definitely not the intended target. Although certain death was inevitable, British honour would not allow the orders to be questioned further, and the British cavalry, led by Lord Cardigan, charged straight at the Russian artillery regardless. This, of course, resulted in huge casualties and the failure to gain any military advantage whatsoever … It should be noted that the hero of my picture took no part in the ensuing battle, and after delivering those ill-fated lines, rode off in the opposite direction to the safety of the rear of the British lines.[91]

The artist's narrative is an alternate history, as Captain Louis Edward Nolan (1818–1854), the army officer who carried the message to Lord Raglan, did in fact fight in the charge and was the first casualty. This intentionally skewed history has a number of consequences. First of all, it means that it participates in one of the main strands of steampunk practice (speculative histories), but also the picture suggests both an interrogation of military heroism and more generally a damning indictment of those who escaped the carnage and simply 'watched from the Heights above'.[92] This is confirmed by the fact that the 'hero' of Simpson's piece has sat for this photograph in his drawing room (or perhaps a photography studio), both of which are far from the battle proper (both in time and in location). Whilst Simpson's childhood recollections are clearly an autobiographical part of the picture in the rocking horse imagery, it is also clear that Simpson's target is the heroic ideal: 'Every man must have known they were riding to their deaths that day, and yet they were too proud and noble to question the fact. How very British, how very absurd, and how very Victorian.'[93] Correlated with Doctor Geof's reflection on Empire and jingoism, Simpson uses the rocking horse to explore the imperial logic implicit in representations of heroic masculinity. Elleke Boehmer traces the ways in which the late nineteenth century (which is also the fictional date of Simpson's composition) was marked by 'an ethic of action over an ethic of contemplation ... fundamental to Britain's imperial endeavours, namely, that war is like a sport and, therefore, that war is the more successful the more it is played out as a game on a public-school playing field'.[94] The public school ethos and war are closely linked in historical and fictional accounts of war, including the First World War. Septimus Warren Smith, a shell-shock victim in Virginia Woolf's novel *Mrs Dalloway* (125), famously describes the First World War as a 'little shindy of schoolboys with gunpowder'.[95] Robert Baden-Powell's *Scouting for Boys* (1908) also exploits this link between public school and war, and it is in this tradition that we may

view Simpson's picture.[96] It is especially interesting that due to the
photographic technology of the period, the (fictional) sitter would
be required to hold this action-packed pose for some length of time
(we must remember here that this composition is part of the equally
fictional Bumforth Manor collection, produced by Gascoigne-
Simpson in the late nineteenth century). The idea of an 'ethic of action',
clearly represented in the sabre held aloft and the aggressive facial
expressions of the subject, is entirely undercut, both by photographic
technology which would require a static subject and by the paradox
that this fictional soldier hypocritically took no part in the action that
day at Balaklava. At the same time, the idea of war as a game is a
damning indictment of the dangerous childishness of this form of play.
Ultimately, the message of this parodic tableau, despite its seeming
potential for homage and reverence of nineteenth-century battle, is
the need for pacifism. The 'Blunderer of the Thirteenth Light' also
neatly underscores nineteenth-century technological developments
in other ways. The use of the phonograph to the left of the subject
(an invention developed in 1877) anachronistically highlights
the visibility of technology in the Crimean War, a point outlined
earlier in this chapter. But it also suggests the pointless circularity of
communication – the subject's battle cry (his mouth is open, so we
can safely assume he is in the moment of exclaiming 'there are your
guns, sir!') is an empty gesture directed to the phonograph, which can
but imperfectly repeat and echo any directive he utters. The sitter and
the phonograph are in a perpetual state of shouting at each other, with
little to no real effect. By the same token, the eyewitness accounts in
newspaper coverage, similarly brought to the public by technological
innovation, were then reiterated throughout drawing rooms and
parlours across the country. This echo-chamber effect of imperial
heroic masculinity is found in Tennyson's poem as a commemoration
of the event (however ambiguous), especially given its subsequent
ubiquity on the battlefield (Tennyson sent copies to soldiers at the

front), and resurgence of the poem's popularity during the First World War. The war's representation in contemporary photography (Roger Fenton's Crimea Exhibition being the obvious example) and the homage to the survivors in Kipling's poem 'The Last of the Light Brigade' (1890) each participates in a discursive framework which fails to offer a critique of colonial casualty, and in some cases, actively celebrate the English national paradigm of masculine heroism.[97] By capturing this echo-chamber, and parodying it, Simpson highlights the futility of Balaklava, and also seeks to criticize the ideology of manhood underpinning the charge itself.

Powering your steampunk rhino – The inventor hero and technology

In their article on the 'technician hero' in steampunk, or what we have been referring to as the mad inventor/scientist trope, Mirko M. Hall and Joshua Gunn explain that 'even though steampunk has never had a monolithic superstructure in terms of cultural-political philosophies, its foundation in a kind of nostalgic Victorian masculinity can neither be overlooked nor simply ignored: it continues to exert considerable influence even today'.[98] Many of the icons of the steampunk movement, including engineers such as Isambard Kingdom Brunel (1806–1859) and George Stephenson (1781–1848), mathematicians such as Charles Babbage (1791–1871), as well as inventors like Joseph Swan (1828–1914), Thomas Edison (1847–1931) and Nikola Tesla (1856–1943), were part of a broader trend in the nineteenth century of 'the advent of amazing new devices and machines in the area of communication technology (the electric telegraph, cinema, and telephones) and transportation modes (aircraft, automobiles, railroads and steamships). These advances were made possible by industrial processes that were underpinned by the development

and application of steam technology'.[99] Hall and Gunn discuss the gendered model of public and private spheres, stating:

> The increased functional differentiation of European (and Victorian) society – caused by the progressive industrialization and administration of civil society – precipitated the creation of two distinct spheres of cultural-political influence. This differentiation had a profound effect on middle-class gender dynamics: it enacted a public sphere of agonistic, competitive males in the world of politics and employment, and a private sphere of sensuous, nurturing females in family and home.[100]

Other critics on masculinity have emphasized that the public and private spheres are by no means mutually exclusive, and in fact, 'it is now widely recognised that constant emphasis on the "separation of spheres" is misleading, partly because men's privileged ability to pass freely between the public and the private was integral to the social order'.[101] Matthew Sweet concurs, explaining that 'if nineteenth-century women were leading more complex and productive lives than the widely circulated stereotype suggests, so too were Victorian men, who were involved in the domestic sphere to a much greater extent than is customarily acknowledged'.[102] The complexity of Victorian masculinity has also been noted by Heilmann and Llewellyn in their introduction to the special issue of *Victoriographies* on Neo-Victorian manhood. They explain:

> Late-Victorian masculinity in particular … is a live site for reflection on and adaptation of contemporary forms of male identity. Perhaps precisely because of the ambiguity of what masculinity represented in the 1880s and 1890s, this has proved to be a period rich for exploration. The middle-class clerk, the professions of church, law, and medicine, and the challenges to normative patriarchal models encapsulated by the decadent and the dandy engendered a sense of a masculinity in fluidity.[103]

In the light of this debate, Nick Simpson's imagined great-grandfather, as well as the compositions such as 'Dr Crighton's apparatus for the exploration of others worlds being without benefit of a breathable atmosphere' (Figure 7) and 'The Astonishing Steam Rhinomotive' (Figure 8) participate in a broader discussion about the masculinity of the steampunk inventor-scientist. In each instance, Simpson's

Figure 7 Nick Simpson, 'Dr Crighton's Apparatus'.

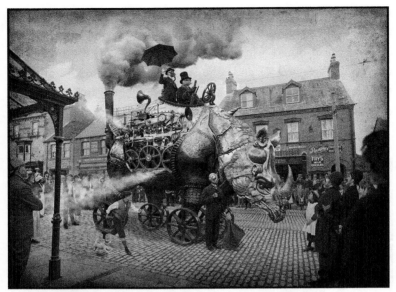

Figure 8 Nick Simpson, 'The Astonishing Steam Rhinomotive'.

composition unites a valorization of Victorian technology and exploration, whilst at the same time undercutting the ways in which masculinity and science have been aligned. Thus in many ways, Simpson (like Doctor Geof) escapes an easy nostalgia for bygone gender stereotypes by representing them and also by imbuing them with irony. In common with Doctor Geof's artwork, both of these pieces hinge on the notion of incongruity. The juxtaposition of a Victorian gentleman with the twentieth-century moon landings, or a steam-powered rhinoceros as a means of travel, clearly frames Simpson's gentlemen inventors in the realms of the parodic and humorous, unpicking the paradigm of the Victorian inventor-scientist and undercutting it with comedy.

If we reflect more generally on steampunk tropes, we can discern, with Hall and Gunn, that many subcultural personae on the scene hinge on 'the white, male, and socially mobile genius-adventurer of

popular Victorian romantic fiction, particularly in the works of Wells and Verne ... This nexus of adventurism, ingenuity, and technology is embedded within a larger discursive network that valorizes Steampunk's utopian impulse to secure the great dreams and hopes of humankind – through modes of technology that had previously gone awry'.[104] Initially it might appear that Simpson merely subscribes to this masculine paradigm. He explains that 'as a boy I devoured Jules Verne and H. G. Wells and although I didn't consciously acknowledge it at the time of making this image [Dr Crighton's apparatus], looking back, the various works of both writers were undoubtedly a great influence upon me'.[105] However, there is a great deal in the imagery in the tableau-style photography of 'Dr Crighton's apparatus' (Figure 7) which suggests interrogation rather than an uncomplicated appropriation. Simpson's portrait has as its subject the fictional Dr Crighton, modelled by the real-life friend of the artist, Ian Crighton, who enjoys a great deal of steampunk celebrity under the pseudonym Herr Doktor. As soon as we explore the various names associated with the model, an uncomplicated approach to masculine identity becomes impossible. 'Dr Crighton' is a fractured and multiple identity: he is both partly fictional and partly real (he borrows the name of the real-life artist as well as his pseudonym). He is identified as an artist, a friend, a fictional explorer. The status of 'Dr Crighton' is further complicated when we realize Simpson's composition includes a Victorian 'space helmet', made by Ian Crighton/Herr Doktor himself, which has been exhibited widely and is generally received as an object of science fiction. At this point, we can see how reality and fiction blur in a performative gesture, and we may note how far Simpson is locating his image within the paradigm of the inventor-scientist, or the gentleman who was motivated by 'the virtues of courage, industry, ingenuity, sobriety, resolution, and virility' and who 'no longer received his status from aristocratic origins or positions of patronage, but rather from his own self-discipline and pursuit of moral and intellectual excellence'.[106]

Akin to the heroes of Verne and Wells, 'Dr Crighton' is an explorer and inventor extraordinaire, poised in the portrait to venture into space. He carries with him the Union Jack and wears a pith helmet, both symbolizing the imperial conquest of space. His 'space helmet' contraption is a glass dome, which is oddly resonant of the Victorian bell jar, commonly used in science to create a vacuum effect, but more decoratively used in the homes of the Victorians to cover taxidermy specimens, clocks and other *objet d'arts* to protect them from environmental damage. So in many ways, the bell jar suggests 'Dr Crighton', or the image of masculinity that he represents, is being subject to careful scrutiny and dissection that we as viewers of the picture are invited to participate in and read through an ironic lens. Simpson confirms this with his explanation of the full title of the piece: 'Dr Crighton's apparatus for the exploration of other worlds being without the benefit of a breathable atmosphere.' He states 'the full title … sounded to me just the type of formal, long-winded title a true nineteenth-century gentleman photographer would give to such an obviously scientific documentation.'[107] In common with other parodies of overblown scientific discourse from the period (we might think of the rather pedantic and pompous narrator in John Fowles's novel, *The French Lieutenant's Woman* from 1969, as another Neo-Victorian example here), Simpson is deploying this pretentious register in order to poke gentle fun at the subject, Dr Crighton, and also the fictional gentleman photographer, Gascoigne-Simpson himself.

So if Dr Crighton is under the bell jar of scrutiny, we are meant to take from the image a satirical reflection on Victorian masculinity. Importantly, Crighton holds in his left hand a pipe, which is patently foolhardy (and humorous) given that his helmet prevents him smoking: this is clearly a posture intended to register his gentlemanly status. However, it also suggests incongruity as to the impossibility of a Victorian gentleman smoking in the depths of space. Its symbolic

value, correlated with the technology of the helmet, also suggests a precarious and spectacular display of masculinity. In their discussion of the technician hero, Hall and Gunn explain that this is 'a masculinity poised on the autonomy so blatantly represented by the machine-as-surrogate phallus'.[108] Indeed, the phallic weapon features in Ian Crighton's own creations. His 'The Thunderbuss: A Gentleman's Sonic Hunting Rifle' participates in all the motifs we have been addressing so far (imperial masculinity, warlike aggression), but these are rendered laughable and contemptible in turn by the settings' gauges, which are labelled 'Quiet, Loud, Louder, Pardon?' and 'Wound, Hurt, Kill, Liquefy'.[109] This is an obvious parody of the phallic weaponry often featured in steampunk personae. Libby Bulloff explains that 'I have grown quite tired of all the pretend weaponry and implied violence in so many Steampunk images … It is not attractive nor especially clever to parade about in front of a camera with a plastic gun, especially in the wake of the school shootings in the United States … I would hope that we'd be self-aware enough to realize how crass it is to laud violent imagery or pictures that aren't especially feminist or intelligent'.[110] For Bulloff, as for so many others, weaponry isn't a plaything. It seems Herr Doktor's weaponry is humorously produced in a similar spirit, aware of its ideological freight and its gendered associations. Relating this discussion of the phallic substitute and masculine authority in Simpson's image, we might note that the phallus is signified by both the upright (erect) flag pole and the pipe, a repetition of the phallic symbolism which betokens an anxiety around masculinity, rather than a celebration of it. Despite both the overblown language of the title and the masculinity of the imagery in Simpson's photograph, it is also noteworthy that the whole thing is framed as a salon-style composition. Simpson used an original lens and camera from 1870, with a landscape backdrop and a curtain drawn to one side, and a large animal skin rug (again suggestive of imperial hunting and conquest). This is a curiously domestic backdrop for a piece so invested in other

worlds and the masculinity of the public sphere. Like 'The Blunderer of the Thirteenth Light', the artifice of the salon photograph suggests the constructed nature of the image (as well as perhaps, the nature of gender itself), and it also embeds the explorer within the private, domestic sphere: it appears that despite his utopian impulses, he has never left his drawing room. This suggests how far, as John Tosh explains, men were able to move between the separate spheres of public (masculine) and private (feminine), even whilst invested in the notion of Empire as 'a projection of masculinity'.[111]

'The Astonishing Steam Rhinomotive' (2016) (Figure 8) is another clear example of this interrogation of the masculine inventor trope. Simpson explains that he sought to explore the significance of the North of England in relation to the Industrial Revolution: 'On Friday, the 17th of October 1902, Gascoigne-Simpson erected his heavy wooden camera and tripod on a cobbled street in County Durham, and using his hat as a makeshift shutter, captured Lord Darlington's latest folly:- "The Astonishing Steam Rhinomotive" – a magnificent steam–powered beast of prodigious proportions.'[112] Using Beamish Museum in County Durham as a location is important, as the region is celebrated for a number of engineering notaries, including George Stephenson and Robert Stephenson (his son), who designed Stephenson's Rocket in 1829. This locates the picture within a broader history of masculinity, invention and engineering (as Chapter 1 outlined, this is a common subject in steampunk – The Men That Will Not Be Blamed for Nothing's song 'Steph(v)enson' is a testament to this, from the 2010 release *The Steampunk Album That Cannot Be Named for Legal Reasons*). Like other alternative histories explored in this chapter, Simpson provides a fictional 'eyewitness' account from *The Durham Chronicle*, published October 1902:

A low bass rumble deep from within its bowels threatens to dislodge the very windows from the surrounding houses; boilers gurgle, gears clank and steam jets forth; filling the street with

clouds of ungodly vaporous mist. Then – in a deafening crescendo of protesting metal – gears reluctantly engage and the magnificent iron beast lurches forward, its master at the helm the only thing preventing total destruction of everything in its path.[113]

In the photograph, the rhinomotive has brought a sizeable crowd of people into the cobbled street of terraces to observe the strangeness of its perambulations. It is also curiously threatening: the fictional eyewitness account suggests the danger of such engineering as much as how far it promises a utopian future. The machine possesses 'bowels' in an oddly anthropomorphic image and promises 'destruction'; steam billows forth as 'ungodly mist' whilst it is simultaneously impressive or 'magnificent'. The threat and the dirt of these new-found technologies are emphasized here, so that 'the allusions to "dirt" and "filth" serve not just as an aesthetic strategy, but convey the artist's personal declination of Victorianism'.[114] Provocatively, what is interesting here is that the source of 'dirt' is not the cobbled street, or the ordinary working people, but rather, the preposterous invention of the aristocratic technician hero. In some ways, the inventor is tainted by his splendid and foolish creation, implicated in the environmental conditions which became so detrimental to health in the period. More generally, the picture stages the 'oppressive social hierarchies and ghastly urban disparities between the bourgeoisie and the proletariat that were brought about by the Industrial Revolution'.[115] Perhaps counter to much steampunk iconography, which sees the dirt and dust of machinery as the promise of a utopian future-past, Simpson here reflects upon the grimy reality such industrialization was to create.

This *unheimliche* image of mechanical rhino (rendered even more unhomely given its juxtaposition with the ordinary homely street in the background) implies a number of related discourses, one of which is social class. The inventor figure is often a privileged individual, enjoying the hegemonic authority that his masculinity

may, in some instances, provide. His class status and disposable income mean he has sufficient leisure time to explore such interests. The character here, Lord Darlington, is no exception. He has one servant who stands at his side atop the rhinoceros and seemingly protects him from the belching steam with a large umbrella. At the foot of the rhinoceros is an automaton, presumably another servant, who carries a flag to warn of the oncoming vehicle. Whilst the automaton is a trope in a number of steampunk fictions (we need only think of Jeter's *Infernal Devices* here), the relevance of class inequality is difficult to escape. Given his position high up on the top of the rhinoceros, Lord Darlington is literally above everyone else in the street. The automaton-servant suggests the dehumanization of the lower classes, whilst the spectacle of the rhinomotive renders the whole picture utterly absurd. In common with the incongruity theory of humour, it is somewhat difficult to take Lord Darlington seriously, riding about on a rhinoceros, a curious parody of the steam locomotive. Indeed the rhino itself is significant. Simpson explains he chose the rhino because he has a fondness for the animal (especially the *Rhinoceros unicornis*, or Indian Rhinoceros), as well as an admiration for Albrecht Dürer's (1471–1528) woodcut of a rhino from 1515.[116] This is evident in the intricate design of the armour plating on Simpson's rhino, which emulates Dürer's woodcut. Dürer's composition was highly speculative, given that he had never seen a rhinoceros and was relying on descriptions and sketches. This gestures towards one of the foundational questions of steampunk, related to the interpretative nature of our histories, and the potential for alternative or imagined narratives to develop. Alongside this intertextual influence, however, is the discourse of imperialism. In *The Empire of Nature: Hunting, Conservation, and British Imperialism*, John M. MacKenzie explains that the rhinoceros was hunted in alarming numbers in Africa, though in India this was less significant due to difficulties of terrain and the fact that many rhinos

occupied Indian Princely States (outside of imperial jurisdiction). More generally, the rhino was 'vulnerable because it presented, like the elephant, a valuable and easily realised asset, its horn'.[117] Whilst there is a clear distinction between Indian and African colonial experiences of hunting here, as a victim of imperial masculinity, the steam-rhino acquires a powerful symbolism, a creature harnessed to the commodity culture of the Victorians. It is perhaps no accident that the street scene is also populated with Victorian advertisements, another symbolic testimony to the rise of the urban capitalist machine in the nineteenth century, as well as the way in which steampunk and Neo-Victorianism disavows chronological time frames (the composition is dated 1902, after Victoria's death). Simpson also explains that the imagined rhino is more broadly linked to 'man's ability to use the imagination to fill in the missing information and create a mythical creature sometimes more fabulous than the actual one'.[118] Whilst Dürer's woodcut is one example of this phenomenon, additionally, it might be correlated with the Victorian practices of taxidermy. Simpson explains the imaginative faculty required to draw an animal one has never seen is also one found in the reconstructive process of handling and mounting taxidermy specimens (he draws a comparison with the 'overstuffed walrus' at the Horniman Museum in London[119]). Seeking taxidermy specimens is itself often part of the imperial adventure. Shooting and hunting in Africa were common manly sports in these narratives. Thus, the rhino as symbol speculates on imperial conquest. Is it also a automaton, being half machine, half rhino. As an uneasy hybrid of nature and machine, its unnaturalness is as startling as its inventor is overblown and preposterous. The upper-class figure of Lord Darlington, as the creator of this rhinomotive, is implicated in these discourses and held up to the lens of satirical humour: Darlington is both hunter and mad inventor. Each of the masculine subject positions presented in Simpson's picture (aristocrat, inventor, hunter) interrogates and

parodies Victorian models of gender behaviour, and rather than offer a nostalgia for these bygone models, approaches them with suspicion as much as fascination.

Conclusion

If Nick Simpson and Doctor Geof playfully and humorously address the models of nineteenth-century gender, it is important to evaluate how this relates to the perspective of the present day. Margaret D. Stetz's discussion of Neo-Victorian masculinity is relevant here. She notes that 'neo-Victorianism has offered male and female authors alike a mask through which to speak about millennial masculinity and to express dissatisfaction with it; a pseudo-historical space in which to create visions of alternative masculinities, often in idealised form; and a didactic genre ... through which to educate and reshape readers' gender norms for men'.[120] Not only does the artwork analysed in the preceding pages suggest ways in which to rethink stereotypes of historical masculinity and femininity (through bathos, incongruous humour, carnivalesque excess and irony), but each piece also reflects upon the ways in which our contemporary moment can rethink these stereotypes. If the common practice among steampunk practitioners is, as Hall and Gunn suggested, a stereotypical and nostalgic idea of nineteenth-century gender, then these artists offer an alternative way of thinking.[121] Jeff Vandermeer notes in *The Steampunk Bible* that 'many of the people who today call themselves Steampunks have not read the literature, taking cues instead from history, visual media, and the original fashionistas who sparked the subculture in the 1990s'.[122] This is not to suggest an inauthenticity in their practice, but rather that some artists are thinking outside of these normative values and that it might be possible to think of a steampunk culture which fractures these assumptions, rather than replicating them.

Notes

1 Art Donovan, *The Art of Steampunk* (East Petersburg: Fox Chapel, 2011), p. 25.

2 See Nick Simpson's website, http://www.bumforthmanor.com/ [accessed 5 February 2018].

3 Marie-Luise Kohlke and Christian Gutleben, 'What's So Funny about the Nineteenth Century?', in *Neo-Victorian Humour: Comic Subversions and Unlaughter in Contemporary Historical Re-Visions*, ed. Kohlke and Gutleben (Leiden and Boston: Brill-Rodopi, 2017), p. 3.

4 Kohlke and Gutleben, 'What's So Funny about the Nineteenth Century', 2.

5 Noël Carroll, *Humour: A Very Short Introduction* (Oxford: Oxford University Press, 2014), p. 17.

6 Doctor Geof, personal interview with the author, 9 July 2017.

7 Nick Simpson, personal interview with the author, 28 November 2017.

8 Doctor Geof, *The Steampunk Literary Review*, Volume I, Series B, Issue 1, p. 6.

9 Annamarie Jagose, *Orgasmology* (Durham and London: Duke University Press, 2013), p. 80.

10 Edmund Burke, *A Philosophical Enquiry into the Origins of Our Ideas of the Sublime and Beautiful* (1757) (Oxford: Oxford University Press, 1990), p. 103.

11 See Gillian Perry, *Femininity and Masculinity in Eighteenth-Century Art and Culture* (Manchester: Manchester University Press), p. 12.

12 Carroll, *Humour*, 26–27.

13 Carroll, *Humour*, 23.

14 Kohlke and Gutleben, 'What's So Funny about the Nineteenth Century?', 12.

15 M. M. Bakhtin, *Rabelais and His World*, trans. Hélène Iswolsky (Bloomington: Indiana University Press, 1985), pp. 18–19.

16 Sue Vice, *Introducing Bakhtin* (Manchester: Manchester University Press, 1997), p. 157.

17 Bakhtin, *Rabelais*, 26.

18 Doctor Geof, Personal Interview, 9 July 2017.

19 Sneja Gunew, *Framing Marginality: Multicultural Literary Studies* (Carlton, Victoria: Melbourne University Press, 1994), p. 102. One of Doctor Geof's comic series, *Fetishman* (7), was a direct response to the Coroners and Justice Act *c.* 2 (2009), which contained a provision for 'dangerous cartoons', whether realist or not, with juveniles as subjects (this could be applied to manga, anime and other well-respected comic traditions).

20 Clair Wills, 'Upsetting the Public: Carnival, Hysteria, and Women's Texts', in *Bakhtin and Cultural Theory*, ed. Ken Hirschkop and David Shepherd (Manchester, Manchester University Press, 2nd ed., 2001), pp. 92–96.

21 Doctor Geof, *The Steampunk Literary Review*, Volume I, Series B, Issue 1, back page.

22 Doctor Geof, Personal Interview, 9 July 2017.

23 Eckhart Voights-Virchow, 'In-yer-Victorian-face: A Subcultural Hermeneutics of Neo-Victorianism', *Literature Interpretation Theory* 20:1 (2009), 108–125, 112.

24 Doctor Geof, Personal Interview, 9 July 2017.

25 For further details, see Patrick Bratlinger, 'Imperialism at Home', in *Victorian World*, ed. Martin Hewitt (Abingdon: Routledge, 2012), p. 137.

26 John Tosh, *Manliness and Masculinities in Nineteenth-Century Britain* (Harlow: Longman, 2005), p. 193.

27 Doctor Geof, *The Steampunk Literary Review*, Volume I, Series B, Issue 2, p. 1.

28 Jessica Meyer, *Men of War: Masculinity and the First World War in Britain* (Basingstoke: Palgrave Macmillan, 2009), p. 3.

29 Meyer, *Men of War*, 3.

30 Meyer, *Men of War*, 5–6.

31 Steve Attridge, *Nationalism, Imperialism and Identity in Late Victorian Culture: Civil and Military Worlds* (Basingstoke: Palgrave Macmillan, 2003), p. 6.

32 Benedict Anderson, *Imagined Communities: Reflections on the Origin and Spread of Nationalism* (London: Verso, 1991, rev. ed.), p. 9.

33 James Taylor, '*Your Country Needs You*': *The Secret History of the Propaganda Poster* (Glasgow: Saraband, 2013), pp. 10–12. See also James Thompson, 'Posters, Advertising and the First World War in Britain', in *The Edinburgh Companion to the First World War and the Arts*, ed. Ann-Marie Einhaus and Katherine Baxter (Edinburgh: Edinburgh University Press, 2017), pp. 166–184.

34 Rachael Teukolsky, 'Novels, Newspapers, and Global War: New Realisms in the 1850s', *NOVEL: A Forum on Fiction* 45:1 (2012), 31–55, 31.

35 It is noteworthy that this mode of address is common in advertisements. It addresses mass audiences, as if they were individuals. Norman Fairclough's *Language and Power* (London: Longman, 1989) has theorized this as synthetic personalization.

36 James Beattie, cited in Graeme Ritchie, *The Linguistic Analysis of Jokes* (London: Routledge, 2004), p. 46.

37 Graeme Ritchie, 'Developing the Incongruity-Resolution Theory' (2000), https://www.era.lib.ed.ac.uk/bitstream/handle/1842/3397/0007.pdf?sequence=1&isAllowed=y [accessed 7 February 2018].

38 Doctor Geof, Personal Interview, 9 July 2017. For discussion of Anglo-Chinese trade relations in the nineteenth century, see J. Y. Wong, *Deadly Dreams: Opium and the Arrow War (1856–1860) in China* (Cambridge: Cambridge University Press, 2002), p. 355. See also Erika Rappaport, *A Thirst for Empire: How Tea Shaped the Modern World* (Princeton, NJ: Princeton University Press, 2017).

39 Doctor Geof, Personal Interview, 9 July 2017.

40 Doctor Geof, Personal Interview, 9 July 2017. See also *The Steampunk Literary Review*, Volume I, Series B, Issue 2, p. 3.

41 Doctor Geof, Personal Interview, 9 July 2017.

42 'The First Tea Company', Facebook Group, https://www.facebook.com/groups/157496057594395/about/ [accessed 8 February 2018].

43 I am extremely grateful to Dr Ann-Marie Einhaus for this subtle distinction.

44 Anon, 'Rees Mogg Launches Steampunk Revolution', http://www.
 thedailymash.co.uk/politics/politics-headlines/rees-mogg-launches-
 steampunk-revolution-20180126143249, 26 January 2018 [accessed 26
 January 2018].

45 See Raphael Samuel, 'Mrs Thatcher's Return to Victorian Values',
 Proceedings of the British Academy 78 (1992), 9–29.

46 Jason Murdock, 'Ukip Declares It's "Ready for War" over Second Brexit
 Referendum, Twitter Responds with Memes', http://www.ibtimes.co.uk/
 ukip-declares-its-ready-war-over-second-brexit-referendum-twitter-
 responds-memes-1655201, 15 January 2018 [accessed 16 January
 2018]. Coverage in the tabloid press also uses the symbolism of war
 in discussing the EU. See Daniel Hannan, 'If the EU turn hostile on
 Brexit and see us leaving as an act of aggression – it's time to turn to
 trade deals and the open seas', *The Sun,* https://www.thesun.co.uk/
 news/6857039/hostile-eu-uk-daniel-hannan-opinion/, 25 July 2018
 [accessed 7 September 2018].

47 Rowena Mason, Larry Elliott and Daniel Boffey, 'Brexit War of Words
 Heats Up as "Enemy" EU Tells Britain to Pay Up', https://www.theguardian.
 com/politics/2017/oct/13/brexit-war-of-words-heats-up-as-enemy-eu-
 tells-britain-to-pay-up, 13 October 2017 [accessed 16 January 2018].

48 For a contextual discussion of this speech, see Harold D. Clarke,
 Matthew Goodwin and Paul Whiteley, *Brexit: Why Britain Voted to
 Leave the European Union* (Cambridge: Cambridge University Press,
 2017), p. 86.

49 For example, see the Turkish newspaper *Yeni Akit*, https://www.
 yeniakit.com.tr/haber/bu-kafadan-kaygiliyiz-440459.html, 26 March
 2018 [accessed 8 September 2018]. This anti-German sentiment can
 be traced back further than the EU referendum, though. See Elizabeth
 Flock, 'Angela Merkel Depicted as Nazi in Greece, as Anti-German
 Sentiment Grows', *The Washington Post,* https://www.washingtonpost.
 com/blogs/blogpost/post/angela-merkel-depicted-as-nazi-in-greece-
 as-anti-german-sentiment-grows/2012/02/10/gIQASbZP4Q_blog.
 html?utm_term=.002b38f83ce6, 10 February 2012 [accessed 8
 September 2018].

50 Heather Stewart and Rowena Mason, 'Nigel Farage's Anti-migrant
 Poster Reported to Police', https://www.theguardian.com/politics/2016/
 jun/16/nigel-farage-defends-ukip-breaking-point-poster-queue-of-
 migrants, 16 June 2016 [accessed 8 February 2018].
51 Geoffrey Evans and Anan Menon, *Brexit and British Politics*
 (Cambridge: Polity Press, 2017), p. 14.
52 Ian Dunt, *Brexit: What the Hell Happens Now?* (Kingston upon Thames:
 Canbury Press, 2017, rev. ed.), p. 49. See also Evans and Menon, *Brexit
 and British Politics*, 14, and Clarke, Goodwin and Whiteley, *Brexit: Why
 Britain Voted to Leave the European Union*, 88–89.
53 Clarke, Goodwin and Whiteley, *Brexit: Why Britain Voted to Leave the
 European Union*, 92.
54 Clarke, Goodwin and Whiteley, *Brexit: Why Britain Voted to Leave the
 European Union*, 136.
55 Clarke, Goodwin and Whiteley, *Brexit: Why Britain Voted to Leave the
 European Union*, 109, note that 'UKIP members are overwhelmingly
 male, but they also are overwhelmingly quite elderly and many
 are pensioners'. This is not to say that all servicemen, or older
 men, supported the Leave campaign but that one of UKIP's target
 demographics included older men.
56 Tom Peck, 'Only Two Days after Vote for Brexit and Already the
 Broken Promises Are Mounting', http://www.independent.co.uk/news/
 uk/politics/brexit-lave-campaign-broken-promises-mounting-live-
 updates-polls-7103076.html, 25 June 2016 [accessed 3 January 2018].
57 Kohlke and Gutleben, 'What's So Funny about the Nineteenth
 Century?', 14.
58 'Sh! Our Story', https://www.sh-womenstore.com/our-story [accessed
 12 February 2018].
59 Sh! Women's Erotic Emporium, https://www.sh-womenstore.com/
 [accessed 12 February 2018].
60 Brian McNair, *Striptease Culture: Sex, Media and the Democratization of
 Desire* (London: Routledge, 2002), pp. 11–12.
61 Feona Attwood, '"Sexed Up" Theorizing the Sexualization of Culture',
 Sexualities 8:5 (2006), 77–94, 87.

62 Attwood, 'Sexed Up', 85–86.

63 'Sh! Our Story', https://www.sh-womenstore.com/our-story [accessed 12 February 2018].

64 For further discussion of cone bras in relation to fetish, see Valerie Steele, *Fetish: Fashion, Sex and Power* (Oxford: Oxford University Press, 1996), pp. 135–136.

65 Gunew, *Framing Marginality*, 101.

66 For detailed analysis of burlesque and neo-burlesque, see Kay Siebler, 'What's So Feminist about Garters and Bustiers? Neo-burlesque as Post-feminist Sexual Liberation', *Journal of Gender Studies* 24:5 (2015), 561–573, Jacki Willson, *The Happy Stripper: The Pleasure and Politics of New Burlesque* (London: I. B. Tauris, 2007), Claire Nally 'Grrrly Hurly Burly: Neo-burlesque and the Performance of Gender', *Textual Practice* 23:4 (2009), 621–643. Jacqueline Millner and Catriona Moore, 'Performing Oneself Badly?' Neo-Burlesque and Contemporary Feminist Performance Art, *Australian and New Zealand Journal of Art* 15:1 (2015), 20–36. For the history of burlesque as performance, see Robert C. Allen, *Horrible Prettiness: Burlesque and American Culture* (Chapel Hill: University of North Carolina Press, 1991).

67 Steele, *Fetish*, 169.

68 Steele, *Fetish*, 171. She also notes that the riding crop or whip may be a 'punishing penis', a further reference to the idea of the phallic woman.

69 Maria Elena Buszek, *Pin-Up Grrrls: Feminism, Sexuality and Popular Culture* (Durham, NC and London: Duke University Press, 2006), p. 269.

70 Doctor Geof, Personal Interview, 9 July 2017.

71 'Supporting Women in Science', http://www.womeninstem.co.uk/women-in-science/interviews [accessed 13 February 2018].

72 See Amanda DiGioia and Charlotte Naylor Davis, 'Cursed Is the Fruit of thy Womb: Inversion/Subversion and the Inscribing of Morality on Women's Bodies in Heavy Metal', in *Subcultures, Bodies and Spaces: Essays on Alternativity and Marginalization*, ed. Holland and Spracklen (Bingley: Emerald, 2018), 27–42.

73 Camille Paglia, *Sexual Personae: Art and Decadence from Nefertiti to Emily Dickinson* (New Haven, CT: Yale University Press, 2001), p. 13.

74 Jess Nevins, *The Encyclopaedia of Fantastic Victoriana* (Austin: Monkey Brain, 2005), p. 786. For a more general discussion of the mad scientist as a literary trope, see Margaret Atwood, 'Of the Madness of Mad Scientists: Jonathan Swift's Grand Academy', in *In Other Worlds: SF and the Human Imagination* (London: Virago, 2011), pp. 194–211.

75 Kohlke and Gutleben, 'What's So Funny about the Nineteenth Century?', 15–16.

76 Doctor Geof, Personal Interview, 9 July 2017.

77 Doctor Geof, *The Fetishman Filthology: The Collected Early Adventures of Fetishman* (Leeds: Doctor Geof, 2016), p. 390.

78 Nick Simpson, Personal Interview, 28 November 2017.

79 Nick Simpson, https://www.artsyshark.com/2015/09/14/featured-artist-nick-simpson/ [accessed 19 February 2018].

80 Nick Simpson, Personal Interview, 28 November 2017.

81 Nick Simpson, 'About the Bumforth Manor Collection', http://bumforthmanor.com/about [accessed 19 February 2018].

82 Helen Groth, 'Technological Mediations and the Public Sphere: Roger Fenton's Crimea Exhibition and "the Charge of the Light Brigade"', *Victorian Literature and Culture* 30 (2002), 553–570, 561–562.

83 Stefanie Markovits, 'Giving Voice to the Crimean War: Tennyson's "Charge" and Maud's Battle-song', *Victorian Poetry* 47:3 (2009), 81–503, 481.

84 Groth, 'Technological Mediations and the Public Sphere', 555.

85 Teukolsky, 'Novels, Newspapers, and Global War', 31–55, 34.

86 Alfred Lord Tennyson, *Selected Poems*, ed. Aidan Day (Harmondsworth: Penguin, 1991), pp. 289–290.

87 Markovits, 'Giving Voice to the Crimean War', 489, notes the 'fundamental ambivalence as to the cultural value of the conflict' in Tennyson's poem.

88 Nick Simpson, Personal Interview, 28 November 2017.

89 There is more than a passing resemblance to the figure in Simpson's photograph and the bumbling father figure from *Punch*'s coverage of the war. See *Punch*, 27 (25 November 1854), 213, 'Enthusiasm of Paterfamilias, On Reading the Report of the Grand Charge of the British Cavalry on the 25th' by John Leech.

90 See John Horne, 'Masculinity in Politics and War in the Age of Nation-States and World Wars, 1850–1950', *Masculinities in Politics and War: Gendering Modern History,* eds Stefan Dudink, Karen Hagemann and John Tosh (Manchester: Manchester University Press, 2004), pp. 27–28. Horne notes that new roles of masculinity emerged following the romantic nationalism of the eighteenth century: 'Given the traditional prominence of warfare for masculine prestige, an updated and idealised version of the soldier provided one form of masculine claim on the nation, and vice versa. The volunteer ready to die in defence of the fatherland was the most obvious expression of this idea.' Horne continues that valour, sacrifice and martyrdom were the hallmarks of this model of masculinity, which may be linked to the actions of the Light Brigade at Balaklava.

91 Nick Simpson, Personal Interview, 28 November 2017.

92 Markovits, 'Giving Voice to the Crimean War', 485.

93 Nick Simpson, Personal Interview, 28 November 2017.

94 Elleke Boehmer, 'The Worlding of the Jingo Poem', *The Yearbook of English Studies* 41:2 (2011), 41–57, 53. See also Richard Aldington's *Death of a Hero* (1929) for a combative contestation of public school masculinity leading to war and the slaughter of a generation in the First World War.

95 Virginia Woolf, *Mrs Dalloway* (1925: Harmondsworth: Penguin, 1992), p. 105. Tennyson's poem became very popular during the First World War. See Markovits, 'Giving Voice to the Crimean War', 488.

96 Baden-Powell himself strongly refuted that his training was militaristic and/or prepared boys for war.

97 For further discussion of Fenton's Crimean War photography, see Groth, 'Technological Mediations and the Public Sphere', passim.

98 Mirko M. Hall and Joshua Gunn, '"There Is Hope for the Future": The (Disenchantment) of the Technician-Hero in Steampunk', in *Clockwork Rhetoric: The Language and Style of Steampunk*, ed. Barru Brummet (Jackson: University Press of Mississippi, 2014), p. 4.

99 Hall and Gunn, '"There Is Hope for the Future"', 5.

100 Hall and Gunn, '"There Is Hope for the Future"', 6.

101 Tosh, *Manliness and Masculinities in Nineteenth-Century Britain*, 39.

102 Matthew Sweet, *Inventing the Victorians* (London: Faber and Faber, 2001), p. 182.

103 Ann Heilmann and Mark Llewellyn, 'Introduction: To a Lesser Extent? Neo-Victorian Masculinities', *Victoriographies* 5:2 (2015), 97–104, 99.

104 Hall and Gunn, '"There Is Hope for the Future"', 7. They also note (p. 14) that Captain Nemo from Verne's *20,000 Leagues Under the Sea* (1870) is an exemplar of the technician-hero.

105 Nick Simpson, Personal Interview, 28 November 2017.

106 Hall and Gunn, '"There Is Hope for the Future"', 6.

107 Nick Simpson, Personal Interview, 28 November 2017.

108 Hall and Gunn, '"There Is Hope for the Future"', 7.

109 For details of the Thunderbuss, see Donovan, *The Art of Steampunk*, 79.

110 *The Steampunk User's Manual*, ed. Vandermeer and Boskovich, p. 35.

111 Tosh, *Manliness and Masculinities in Nineteenth-Century Britain*, 193.

112 Nick Simpson, Personal Interview, 28 November 2017.

113 Cited in Nick Simpson, Personal Interview, 28 November 2017.

114 Saverio Tomaiuolo, 'The Aesthetic of Filth in *Sweet Thames, The Great Stink*, and *The Crimson Petal and the White*', *Neo-Victorian Studies* 8:2 (2016), 106–35, 108.

115 Hall and Gunn, '"There Is Hope for the Future"', 4.

116 Albrecht Dürer, *The Rhinoceros* (1515), woodcut, 23.5 cm × 29.8 cm (9.3 in × 11.7 in), National Gallery of Art, Washington.

117 John M. MacKenzie, *The Empire of Nature: Hunting, Conservation and British Imperialism* (Manchester: Manchester University Press, 1997), p. 128. MacKenzie, *The Empire of Nature*, 283–284, notes that the Indian Forest Act, No. VII of 1878, sought to regulate game and hunting in India. By the 1920s, it was argued that the legislation was virtually ineffectual.

118 Nick Simpson, Personal Interview, 28 November 2017.

119 Nick Simpson, Personal Interview, 28 November 2017. For more on taxidermy, see Rachel Poliquin, *The Breathless Zoo: Taxidermy and the Cultures of Longing* (Pennsylvania: Penn State University Press, 2012)

and Sarah Amato, *Beastly Possessions: Animals in Victorian Consumer Culture* (Toronto: University of Toronto Press, 2015), especially Chapter 5, 'Dead Things: The Afterlives of Animals', pp. 182–223.

120 Margaret D. Stetz, 'The Late-Victorian "New Man" and the Neo-Victorian "Neo-Man"', *Victoriographies* 5:2 (2015), 105–21, 113.

121 Hall and Gunn, '"There Is Hope for the Future"', 4.

122 Jeff Vandermeer and S. J. Chambers, *The Steampunk Bible*, p. 9.

Freak Show Femininities: Emilie Autumn

Introduction

Emilie Autumn's stage performances and her public persona represent a noteworthy example of the ambiguity of gendered steampunk which this book continues to address in relation to examples across the subcultural and popular cultural spectrum. Through her music and her writing, Autumn validates potentially problematic gender paradigms underlying various aspects of seemingly revolutionary steampunk practice, especially in the way she aligns disability, madness, alternative sexualities and femininity. Autumn functions as a role model for many young women and adolescent girls, especially in her frank discussion of mental health issues like self-harm and suicide, but problematically, this is often presented in a highly sexualized, sensational or exhibitionist manner. The resulting performance, implicated in the freak show discourses which Autumn espouses, is a complicated and not entirely positive delineation which maps a lurid femininity onto madness, sexuality and disability.

Autumn is also a useful figure to reflect upon the ways in which steampunk has intersected with other subcultures and movements, such as goth and Neo-Victorianism, neo-cabaret and burlesque, as well as how far her representations of sexuality, mental health and gender provide more popularized (and potentially capitalist) approaches to steampunk motifs. Autumn's stage shows are marked by a dark spectacle, alongside elaborate dress, corsetry and references to the Victorian period. Certainly Autumn doesn't position herself in

any one genre. She is a vocalist and classical violinist, who represents herself frequently in interviews and articles as 'victoriandustrial'.[1] However, this seems to be a shorthand term for the way in which she draws on steampunk, gothic and Neo-Victorian ideas, as elaborated in her music, her sartorial style and her stage performances. In *The Steampunk User's Manual*, Jeff Vandermeer and Desirina Boskovich note that Autumn is 'one of those "outsider" musicians who have been embraced by Steampunk fans'.[2] Autumn claims descent from Alice Liddell, the original Alice in Wonderland, having a strong following particularly (but not exclusively) among younger women and girls, in part because she fosters a Goth Lolita style. She has performed live with Courtney Love, and she has a solid media presence, appearing on various chat shows in the United States as well as enjoying a more subcultural visibility, performing at one of the largest European Goth Festivals in Leipzig, Germany (Wave Gotik Treffen), in 2007 and 2008. Her first album was *Enchant* (2003), but it wasn't until *Opheliac* (2006) and later *Fight Like a Girl* (2012) that the themes under consideration in this chapter become codified. She articulates a fascination with goth tropes, with songs referencing Ophelia from *Hamlet*, as well as song titles like 'Dead Is the New Alive' and 'Gothic Lolita'. *Fight Like a Girl* was derived in part from autobiographical material surrounding her own experiences of mental health, including the psychiatric treatment she experienced for bipolar disorder, self-harm and attempted suicide. The album itself drew heavily from Autumn's novel *The Asylum for Wayward Victorian Girls* (2009), which in turn forms the conceptualization behind the *Fight Like a Girl* tour of 2013. The novel is especially fruitful for academic analysis: having been heavily revised and rereleased in 2017, it offers an interactive element, where the reader solves puzzles to gain access to 'Asylum Treasure' ('The Spoon of the Royals'), but importantly, the new version also divests itself of much of the sensationalized photographs which featured in the earlier version. It is also highly literary, providing

many intertextual references: *Alice in Wonderland* (tea parties); Charlotte Brontë's *Jane Eyre* (the *bildungsroman* tradition generally, but specifically the final scenes of the novel reveal the girls from the Asylum jump off the roof of the flame-ravaged, collapsing building, very much like Bertha Mason); and various high gothic models of patriarchal threat – the Count de Rothsberg seems derived from the eighteenth-century gothic tradition, as well as more modern fiction such as Angela Carter's 'The Bloody Chamber' (1979). In the following discussion, I will address the ways in which the asylum features in Autumn's theatrical performance onstage, how this functions in the novel, photography and illustrations, and in song lyrics, whilst thinking about the ways femininity, disability and mental health issues overlap with steampunk culture in terms of gender, sexuality and commodity culture.

The Asylum for Wayward Girls is a novel of trauma. It tells the semi-autobiographical story of Emilie Autumn, who has attempted suicide and agreed to treatment in a psychiatric facility. Part of her trauma relates to a recent abortion: she explains that 'I have not cried since leaving Planned Parenthood seven days ago, bleeding, barely able to stagger, the old white man with his Jesus cross and cardboard sign bellowing in my face, spitting, calling me a whore, and, even then, I was ashamed of my tears'.[3] Early on, the novel registers that this is a confrontation between womanhood and patriarchal control of the female body.[4] Having agreed to medical intervention, Emilie then becomes convinced that her emotional and mental well-being is not best served in the psychiatric ward, and the narrative starts to give way to letters that Emilie claims to find from 'Emily-with-a-y', a young woman incarcerated in a Victorian lunatic asylum. It is possible that this doubling of names (same but different) and experiences in part not only functions as a metaphor for Autumn's bipolar disorder but also serves to highlight the ways in which Autumn conflates nineteenth-century experiences and the contemporary moment: 'The reason I

live in the Victorian era on paper is that then as now when you're a girl with depression manic or otherwise you're on your own and all of the attempts at mental health care are nothing but a shabby façade.'[5] The text anachronistically conflates different periods of the nineteenth century, in terms of how mental illness was treated at various points in the century. At the same time, Autumn unites Victorian experiences with the present, codifying this as a broader trend in the gendering of insanity as specifically feminine. Elaine Showalter has noted that 'by the middle of the nineteenth century, records showed that women had become the majority of patients in the public lunatic asylums. In the twentieth century too, we know that women are the majority of clients for private and public psychiatric hospitals, outpatient mental health services, and psychotherapy.'[6] Similarly, she discerns dual images of female insanity in nineteenth-century art: 'madness as one of the wrongs of woman; madness as the essential feminine nature unveiling itself before scientific male rationality.'[7] Gilbert and Gubar explain that 'imprisonment and escape are so all-pervasive in nineteenth-century literature by women that we believe they represent a uniquely female tradition in this period ... Defining themselves prisoners of their own gender, for instance, women frequently create characters who attempt to escape, if only into nothingness, through the suicidal self-starvation of anorexia.'[8] However, other historians of madness have interrogated this paradigm, certainly in the case of unlawful imprisonment in asylums, as Autumn describes. Sarah Wise notes that 'malicious asylum incarceration ... was slightly more likely to have been a problem for men than for women, certainly in the first sixty years of the century. As for those people who were indisputably mentally disordered, the mysterious lunatic in the attic was as likely to have been Bert as Bertha.'[9] Part of this is due to the fact that men inherited property and were also under threat from societal pressures to conform to Victorian masculinity.[10] However, it remains the case, as Voights has argued, that the Victorian 'lunacy panic' and its

representation in sensation fiction in the 1850s play into the union of sensationalist scopophilia and feminine irrationality which Autumn performs and say as much about our modern-day perspective as it does the Victorians themselves.[11]

Emilie Autumn's Steampunk

Emilie Autumn's affinity with steampunk has been discussed by fans and commentators online at some length. James Richardson Brown, an artist and prominent figure on the steampunk scene, coined the term 'steamgoth' in 2007, which is a useful way into approaching the overlap between subcultures in Autumn's visual aesthetic, themes and music styles: 'Steamgoth is a far darker view of the steampunk world. Whereas steampunk can often be said to be science fiction set in an alternative Victorian-era world, Steamgoth would be horror set in that same world.'[12] The 'Art of Steampunk' blog identifies that Autumn uses this notion of steamgoth in her sartorial style and performative aesthetic:

> Let's see, neo-victorian attire such as corsets, garters, and striped stockings? check. Occasional top hats? check. Classical instruments blended with modern electronics? check. Lyrics that tell adventurous or at least very emotional stories? check. An attitude of wild rebellion against anyone trying to classify and homogenize them into a single straight-laced musical type? check x 100.[13]

Autumn delineates her interaction with goth (and gothic) as follows:

> I've always loved all the old Gothic literature from Walpole's 'The Castle of Otranto', to Ann Radcliffe, to Edgar Allan Poe, to even Dickens and Wilkie Collins … To me, that's real Gothic art. Gothic is not a black trench coat … which I love too but that's not the point … and Gothic isn't a style of music with people wailing;

that's not what it is, although that can all be very entertaining and Gothic dancers … very entertaining, which I actually love, I mean, this is awesome. I know I don't really have to say it because you know what I mean by this … our Gothic fans are amazing … but what Gothic actually means, and they should know this more than anyone, there are actual fucking authors, and painters, and Goya, and all these things, and that's Gothic.[14]

Whilst this chapter will be focusing on Autumn's use of steampunk, it is important to acknowledge that her aesthetic cannot be neatly categorized. Indeed, her participation in several subcultures suggests a very postmodern articulation of fragmented identity. This accords with many of the arguments put forward by post-subculture critics, who suggest that a departure from the Hebdige model of subculture is needed to account for postmodernity: 'Underlying the move towards post-subcultural analysis is an argument that subcultural divisions have broken down as the relationship between style, music taste and identity have become progressively weaker and articulated more fluidly.'[15] The way in which Emilie Autumn's work intersects with several subcultures suggests this notion of post-subculture.[16] Her work also appeals (not exclusively) to teenage girls, especially those who are disaffected or otherwise alienated by mainstream culture.[17] Her narratives of empowerment and of resistance in the face of patriarchal injustice make her a captivating but edgy role model for a younger audience. However, her engagement with burlesque and commercialism might be seen to complicate her feminist agenda. She explains that her engagement with burlesque in her stage shows is based in parody and satire, which accord with much of the critical work on neo-burlesque as a phenomenon:

We can sexualise things – and this is a feministic view of things – but it's like, yeah, you can use sex or you can sexualise these things, that's okay, we can accept that, but not necessarily from a woman's point of view selling it herself. I'm okay for a guy to be like 'that's

hot', there's no problem with that but I'm even more okay with me taking control of my own sexuality if I'm gonna sell it. I mean, yeah, we use it onstage because it's an awesome, powerful tool to use as an art form and to spread a message that you want to, and that is true that the things I think are most important ... And then, any other tool you have like physical beauty, sexuality, all of that because ... and it goes back also to what I do think of the show as, if I were going to label it, is a true burlesque in the real sense of it because it isn't Bettie Page. That's awesome but that's not what burlesque means. Burlesque means a Victorian and turn of the century, and even earlier, entertainment; a show that was mainly using humour and sexuality to make a mockery of things that were going on socially and politically. That's what burlesque means, and that's what we're actually doing.[18]

Certainly Autumn's staged performance of madness and excessive sexuality suggest a parodic theatricality. However, the incessant references to an infantilized and/or disabled model of womanhood undercut this potential for social critique. She describes grown women as 'girls' and identifies madness as a feminine trope, whilst her use of a wheelchair onstage has provoked criticism from her fans.

Emilie Autumn describes *The Asylum for Wayward Girls* as 'a bit of a time travel thing with the alternate reality that I had to create when I was locked up' with 'Wayward Girls' being a potential reference to Angela Carter's edited collection of short stories *Wayward Girls and Wicked Women* (1986).[19] Quite clearly, we can observe the time-travelling narrative as a cornerstone of steampunk narratives: we only need to think of H. G. Wells's *The Time Machine* (1895) as a fairly consistent referent in steampunk culture. The treatment of mental health in *Wayward Girls* also overlaps with steampunk tropes: 'The Asylum' (Lincoln, UK) is the venue for an annual steampunk festival, hosted in venues including Lincoln Castle, used in the nineteenth century as a prison.[20] More importantly, perhaps, is the visibility of machinery in steampunk and how this is articulated in *Wayward*

Girls. One of the most important manifestos for steampunk, from the *Steampunk Magazine*, notes that 'first and foremost, steampunk is a non-luddite critique of technology'.[21] This emerges as both a fetishization of Victorian technology and an anxiety about technology and its relationship to modernity.[22] Martin Danahay has claimed, 'As in the futures imagined in much Victorian science fiction, the reconfigured past in steampunk speaks to contemporary debates about new technologies, just as stories by H. G. Wells are now viewed as extrapolations of anxieties caused by advances in biology and geology.'[23] Similarly, it is possible to suggest that Emilie Autumn's flirtation with steampunk motifs relates to how the nineteenth century is a point on the continuum which results in the present-day treatment of mental health. She says as much in an interview:

> I am terribly interested in the Victorian era for several reasons, not the least of which being that it was the era that gave birth to the modern notion of psychiatry, something I am only too familiar with. It was also characterised by the Industrial Revolution, the advent of capitalism, class disintegration, public health care (for better or worse), and many many of the social, medicinal, psychological, sexual and behavioural traditions we carry with us today.[24]

Whilst this statement seems entirely Neo-Victorian, but perhaps not particularly steampunk, Autumn also demonstrates her affinity to steampunk in a number of ways. The semi-autobiographical novel, which inhabits both a fictional nineteenth century and the contemporary moment, shows how Autumn plays with alternative histories and temporal dislocations: 'Alternate history in steampunk acts as an important cultural register of the temporal heterogeneity emerging out of time-criticality: an imaginative experiment merging an awareness of history with the idea that history can also be disrupted and manipulated.'[25] She also presents science and

technology, including steampunk machinery, as dangerous and a threat. For instance, the steampunk commonplace of clocks and especially cogs decorate the 2009 version of the book, along with the sepia-toned colour palette common in the movement. The book also employs the paradigm identified by Jeff Vandermeer in *The Steampunk Bible*: 'Steampunk = Mad Scientist Inventor [invention (steam x airship or metal man/baroque stylings) x (pseudo) Victorian setting] + progressive or reactionary politics x adventure plot.'[26] Certainly Autumn's progressive politics are easily discernible (how successful they are is another matter, as will be discussed later in this chapter), as is the Neo-Victorian backdrop of the novel. Most notable for our purposes, however, is the idea of the mad scientist inventor. The director of the Asylum, Dr Montmorency Stockill, clearly accords with this steampunk paradigm. It emerges that Stockill's project to reform wayward women is actually an amalgam of several historical occurrences: the use of bodysnatching and experimentation on unfortunates seem to reference Mary Shelley's *Frankenstein* (1818), as well as the infamous case of Burke and Hare, who were tried in 1828 for a series of murders motivated by profit, as the corpses were sold to Dr Robert Knox, a Scottish anatomist, for dissection in his lectures. Dr Stockill's laboratory clearly figures him as a mad scientist. Described as the 'ingenious director' of the Asylum, he practises his medical experimentation in an underground chamber.[27] Emily describes this chamber as follows: 'A makeshift laboratory had been constructed, and hanging gas-lamps encircled a wooden slab in the center of the room, coarse and bloodstained. Deep within the surrounding shadows, I could faintly distinguish the outlines of machinery – massive gears and wheels, levers, cogs, and chains surrounded an iron closet, large enough for perhaps six people to stand inside.'[28] The machinery is actually some form of incineration device, constructed to expedite the murderous objectives of Stockill and his pathological hatred of women (derived from his resentment of his infant sister, his first

victim). These are women whose disappearance society will not notice: they are subjected to a lethal cocktail of chemicals (predominantly arsenic) and also other medical experiments (clitoridectomies, uterine removal, leeches). Additionally, Dr Stockill created a strain of bubonic plague which would be resistant to conventional drugs: 'There lay far more power in the hands of one who could *cause* the Plague than in those of one who could *cure* it, and that to accomplish both would be to control society completely, rendering one a veritable god amongst the entire human race – worshipped and obeyed by all.'[29] The description of Stockill's laboratory is crucial to Autumn's use of steampunk, as it participates in the materiality of the genre (the descriptions of machinery and their uses feature prominently in this scene), alongside a deep suspicion about science and medicine. David Pike suggests that the science of steampunk is 'an imagined technology [which] interacts with a known set of Victorian spatial practices to represent simultaneously their apocalyptic and utopian potentials'.[30] Autumn's exploration of technology to situate mental health treatment is demonstrated early in the text, when Emily-with-a-y states, 'I heard a rumbling from somewhere below us, then the turning of gears.'[31] Gears, of course, are another steampunk motif, but they are figured in the novel as a synecdoche for the traumatic consequences of experimental science and its links to medicine, but with specific reference to women, madness and agency.

Much of the anxiety related to technology and medicine in the text also relates to the depersonalization of humanity. The reader notes that Dr Stockill moves 'mechanically' when he experiments on Veronica and uses a 'sort of fleam' which has a hidden latch and is spring-loaded in the best steampunk fashion.[32] Incarcerated in quarantine, Emily explains that the sound beneath her was 'something like the gunning of a freight train … a great puff of steam followed by a low rumble'.[33] Indeed, machinery is always an agent of enslavement in the novel: 'I heard the grinding of gears, the rattle of unseen machinery,

and I knew that Dr. Stockill was securing the Asylum.'[34] Relatedly, steampunk's engagement with dystopian models of science fiction is well established and in *The Asylum for Wayward Girls*, this apocalyptic vision is given a particularly feminist slant. Fredric Jameson explains in his *Archaeologies of the Future* that the taxonomies of science fiction need to account for 'subjectivity and representation ... enlarged to make a place for a second wave of feminism from 1969 onwards'.[35] The notion of subjectivity correlates with the issues experienced by women with reference to mental health and underpins Autumn's dystopian steampunk.

Women and madness – The *Fight Like a Girl* Tour (2013)

In the opening scene at the Victorian asylum in *Wayward Girls*, Emily is presented with a façade of respectability:

> Tall, ivory candles ensconced in gold sparkled from their place on the mantelpiece. The hearth itself was so large I could have walked into it on my toes, were I so inclined. On the left of the fire, richly upholstered chairs were assembled casually around a tea table set with bone china and laden heavily with delicacies almost too beautiful to eat. Cakes stacked high and frosted with swirls of icing and lemon drops were flanked by tiered trays of strawberry tarts ... To the right, a small gathering of ladies lounged upon overstuffed settees, books and needlework in their laps, whilst others sat around a lace-covered card table, playing at whist or some other such game. All were dressed elegantly, yet with modesty.[36]

As soon as it emerges that Emily has no family that the Asylum needs to impress, the butler, Maudsley, turns a knob underneath a gas lamp, and the whole tableau shifts to the grime and degradation of the everyday experiences of inmates. The women, formerly 'a

small gathering of ladies', are now vulgar and stereotypically lower-class servants, addressing each other as 'tart' and 'dollymop', whilst Madame Mournington, the mother of the Asylum's doctor, addresses all of them as 'slatterns'. Emily observes:

> I glanced over to the ladies cavorting in the corner; they had discarded their perfectly coiffed hair, revealing their own slovenly arranged locks … All actors piled their castoff costumes onto one of the settees and bounded off to their regular duties. Was all of this contrived simply to convince the friends and family of a mad girl that this is a safe place to leave her?[37]

We might note how the 1845 Lunacy Act prompted a shift in ideology, so that the Victorian asylum was ostensibly remodelled according to the Victorian home – libraries filled with books, art and leisurely day rooms were advocated in order to camouflage the fact that the lunatic was imprisoned. In her stage production *Fight Like a Girl*, as well as in the novel, Autumn suggests that falsification and arbitrary distinctions support such gestures: 'What ingenious mind had designed a system of such mechanical brilliance? And why? Away went the furniture, away went the tea table, cakes and all, none of which had been real.'[38] Her point is that the duplicity and sleight of hand commonly associated with the Victorian period (the tropes of Madonna/Whore, respectability/disrepute, etc.) were enabled by technological advancement of modernity – the servants are 'tarts' or 'slatterns' who appear respectable by virtue of a mechanical tableau. Similarly, the Asylum itself is merely a foil for medical experimentation on vulnerable women, which in turn becomes a criticism of contemporary psychiatric treatments which Autumn states she has undergone. Fredric Jameson has identified that one definition of dystopian fiction relates to the '"if this goes on" principle'.[39] In the same way, Autumn is establishing a continuum between her contemporary experiences of the psychiatric ward and

the historical treatment of lunatics and suicides. For Autumn, this interrogation of reality is equally applicable to how we categorize the mad and the sane. This is confirmed when the contemporary Emilie identifies her madness as performative: 'I unpin my hair ... I decide to leave it loose; I even tangle it a bit so that I look half as crazy as I'm being treated. I imagine this is what Ophelia looked like – sane but crazy, crazy but sane.'[40]

If we think about how Foucault characterizes the birth of the asylum in the nineteenth century, he argues that the nexus of silenced subjects, a boundary between reason and unreason drawn through confinement, surveillance and pathologization, is maintained through the asylum as a specifically medical space and through the authority of the doctor. He says 'the doctor's intervention is not made by virtue of a medical skill ... [but] as a wise man'.[41] Foucault observes that the construction of the asylum was more about moral position and the quasi-miraculous: '[The doctor's] presence and his words ... revealed the transgression and restored the order of morality'.[42] In common with Foucault, Autumn seeks to complicate the distinctions between sanity and madness or the asylum space and normative public space. The categorization of legitimate and illegitimate, of order and morality which the Victorian asylum policed and maintained, is directly challenged by Autumn's Asylum. Unruly women and polymorphous sexualities feature strongly throughout the tour, as in the novel (in both versions). The theatre space seemingly seeks to uncover and represent the marginalized and the deviant through the history of medical discourses. However, whether this is quite convincing is another matter, especially given the way in which Autumn conflates the asylum with the freak show in her performances.

Perhaps the most effective, but also the most troubling, aspects of Autumn's performance relate to her exploration of mental health. During her neo-burlesque 'glove peel', Autumn not only flaunts the tattoo on her upper arm (W14A – the number of her cell during

her institutionalization) but seems to remove the glove by clawing at her arm in a routine escalating in its increasing madness. Given that the show is paired with such song lyrics as 'the prettiest broken girl you've ever seen' and 'crazy little girls', as well as the title song 'Fight Like a Girl', there is a danger here of slipping into some fairly common tropes of femininity, infantilization and madness without any real sense of irony. Earlier in this chapter, I noted how Elaine Showalter has documented the ways in which madness is seen as feminine. Indeed, she counsels against practices which 'come dangerously close to romanticizing and endorsing madness as a desirable form of rebellion … A serious historical study of the female malady should not romanticize madness as one of women's wrongs any more than it should accept an essentialist equation between femininity and madness'.[43] Her analysis of Charlotte Perkins Gilman's 'The Yellow Wallpaper' (1892) is especially useful here, reading the story as a 'protest against the rest cure … the sexual violence that some nineteenth-century American feminists saw reproduced in the relations of male doctors and female patients'.[44] Autumn draws several analogies with that short story. First of all, Emilie identifies her own experience as comparable with the rest cure that Gilman endured under Dr Weir Mitchell in 1887, which included the prohibition of writing: 'No, it is the act of writing that may save me, for through my pencil the story is exorcised; left inside my head, it smothers me.'[45] Autumn's persona in the modern day, like Gilman's narrator, becomes fixated on the wallpaper of her room:

> I lift my hand to touch the wall … I feel a tiny crack in the paint … I pick at it … bits of paint flake off onto the speckled linoleum floor … I can't stop … larger flakes are peeling off … I am tearing at the wall now … I've made a large hole in the plaster … I'm still tearing … my fingers are bleeding, smearing the wall with red. Finally, I sit back and look at what I've done. Where the plaster

has been torn away, I see the layer beneath … stripes … black-and-white … they're moving.[46]

The idea that madness equates with liberation seems prominent here, as Showalter explains of the narrator in Gilman's story, 'she escapes into madness, making the room her refuge, creeping around its margins.'[47]

Of course the stripes are linked to Emilie's stockings, to the stockings that the Captain in the Asylum wears, as well as Autumn's fandom 'The Striped Stocking Society', which in turn are all traumatically linked to sexualized violence: the cover of the 2017 version sports Emilie Autumn's legs in ripped black-and-white striped stockings (a gothicized variant of steampunk's sepia tones), which are explained as follows:

> I have begun to feel somehow protected by my legwear. I am reminded of a true accounting of a young girl in the nineteenth century who was the victim of a serial killer. The villain lured the girl up to the attic of her own house where he raped (how original) and murdered her, then set the house on fire in order to destroy the evidence. The strange bit was that, the next day, the house was burned to bits, as was the girl's body, with the exception that her legs, which remained completely unmarred beneath her striped stockings …. I would very much like to have those stockings.[48]

The text aligns the character of Dr Greavesly, also known as 'The Butcher', with that of Jack the Ripper as well as Burke and Hare: he is a character who frequents Whitechapel, has a fascination with dissection, illegally sells the corpses of the murdered women to anatomy colleges and dies by his own nefarious methods: 'I … grasped the spoon I had left standing upright in the Doctor's stomach, and pulled it downwards, slicing through the length of his abdomen.'[49] Equally sexualized is the death of Dr Stockill, whom Emily kisses before plunging a sharpened spoon in his back: 'The Doctor stared at

me in utter despair, and this is when I kissed him. I kissed him, Diary, and I saw more horror fill his eyes than my knifepoint could ever inspire.'[50] Of course part of Dr Stockill's response is revulsion at the female sex, but even so, the conflation of revenge, sex, madness and death here makes uncomfortable reading.

These subjects also feature strongly in the photography and illustrative material of the 2009 edition (excised entirely from the 2017 version). This version provides close reference to the material culture we associate with steampunk. The entries such as the 'Cutting Diary' are handwritten, whilst others are typewritten. At various points the physicality of the book, and equally the visceral nature of Emilie's experience, is emphasized (images taped into the text, sketches, paperclips, tea bags, parody Victorian advertisements, hospital bracelets and psychiatric admission notes, syringes, etc.). Our attention is repeatedly drawn to the personal: the homemade and the DIY nature of the book is underscored, whilst simultaneously these items provide 'evidence' for the narrative (the inclusion of the Victorian Asylum admission form, for instance, lends a certain authenticity to a fictional story). But at the same time, there is a sexualized and sensationalist spectacle which places the reader in the same position as the scopophilic viewer of the Ophelia performance. Photographs show Autumn gloriously revelling in her status as mad woman, posing in knickers and skimpy T-shirt bearing the word 'Inmate'.[51] At another point, Emilie Autumn sports fishnets, a bejewelled corset and nipple pasties, seemingly shouting in response to the narrative which has just seen her fictional friend murdered.[52] Equally problematic is her discussion of self-harm in this version of the novel. It is very difficult to encounter these sections without being confronted with a sexualized celebration of mental instability. Autumn's diary explains 'a wee slit on the inner flesh of a thigh … the beautiful, beautiful BEAUTIFUL droplets of blood that are rising slowly to the surface of the wounds I have only just made. It's kind of like when I cry, but so much prettier.'[53] This section

of the diary is accompanied by photographs of Autumn's thigh, replete with multiple cuts and glamorous dark nail polish. The experience of self-harm is disturbingly aestheticized at this point, and this is reiterated later when Autumn explains 'My god, it was so beautiful ... what a color blood is, really.'[54] Combined with the sexualized body of Autumn – the corsets, nail polish, nipple pasties – it seems whilst presenting solidarity with her (often teenage and female) fans, Autumn is also revealing her experiences as perversely aspirational. She does offer a caveat in the 'confiscated notebook' of the 2017 edition: 'Do not think that I am recommending suicide as a course of action for anyone.'[55] Despite this, she also explains that 'I made my cuts in particularly intimate areas of my body that would only be known to the next person I allowed too close in a moment of forgetfulness.'[56] By the same token, the sexualization of mental health is complex and ambiguously performed in Autumn's music and stage show. In her song 'Take the Pill', Autumn registers her anger at pharmaceutical drugs used to treat her manic depression. However, she also correlates such treatment with oral sex, through the repeated and progressively more aggressive iteration of the word 'Swallow'. In the novel, she explains 'the entire song is a sexual metaphor. It's no secret. That's kind of the point.'[57]

Autumn's stage show performances reflect this sexualization. The promotional copy for the *Asylum* tour reads:

> Emilie is backed by her all-girl burlesque circus, a *dangerously sexy* troupe of what she calls her 'fellow inmates', and which includes singers, stilt-walkers, fire-eaters, burlesque dancers, aerial performers, and dramatic actresses, all of whom conspire nightly to *tease, tantalize, and terrify* ... the girls ... passionately kiss each other, as well as lucky members of the audience who may be called onto the stage.[58]

The emphasis here is on sexual spectacle, which complicates Autumn's declared objective in challenging patriarchy. If anything,

the performance registers a very conventional approach to femininity: tightly corseted female dancers with impeccably small waists, glamorous costumes and make-up, accompanied by a frisson of madness and fear, which invites comparisons to the *femme fatale*. One of the most sexually charged parts of Autumn's stage shows is what Autumn has dubbed 'The Rat Game.' This performance featured in Autumn's earlier shows and has been retained in her recent tours.[59] Here the character of Veronica (played by Veronica Varlow, burlesque performer) takes centre stage. The Veronica character is actually a nymphomaniac, described as follows:

> There is a voluptuous beauty called Veronica who occupies the bed next to mine in Ward A. Veronica began her career as a dance hall girl, but had later developed her own act, or so she says ... She is quite notorious for loudly calling out to the Chasers [warders] as they patrol the corridor outside of our cells and taunting them into giving her things she wants (usually a bit of food, a cigarette, or a newspaper) in exchange for particular 'favours'. Her shouts of 'who wants to kiss me?' echo through Ward A at least thrice daily ... She seems always to be in the act of taking off her clothes.[60]

Onstage, Veronica's 'Rat Game' begins with orgasmic sighs, followed by a discussion between her and Autumn cross-dressed as a Victorian boy, culminating in the two exchanging a passionate kiss. This is perhaps one of the more radical aspects of Autumn's performance, as it invokes the very slippery nature of gender dynamics. Here, Autumn sports a flat cap which disguises her very feminine long hair, with trousers and a tiny waistcoat. As Veronica claims she isn't attracted to boys, Autumn rips her waistcoat open, revealing a glamorous pink bra underneath. Her femininity, despite attempts at a masculine swagger, is never really absent. Thus, we might theorize this scene in terms of the drag king phenomenon (female-to-male impersonators). As J. Halberstam notes:

A drag king is a female (usually) who dresses up in recognizably male costume and performs theatrically in that costume. Historically and categorically, we can make distinctions between the drag king and the male impersonator. Male impersonation has been a theatrical genre for at least two hundred years, but the drag king is a recent phenomenon. Whereas the male impersonator attempts to produce a plausible performance of maleness as the whole of her act, the drag king performs masculinity (often parodically) and makes the exposure of the theatricality of masculinity into the mainstay of her act.[61]

In common with Halberstam's concept of the drag king, Autumn doesn't present a 'plausible male', but rather enacts a routine which flags up the contingencies and problems of gendered performance itself. However, situating this within the Asylum, however sympathetically, shores up the demarcations of rational/irrational, normal/abnormal which Autumn seeks to challenge.

Apparently, needing lessons in 'the art of lovemaking', Veronica invites women in the audience to 'get up close and personal with [her]'. In her 2010 Berlin performance, some members even bear handmade signs asking Veronica to 'be my first (lady) kiss'. The whole spectacle is described as a 'vile, deplorable sideshow', clearly a satirical reflection on the ways Victorian culture policed and demarcated legitimate and non-legitimate sexualities. However, we do have to look at the scopophilic logic underpinning this performance. Several fans have commented that the introduction of the Rat Game made Autumn's show less appealing. Discussing Veronica Varlow's persona, one fan explained: 'Her stage persona seems nothing more than sexy and I cringe at the whole lesbian rat game act. She can be very funny and I think she can bring more to the show than she does now. Sorry.'[62]

The sensationalism of the scene (or what Eckart Voights has termed 'sexsation') actually shores up the paradigm of normative and non-normative, rather than challenging it in any real way.[63] Foucault's idea

of the 'repressive hypothesis' is useful here: 'If it were truly necessary
to make room for illegitimate sexualities, it was reasoned, let them
take their infernal mischief elsewhere … The brothel and the mental
hospital would be those places of tolerance … Only in those places
would untrammelled sex have a right to (safely insularised) forms
of reality.'[64] Such a performance, contained as it is in the theatrical
space, doesn't challenge the logic of the asylum as much as replicate
it. Nowhere is this more obvious than Veronica's statements about the
two volunteers she kisses – Crystal is characterized as a 'virgin' whilst
her companion, Stormy, is dubbed 'the most horrible harlot that
ever lived' – a somewhat comedic but nonetheless unreconstructed
portrayal of the Madonna–Whore dichotomy. Returning the two
women to the audience following the kiss, Veronica exclaims, 'Another
two defiled for your sick pleasure. Get down there, Harlots … harlots.'

We might note at this point that the Veronica character is
positioning herself ironically as a freak show compere, and certainly
the book *Wayward Girls* features a number of spectacular scenes
where women's bodies are subjected to a readerly surveillance akin to
the freak show. For instance, the mental health patients dress up and
perform as 'Ophelias' for the fundraising event attendees:

> The Ophelia Gallery … the icon as the Asylum wished to portray
> her, for, though we would not profit by it in any way, a great deal of
> money rested upon the quality of our performance. Having been
> directed to languish, to sigh, our hands to our foreheads as though
> we would faint, it was time to don our costumes. We were dressed
> in long, sheer gowns that moved like air against our skins …. Yet,
> with our dropping flowers and long, shimmering hair, we were
> somehow … magnificent.[65]

Of course, as readers, we are complicit in this viewing of the lunatic,
but the prose also seems to suggest we should admire this vision,
or find it aspirational, given the reference to being 'somehow …

magnificent'. At various points, Emily's body is opened up, internally explored and transgressed by medical procedures, whilst patients pose for pornographic photos in order for hospital authorities to market their bodies: 'Page after page of photographs ... strange photographs ... followed by records of age, physical characteristics (the deformities of particular girls were actually listed as selling points), assurances of virginity (ha!), and, of course, price. Price per hour.'[66] In each instance, what is noteworthy is the capitalist imperative underpinning the freak show spectacle. As Helen Davies has noted in her discussion of Neo-Victorian freakery, 'the rise in popularity of American freak shows in the nineteenth century was linked intrinsically to modernity'.[67] Here, modernity is overtly correlated with the rise of consumerism (and concomitantly, prostitution). Davies's discussion merits careful attention here, as she notes that there is a potential for 'reinstalling the agency of people who performed in nineteenth century freak shows which allows us to rethink the outright condemnation of this very Victorian institution'.[68] Clearly part of Autumn's enterprise here relates to her own agency as a mental health sufferer, but this is somewhat distinct from fictionalizing the experiences of, indeed *speaking for*, nineteenth-century women. Whilst Autumn's objective is to give voice to the injustices of the nineteenth-century asylum system, by asking us to reflect upon our complicity as viewers and readers of this material, it is also a fantasy which bears little relation to the historical conditions of asylums in the period.

An alignment with the spectacle of the freak show is not without its problems, especially when Autumn's stage show draws on sensational models of extraordinary bodies. During the 'Rat Game', Veronica demands Stormy and Crystal 'get together and pretend you are Siamese twins'. The appropriation of silenced subjects such as Siamese twins, especially in the context of the freak show, is somewhat problematic. We might note how the freak show historically offered a combination of revulsion and fascination: Elizabeth Grosz has

explained that 'the initial reaction to the freakish and the monstrous is a perverse kind of curiosity'.[69] Indeed, as Helen Davies argues, such contemporary replications of historical experience reflects 'neo-Victorianism's reimagining of nineteenth century sexualities as exotic other ... [especially when] the sexualized bodies under scrutiny were marked as abnormal, freakish, or other in their own historical moment'.[70] In other words, the Rat Game's playfulness in terms of lesbian identity and disability offers little more than a replication of freak show scopophilia. In other parts of the show, Autumn performs in a wheelchair, a testimony to her experience in the psychiatric institution, and indeed, her characterization of herself as a damaged individual, an 'Opheliac'. There is some precedence to pop stars performing disability: in 1992, Kurt Cobain was wheeled around the stage at Reading Festival 'wearing a blonde wig and hospital gown', which was reported as a 'comment on media speculations about his mental health' whilst Lady Gaga appeared onstage in a wheelchair, as 'Yuyi the mermaid' at a concert in Sydney (2011).[71] Fans have also registered some offence at Autumn's display, as she isn't in any way physically disabled. One online forum contributor remarked: 'As someone who has been confined to a wheel chair a good chunk of my life, her wheel chair routine in her concert offends me a lot. I'm sick of the ableism'.[72] At one point in the show, she sits in the wheelchair (dubbed Wheelie) with splayed legs, whilst her fellow dancers engage her in an erotic spectacle of touch. Indeed, commenting on an occasion when her strip show went wrong, Autumn explains that it is intended to be a sexualized display: 'At one point I do this crazy strip show standing on my wheelchair and, when I do that, I'm trying to look all sexy and cool combined with the music, and choreography, and the rest of it'.[73] In terms of the ethics of representation, it is worth thinking about how Neo-Victorian criticism sheds light on these appropriations, not only in terms of historical trauma, but also in terms of present-day experience of disability: 'The ethical

dilemma involved … is the question of recreating historical traumas by way of bearing after-witness … which is necessarily a secondary, appropriated and possibly misrepresented experience.'[74] Attempting to speak for those nineteenth-century inmates in asylums is thus highly complex. Perhaps most interestingly, Autumn doesn't need a wheelchair for any physical disability (she is a perfectly able-bodied woman). The wheelchair actually seeks to signify visually her mental disability – her bipolar disorder. This identification of mental health with disability also features in the *Asylum* novel, where Emilie elaborates 'if I ask questions, one of the wardens will speak to me very slowly as though I were not only a child but also a mentally disabled one, which, I suppose, is exactly what I am.'[75] In terms of recent developments in disability studies, we might note that the able-bodied performer playing the physically disabled has been dubbed by Tobin Siebers as 'disability masquerade'. He explains that the stigma of disability is placed on display to set the character apart as a freak and frequently, as we can see in Autumn's performance, provides 'an exaggerated exhibition of people with disabilities but questioning both the existence and permanence of disability. It acts as a lure for the fantasies and fears of able-bodied audiences and reassures them that the threat of disability is not real, that everything was only pretend.'[76]

Certainly if we see Autumn as an able-bodied performer, her performance is double-edged and merely shores up societal prejudices about disability. The fact that she can climb out of the wheelchair correlates with public fears that the disabled are 'just faking it', and they are not as disabled as they maintain. However, if we think about Autumn's mental health issues, we encounter a different effect. Siebers notes that the use of prosthetics (fake arms, crutches, wheelchairs) is understood in popular opinion to flag up the fact that someone is disabled – visualizing their limitation through a symbol is necessary to legitimate special treatment (ramps, boarding a plane before

other passengers, etc.).[77] It is important to have a visual signifier to distinguish normal and abnormal – a form of overcompensation to negotiate the world. Invisible health problems (including, we might add, mental problems) are often dismissed as it is difficult to see what is actually wrong with a person: as Sieber claims, 'the masquerade may serve as a form of communication, either between people sharing the same disability or as a message to able-bodied people that a disabled person is in their midst'.[78] As such, Autumn's use of the wheelchair, as well as her graphic spectacle of self-harm, discloses her limitations, even if it is 'faked' or exaggerated for performative effect. However, an attendant problem is the stigma associated with the 'incomplete' or 'frail' body, which Autumn's freak show logic does little to challenge. Indeed, it is very difficult to see how Autumn's experience of incarceration in the psychiatric unit can be easily conflated with the freak show spectacle in the way that she claims. Certainly, other Neo-Victorian critics (such as Kohlke and Gutleben) have identified the 'healing mechanism' of revisiting a traumatic history of exploitation and abuse, but it is one which needs to be handled with some care.[79] Ultimately, Emilie Autumn's show commodifies such experiences, as the eager audience pay handsomely to fantasize about complicity in such a freak show.

This commodification is also inherent in several other examples from Autumn's *Wayward Girls* book, as well as her website. Chris Loutit has identified how Neo-Victorian novels such as Michel Faber's *The Crimson Petal and the White* (2002) are often marked by 'delight in the new consumer culture' which emerged in the nineteenth century, and in this way, the wares, trinkets and products of the Victorian home can become uneasily implicated in the equivalent rise of sexualized commodity through pornography and prostitution.[80] Certainly *Wayward Girls* is critical of such sexualized consumerism, as where Emily-with-a-y discovers a book, 'page after page of provocative photos … the peepshow began with a

large card printed with *my* picture … I removed the card from the book and turned it over; on the back was an advertisement for a brothel, a house of prostitution – call it what you like – but it was *our* house'.[81] However, this critique is rather difficult to reconcile with Emile's appearance in *Playboy* and her subsequent defence of the magazine.[82] Natasha Walter and Ariel Levy are somewhat critical of this 'undressing-as-empowerment rhetoric', and it sits particularly uneasily when located alongside Autumn's aestheticization of madness.[83]

The sexualization of mental health issues in *Wayward Girls* seems to be at odds with Autumn's critical approach to modern sexual culture elsewhere in the novel. We might also note it is rather expensive to join Autumn's Asylum army, especially given that her fanbase is composed of a high proportion of teenage girls. Indeed, the payment to access parts of a website has much in common with online pornography and erotica. How far is she revealing the history of exploitation and prejudice inherent in the nineteenth-century asylum, and how far is she actually mimicking this in a twenty-first-century performance? Autumn's stylization of mental health as sexy relates more generally to the popularization of sexual material, and relatedly, Bryan McNair's claim that we are living in a 'striptease culture'.[84] He notes how the twenty-first century has seen 'the transformation of desire and the promise of sexual pleasure into various types of commodity (pornographic books and films, sex aids, fashion and appearance enhancers of various kinds, and all the sex-saturated products of art and popular culture)'.[85] Staging the Asylum as overtly sexual, full of titillatingly aberrant sexualities, freak show imitators and burlesque beauties, seems to undercut the overwhelming sympathy Autumn clearly has for the alienated and those who are suffering, whilst a parody of disability, however it may seek to reveal invisible mental health issues, nonetheless is somewhat uneasy when we position it alongside disability studies research.

Conclusion

So ultimately, how do we respond to Autumn's steampunk burlesque? In many instances, there is interaction between commodity, disability, burlesque and steampunk aesthetics which compromises the ethical integrity of the performance, whilst there is also a less than careful reflection on the logic of the freak show. The audience is placed in a position of voyeurism in relation to the abject, monstrous visions of femininity onstage whilst it becomes complicit with some very problematic ideas about the freak show body (as the Rat Game testifies). The declared 'punk' ethos and anti-establishment claims of Emilie Autumn are severely undercut by the way in which the Asylum space repeats, but does not entirely challenge, the discourses of nineteenth-century medicine, which render alternative sexualities, the mentally ill, the disabled and the deformed as needing management and careful surveillance.

Notes

1 See *TWF Magazine*, 'The World according to Emilie Autumn', Issue 8, Spring 2007, p. 31.

2 Jeff Vandermeer and Desirina Boskovich, *The Steampunk User's Manual: An Illustrated Practical and Whimsical Guide to Creating Retro-Futurist Dreams* (New York: Abrams, 2014), p. 188.

3 Emilie Autumn, *The Asylum for Wayward Victorian Girls* (ebook, 4th ed, 2017), location 252.

4 See Eckart Voights, '"Victoriana's Secret": Emilie Autumn's Burlesque Performance of Subcultural Neo-Victorianism', *Neo-Victorian Studies*, 6:2 (2013), 15–39, 15. The Asylum features in many Neo-Victorian novels, including among others, Sarah Waters's *Fingersmith* (2002), John Harwood's *The Asylum* (2013) and Adam Foulds's *The Quickening Maze* (2010).

5 *Wayward Victorian Girls* (2017), location 3825–3839.

6 Elaine Showalter, *The Female Malady: Women, Madness and English Culture, 1830–1980* (London: Virago, 1985), p. 3. See also Showalter's discussion of Victorian asylums and abuse, pp. 25–26.

7 Showalter, *The Female Malady*, 3.

8 Sandra M. Gilbert and Susan Gubar, *The Madwoman in the Attic: The Woman Writer and the Nineteenth-Century Literary Imagination* (New Haven, CT: Yale University Press, 1979), pp. 85–86.

9 Sarah Wise, *Inconvenient People: Lunacy, Liberty and the Mad-Doctors in Victorian England* (London: Vintage, 2013), p. xvii.

10 Wise, *Inconvenient People*, xix. See also Matthew Sweet, *Inventing the Victorians* (London: Faber and Faber, 2001), p. 183.

11 See Voights, "'Victoriana's Secret'", 18–19. See also Lisa Appignanesi, *Mad, Bad and Sad: A History of Women and the Mind Doctors from 1800 to the Present* (London: Virago, 2008), pp. 7–8. *The Asylum* (2017), location 2800 notes that 'insanity is on the rise, or so they say, and a witch-hunt for the mad is spreading its poisoned shadow over the country'.

12 http://www.decimononic.com/blog/steamgoth-in-a-nutshell-1-of-6-intro [accessed 8 August 2017]. This series of webpages (1/6) has a very useful introduction to 'steamgoth' as a variant on the steampunk aesthetic.

13 http://artofsteampunk.blogspot.co.uk/2012/02/emilie-autumn-steampunk-goth-style.html [accessed 8 August 2017].

14 *Metal Discovery*, Interview with Emilie Autumn – 9 March 2010 http://www.metal-discovery.com/Interviews/emilieautumn_interview_sheffield_2010_pt2.htm [accessed 8 August 2017].

15 Andy Bennett and Keith Kahn-Harris, *After Subculture: Critical Studies in Contemporary Youth Culture* (Basingstoke: Palgrave, 2004), Introduction, p. 11.

16 Bennett and Kahn-Harris, *After Subculture*, 11ff, provide a useful discussion of the different articulations of post-subcultural theory (neo-tribe, lifestyle, scene). Whilst maintaining a sense of collective identity, these post-subcultures tend to be more 'fluid and unstable' in terms of mixing of styles and genres (p. 12).

17 See Angela McRobbie, *Feminism and Youth Culture* (Basingstoke, Macmillan: 1991), for a discussion of young women and subcultural critique. It is very much the case that Autumn's novel, stage show and music foster a sense of female solidarity and sorority among younger women.

18 *Metal Discovery*: Interview with Emilie Autumn, Sheffield, 2010, http://www.metal-discovery.com/Interviews/emilieautumn_interview_sheffield_2010_pt2.htm [accessed 8 August 2017]. For the ambivalence of burlesque as feminist performance, Jacki Willson, *The Happy Stripper: Pleasures and Politics of the New Burlesque* (London: I. B. Tauris, 2008), Robert C. Allen, *Horrible Prettiness: Burlesque and American Culture* (Chapel Hill: University of North Carolina Press, 1991) and my own 'Grrly hurly burly: neo-burlesque and the performance of gender', *Textual Practice*, 23:4 (2009), 641–663.

19 *Metal Discovery*: Interview with Emilie Autumn, 30 January 2010, http://www.metal-discovery.com/Interviews/emilieautumn_interview_2010_pt2.htm [accessed 8 August 2017].

20 http://www.lincolncastle.com/content/victorian-prison [accessed 2 August 2017]. More generally, the prevalence of H.P. Lovecraft's work in steampunk, specifically the Cthulhu mythos, suggests a fascination with the edges of reason.

21 The Catastrophone Orchestra and Arts Collective (NYC), 'What, then, is steampunk?', *Steampunk Magazine*, Issue 1, p. 4.

22 See Elizabeth Ho's discussion of *Steamboy* (2004), in *Neo-Victorianism and the Memory of Empire*, p. 165ff.

23 Martin Danahay, 'Steampunk as a Postindustrial Aesthetic: "All That Is Solid Melts in Air"', *Neo-Victorian Studies* 8:2 (2016), 34.

24 'The World according to Emilie Autumn', *The Worst Fanzine*, p. 32.

25 Roger Whitson, *Steampunk and Nineteenth-Century Digital Humanities: Literary Retrofuturisms, Media Archaeologies, Alternate Histories* (London: Routledge, 2017), p. 38.

26 Jeff Vandermeer, *The Steampunk Bible* (New York: Abrams, 2011), p. 9.

27 *The Asylum for Wayward Girls* (2009), 56.

28 *The Asylum for Wayward Girls* (2009), 237.

29 *The Asylum for Wayward Girls* (2017), location 2655.

30 David Pike, 'Steampunk and the Victorian City', from Rachel A. Bowser and Brian Croxall (eds), *Like Clockwork: Steampunk Pasts, Presents, and Futures* (Minneapolis: University of Minnesota Press, 2016), p. 14.

31 *The Asylum for Wayward Girls* (2017), location 1093. The same passage features in the 2009 edition, p. 56.

32 *The Asylum for Wayward Girls* (2017), location 2208.

33 *The Asylum for Wayward Girls* (2017), location 2951.

34 *The Asylum for Wayward Girls* (2017), location 3146–3159.

35 Fredric Jameson, *Archaeologies of the Future: The Desire Called Utopia and Other Science Fictions* (London: Verso, 2007), p. 93.

36 *The Asylum for Wayward Girls* (2009), 56.

37 *The Asylum for Wayward Girls* (2009), 56.

38 *The Asylum for Wayward Girls* (2009), 56.

39 Jameson, *Archaeologies of the Future*, 198.

40 *The Asylum for Wayward Girls* (2017), location 272.

41 Michel Foucault, *Madness and Civilisation: A History of Insanity in the Age of Reason*, trans. Richard Howard (New York: Vintage, 1998), p. 270.

42 Foucault, *Madness and Civilisation*, 273.

43 Showalter, *The Female Malady*, 5.

44 Showalter, *The Female Malady*, 142.

45 *The Asylum for Wayward Girls* (2017), location 1277.

46 *The Asylum for Wayward Girls* (2017), location 3624.

47 Showalter, *The Female Malady*, 142.

48 *The Asylum for Wayward Girls* (2017), location 346.

49 *The Asylum for Wayward Girls* (2017), location 2452 and 3235.

50 *The Asylum for Wayward Girls* (2017), location 3314.

51 See *The Asylum for Wayward Girls* (2009), flyleaf page.

52 See *The Asylum for Wayward Girls* (2009), 241.

53 *The Asylum for Wayward Girls* (2009), 79.

54 *The Asylum for Wayward Girls* (2009), 91.

55 *The Asylum for Wayward Girls* (2017), location 3967.

56 *The Asylum for Wayward Girls* (2017), location 3709.

57 *The Asylum for Wayward Girls* (2009), 19.

58 CY Press, 'EA Live Show Promo Text', www.cypress-agentur.de/
 fileadmin/pdf/mod_press/EmilieAutumnInfo.pdf [accessed 8 August
 2017]. Italics mine.

59 See https://www.youtube.com/watch?v=4ApFvVobL4Q, for an example
 of 'The Rat Game', from The Key Tour (Berlin 2010). It was this tour
 which introduced fans to *The Asylum for Wayward Girls*. In part, 'The
 Rat Game' facilitates costume change and thus has a practical element
 which links to the musical hall and burlesque tradition.

60 *The Asylum for Wayward Girls* (2009), 126.

61 J. Halberstam, *Female Masculinity* (Durham: Duke University Press,
 2000), p. 232.

62 See http://waywardvictorianconfessions.tumblr.com/search/Rat+game
 [accessed 7 August 2017].

63 Voights, 'Victoriana's Secret', 26.

64 Michel Foucault, *The History of Sexuality*, vol. 1: 'The Will to Knowledge',
 trans. Robert Hurley (Penguin: Harmondsworth, 1998), p. 4.

65 *The Asylum for Wayward Girls* (2017), location 1940–1945.

66 *The Asylum for Wayward Girls* (2017), location 2535.

67 Helen Davies, *Neo-Victorian Freakery* (Basingstoke: Palgrave, 2015), p. 11.

68 Davies, *Neo-Victorian Freakery*, 13.

69 Elizabeth Grosz, 'Intolerable Ambiguity: Freaks as/at the Limit', in
 Freakery: Cultural Spectacles of the Extraordinary Body, ed. Rosemarie
 Garland Thomson (New York: NYU Press, 1996), p. 64.

70 Davies, *Neo-Victorian Freakery*, 10.

71 See Katie Ellis, *Disability and Popular Culture: Focusing Passion,
 Creating Community and Expressing Defiance* (Abingdon: Routledge,
 2016), p. 115.

72 http://waywardvictorianconfessions.tumblr.com/post/15298452519/
 as-someone-who-has-been-confined-to-a-wheel-chair (accessed 31
 August 2014).

73 *Metal Discovery*, Interview with Emilie Autumn, 2010, http://www.
 metal-discovery.com/Interviews/emilieautumn_interview_2010_pt1.
 htm [accessed 8 August 2017].

74 Andrea Kirchknopf, *Rewriting the Victorians: Modes of Literary Engagement with the 19th Century* (Jefferson, NC: Mcfarland, 2013), p. 44.

75 *The Asylum for Wayward Girls* (2017), location 551.

76 Tobin Siebers, 'Disability as Masquerade', *Literature and Medicine* 23:1 (2004), 1–22, 18.

77 Siebers, 'Disability as Masquerade', 12.

78 Siebers, 'Disability as Masquerade', 9.

79 See Marie-Luise Kohlke and Christian Gutleben (eds), *Neo-Victorian Tropes of Trauma: The Politics of Bearing After-Witness* (Amsterdam: Rodopi, 2010).

80 See Chris Loutitt, 'The Novelistic Afterlife of Henry Mayhew', *Philological Quarterly* 85:3/4 (2006), 315–341, 330.

81 *The Asylum for Wayward Girls* (2009), 203.

82 Autumn appeared in *Playboy* in Spring 2010. She tweeted in response to this 'I'm in the new *Playboy*! And before anyone starts getting their bloomers in a bunch, yes, I'm all for this, nope, nobody made me. Enjoy!' See the Twitter account @emilieautumn, 24 March 2010.

83 Natasha Walter, *Living Dolls: The Return of Sexism* (London: Virago, 2010), p. 43. See also Ariel Levi, *Female Chauvinist Pigs: Women and the Rise of Raunch Culture* (London: Simon & Schuster, 2005).

84 Brian McNair, *Striptease Culture: Sex, Media, and the Democratisation of Desire* (London: Routledge, 2002).

85 McNair, *Striptease Culture*, 5–6.

Steampunk and the Graphic Novel

Introduction: Nostalgia and Ironic Distance

The steampunk comic book represents an ideal subject for addressing visual culture, the intersection of privileged discourses on art and literature and so-called low culture, as well as a clear reflection on contemporary society through the lens of an imagined Victorian future. In many ways, these texts are palimpsests which reproduce and reconfigure the nineteenth century through intertextual play. In order to address the portrayal of gender in such texts, this chapter will look at Alan Moore and Kevin O'Neill's (et al.) *The League of Extraordinary Gentlemen* series and Bryan Talbot's *Grandville*. The chapter will maintain, in common with Linda Hutcheon's theories of nostalgia, that these texts deploy an ironic distance which reflect not only upon the past but also on our contemporary moment. In doing so, these texts invoke steampunk and postmodern intertextuality to provide a 'double-vision' in terms of politics, gender and sexuality. Alison Halsall has argued of Moore (and a similar case can be made for Talbot) that 'his fascination with Victoriana ... does not stem from nostalgia. His interest in representing distinct historical periods centers on using key visual and literary cues to evoke for the readers the atmosphere and dominant ideologies of a particular era in a visual medium'.[1] As such, the target of Moore's and Talbot's satire is not just the Victorians but also our appropriation and conceptualization of them.

In her article 'Irony, Nostalgia and the Postmodern', Linda Hutcheon asks whether the postmodern is a 'recalling of the past as an example of a conservative – and therefore nostalgic – escape

to an idealized, simpler era of "real" community values? Or did it express but through its ironic distance, a "genuine and legitimate dissatisfaction with modernity and the unquestioned belief in … perpetual modernization?"[2] This reflection on ironic distance and conservatism has many applications in Neo-Victorianism and specifically steampunk.[3] It is important to reflect upon what it means to recreate an imagined nineteenth century from the perspective of the present and why such a gesture might be ubiquitous at certain historical moments. Hutcheon suggests certain 'millennial moments' (such as those on the cusp of the twenty-first century) might give rise to nostalgia, but, as she affirms, the past is ultimately irrevocable and is only experienced through contemporary desires and idealized memories.[4] As such, it has perhaps more to say about the present than reflecting on any historical experience. The relevance of Hutcheon's exploration of nostalgia becomes especially obvious when she suggests 'the power of nostalgia … comes in part from its structural doubling-up of two different times, an inadequate present and an idealized past'.[5] However, as we might note in both Moore's and Talbot's work, nostalgia is not without the power of critique: 'Our contemporary culture is indeed nostalgic; some parts of it – postmodern parts – are aware of the risks and lures of nostalgia, and seek to expose those through irony'.[6] Ultimately, the revival of Victorian aesthetics and social mores in *Grandville* and *The League of Extraordinary Gentlemen* do not so much celebrate the nineteenth century, as much as they 'acknowledge the final impossibility of indulging in nostalgia, even as [they] evoke nostalgia's affective power'.[7] So nostalgia for the Victorian is used in these texts in order to be rejected: 'invoked, but, at the same time, undercut, put into perspective, seen for exactly what it is – a comment on the present as much as the past'.[8] Indeed, if we are thinking about two temporalities simultaneously represented in one moment, we might perceive the graphic novel as a particularly apposite medium through which to explore this intersection of past

and present. The comic (also known as sequential art) can be sold retrospectively and commercially in a collected version known as a graphic novel (so all graphic novels are comics but not all comics are graphic novels, as some of these texts may only appear as shorter comic strips). Whilst Alan Moore's *League* was originally serialized, Bryan Talbot's *Grandville* was first published as a graphic novel.

The comic emphasizes spatial and temporal juxtaposition: individual pictures (panels) are combined on a page to produce a narrative, whilst the space between the panels (the gutter) stands in for the passage of time and provides an imaginative space for the reader. Indeed, Scott MacCloud defines the medium as akin to a reel of film prior to projection.[9] The physicality of sequential art, he explains, 'fracture[s] both time and space, offering a jagged, staccato rhythm of unconnected moments. But closure [observing parts but perceiving a whole] allows us to connect these moments and mentally construct a continuous, unified reality'.[10] This unified reality is the temporal experience of steampunk more generally: it allows readers (in this instance) to participate in two or more time frames concurrently, whilst also interrogating our partial historical perspective. Interestingly, the graphic novel is a logical progression from the more standard novel form, especially if we think about how many Victorian novels were serialized in parts and how they had a commercial imperative as well as an artistic one. This nineteenth-century parallel, alongside the interaction of visual and written culture, suggests the medium provides a useful intervention in steampunk texts.

In Talbot's *Grandville*, a reflection on the present functions as a critique of the far right and the concomitant construction of masculinity in such discourses. Therefore, Talbot's engagement with 9/11 and the War on Terror addresses not only notions of race and prejudice but also a broader reflection on different models of masculinity, as demonstrated in the characters of LeBrock, Roderick,

Lapin and Mad Dog. Comparatively, Alan Moore's *League* relates to the idea of backlash against models of contemporary feminism (we can draw some very clear parallels between reactions to Mina as the head of the League and the gains made by women following some of feminism's successes), as well as representing alternative models of masculinity which reflect on age, vulnerability, and complicate easy assumptions about gender.

In both Talbot's and Moore's work, the nostalgic Victorian is invoked and repudiated through various steampunk tropes: aesthetics, technology and self-conscious referentiality. Many steampunk texts employ intertextuality to parody other literary sources and collapse distinctions between 'high' and 'low' cultures, and this is something which Alan Moore does in *The League of Extraordinary Gentlemen* at some length. Annalisa Di Liddo comments that 'intertextuality permeates Moore's oeuvre in all its facets and covers not only the domain of literature, but cinema, music, popular culture and, last but not least, comics'.[11] Additionally, as Jerome de Groot discusses in his *Consuming History*: 'The League ... takes a cast of characters from Victorian fiction (Alan Quatermain, Hawley Griffin, Mina Murray, Captain Nemo, Edward Hyde) and pitches them together in 1898. The collection is a fictional what-if pastiche, complete with accompanying breathless boy's own adventure tales, which again meditates on heroism and the iconic.'[12] Alan Moore has said of the *League* series of graphic novels that 'it is a big literary game, but it is one that lets us touch upon a surprising amount of stuff that's in some way relevant to the contemporary world'.[13] So whilst there is the 'adventure narrative' of the 'boy's own comic' style, it is a parody of 'good versus evil' and a carefully coded treatment of modern society. In the context of parody and Moore's use of ironic nostalgia, it is useful to consider the prefatorial material which accompanied the text (whilst the volumes were originally serialized, it is safe to assume most readers will encounter the text through the collected volume editions). The

author biography on the back cover is one of the first instances of this playful and postmodern approach to truth. Whilst claiming authorship, Moore is quite clearly projecting a fictive persona: 'Mr Alan Moore, author and former circus exhibit (as "The What-Is-It from Borneo"), is chiefly famed for his chapbooks produced with the younger reader in mind. He astounded the Penny Dreadful World with such noted pamphlets as "A Child's Garden of Venereal Horrors" (1864) and "Cocaine and Rowing: The Sure Way to Health" (1872) before inheriting a Cumbrian jute mill and, in 1904, expiring of Scorn.' With this in mind, we might note how far this plays with Neo-Victorian stereotypes (chapbooks, narratives of drug addiction and sexually transmitted disease, the Penny Dreadful and the monstrosity of the circus exhibit). It also is a projection, a conscious performance of selfhood: the writer becomes a *persona*. However, this attempted projection of a singular, unified selfhood is frustrated by the other contributors to the text: Kevin O'Neill, Benedict Dimagmaliw, William Oakley and others feature on the spoof advertisement page. In 'My Message to Our Readers', we might note the relevance of Gerard Genette's concept of 'fictive prefaces'.[14] We have 'Scotty Smiles' as the 'editor' of the book, in a parody of nineteenth-century boy's own stories. The archaic register ('Mohammedans' for Muslims, for example) creates distance between the reader and the text, and whilst the 'picture periodical' is described as being 'for boys and girls', the inconsistency of this becomes obvious when we see how Smiles says he is a friend and confidant of 'boys everywhere' – to the exclusion of girls. As Lara Rutherford has explained: 'The humour of this letter comes from Smiles's cheerful emphasis on the wide class and educational disparities that characterized the Victorian juvenile readership.'[15]

So we have a dizzying array of origins for the text, and each of these fictive personae has a multiplying effect: it is difficult to ascertain an authoritative voice within the texts or even a stable identity. Gerard

Genette proposes that the composition of prefaces ultimately signals a form of self-awareness, which, I would argue, defeats the nostalgic and lazy identification with the nineteenth century:

> The prefatorial malaise, whether it proceeds for a sincere modesty or from unavowed disdain, turns into a kind of generic hyperconsciousness. No one writes a preface without experiencing the more or less inhibiting feeling that what's most obvious about the whole business is that he is engaged in writing a preface.[16]

Arguably, the employment of (multiple) prefaces in *The League* underscores the self-consciousness of the author, but importantly, this self-awareness is also a strategy to defeat an uncritical appraisal of the Victorians.

This self-consciousness is also apparent in Bryan Talbot's character of LeBrock, who is derived from several sources, the most obvious being Sherlock Holmes, as will be explored in detail later in this chapter. However, Talbot also exploits other works in the genre, such as Juan Díaz Canales and Juanjo Guarnido's *Blacksad* (2000–), another anthropomorphic graphic novel series, which features a noir cat detective. Kenneth Grahame's *Wind in the Willows* (1908) is another reference point, in so far as Badger is a reliable character in that novel (and indeed a Rat and a Mole are interviewed early in *Grandville*). At this point, it is also worth noting the policeman squirrel is called Nutkin, recalling Beatrix Potter's *Squirrel Nutkin* (1903). Indeed, an early scene in *Grandville* puts us in a place called 'Nutwood', where Rupert the Bear lives, and his father makes a brief cameo in the background of one panel (he is cutting the hedge behind LeBrock). At a train station, the signage clearly locates us in Rupert's world.[17] Likewise, the character of Snowy, Tintin's companion, is unfortunately drug-addled in an opium den.[18] So in many ways, Talbot's references relate back to earlier comics and illustrative material for children in a highly self-conscious way. This also returns us to the interrogation of

high and low art which we might find in steampunk. For instance, the painting *The Travelling Companions* (1862) by Auguste Egg features in the first volume of *Grandville* in the background of the main action – with the two main subjects being replaced with birds.[19] The effect is to displace the authority of the prior artwork, to destabilize its status satirically. There is also reference to the *A Bar at the Folie-Bergère* (1882) by Édouard Manet, juxtaposed with *Omaha the Cat Dancer* (an erotic comic series by Reed Waller and Kate Worley, which was launched in 1978), who has a cameo in the poster in the background of the scene.[20] In the same scene, we also have a parody of the nineteenth-century Art Nouveau image of the actress Sarah Bernhardt (1844–1923), who is clearly the badger Sarah in the text, and Sarah's apartment in Grandville is actually modelled on Sarah Bernhardt's flat in Paris.[21]

Alan Moore has identified (in common with Bryan Talbot) that one of his satirical targets was post-9/11 rhetoric. He explains that 'although things have obviously changed since Victorian times, you'll still find that at least a couple of members of, say, George Bush's "Axis of Evil" have kind of got a bit of a Yellow Peril slant to them. These are perpetual hobgoblins of the human mind that always stay fresh. Invasion, we're always terrified of invasion.'[22] However, he also parodies art more generally, inserting playful references into the text at various intervals in order to temper nostalgia with ironic distance. Both Moore's and Talbot's graphic novels draw attention to the status of the text as an art object in a very self-conscious way. But moreover, such references destabilize an easy nostalgia, identifying the ways in which this is a defamiliarized parody of our own culture. We are submerged in an alternative history, which is also paradoxically the same as our own world, and we are also forced to view our behaviour with critical opprobrium. This has much in common with Hutcheon's claim that nostalgia in its postmodern, satirical inflection is 'called up, exploited, *and* ironized'.[23] In all instances, it is clear that we are

intended to approach these graphic novels with an ironic and critical distance, rather than simple nostalgia.

The *Grandville* world – Gender, nationalism and the far right

Bryan Talbot's *Grandville* series was launched in 2009 and concluded in 2017. The premise of *Grandville* relates to a highly complex web of literary and artistic references, alongside steampunk technology and anthropomorphism (where animals are given human characteristics) in order to offer a critique of racism and prejudice. Our two main characters, Detective Inspector LeBrock and Roderick the Rat, draw several parallels with Sherlock Holmes and Dr Watson as a crime-fighting duo, whilst more generally, Talbot characterizes the text as a 'scientific romance thriller' (which we can see as synonymous with steampunk). Most obviously, there is a peculiar defamiliarization strategy which Talbot uses: most of his characters are animals. We might note at this point that one of the major influences on *Grandville* the graphic novel was Jean Gerard, a nineteenth-century French illustrator, and his pen-name was Grandville. The anthropomorphism of Gerard's drawings, satirizing French society, combined with the notion of Grandville as a possible nickname for an alternative Paris, prompted Talbot to borrow the name.[24] What is also significant is Gerard's satirical intent in creating his art. The effect of Talbot's use of anthropomorphism is 'a visually arresting way of emphasizing the otherness of this alternate world – one that … is the same as ours, and very different'.[25] Animals are used to satirize human behaviour, which facilitates the ironic distance needed to offer a postmodern critique, rather than a simple nostalgic reflection. Writing about Talbot's graphic novel, Tim Killick suggests, *Grandville* is a 'nod towards the exploration of humanity's animalistic impulses explored by Stevenson through Jekyll and Hyde, and by Wells through

the vivisections of Dr Moreau'.[26] By defamiliarizing human behaviour and the environment to which we are accustomed, we are then forced to re-evaluate history and humanity itself.

Killick has also suggested that 'Neo-Victorian graphic novels make the nineteenth century speak to the modern reader by showing us the past in a way that simultaneously critiques the follies and foibles of history and reveals its troubling parallels with the present'.[27] This is very much the case with *Grandville*, which juxtaposes modern imperialism, the politics surrounding 9/11 and Islamophobic suspicions of a threat from the East, and that of an imagined nineteenth century. This also involves the counterfactual history – in *Grandville*, the setting is twenty-first-century Paris, but it looks very much like the 1890s. One of the major targets for Talbot is racism and intolerance, which simultaneously mirrors both the Victorian Empire and contemporary colonial rhetoric. As the subsequent discussion will demonstrate, this dual perspective offers a critique of extreme nationalism and neo-conservatism, and ultimately, the war-like masculinity of imperial discourses.

In *Grandville*, the first volume of the series, Britain was allowed independence from France and became known as the Socialist Republic of Britain 'after a prolonged campaign of civil disobedience and anarchist bombings'.[28] However, in common with Hutcheon's notion of nostalgia as a device which functions as 'a comment on the present as much as on the past', Talbot is reflecting upon nineteenth-century history and its influence in the present.[29] He is also drawing parallels between Victorian inequality, injustice and the present day through various referents to 9/11 and the War on Terror. Ultimately, these referents also suggest a studied analysis of the ways in which such discourses are gendered, and finally, how gender in the steampunk world can be unstable, contradictory, radical or conservative.

Grandville references 'Ground Zero' in an obvious reflection of the 9/11 bombings. Indeed, the anarchist resistance is reported to

have driven a dirigible packed with explosives into the Robida Tower building (Figure 9).[30] Talbot's illustration of Ground Zero, in common with its historical counterpart, represents how 'the event came to serve as the index of a new and terrifying era'.[31]

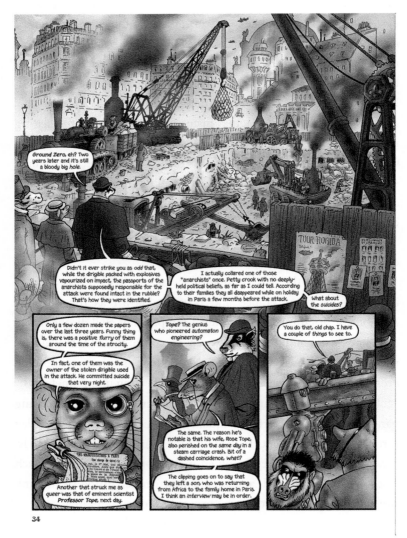

Figure 9 Bryan Talbot, *Grandville*, 'Ground Zero', vol. 1, p. 34.

Not only that but as Art Spiegelmann elucidates through the title of his graphic novel *In the Shadow of No Towers* (2004), 'the visible absence on the New York skyline' came to be a synecdoche for what was constructed as a national trauma.[32] Talbot's half-page panel therefore reflects upon both the fabricated historical moment of the narrative (an imagined nineteenth century) and our contemporary experience of 9/11, with the concomitant effect that we imaginatively insert the Twin Towers of New York into the landscape of the city of Grandville. Additionally, as Liane Tanguay has carefully articulated, the media and the American administration projected 'a very *real* trauma – that of the actual victims and their families – onto the broader level of the cultural imaginary as experienced by the majority of the viewing public and in such a way as to suggest that the nation itself (and by implication, the state) had been brutally victimised for no imaginable reason.'[33] As Tanguay notes, 'Certainly the event was traumatic for those directly affected, including thousands of bereaved families, but the concept was vastly manipulated and deployed in such a way as to draw in the entire nation (and even the world) as one large, collective victim.'[34] The ensuing action in *Grandville* addresses the political rhetoric which developed after 9/11, including the demonization of the East, the codification of a neoconservative agenda and the notion of 'Weapons of Mass Destruction' (including chemical, biological and nuclear warfare), which was deployed by politicians (Bush/Blair) without evidence to support the invasion of Iraq. At the same time, a generalized Other emerged: nearly 70 per cent of Americans in 2003 believed there was a direct link between Saddam Hussein and the terrorism of 9/11.[35] This construction of a racialized Other was clearly related to the imperialist discourses in circulation throughout history: following 9/11 George W. Bush's speeches emphasized the enemy 'likes to hide and burrow in'; they 'can only survive in darkness'; 'they dwell in dark corners of earth'; they 'hide in caves' and must be 'smoked out of their holes'.[36] That this racialized enemy of neoconservatism

rearticulated the discourses of imperialism becomes more apparent
in George W. Bush's (subsequently retracted) bid to 'rid the world
of evil-doers ... This crusade, this war on terrorism, is going to take
a while'.[37] The Crusades describe the medieval Christian military
expeditions into the Holy Land to reclaim that territory from Islam,
and as such reference a history of an external threat (Islam) against
which a nation or belief system (Christianity) defines itself in order
to establish social cohesion. Contemporary America constructed its
national identity with the implicit designation of outsiders as external
threats, and Talbot's use of 9/11 provides criticism of such a rhetoric:

> The restoration of a collective identity at the national
> level – embodied in the proliferation of American flags, the
> memorialization of the attacks in countless forms, and so forth
> ... was indeed a key element of the healing process following 11
> September. By fashioning a national trauma from a local one, the
> media had already to some extent set the stage for such an assertion
> of solidarity. And implicit in this was a reassertion of 'traditional
> American values' in the face of a palpable threat to them.[38]

There is a direct parallel here with LeBrock's conversation with the
Archbishop of Paris, who explains 'a common enemy. A terrifying
spectre to fear and hate. And an event so shocking that it would
shock the very core of their souls. Something that would shatter their
world view so drastically, they'd be ripe for manipulation'.[39] In Talbot's
alternative world, we have the Prime Minister, Jean-Marie Lapin (the
leader of a far-right organization), who gains power following the
attack on the Robida Tower, who promises a 'War on Terror' and a
hard line against 'British Anarchy'.[40] As well as bearing the French
name for 'rabbit', Lapin clearly references Jean-Marie Le Pen, former
head of the French National Front.

LeBrock's conversation with the ambassador, Citizen Turtell, is
especially instructive here, centring on whether Britain is building a

'super bomb' to target Paris.[41] This is not a far remove from the Blair–Bush iterations of 'Weapons of Mass Destruction' during their military campaigns in Afghanistan and Iraq.[42] Talbot uses an alternative history of Anglo-French relations to discuss the formation of these ideas – and this is especially visible in his treatment of race and Otherness. In a parodic gesture, intolerance of the British is flagged up throughout the text. For instance, there is an extended and humorous discussion of the great British breakfast, with the accompanying comment: 'He respectfully suggests that you stick your Full English Breakfast up your hairy English bottom.'[43] Racial signifiers, usually directed to the Other, are brought home to the English themselves. This is furthered when we realize that the 'doughfaces' (who are the underclass in the text) are actually exploited human beings.[44] They suffer racial slurs, stereotypes and various other indignities: for instance, they are usually in some form of servile role in the text, a careful reflection on the history of enslavement. They are not permitted to have passports and are seen as a 'hairless form of chimpanzee', something which simultaneously reflects many of the racial discourses of the Victorian period proper, as well as the contemporary othering of the East (including racial profiling in airports as a direct response to 9/11).[45] This comparison is rendered more overt in Talbot's representation of Grandville's media towards the end of the novel. Madame Krupp (a wombat) owns the newspapers of this alternative universe, and also is one of the biggest weapons manufacturers (clearly a reference to the US arms exports to the Middle East). She reveals that 'an empire needs to be at war … it's its engine, its driving force … and we need Britain's oil'.[46] The plot eventually reveals that a murdered diplomat (Raymond Leigh-Otter) discovered a secret coterie of right-wing officials were behind the bombings blamed on British anarchists, in part because of the oil found in British territories, an obvious parallel to some of the suspected motivations behind the War on Terror.[47] Krupp, however,

serves a higher purpose too, claiming she is 'Patriotic. I'm just … a loyal servant of … the Emperor.'[48] The importance of the use of patriotism here cannot be underestimated, representing in common with the US response to 9/11 'the constitution of a collective "bodily unity" on increasingly parochial, exclusive, and jingoistic grounds …. A chauvinistic nationalism that is less political and more cultural, insisting upon its sovereign exceptionality and its mission to cleanse the world through war'.[49] Indeed, this intersection of morality and war is articulated by the Archbishop, who justifies his actions as follows: 'It was for the good! To save the soul of France! Of French society … A society grown decadent and Godless. Atheism is rampant, Promiscuity and interspecies fornication are rife. The streets awash with alcohol and drugs … what was needed to unite the people, to instil morality … an enemy.'[50] The dictatorship fostered by Emperor Napoleon XII (a lion) is foiled when LeBrock redirects an airship designed to launch the fabricated 'super bomb' on Paris founders on Napoleon's imperial palace in Versailles instead. The news agencies quickly broadcast a statement from the Prefecture of Police (Colonel Gnu), attributing Napoleon's death to Madame Krupp, Jean Marie-Lapin and their associates. The news anchor, however, is most relevant in this scene – as an owl, he is stereotypically thought to be wise and a bearer of knowledge.[51] However, owls actually possess very small brains compared to their body size and are actually quite stupid. Talbot's message seems to be that the media is a somewhat pathetic mouthpiece for the current administration in Grandville, and rather more foolhardy than shrewdly intelligent, and thereby provides a parodic commentary on the way in which the media are complicit in the discursive representations of 9/11. A critique of this jingoism (also apparent in Doctor Geof's artwork, as we saw in Chapter 2) also reflects upon the way in which such discourses are gendered. We might note that a scene with the Knights of Lion (later revealed to be the far-right cabal behind the terrorist attacks) explicitly correlates

this far-right nationalist agenda with the anti-abortion, pro-life movement: 'I think we should abort tomorrow night's … spectacular. There. I never thought that I'd condone an abortion!'[52] Similarly, the French National Front oppose abortion rights for women, and certainly under Jean-Marie Le Pen's leadership espoused 'a macho and sexist philosophy'.[53] Talbot's critique of hypermasculine nationalism is not confined to US or French politics, however. In *Grandville: Mon Amour* (2010), the second volume of the series, LeBrock attends the funeral of Joseph Erisson, a prison guard who aided the escape of Edward 'Mad Dog' Mastock, a Jack the Ripper-style murderer who was formerly a member of the British Resistance. The spectacle of the funeral is especially important, as it situates the historical context of the narrative in Northern Ireland of the Troubles (1968–1998). The status of the military funeral among paramilitary groups (of both Unionist and Republican persuasions) is crucial. Talbot invokes this ceremony by depicting a three-volley salute over the coffin, emblazoned with the Union Jack, enacted by soldiers in black balaclavas synonymous with Irish terror organizations. The association with the Troubles continues with Mastock's nickname: Johnny Adair (also known as 'Mad Dog' Adair) was a senior member of the paramilitary Ulster Defence Association in Belfast and had early associations with the British National Front. The tradition of hypermasculinity in Ireland has been well documented by Joseph Valente, who identifies one of the founding myths of Irish masculinity is Cuchulain, legendary warrior hero of Ulster, who has been invoked by generations of freedom fighters on the Protestant and Catholic side of the political spectrum. Indeed W. B. Yeats's version of Cuchulain in the play *On Baile's Strand* (1903) presents to Valente 'a specimen of extreme hypermasculinity – a thrill seeker, a boaster, and an inveterate brawler'.[54] This representation of a war-like military masculinity also features in more recent Ulster Loyalist and Nationalist discourses: 'The constitution of militarized models of masculinities has been

central to the generation of violent expressions of nationalist struggles in both communities ... In Northern Ireland men's identities as leaders of both ethno-nationalist communities and as combatants engaged in political violence impacted significantly on gender relationships. Women's influence in formal political decisions, styles of political engagement and in military campaigns was limited.'[55] The combination of military rigour, ceremony and memorialization as enshrined in the panel featuring Joseph Erisson's funeral is rendered utterly absurd when the balaclavas are removed, revealing anthropomorphic animals (including a farmyard cockerel, with all the satirical humour that implies). This farce is extended to Prime Minister Drummond, who 'is represented visually as a bulldog, whose tenacity and jowly appearance are strongly associated with dogged wartime leadership of Winston Churchill'.[56] Hawthorne also notes that the portrait of the Prime Minister in *Grandville: Mon Amour* is a mock-up of Churchill's photographic portrait by Yousuf Karsh (1941), the most iconic and recognizable image of the Prime Minister in circulation during wartime.[57] Again, the absurdity of iconic and war-like masculinity is emphasized when it becomes obvious that Drummond is also based on the cute and popular advertisements from Churchill Insurance, featuring a talking nodding dog mascot, whose catchphrase, like Drummond's, is 'Oh yus.'[58] Again, we are occupying several distinct time frames – the 1940s of Second World War Britain, the contemporary moment where Churchill's advertising campaign has currency and the pseudo-Victorian world of Grandville itself. The complexity of this portrait is magnified in Churchill's use of 'crowd control' (basically a form of tear gas) in the Middle East, against Mesopotamian tribes, and authorized use of chemical weapons by the RAF.[59] The war-like stiff upper lip, the way in which Churchill, the Union Jack and ideas about English tenacity have all become synonymous with a masculinized far-right political agenda, is therefore codified in Talbot's presentation of Drummond.

Alternative models of masculinity

However, it is also possible to identify that the tropes of gender explored in the *Grandville* series offer pluralities of masculinity and femininity, and a clear example of new masculinity is the hero himself, Detective Inspector Archibald 'Archie' LeBrock. Initially, we may read LeBrock as a stereotypical masculine hero. He is, in common with Sherlock Holmes himself, a rational and authoritative individual, as we see when we first meet him, where he quickly deduces (in a homage to Conan Doyle's locked room motif in the 1892 Holmes story, 'The Speckled Band') that Raymond Leigh-Otter couldn't have committed suicide. By comparison, the other investigating officers are shown up as bumbling fools. Akin to his Victorian predecessor, LeBrock sports an overcoat, complete with the iconic Inverness cape, and his bowler hat, whilst not as recognizable as the deerstalker, was in fact sported by Jeremy Brett in the 1980s *Sherlock Holmes* TV series. This identification with the Victorian Holmes is important to note, as Holmes is often defined as 'an icon possessing all of the qualities defined as masculine in Victorian society, such as "observation, rationalism, factuality and logic, comradeship, daring, and pluck"'.[60] However, in *Grandville: Force Majeure* (2017), the final volume of the series, this identification is called up and ironized, in common with the notion of postmodern nostalgia. LeBrock asks his girlfriend, Billie, why she has brought him to this particular part of town: he asks, 'What's so special about Baker Street?' In response, Billie explains, 'Why, Tussard's famous wax museum, of course.'[61] Sherlock Holmes is invoked as part of our readerly expectations, only to be humorously dismissed: LeBrock both is and isn't Holmes. This is compounded when LeBrock's backstory reveals his mentor early in his career, the legendary Detective Chief Inspector Stamford Hawksmoor, whose deerstalker hat, overcoat and Inverness cape, pipe smoking and magnifying glass (which first featured in Conan Doyle's *A Study in*

Scarlet (1887)) all offer the reader a visual shorthand to identify the famous detective, as circulated in popular culture throughout the twentieth century. As Amanda J. Field notes:

> Holmes's visual iconography ... The most common visual symbols used are the deerstalker, Inverness cape, pipe, and magnifying glass. In terms of indicating that the person illustrated is indeed Holmes, often the deerstalker and magnifying glass suffice.[62]

So *Grandville* identifies its literary predecessors, such as Holmes, through popular cultural tropes, and also fractures and multiplies them. In several panels clearly influenced by Quentin Tarentino, LeBrock's use of uncompromising violence is frequently illustrated (always against the 'bad guy'), alongside his hypermasculine, muscular physique.[63] Like Holmes's skill in his boxing and bartitsu, LeBrock is a fighter. At one point, a couple of customs officials (a zebra and a parrot) observe in conversation:

> Zebra: Did you see what that big bastard had in his bag? Mad bugger.
> Parrot: Built like a brick shithouse though. Got a chest like a bloody beer barrel.[64]

The physicality of the detective is underscored, flagging up his stereotypical masculinity. The text later reveals that LeBrock is actually transporting some large barbells in his bag, which serves to highlight this point further. Indeed, this is something which is a hallmark of masculinity and the 'lad culture' of the 1990s as much as the nineteenth-century ideal of masculinity. As Bethan Benwell notes:

> Heroic masculinity tends to be active, rational, professional, autonomous, knowledgeable, and authoritative. Yet, interestingly, it is the physical aspect of masculinity, either through a focus on the body or through actions – often violent – performed by the male body, that predominantly characterizes this idealized masculinity.[65]

So LeBrock's physical presence is emphasized, but this is clearly undercut by Talbot's characterization at several junctures. That LeBrock is a badger is important to note, as Mel Gibson has highlighted. Whilst he is clearly an adaptation of Badger from *Wind in the Willows*, emphasizing 'tenacity, loyalty and strength', he is also important because 'actual badgers are currently under threat from government culls in Britain, [which] gives an additional charge of vulnerability to the character'.[66] This combination of stereotypical aggression and precarious or redefined masculinities is specific to the cultural moment of Neo-Victorian (and I would argue, many steampunk) texts. LeBrock practises his bicep curls with one hand (Figure 10) and in the other reads from a book entitled *Vidocq*, referencing Eugène François Vidocq (1775–1857), the former French criminal-turned-Private Detective, who founded the Sûreté Nationale, a predecessor to the modern police force.[67] Therefore, LeBrock accords with several adaptations of Sherlock Holmes, including *Sherlock*

Figure 10 Bryan Talbot, *Grandville*, 'LeBrock', vol. 1, p. 45.

(BBC, 2010–), which, as Graham and Garlen note, represents 'a new masculine ideal that equates intellectual acuity with sexual desirability, with more television programs and films than ever before celebrating the sexy geek as icon, hero and heartthrob'.[68] Combining intelligence and physical rigour, LeBrock is very much part of contemporary Sherlockian adaptations.

Whilst Heilmann and Llewellyn have asserted that there is a dearth of critical analysis on Neo-Victorian masculinities, it is important to situate these representations within the wider context of twenty–first century gender debate.[69] Whilst the 'new man' might be a construction of what a pro-feminist man looks like in the media, perhaps a more nuanced (and intersectional) response to ideas of backlash against feminism might also identify how 'the very uneven access specific groups of men have to the structures of sexual power'.[70] Curiously, this is explored in Talbot's representation of his detective hero and his class disenfranchisement alongside his hegemonic masculinity. On the one hand, LeBrock's encounters with Billie (a prostitute who he pays for sex) might initially suggest a conventional notion of masculinity aligned with sexual exploitation, despite the fact that his emotional distance belies his concern for her well-being (anyone who becomes close to LeBrock seems to end up dead). Talbot is clearly representing 'the dominant social order, so that the use, consumption and circulation of women's bodies make prostitution the arena where men's desires are performed and "female sexuality is entirely constructed as an object of male desire"' (Bell 1994: 80).[71] On the other hand, one of LeBrock's most pronounced characteristics is his working-class status – at various points in the series, markers of class identity signal him as an outsider in (upper) middle-class environments. For instance, he is served champagne at the house of Jules Rocher, but requests beer.[72] Similarly, he assumes Mrs Cherie Rocher, Jules's wife, has cooked dinner, when of course she has a cook, and in the same scene, LeBrock encounters gazpacho for the first time,

mistaking it for cold soup.[73] LeBrock's sidekick, Roderick the Rat, has to instruct his superior at dinner in the correct cutlery to use for each course: 'Er, DI. Start with the tackle on the outside and work your way in with each course.'[74] The bewildered LeBrock, far from being invulnerable, is disenfranchised by his working-class heritage, as much as his masculinity might appear stereotypical. The result is a complex portrayal of Neo-Victorian masculinity, paradoxically vulnerable and impervious.

Whilst LeBrock is a useful reference point for the complexity of contemporary masculinity, as well as providing reference to Victorian gender ideals, Roderick the Rat (LeBrock's Watson) is a different model of masculinity. He is an emphatically aristocratic figure, with his monocle, boater and bow tie. Whilst he is identified with Ratty from *Wind in the Willows*, his linguistic register also gestures towards the upper-class mannerisms of Wodehouse's Bertie Wooster and Dorothy L. Sayers's Lord Peter Wimsey. His frequent verbal tics such as 'I say' and 'jolly good', 'chap' are hallmarks of a privileged (if chiefly archaic) mode of speech.[75] Roderick is a 'rat of independent means. He's a detective for the challenge, not the money.'[76] So in many ways, Talbot's *Grandville* series offers different versions of competing masculinities – a point perhaps emphasized by the character of André Pegasus, who gestures towards a very contemporary form of 'lad culture' from which we are alienated through anthropomorphic satire. Imelda Whelehan has identified that such ironic repetition of an image (in this case, sexism) will 'have resonances of its original context. Critics would argue that the pose can be used ironically, playfully, and can even deconstruct the original meanings of the image, therefore generating completely new inflections on an old standard … But the new irony makes it difficult to object to anything potentially offensive.'[77] In many ways, this double bind is the dilemma of steampunk more generally: ironic repetition presumes a sophisticated readership who will pick up on the visual and verbal clues intended to satirize a particular type of behaviour.

Talbot's answer to this quandary appears to be parodic excess – the anthropomorphic character becomes so comedically absurd as to be beyond both imitation and valorization. For instance, one panel shows Pegasus (an underworld chief with investments in brothels and drug dealing) legs splayed, laughing riotously at the spectacle of a dancing prostitute, sashaying about the room in her corset and bloomers: 'Lookit her go! That bitch is on fire, man!'[78] The epithet 'bitch', whilst being humorous (as reference for a female dog, it is entirely correct, if utterly farcical in this context), also signifies linguistic ambiguity and points to the way in which irony functions in the text: the word 'bitch' is both accurate and sexist, whilst Pegasus is both a contemporary 'lad' and its antithesis, the 'white horse' bearing a prince, a reflection on chivalric masculinity. In *Grandville: Noël*, Pegasus makes another appearance, posing as Apollo, the cult leader (who is a unicorn). Entering Apollo's private chambers, he observes the harem with the declaration, 'Woah! Check out the chicks!'[79] The absurdity of such objectification is rendered even more poignant when the subsequent panel reveals actual yellow chicks, dressed in red gowns, reminiscent perhaps of Margaret Atwood's *The Handmaid's Tale* (1985).

As an ancient Greek symbol of strength and beauty, Talbot's Pegasus represents nothing but a bathetic imitation of the heroic white horse of old – he is so odious in fact that we are clearly meant to be revolted by his persona. Equally, his machismo is undercut by LeBrock exclaiming, 'Calm down, sunshine. Give your ego a rest.'[80] It seems that Pegasus, occupying a pseudo-Victorian world, is nonetheless a critique of modern masculinity, which, as Bethan Benwell has argued, 'point[s] to more obvious manifestations of sexism, such as "softporn" representations of women and their accompanying objectification through language'.[81] The use of animal characters in this instance, as in so many others in the series, underscores the absurdity of human behaviour, which in this instance critically reflects upon the male gaze as a determinant of lad culture.

Technology and gender

An ironized recourse to the past is visible in Talbot's use of steampunk technology, which is a pastiche of different periods of mechanization. Rebecca Onion has articulated that steampunk also provides a mashup of disparate periods of history:

> It picks and chooses from previously existing styles of physical technology and ideological modes of technological engagement. In their love for the breadth and the perceived innocence of technological and scientific knowledge, exemplified by the figure of the gentlemen-scientist and/or tinkerer, steampunks look back to the Victorian era. In their disaffection for the technology of their own time, steampunks echo the anger of the anti-moderns of the late nineteenth and early twentieth century.[82]

David Pike has observed that steampunk technology in literature can articulate 'a threat to the fabric of society', frequently through Cold War anxieties about the atomic bomb.[83] Certainly Alan Moore's cavorite in volume 1 of the *League* replicates some of these anxieties, as well as more generally a 'threat from the air', which both Moore and Talbot use to reflect upon 9/11. The object of the League's pursuit in the first volume (cavorite from H. G. Wells's 1901 novel *The First Men in the Moon*) is basically an anti-gravitational force which is being used to power Fu Manchu's airship. Once retrieved and delivered to Bond of MI5, the cavorite is used by Moriarty in his plot to destroy Limehouse in an aerial raid. Despite this, both texts also represent a celebration of, as well as anxiety about, technology. A theme throughout the *Grandville* books is the use and abuse of technology. Robots and automatons also feature throughout the series, usually with some degree of mistrust (a mechanical pilot is used in volume 1, for instance, to drive the aircraft on its terrorist mission). This suspicion is also tempered by a steampunk celebration

of the intricacy of machinery (Talbot's endpapers use an Art Nouveau steampunk design replete with the ubiquitous steampunk cogs). Indeed, Talbot identifies French artist and writer Albert Robida (1848–1926) as a key influence on *Grandville* (the bombed building in *Grandville* is called 'Robida Tower', for instance). In Robida's art, there is the juxtaposition of nineteenth-century culture, including the everyday (often humorous) alongside futuristic technological developments – all of which have much in common with steampunk. Robida's idea, the 'telephonoscope', translates into the 'pneumail' in *Grandville*, a parody of voice communication and email. Robida is a crucial figure in science fiction, having written parodies or spoofs of Jules Verne, and of course we know Jules Verne as a touchstone of steampunk culture (comedically Robida wrote *Around the World in More Than 80 Days*). He populated his narratives with elaborate airships, submarines and weaponry, and pointed to how the trauma of the First World War suggested technology can be problematic and destructive, especially in its military applications (the First World War was known as the first truly modern, technologically developed war). Indeed in *Le Vingtième Siècle* (1883), Robida illustrates the '1910 Great Wars' as a universal cataclysm.[84] Again, this is something which we find in many steampunk texts: authors frequently hover between a celebration of human achievement in scientific endeavours and a long-standing suspicion about where humanity is headed.

However, retrofuturistic technology also opens up imaginative opportunities for alternative histories, including representations of femininity. In *Grandville: Bête Noire*, Billie, the love interest for LeBrock, escapes a violent mob by commandeering a motorbike and exclaiming 'Full steam ahead!'[85] Later in the same scene, when Roderick expresses his surprise that Billie can ride a motorbike at all, Billie responds, 'I grew up on the streets, Roderick. I've a whole catalogue of disreputable skills.'[86] Not only does the anachronistic technology of the motorbike give Billie autonomy and freedom but the notion of *disreputable skills*

correlates with nineteenth-century discourses on women and cycling. Notably, given this alternative Parisian cityscape, the earliest bicycle appeared in Paris in 1867, whilst the pneumatic tyre dates from 1888.[87] From the very beginning, female cyclists were castigated, as riding 'was seen as essentially masculine. Women's riding therefore posed a threat to gender definition. It was also perceived as threatening women's sexual purity ... and when unmarried men and women rode together, cycling threatened chastity and order'.[88] The bicycle was also overtly sexual, as it was seen to promote masturbation (in the same way as straddling rocking horses was denied to small girls in previous decades). Thus bicycle-riding problematized a woman's decency (which is less of a problem for Billie, perhaps, as a prostitute). Riding a bicycle meant freedom, as women were able to travel unaccompanied, in mixed company, and it thus became synonymous with feminism and emancipation. Alongside this context, we also have the fact that this is a motorized, steam-powered cycle, and Billie's attire seems to reference a more twentieth-century subcultural sensibility (she has just been disturbed from a BDSM encounter with a punter). Her studded collar, red and black corset and coat framed alongside the motorbike suggest she is approximate to a nineteenth-century Hell's Angel. Arguably, this technological anachronism allows for a coded reflection on gendered discourses, women's freedoms as well as limitations, in the nineteenth century. The reader is positioned simultaneously in two time frames, which circumvent an unreflective nostalgia by flagging up the ways in which women's movements were policed.

Notably, Billie's role as a prostitute is well established in Neo-Victorian fiction. Miriam Burstein has commented, somewhat humorously:

> There must be at least one Prostitute, who will be an Alcoholic and/ or have a Heart of Gold. If the novel is *about* a prostitute, however, she will have at least one Unusual Talent not related to her line of work.[89]

This trope is ubiquitous in Neo-Victorian fiction generally, and we need only think of texts such as Michel Faber's *The Crimson Petal and the White* (2002) or Sarah Waters's *Tipping the Velvet* (1998) for confirmation. However, Billie's identity is very much in accord with Judith Walkowitz's assertion that 'one must challenge the simple interpretation of the prostitute as passive victim'.[90] Indeed, whilst Billie accords with the Neo-Victorian prostitute trope (she does have a heart of gold, and motorbike riding in nineteenth-century Paris is an unusual talent), her self-reliance and independence also correlate with wider issues related to women and the rejection of passivity. This theme is also discernible in the character of Mina in *The League of Extraordinary Gentlemen*, as will be discussed below.

The League of Extraordinary Gentlemen

The title of Alan Moore and Kevin O'Neill's graphic novel series, *The League of Extraordinary Gentlemen*, is in many ways a misnomer. Jess Nevins explains that the title has several predecessors, including Baroness Orczy's *The Scarlet Pimpernel* (1905) and John Boland's *The League of Gentlemen* (1958).[91] Alan Moore has explained that '"The League of Extraordinary Gentlefolk" in Victorian Britain [would be unthinkable], they'd have just ignored the fact that there was a woman present'.[92] Indeed, despite the importance of Mina Murray's leadership in the text, this fact also underscores one of the major differences in the film version.[93] Many of Moore's texts have been translated onto big screen (including *From Hell* and *V for Vendetta*), but he is always resistant to such adaptations and insists on the removal of his name from the film credits. Given the dilution of the political message of *The League* and other texts, this disengagement with the film adaptation is perhaps not surprising. Unlike in the film, where Alan Quatermain is recruited to the League to find the other members, it is actually Mina in the beginning of the graphic novel

who is given such authority. In the film, whilst at various points we can clearly see Mina resisting the traditional stereotype of a damsel in distress ('What makes you think I need protecting?', she asks, as she attacks her assailant with vampire fangs), this is also undercut in a number of ways. She is the source of visual pleasure for men in the film: Dorian Gray and Tom Sawyer both make advances, whilst in Moore's graphic novel, it is actually Alan Quatermain who becomes romantically involved with her (an excision from the film which testifies to the problem of representing ageing sexuality in Hollywood). Similarly, the graphic novel makes a point of Mina rejecting her married name. Harker is summarily dismissed in the discussion with Bond: 'Thankfully, my former husband's feelings are no longer my concern, nor are they yours.'[94] Nonetheless, she is addressed as Mrs Harker in the film, which does not suggest that 'Harker' is a more recognizable name than 'Murray' in the Dracula mythos, so much as it easily excises the female adventurer/detective as the lead in a film of this kind.[95]

In common with the scene where Billie is pictured riding a bicycle from Talbot's *Grandville* series, we can identify Mina as a representative of the New Woman. This is visible in Bram Stoker's *Dracula* (1897), where Mina's secretarial skills aid Van Helsing and his team of vampire hunters in pursuing Dracula:

> [Dr Seward] brought back the phonograph from my room, and I took the typewriter. He placed me in a comfortable chair, and arranged the phonograph so that I could touch it without getting up, and showed me how to stop it in case I should want to pause. Then he very thoughtfully took a chair, with his back to me, so that I might be as free as possible, and began to read. I put the forked metal to my ears and listened.[96]

The 'New Woman' is a term coined by Sarah Grand in her essay 'The New Aspect of the Woman Question' (1894), achieving widespread

currency in the early twentieth century.[97] Whilst there was a general lack of consensus among late Victorian writers as to what constituted a 'New Woman' (with notions varying from a celebration of motherhood to an attack on maternity, from free love to sexual virtue[98]), there are some key characteristics which are important here. The New Woman was 'a challenge to the apparently homogenous culture of Victorianism which could not find a consistent language by which she could be categorised and dealt with. All that was certain was that she was dangerous, a threat to the *status quo*'.[99] She was frequently associated with sexual decadence; challenges to the traditional notion of marriage; a professional career and education, rather than 'feminine' characteristics such as childrearing; and importantly, masculine appearance. One commentator from the 1890s notes that the New Woman is 'a woman [who] does anything specifically unfeminine and ugly … A woman who smokes in public and where she is forbidden, who dresses in knickerbockers or a boy's shirt … who flouts conventional decencies and offends against all the canons of good taste'.[100] So, how does Moore's Mina fit with this idea? First of all, she smokes cigarettes on several occasions in the text.[101] She is described as 'a smelly little lesbian' by Moriarty, suggesting how challenging the persona of the New Woman is to patriarchal authority.[102] Men are clearly threatened by her. Her relationship with Quatermain, graphically depicted in *The League*, is an example of transgressive sexuality (outside marriage), as well as a parody of the traditional romance plot (see Chapter 5 on steampunk romances), where an experienced older man seduces a younger woman – following their return to their guest house, Mina is shown leading Quatermain up the stairs, explaining to a servant that they will be having an early night. She then proceeds to undress in front of the bewildered older man, instructing him to aid her with unfastening her corset, whilst he feebly protests 'I … I don't know what to say. Mina, I'm too old for you. I … ' to which Mina responds 'Be quiet' and

in a graphic representation of their sexual encounter, Mina climbs on top of the aged Quatermain when he explains he 'can't keep this up'.[103] Quatermain's compromised masculinity in this scene is a counter to the heroic imperialism associated with his character.

Mina is quite plainly able to take care of herself (as she explains at one point when Quatermain warns her about a potential attacker, stating 'I'm not incapable, you know'[104]). As an immortal, and a divorcee, she represents independence and an air of scandal. Her red scarf, whilst obviously denoting blood and disguising her scars, also has much in common with *The Scarlet Letter* of Nathaniel Hawthorne's novel – it singles her out as a fallen woman. Nonetheless, she is also an object of desire, but perhaps not in the most conventional context. She warns the aged Quatermain to refrain from looking up her skirts as she is climbing a ladder early in the text, and certainly at the end of the graphic novel, she curses her 'ridiculous female naiveté' for failing to guess Moriarty's machinations and the League's status as a mere pawn in a wider imperialist game.[105] Quatermain's response, that he is equally culpable, goes some way to confound his earlier conversations with Dr Jekyll, in which she is characterized as merely an 'infuriating woman', a bit of a scold and of 'rather striking' appearance.[106]

We might also note that Mina presents a foil to Empire and masculinity. Quatermain's first appearance in fiction – H. Rider Haggard's *King Solomon's Mines* (1885) – is in many ways a fulfilment of a model of masculinity which circulated throughout the nineteenth century and was to continue throughout many Quatermain adventures through to the 1920s. Certainly this form of masculinity was influenced by the Boer War (1899–1902), which Steve Attridge has characterized as 'a pendulum that swung not only between centuries, but between national assurance and introspection, between Victorian certainties and the doubts and vicissitudes of modernity, between a national character that knew exactly who it was and one which was confused'.[107] Thus, Quatermain's masculinity is not that of the boy's

adventure story, but rather he is old, vulnerable, scarred and in many ways quite fragile.[108] Nowhere is this more apparent than in the scenes on the Nautilus which succeed his liberation from the opium den: Quatermain is pictured with Mina in a scene resonant of the Christian *Pietà* in medieval and Renaissance art, where the Virgin Mary cradles the dead and broken body of Christ the Saviour.[109] However, the comparison is entirely ironic, given that Mina is far from a virgin, and Allan is no longer in a position to save anybody, as Nemo emphasizes: 'And how is the great colonial explorer that your empire sent you here to salvage?'[110] This critique of imperial masculinity is most clearly visible in Mina's scathing address to Nemo and Quatermain towards the end of the first volume, during one of their squabbles:

> Oh, how typical! Are you men, or little boys? You play your little games with your elephant guns and your submersible boats, but one raised voice and you hide like little children!.. The point is that I'm supposed to be organising this … this menagerie! But that will never do, will it? Because I'm a woman. They constantly undermine my authority, him [Nemo] and Quatermain.[111]

It is noteworthy that Mina characterizes the imperial project as the 'little games' of boys, whilst at the same time asserting her authority and emphasizing that the reason the two men do not respect her is because of her gender: '[Mina] is the main tool Moore uses to expose the insubstantiality of the Victorian ideals of strength and respectability, of imperial rule and especially of male authority.'[112] Mina's outsider status allows her a very different perspective on the martial logic of both Quatermain and the colonized figure of Nemo: as Virginia Woolf articulated in her reflections on gender and Empire in 'Three Guineas', it is worthwhile to evaluate 'how much of "England" belongs to her' [i.e. 'the daughters of educated men'].[113] The England that Quatermain represents actively excludes a woman's participation. The value of steampunk narrative here is that women's agency is written back into

history, albeit fantastically and retrospectively. At the same time, a naïve valorization of imperial heroism is tempered by a sober reflection on the inequality of historical experience, in which men are heroic adventurers, not women.[114]

This interrogation of masculinity is also encountered in Moore and O'Neill's depiction of Hawley Griffin, the Invisible Man. Clearly, Hawley's aggressive masculinity emerges first in 'Miss Rosa Coote's Correctional Academy for Wayward Gentlewomen' (Rose Coote featured in the erotic short story collection *The Pearl*, published between 1879 and 1880), where he has non-consensual sex (because he is invisible, it is difficult to see these scenes as anything other than rape) with a number of young girls at the school.[115] His behaviour essentially anticipates his psychological rape of Mina in the second volume, but through Griffin's actions, Moore also pillories the mysticism of conventional faith and the way in which Victorian morality privileged virginity (three girls become pregnant and attribute this to an immaculate conception), whilst at the same time satirizing the rape culture of the twenty-first century. He explains that the target of his humour is not sexual violence, but rather Victorian sensibilities about women's sexual innocence: 'Rape is serious, the idea of rape is a horrible thing and there's no intention to trivialise it. However, one of the unspoken pillars of Victorian fiction was the notion "the fate worse than death"'.[116]

By comparison, Griffin's highly sexualized attack on Mina in the second volume addresses the toxic masculinity which we might more obviously associate with twenty-first-century discourses around rape culture. Indeed, Laura Bates remarks on 'the invisibility of rape culture' as a silencing strategy (alongside victim-blaming and social acceptance) in cases of sexual assault.[117] Indeed, the notion of cultural invisibility might usefully map onto the scenes with Griffin and his victims, where his literal invisibility is used to his advantage. In the second *League* volume, Griffin's violence towards Mina extends over

several panels, but Moore's objective here is to represent the ways in which women are silenced or otherwise devalued. Mina certainly bravely attempts to counter his attacks with her usual authority: 'Why aren't you saying anything? I demand to know what's–' and results in him insisting she repeats the sexualized phrase 'I'm a stuck-up little tart.'[118] She later recounts his grotesque humiliation of her: 'He made me grovel. I couldn't feel more sick of myself if he'd put his affair in me. I can't even write his name.'[119] The rape motif becomes more overt when Hyde remarks that 'his smell's all over her. He was naked. Help her. Clean her up and help her.'[120] Indeed, Laura Hilton's discussion of this scene is instructive here:

> Griffin demonstrates a specific dislike of Mina's independence and capabilities, resenting her ability to outsmart and capture him … Griffin's attack could be interpreted as an attempt to generate a position of gender-based power through the combination of a violent physical attack and a kind of psychological rape, as indicated through the dialogue … Griffin's attack marks the first occasion where neither Mina nor her companions are able to stop a perpetrator, and Mina only survives Griffin's attack because Griffin himself allows her to do so.[121]

However, this scene is not about Mina accepting her limitations, as Hilton argues, but rather a damning indictment of backlash culture in the late twentieth century.[122] It is Mina's independence, her leadership and her strength which makes Hawley Griffin want to put her in her place, whilst at the same time asserting his threatened sense of masculine identity. Susan Brownmiller notes that historically 'rape became not only a male prerogative, but man's basic weapon of force against woman, the principal agent of his will and her fear … It is nothing more or less than a conscious process of intimidation'.[123] Griffin's sexual and physical aggression suggests a gendered confrontation which expresses itself in war-like behaviour of conquest and subjugation. We might also note that such action

is a common theme of imperial masculinity (mirrored in Hyde's subsequent retaliatory rape and murder of Griffin). Indeed, as the next section demonstrates, like Talbot, Moore's critique also extends to a contemporary articulation of imperialism, the 'War on Terror'.

The threat from the air

In *The League of Extraordinary Gentlemen*, the most recognizable and iconic use of speculative engineering, or steampunk technology, is O'Neill's illustration of Captain Nemo's submarine, the Nautillus, which itself first featured in Jules Verne's *20,000 Leagues Under the Sea* (1870). Whilst O'Neill's Nautillus design in *The League* resembles the aesthetic of the Cthulhu mythos (whilst Lovecraft did not actually credit the Elder Gods as having tentacles, later writers characterized them as octopus-like water-beings), its design is far from that of Jules Verne and is entirely unique to *The League*. The technology of the Nautillus also gestures towards the steampunk technology of the series. The science of this alternative nineteenth century has advanced on an entirely different trajectory to that of familiar history. In one of the first scenes with Edward Hyde, the illustration features an 'Edison Teslaton' junction box, referencing Thomas Edison (1847–1931) and Nikola Tesla (1856–1943). Whilst Edison and Tesla were basically rivals, it seems that this alternative reality has combined the endeavours of the two scientists, 'with the obvious result of technology becoming much more advanced than it really was'.[124] But, as with Talbot's ambivalent approach to technological development, Moore and O'Neill represent mechanization as potentially dangerous, foolhardy or subject to failure. Fu Manchu's airship, the 'threat from the air', anticipates the major narrative drive of the second volume, which is a Martian invasion influenced by Wells's *The War of the Worlds* (1897). Moore explains that both the first and second volumes are inspired by the instability of the turn of the twentieth century and

a similar trajectory with the approach of the millennium.[125] Indeed, akin to Bryan Talbot, Moore discerns a clear analogy with his 'threat from the sky' and post-9/11 political rhetoric:

> When Mina Murray is talking ... about how the sky had previously seemed something that sheltered humanity, but now that these alien cylinders had turned up, it's suddenly an object of fear, and that seemed to me to have a resonance ... after 9/11 I bet there's a lot of people walking around squinting occasionally at the sky if they hear an airplane passing.[126]

Pseudo-Victorian science fiction technology is used here as a satirical device to offer criticism of contemporary politics. Like Talbot, Moore locates the evolution of this culture of fear firmly with politicians and cites the Home Secretary David Blunkett, who proposed a test of good citizenship for immigrants into the UK.[127] As such, Britannia, the iconic symbol of the British Empire, is presented in both volumes as a compromised, absurd figure. Mina and Bond's first meeting is atop a 'Channel Causeway', an incomplete bridge to connect England and France, which has 'a revised completion date due to mechanical difficulties'.[128] The bridge features a statue of a martial Britannia, the female symbol synonymous with military might, and the colonizing strategies which produced the British Isles (following the Act of Union in 1707). She is positioned alongside a regal lion bearing a plaque 'Albion's reach' and carries a trident and shield (emblazoned with a Union Jack and the word 'Industry'). However, this nationalistic scene is undercut in several ways: Britannia lacks an arm and is placed on a rather shabby plinth, whilst 'Albion's reach' suggests both the colonizing impetus of England (its influence spreads beyond the physical geography of England) and the limits of its power (reach in terms of 'extent' or 'limit'). Overall, the structure has a dilapidated feel to it, aided by hovering seagulls and rusting machinery. Combined with the fact that Moore and O'Neill

are parodying the delayed competition of the Channel Tunnel (which connected England to France in 1994), we have yet another example of how Moore's steampunk reality is used to foster a critical position with reference to nationalism and the re-energized far right, very much in common with the logic of ironic nostalgia. Indeed, a very different Britannia also features in the 'Message to Our Readers' as an overweight, bespectacled (therefore myopic) and busty woman drinking (presumably) beer from a pint glass whilst she looks on at Victorian poverty. Throughout the 1980s, Britannia was correlated with the persona of Prime Minister Margaret Thatcher:

> The identification of the Prime Minister with the renewed grandeur of Great Britain [after the Falklands War] was accomplished in part through the language of female representation; it was natural, as it were, to see Mrs Thatcher as the embodiment of the spirit of Britain in travail and then in triumph … Britannia's image, developed through coins, banknotes, stamps, political propaganda and cartoons, has become synonymous with being British, with belonging to Great Britain … Margaret Thatcher does not reject the combative identity and the imperial attitudes epitomized by late Victorian Britannias; she rather revived them.[129]

Indeed, Moore's resistance to the far-right agenda, encapsulated by Thatcher in the 1980s, as well as post-9/11 rhetoric, also neatly critiques several nostalgic threads of Neo-Victorianism.[130] As Simon Joyce has identified, the importance of the Victorians escalated with the Conservative government's election success in 1979, accompanied by the repeated iteration of a return to Victorian values in terms of policy (and iconography).[131] Looking back on these 'Empire Dreams' as anti-authoritarian Moore dubs them, the *League* highlights the parasitic nature of the colonial scramble, and ultimately, overwhelms our fantastical and partial nostalgia for the Victorian period, supplying instead a grotesque version of imperial Britannia, comedic in her very inadequacy.

Conclusion

In conclusion, this chapter has focused on the way steampunk texts
have the capacity to interrogate representations of gender, technology
and race, particularly inflected with a critical approach to such
contemporary concerns as 9/11 and the War on Terror. More generally,
these texts suggest an 'ironic nostalgia' in their consideration of the
Victorian period proper through various strategies, including self-
conscious intertextual references to the arts and wider culture. The
critique embedded in the steampunk graphic novel not only collapses
the notion of progress (from a period of inequality and injustice to our
enlightened contemporary moment) but also holds an uncomfortable
mirror up to some of our own racial and sexual prejudices. All of this
material marks the ways in which steampunk texts seek to revise,
reformulate and reinvigorate our appraisal of the nineteenth century.
Steampunk literary and cultural practices reveal how they are heavily
invested with the influences and values of a prior historical moment,
and also address how we need to persistently question the material of
the contemporary moment: the ideologies invested in technology, in
politics and society, and the potential problems inherent in our society
today. Like all the best sci-fi, ideally, the punk ethos of steampunk seeks
to challenge our thinking and revisits what it means to be human.

Notes

1 Alison Halsall, 'A Parade of Curiosities: Alan Moore's *The League of*
 Extraordinary Gentlemen and *Lost Girls* as Neo-Victorian Pastiches', *The*
 Journal of Popular Culture 48:2 (2015), 252–268, 252.
2 Linda Hutcheon, 'Irony, Nostalgia and the Postmodern', http://www.
 library.utoronto.ca/utel/criticism/hutchinp.html (1998), citing Andreas
 Huyssen, 'Mapping the Postmodern', in *A Postmodern Reader*, ed. Joseph
 Natoli and Linda Hutcheon (Albany, NY: SUNY Press, 1993), p. 112.

3 For further on the notion of Neo-Victorianism in graphic novels, see
 Jeff Thoss, 'From Penny Dreadful to Graphic Novel: Alan Moore and
 Kevin O'Neill's Genealogy of Comics in *The League of Extraordinary
 Gentlemen*', *Belphégor* 13:1 (2015), [online], http://belphegor.revues.
 org/624 [accessed 15 August 2017].

4 Hutcheon, 'Irony, Nostalgia and the Postmodern' (1998).

5 Hutcheon, 'Irony, Nostalgia and the Postmodern' (1998).

6 Hutcheon, 'Irony, Nostalgia and the Postmodern' (1998).

7 Hutcheon, 'Irony, Nostalgia and the Postmodern' (1998).

8 Hutcheon, 'Irony, Nostalgia and the Postmodern' (1998).

9 Scott McCloud, *Understanding Comics: The Invisible Art* (New York:
 HarperCollins, 1994), p. 8.

10 McCloud, *Understanding Comics*, 67. For 'closure', see p. 63.

11 Annalisa Di Liddo, *Alan Moore: Comics as Performance, Fiction as
 Scalpel* (Jackson: University Press of Mississippi, 2009), pp. 35–36.

12 Jerome de Groot, *Consuming History: Historians and Heritage in
 Contemporary Popular Culture* (Abingdon: Routledge, 2008), p. 225.

13 'Legendary Comics Writer Alan Moore on Superheroes, *The League*,
 and Making Magic', 23 February 2009, https://www.wired.com/2009/02/
 ff-moore-qa/ [accessed 18 September 2017].

14 Gerard Genette, *Paratexts: Thresholds of Interpretation* (Cambridge:
 Cambridge University Press, 1997), p. 179ff.

15 Lara Rutherford, 'Victorian Genres at Play: Juvenile Fiction and *The
 League of Extraordinary Gentlemen*', *Neo-Victorian Studies* 5:1 (2012),
 125–151, 136.

16 Genette, *Paratexts*, 275.

17 Bryan Talbot, *Grandville* (London: Jonathan Cape, 2009), vol. 1, p. 16.

18 Talbot, *Grandville*, 6.

19 Auguste Leopold Egg, *The Travelling Companions* (1862), oil on canvas,
 Birmingham Museums and Art Gallery, UK.

20 Édouard Manet, *A Bar at the Folies-Bergère* (1882), oil on canvas, The
 Courtauld Gallery, London, UK. For Omaha the Cat Dancer, see http://
 www.omahathecatdancer.com/ [date accessed 18 September 2017]. See
 Talbot, *Grandville*, 21–22.

21 See Talbot, *Grandville*, 45.

22 Jess Nevins, 'Alan Moore Interview', in *A Blazing World: The Unofficial Companion to The League of Extraordinary Gentlemen Volume 2* (London: Titan Books, 2003), pp. 254–255.

23 Hutcheon, 'Irony, Nostalgia and the Postmodern' (1998).

24 Bryan Talbot, 'The Anthropomorphic Tradition', The Lakes International Comic Arts Festival, Kendal, 18 October 2013.

25 Tim Killick, 'The Graphic Novel', in *Victoriana: A Miscellany*, ed. Sonia Solicari (London: Guildhall Art Gallery, 2013), p. 88.

26 Killick, 'The Graphic Novel', 88.

27 Killick, 'The Graphic Novel', 85.

28 Talbot, *Grandville*, 17.

29 Linda Hutcheon and Mario J. Valdés, 'Irony, Nostalgia, and the Postmodern: A Dialogue', *Poligrafías* 3 (1998–2000), 18–41, 23.

30 Talbot, *Grandville*, 34.

31 Liane Tanguay, *HiJacking History: American Culture and the War on Terror* (Montreal: McGill-Queen's University Press, 2013).

32 Tanguay, *HiJacking History*, 154.

33 Tanguay, *HiJacking History*, 146–147.

34 Tanguay, *HiJacking History*, 146.

35 Tanguay, *HiJacking History*, 171, citing George W. Bush's speeches in 2001.

36 Tanguay, *HiJacking History*, 163.

37 'Remarks by the President upon Arrival', South Lawn, 16 September 2001, https://georgewbush-whitehouse.archives.gov/news/releases/2001/09/20010916-2.html, [accessed 25 September 2017].

38 Tanguay, *HiJacking History*, 159.

39 Talbot, *Grandville*, 61.

40 Talbot, *Grandville*, 51.

41 Talbot, *Grandville*, 33.

42 Talbot, *Grandville*, 51.

43 Talbot, *Grandville*, 31.

44 Talbot, *Grandville*, 18.

45 Charles Darwin's theories of evolution in *The Origin of Species* (1859) might be referenced here, but also the degenerative theories of Max Nordau, in *Degeneration* (1892), and the earlier research of Cesare

Lombroso, *L'uomo delinquente* [*The Criminal Man*] (1876). The 'doughface' characters are all references to classic Franco-Belgian comics (Bécassine, Spirou, Gaston) and drawn in a different style to the animals. Notably, Talbot uses line and colour variation to suggest racial difference.

46 Talbot, *Grandville*, 85.

47 Talbot, *Grandville*, 85.

48 Talbot, *Grandville*, 85.

49 Tanguay, *HiJacking History*, 187–188.

50 Talbot, *Grandville*, 61.

51 Talbot, *Grandville*, 96–97.

52 Talbot, *Grandville*, 47. For more detailed accounts of the far right and abortion, Michaela Köttig, Renate Bitzan and Andrea Petö (eds), *Gender and Far Right Politics in Europe* (Basingstoke: Palgrave, 2017). See also Warren Tatalovich, *The Politics of Abortion in the United States and Canada: A Comparative Study* (Abingdon: Routledge, 2015).

53 Léa Bouchoucha, 'In France, Marine Le Pen Pushes Abortion Politics into View' *Women's News*, January 4, 2016, http://womensenews. org/2016/01/in-france-marine-le-pen-pushes-abortion-politics-into-view/ [accessed 26 September 2017].

54 Joseph Valente, *The Myth of Manliness in Irish National Culture, 1880–1922* (IL: University of Illinois Press, 2010), p. 172.

55 Fidelma Ashe, 'Reenvisioning Masculinities in the Context of Conflict Transformation: The Gender Politics of Demilitarizing Northern Irish Society', in *Making Gender, Making War: Violence, Military and Peacekeeping Practices*, edited by Annica Kronsell and Erika Svedberg (London: Routledge, 2012), p. 200.

56 Melanie Hawthorne, 'Bryan Talbot's *Grandville* and French Steampunk', *Contemporary French Civilization* 38:1 (2013), 47–71, 66.

57 Bryan Talbot, *Grandville: Mon Amour* (London: Jonathan Cape, 2010), p. 15.

58 See Talbot, *Grandville*, 92, for an example of Drummond's iteration of the famous catchphrase. At this point, Drummond also wryly references his deal with General Pierre Woolf as an 'insurance policy'.

59 Paul Addison, *Churchill: The Unexpected Hero* (Oxford: Oxford University Press, 2006), p. 102.

60 Claudia Capancioni, 'Sherlock Holmes, Italian Anarchists and Torpedoes', in *Sherlock Holmes and Conan Doyle: Multi-Media Afterlives* (Basingstoke: Palgrave, 2013), p. 87, citing Joseph Kestner, *Sherlock's Men: Masculinity, Conan Doyle and Cultural History* (Aldershot: Ashgate, 1997), p. 2.

61 Bryan Talbot, *Grandville: Force Majeure* (London: Jonathan Cape, 2017), p. 23.

62 Amanda J. Field, 'Sherlock Holmes in Advertising', in *Sherlock Holmes and Conan Doyle: Multi-Media Afterlives*, ed. Sabine Vanacker and Catherine Wynne (Basingstoke: Palgrave, 2013), p. 23.

63 Bryan Talbot identifies his debt to Tarentino in the fly-pages of the first volume in the *Grandville* series.

64 Talbot, *Grandville*, 18.

65 Bethan Benwell, 'Ironic Discourses: Evasive Masculinity in Men's Lifestyle Magazines', *Men and Masculinities*, 7:1 (2004), 3–21, 14.

66 Mel Gibson, '"Badgers? We don't need no steenkin' Badgers!" Talbot's *Grandville*, Anthropomorphism and Multiculturalism', Ian Hague and Carolene Ayaka (eds), *Representing Multiculturalism in Comics and Graphic Novels* (Abingdon: Routledge, 2015), pp. 83–95, 84.

67 See Talbot, *Grandville*, 45.

68 Anissa A. Graham and Jennifer C. Garlen, 'Sex and the Single Sleuth', in *Sherlock Holmes for the 21st Century*, ed. Lynette Porter (Jefferson: McFarland & Co., 2012), p. 33.

69 Ann Heilmann and Mark Llewellyn, 'Introduction: To a Lesser Extent? Neo-Victorian Masculinities', *Victoriographies* 5:2 (2015), 97–104. See also Karen Dodsworth, '[Re]presenting the Nineteenth Century: Victorian Gender in Contemporary Adaptations'. Leeds Beckett University, September 2017, unpublished PhD thesis.

70 Frank Mort, 'Boy's Own? Masculinity, Style and Popular Culture', in *Male Order: Unwrapping Masculinity*, ed. Rowena Chapman and Jonathan Rutherford (London: Lawrence and Wishart, 1988), p. 196. See also Imelda Whelehan, *Overloaded: Popular Culture and the Future of Feminism* (London: The Women's Press, 2000), p. 61.

71 Maria Isabel Romero Ruiz, 'Detective Fiction and Neo-Victorian Sexploitation: Violence, Morality and Rescue Work in Lee Jackson's *The Last Pleasure Garden* (2007) and *Ripper Street's* "I Need Light" (2012–16)', *Neo-Victorian Studies*, 9:2 (2017), 41–69, 61.

72 Bryan Talbot, *Grandville: Bête Noire* (London: Jonathan Cape, 2012), p. 37 (volume 3 of the series).

73 Talbot, *Grandville: Bête Noire*, p. 38.

74 Talbot, *Grandville: Bête Noire*, p. 42.

75 *Grandville* (2009) p. 22, pp 40–41.

76 Brian Talbot, *Grandville: Noël* (London: Jonathan Cape, 2014), p. 93.

77 Whelehan, *Overloaded*, 68.

78 Talbot, *Grandville Noël,* 52.

79 Talbot, *Grandville Noël,* 53.

80 Talbot, *Grandville Noël,* 53.

81 Benwell, 'Ironic Discourses', 7.

82 Rebecca Onion, 'Reclaiming the Machine: A Look at Steampunk in Everyday Practice', *Neo-Victorian Studies* 1:1 (2008), 138–163, 139–141.

83 David Pike, 'Steampunk and the Victorian City' in Bowser and Croxall (eds) *Like Clockwork: Steampunk Pasts, Presents and Futures*, p. 15.

84 Albert Robida, *Le Vingtième Siècle* [*The Twentieth Century*], trans. Philippe Willems, ed. Arthur B. Evans (1883: Middletown, Wesleyan University Press, 2004), pp. 333–334.

85 Talbot, *Grandville: Bête Noire*, 76.

86 Talbot, *Grandville: Bête Noire*, 77.

87 Sarah Wintle, 'Horses, Bikes and Automobiles: New Women on the Move', in *The New Woman in Fiction and in Fact: Fin-de-Siècle Feminisms*, ed. Angelique Richardson and Chris Willis (Basingstoke, Palgrave, 2002), p. 68.

88 Ellen Gruber Garvey, *The Adman in the Parlor: Magazines and the Gendering of Consumer Culture, 1880s–1910s* (New York: Oxford University Press, 1996), p. 108.

89 Miriam Burstein ('The Little Professor'), 'Rules for Writing Neo-Victorian Novels', http://littleprofessor.typepad.com/the_little_professor/2006/03/rules_for_writi.html, 15 March 2006 [accessed 3 October 2017].

90 Judith R. Walkowitz, *Prostitution and Victorian Society: Women, Class, and the State* (Cambridge: Cambridge University Press, 1980), p. 20.

91 Jess Nevins, *Heroes and Monsters: The Unofficial Companion to the League of Extraordinary Gentlemen Volume 1* (London: Titan Books, 2003), p. 21.

92 Nevins, Heroes and Monsters, 216.

93 See *The League of Extraordinary Gentlemen*, dir. Stephen Norrington (20th Century Fox, 2003).

94 Alan Moore and Kevin O'Neill, *The League of Extraordinary Gentlemen* (London: Titan Books, 1999), vol. 1, p. 9.

95 For a comparison of the film and graphic novel versions, see Jason B. Jones, 'Betrayed by Time: Steampunk & the Neo-Victorian in Alan Moore's *Lost Girls* and *The League of Extraordinary Gentlemen*', *Neo-Victorian Studies* 3:1 (2010), 99–126, 103.

96 Bram Stoker, *Dracula*, ed. Maurice Hindle (1897: Harmondsworth: Penguin, 1993), p. 287.

97 Sally Ledger, *The New Woman: Fiction and Feminism at the Fin de Siècle* (Manchester: Manchester University Press, 1997), p. 9.

98 Ledger, *The New Woman*, 10–11, 16.

99 Ledger, *The New Woman*, 11.

100 Quoted in Ledger, *The New Woman*, 16–17.

101 See, for instance, volume 1, pp. 53–54.

102 See volume 1, p. 140.

103 Volume 2, pp. 99ff.

104 Volume 1, p. 91.

105 Volume 1, p. 79, and p. 121.

106 Volume 1, p. 61.

107 Steve Attridge, *Nationalism, Imperialism and Identity in Late Victorian Culture: Civil and Military Worlds* (Basingstoke: Palgrave, 2003), p. 1.

108 See Nevins, *Heroes and Monsters*, 42–43, for discussion of Quatermain's scarred body and physical prowess.

109 Volume 1, p. 19.

110 Volume 1, p. 19.

111 Volume 1, p. 114–115.

112 Di Liddo, *Alan Moore*, 109.

113 Virginia Woolf, *A Room of One's Own/Three Guineas* (Harmondsworth: Penguin, 1993), p. 233.

114 For further discussion on the gendered adventure narrative in Moore, see Rutherford, 'Victorian Genres at Play', 137–140.

115 See volume 1, pp. 46–47.

116 Alan Moore, Interview, *Tripwire* (November 1998), cited in Nevins, *Heroes and Monsters*, 58.

117 Laura Bates, *Everyday Sexism* (London: Simon and Schuster, 2014), p. 35.

118 *League*, vol 2, pp. 72–73.

119 *League*, vol 2, p. 77.

120 *League*, vol 2, p. 76.

121 Laura Hilton, 'Reincarnating Mina Murray: Subverting the Gothic Heroine?' in *Alan Moore and the Gothic Tradition*, ed. Michael J. A. Green (Manchester: Manchester University Press, 2013), p. 203.

122 See Susan Faludi, *Backlash: The Undeclared War against Feminism* (London: Vintage, 1993, new ed.).

123 Susan Brownmiller, *Against Our Will: Men, Women and Rape* (New York, Open Road, 2014, new ed.) p. 33. See Nevins, *Blazing World*, 272, for Moore's discussion of Mina and rape.

124 Nevins, *Heroes and Monsters*, 49.

125 Nevins, *A Blazing World*, 250.

126 Nevins, *A Blazing World*, 251.

127 Matthew Tempest, 'Immigrants to Face Language and Citizenship Tests', *The Guardian*, 7 February 2002, https://www.theguardian.com/politics/2002/feb/07/immigrationpolicy.immigration [accessed 5 October 2017]. The proposals became the 'Nationality, Immigration and Asylum Act, 2002', following the 2002 white paper, 'Secure Borders, Safe Haven'.

128 *The League of Extraordinary Gentlemen*, vol. 1, p. 8.

129 Marina Warner, *Monuments and Maidens: The Allegory of the Female Form* (London: Vintage, 1996), p. 41.

130 Margaret Thatcher infamously attacked 'positive images' of gay people during a debate on Section 28 at the Conservative Party Conference in

October 1987. See Joseph Patrick McCormick, https://www.pinknews.
co.uk/2013/04/08/margaret-thatcher-a-controversial-figure-in-gay-
rights-dies-aged-87/, 8 April 2013 [accessed 11 September 2018].

131 Simon Joyce, *The Victorians in the Rearview Mirror* (Athens: Ohio
University Press, 2007), p. 74–76.

Steampunk Romance: Gail Carriger and Kate McAlister

Introduction

With the increased popularization of steampunk as a literary genre and as a cultural practice, there has also been an intersection of steampunk with other types of fiction, such as erotica or romance. Whilst steampunk is a comparatively recent development, only achieving real acknowledgement in popular culture and academic criticism in the twenty-first century, romance has a long and varied history among readers and particularly women. Steampunk romances' revisitation of the Victorian period can be politically and socially inflected. Women in the romance genre have tended to be perceived as stereotype – prospective wives and mothers, and as such, as Koelke has put it in relation to Neo-Victorianism, they are 'sentenced to discursive non-being in the prison-house of patriarchal history'.[1] This chapter will address the intersection of these two genres, how this provokes a reconsideration of steampunk as a radical form and indeed, how the representation of men and women in this hybrid of steampunk romance might run counter to more radical literature within the subculture, despite the visibility and ostensibly positive message of the fiction under discussion.

Primarily, it is important to note that romance is an ambivalent form: despite its seemingly conservative message, as Janice Radway has argued in her foundational study *Reading the Romance*, women have 'insistently and articulately explained that their reading was a way of temporarily refusing the demands associated with their social role as wives and

mothers ... it functioned as a "declaration of independence," as a way of securing privacy while at the same time providing companionship and conversation".[2] The fantasy space of the romance novel not only grants women some 'me-time' but also supplies an emotional and even sexual outlet which might not be present in their everyday lives (we need only think of the popularity of Mills & Boon, Catherine Cookson or Danielle Steele here). Romance provides women readers with 'a way to say to others, "This is my time, my space. Now leave me alone"'.[3]

This chapter will address this phenomenon of gender and sexuality in steampunk romance novels through two authors: Gail Carriger, who has written the popular 'Parasol Protectorate' series (2009–2012), and Katie MacAlister, whose work *Steamed* (2010) marks a departure from her previous work as a paranormal romance writer. In order to read these texts, this chapter will also employ post-feminist theory, which seeks to articulate choice and lifestyle as part of an emancipating agenda, whilst at the same time paradoxically presenting some very conservative visions of what it is to be a woman. Compellingly, it is not only women who have their sexuality and lifestyle choices contracted in steampunk romance. Male characters too, whether hetero- or homosexual, seem to be represented in highly conventional ways, providing a narrative which offers comfortable nostalgia, rather than an interrogation of the twentieth-century crisis of masculinity.[4] In this schema, heterosexual masculinity (the romantic hero) is rugged and manly (Lord Maccon, Jack Fletcher), whilst the homosexual or queer characters (Lord Akeldama, Madame Lefoux) are represented through conventional signifiers of queer desire.

Steamed by Kate McAlister

Given the focus on visual culture, spectacular subculture and especially sartorial style which compromises a significant aspect of steampunk,

it is perhaps unsurprising that romance genre writers have explored the alternative steampunk world as a useful backdrop to their fictions. The metaphorical journey that the heroine undergoes (the discovery of a new sexual self) is often mirrored in literal journeys to exotic places: 'hence travel, relocation and movement have been central to such romantic trajectories'.[5] In terms of the coalition of steampunk and romance, it is easy to see why an alternate world of a fantastical nineteenth century that never was might have particular crossover appeal: the cityscapes and the appearance of characters within steampunk narratives are lavish and highly detailed. Janice Radway comments that one of the most crucial linguistic devices is the 'genre's careful attention to the style, color, and detail of women's fashions. Extended descriptions of apparel figure repeatedly in all variations of the form … Romantic authors draw unconsciously on cultural conventions and stereotypes that stipulate that women can always be characterized by their universal interest in clothes'.[6] This proliferation of detail also characterizes the steampunk romance, as in this example from MacAlister's *Steamed*:

> 'That's a hell of an outfit', he said, and before I could say anything, moved around behind me, examining the back side. 'Incredible. It's just incredible. I love the scarlet coat. Steampunk, right? You don't see much scarlet in steampunk outfits. Most folks go in for browns and blacks, but the scarlet looks really good, even though you have red hair. I was always under the impression that redheads weren't supposed to wear red, but it looks good on you. And I *really* like the corset … I mean, what man wouldn't love the effect of a corset on a woman's …'[7]

It is very difficult to read this as anything other than an example of the male gaze, functioning to construct women as objects of desire, as Laura Mulvey has clearly articulated: 'In their traditional exhibitionist role women are simultaneously looked at and displayed, with their appearance coded for strong visual and erotic impact so

that they can be said to connote *to-be-looked-at-ness*.'⁸ Of course,
women readers of romance fiction might be situated as spectator in
Mulvey's scheme, rendering the romance heroine a mirror of identity,
something to which the spectator aspires. It is possible to argue that
romance transcends the subject/object binary and in fact positions
women readers as 'both subject and object of the gaze'.⁹ The heroine
in the novel, Octavia Pye, is frequently associated with gloves, dresses,
corsets (and the effects therein on her décolletage), carefully aligning
femininity, visual pleasure and commodity in a highly conservative
way. Julie Anne Taddeo discussed the corset in steampunk fiction
and maintains that it functions in *Steamed* as 'in an announcement
of a woman's place in the public sphere, clad for battle alongside, or
against, men and cyborgs'.¹⁰ The notion of the steampunk corset as
emancipatory is not new. As noted in the Introduction, Valerie Steele
has identified how the corset is an unstable signifier, invested with
specific ideological burdens at different historical moments. However,
it is imperative to reference the section of *Steamed* under discussion.
The purported hero, Jack Fletcher, suggests that Octavia Pye, the
alternate universe/nineteenth-century heroine, should wear her corset
on the outside, as steampunk women do in the twenty-first century:
'Don't you think it gives you a kind of dashing look? Somewhat devil-
may-care? Something that says you're not a slave to convention, that
you set your own trends? … All the steampunk ladies I met wore their
corsets outside their clothes. I never once saw one hide hers.'¹¹ Clearly,
the narrative is seeking to navigate the temporal dissonance between
Octavia and Jack and their resulting different perspectives. Octavia
suggests wearing underwear on the outside 'tells more of a state of
mind so confused, I think it would be safer to be locked inside an
asylum than left to wander the streets with my clothing worn inside
out'.¹² But more importantly, Taddeo's optimistic analysis overlooks the
fact that Octavia is invited to wear her corset on the outside *by a man*.¹³
Whilst it is important to note that this embedded narrative ('The Log

of the HIMA *Tesla*) is authored by Octavia, and thereby might overall reflect a female-centred experience, it also grants agency to the hero: his gaze constructs her identity.[14] As such, the romance is perhaps best experienced as an ambivalent statement on gendered clothing. Indeed, as Mary Talbot has noted, the detailed attention to clothing in romance novels serves to 'articulate a fashion discourse, spilling into a discourse of sexuality in which sexual difference is maximized. The details of "feminine" clothing contribute to eroticizing the difference between masculine and feminine'.[15]

The intersection of steampunk and romance provides an articulation of the ways popular cultural genres engage with conservative gendered discourses, and also how far they may provide a challenge to narratives of sexual and gender normativity. We might note first of all that most critics of romance (Janice Radway and Tanja Modleski among them) identify romance as a profoundly ambiguous genre: mass produced, it may do very little to challenge women's roles in marriage, in the home or in the workplace: 'it supplies vicariously those needs and requirements that might otherwise be formulated as demands in the real world and lead to the potential restructuring of sexual relations'.[16] Indeed, the models of men and women that romance provides are often highly conventional:

HERO:

1. Invariably tall, lean, white and ruggedly handsome
2. Has animal magnetism
3. Someone to be obeyed both professionally and personally
4. Sexually proficient and experienced – discovers heroine's sexuality
5. Affluent and successful 'since no one dreams of marrying a wimp' (Mills & Boon)
6. Represents paternal power and a hint of violence
7. Not dangerous or wicked at all, but misunderstood.

HEROINE:

1. Beautiful white woman ('young, spirited and inwardly vulnerable' – Mills & Boon)
2. Sexually inexperienced
3. Can be an independent working woman and may be ambitious but is concerned with upward mobility (secret desire for the security of marriage)
4. Tormented by uncontrollable urges – women suppressing their instincts and confused by a desirable man's attentions
5. These unruly emotions are then expressed as anger (anger as sublimated desire).[17]

Relationships are almost inevitably heterosexual and end if not in marriage, then at least in the promise of a secure, fulfilling and permanent union.

Several critics have also identified how romances have been compelled to acknowledge feminist principles. Radway noted that the advance of feminism has necessitated a revision of the romance novel's lead heroine: 'The contradictions within the genre have been intensified by a tendency to consolidate certain feminist agendas for women in the character of a working, independent heroine even while disparaging the women's movement itself, usually through the speeches of the hero.'[18] The resultant text often has a spirited or feisty heroine, who is no longer a virgin, but whose radical potential is often foreclosed by the recourse to heteronormativity and ultimately conventions of femininity. We can see this updated idea of the romantic heroine in MacAlister's novel, *Steamed*. Octavia is an Aerocorps captain on her first mission leading a crew of scallywag men on the airship, *Tesla*. However, the indeterminacy of her empowerment is obvious in an early scene with crewmember Dooley who seeks to test her knowledge of ship engineering:

'You have delivered your message, and may return to your duties'. I spoke in what I hoped was an authoritative, yet kindly, tone. I didn't want to be perceived as an ogre to the crew, not on this, my first assignment. Yet the seven other individuals on board must acknowledge my position of command, or it would all end badly. Firm but tempered, that was the key.[19]

Octavia is aware of her anomalous position, and her tentative 'hopefulness' about her tone suggests a great deal about the ways in which romance negotiates feminism: she hopes to be 'kindly' and 'tempered' – there is none of the brusque authoritativeness we might associate with the male hero's management. Rather it seems to represent a particularly feminine mode of empathic leadership.

More troubling, perhaps, is the way in which the hero of the novel, Jack Fletcher, makes his incursion into the steampunk world. Jack works at Nordic Tech, some form of 'geekified' scientific research facility in which female receptionists flirt with him outrageously.[20] He claims his 'wild ladies' man' status is unfounded, but that he is happy to play up to the role.[21] A woman called Minerva circles him saying, 'He's just like Indiana Jones, isn't he?'[22] Clearly, despite disavowals, Jack is being set up as our stereotypical romance hero. His sister, Hallie, pays a visit to the lab and starts the chain of events which will propel them both into Octavia's life:

'No, you idiot! The lid is off and you're shaking the canister. It's very volatile!'

'This?' She looked down at the helium. 'It's just a thermos of coffee. How can coffee be volatile?'

'It's not coffee – it's liquid helium'.

'Helium?' She held the canister up as if she could see through the stainless steel walls. 'What on earth are you doing with helium?'

'We use it to cool the core of the chip when it's being tested. Now set it down very carefully'.

'Oh, like canned air? I use that all the time at home on my stereo.
I like the way the bottle frosts up when you use it for a while.'[23]

Cue a chemical explosion, and Hallie and Jack are transported to
an alternate universe, and Octavia's airship. Thus whilst espousing
the comparatively feminist idea of a female airship captain, the
text also rejects such radicalism in several ways. First of all,
science, as a discourse, is explicitly gendered masculine – women
have no place in this environment except as giggling, infatuated
receptionists. The exchange between Jack and his sister, moreover,
quite clearly delineates the objective pursuit of rational knowledge
and the scientific endeavour as masculine: women entering this
field merely cause chaos and demonstrate their lack of ability
and general ineptitude. Evelyn Fox Keller has identified how 'the
traditional naming of the scientific mind as "masculine" and the
collateral naming of nature as "feminine"' is still a prominent binary
opposition in academic discourses.[24] Whilst Donna Haraway and
others have challenged such a dichotomy, this gendered history is
especially pertinent to steampunk romance as an emergent genre.[25]
Steampunk may have a radical agenda in arts and crafts terms, and
in literature, it functions to reclaim lost voices. Ada Lovelace, for
instance, features prominently in several steampunk narratives, and
her recuperated visibility accords with what Sally Gregory Kohlstedt
has described as a bid to 'reconcile women's stories with the existing
historical narratives of science, to show their relationship to that
history'.[26] This trajectory is discernible in material such as Sydney
Padua's *The Thrilling Adventures of Lovelace and Babbage* (2015),
which foregrounds Lovelace's contribution to the first computer, as
well as the *Girl Genius* series of graphic novels and fiction by Phil and
Kaja Foglio, in which our heroine, Agatha Heterodyne, is revealed
to be a scientific prodigy, much to the surprise and consternation
of many male characters around her. Interestingly, the first volume
of the series, *Agatha Heterodyne and the Beetleburg Clank* (2006),

parodies the notion of romance: the evil Baron Wulfenbach assumes the genius inventor of a robot ('clank') is Agatha's 'soldier lover', and not Agatha herself.[27] By identifying historical limitations placed on women such as discrimination, access to education and social censure, we can recover women's submerged experiences in science.[28] What *Steamed* does, however, is determine science as a man's terrain where a woman can be nothing but trouble.

If Octavia is an airship captain, a woman with a career, and a leader, she is also very much the romance heroine. We have all the familiar tropes of male pursuit, female unwillingness: "'I am *not* going to be charmed by that rogue" I muttered to myself as I stalked down the hallway toward the galley.'[29] Additionally, we have rivals for Octavia's affection and Jack's concomitant jealousy: "'I assume it's from your friend – it's just signed A at the bottom. It says *My very dearest Octavia*." He frowned and shot me a look. "You did say everything was over between you two?"'[30] Most significantly, perhaps, whilst Octavia acknowledges she has had three lovers (and they recur in the story as romantic foils), it is Jack who 'reveals' her sexuality. Octavia warns Jack 'I'm not quite so easily aroused as you obviously are. I didn't wish for you to be disappointed in what is lacking in me.'[31] He then proceeds to give her the quickest and most intense orgasm she has ever had, four minutes and twenty seconds: 'my body was suffused with warmth that started in my nether parts, and spread in big, rolling waves of pleasure outward to the farthest points of my body'.[32] Rather than negotiate the sexual complexity of the biology of women, the text simply suggests women only need the right man to show them how to achieve pleasure. Similarly, the text cannot reconcile the traditional romance plot with the feisty independence of the airship heroine:

> You like to call the shots … That's a new experience for me. The women I've been with have all been content to let me set the pace. Tell you what – we'll take turns. You let me take the lead this time, and you can have it the next time, OK?[33]

Incapable of resolving the tension between the romance plot and the steampunk heroine, the text hovers in a curious indeterminacy – neither explicitly progressive nor entirely conservative.

Gail Carrier's 'Parasol Protectorate' Series

In many instances in the popular imagination, Victorian society is seen to be a time of manners, civility and elegance. Nostalgic desire, the attempt to replicate a prior period of history, has its roots in retrosexuality, as discussed in the Introduction. Diane Negra notes that 'disordered temporality' marks our post-feminist moment: 'When we can't confidently see a way forward we very naturally look back.'[34] In steampunk romance texts, it is frequently the case that a more radical agenda is juxtaposed alongside a traditional notion of gender relations. This accords with Rosalind Gill's work on post-feminist romance. For Gill, one of the ways we can interpret post-feminism is that it adopts feminism and at the same time rejects it: 'What makes contemporary media culture distinctively postfeminist, rather than pre-feminist or anti-feminist, is precisely this entanglement of feminist and anti-feminist ideas ... feminism is not ignored or attached ... but is simultaneously taken for granted and repudiated.'[35] Gill notes that post-feminist heroines are often more emancipated than their predecessors but that this is also somewhat illusory:

> They value autonomy and bodily integrity and the freedom to make individual choices. What is interesting, however is the way in which they seem compelled to use their empowered postfeminist position to make choices that would be regarded by many feminists as problematic, located as they are in the normative notions of femininity. They choose, for example, white weddings, downsizing, giving up work or taking their husband's name on marriage.[36]

In many of her so-called choices, Gail Carriger's Alexia Tarabotti accords with this post-feminist model. She is the heroine in the 'Parasol Protectorate' series of romance novels, set in a steampunk world where vampires and werewolves live in everyday society, and dirigibles are the chosen mode of travel. She is also a spinster who, despite delighting in her freedoms, at the end the first novel *Soulless* (2009), marries a werewolf (and takes his surname) and in subsequent books has a child, called Prudence. As 'preternaturals' are thought to be incapable of reproduction with 'supernaturals', Alexia's husband assumes she has been unfaithful, which introduces the theme of the Victorian 'fallen woman'.[37] Mike Perschon has argued that Alexia signifies 'a strong sense of agency', given that during her pregnancy, she remains active and flouts conventional representations of health and well-being of mother and baby.[38] However, this idea of choice is also very much a post-feminist trope. Ultimately occupying a traditional place of domesticity and femininity (as wife and mother), Alexia does very little to challenge the status quo. In fact, as Alexia demonstrates, the whole rhetoric of choice in post-feminism often works to shore up some very traditional choices for women: 'Women are endowed with choice so that they can then use their "feminist" freedom to choose to re-embrace traditional femininity'.[39] In an interview with CNN, steampunk romance writer Kady Cross, author of *The Steampunk Chronicles* series (2011–2014), discusses the position of women in the literary subculture. Cross explains that 'in a steampunk world, women can be anything'.[40] Certainly, Carriger's heroine seems invested in pursuing a career in the Bureau of Unnatural Registry (BUR), a sort of covert Civil Service. Alexia explains to Lord Maccon that 'I would so like something useful to do'.[41] However, whilst this statement not only testifies to the notion of class privilege (a job might be useful but is not essential in Alexia's upper middle–class worldview), it is also the case that even with a wealth of post-feminist choice, women such as Alexia are still seen to make some very conventional decisions.

In the first novel of the series, Alexia was judged critically by her family because she wasn't married, which initially implies she is unconventional. Her mother, a satirical portrayal of the aspirational Mrs Bennett from Jane Austen's *Pride and Prejudice* (1813) desperately trying to marry off her daughters, offers her tart speculation on Alexia: 'there was something about Alexia, something … revoltingly independent.'[42] Alexia's family disapprove of her autonomy, her wit and her intelligence (which they feel prevent any right-thinking man in taking her as his wife). Despite this, her spinster state in fact allows her untold freedoms:

> Under ordinary circumstances, walks in Hyde Park were the kind of thing a single lady of good breeding was not supposed to do without her mama and possibly an elderly female relation or two in attendance. Miss Tarabotti felt such rules did not entirely apply to her, as she was a spinster.[43]

Alexia is also a somewhat unconventional heroine. In the opening pages of the novel, Alexia confronts a vampire who attacks her because (as Lord Maccon identifies) she is 'without a chaperone. An unmarried female alone in a room in this enlightened day and age'.[44] Of course we are supposed to read this knowingly, especially given the fact that Alexia can counter the supernatural powers of a vampire with her own preternatural abilities, or 'soullessness'. However, this first scene also identifies some very conventional post-feminist tropes, especially with reference to women and food. The prose is peppered with references to food ('she was particularly fond of treacle tart and had been looking forward to consuming that precise plateful') evidently in an attempt to present Alexia as one who has a reckless approach to body management. A significant proportion of Alexia's subsequent dialogue with Lord Maccon relates to food – 'comestibles' she has missed because she was fighting a vampire, why the party doesn't have good catering, the loss of a good treacle

tart. More generally, whilst the text frequently deploys comedic metaphors and symbolism related to food, all of which identifies the heroine as a (literal) consumer: clothes, food, materialism all function to correlate the feminine with consumption. It also means that femininity is inflected with aesthetic judgement closely aligned with social class: whilst sexual freedom is celebrated, the post-feminist text 'shies away from vulgarity and poor taste – profoundly classed attributions ... The triumph of the commodified aesthetic over the moral can be seen in the way [the protagonists] differentiate themselves from other women who dress badly or have poor interior design taste, etc'.[45] This can be seen most effectively in Alexia's treatment of her friend, Ivy Hisselpenny (later Mrs Tunstell). Ivy's outrageous hats and attire mark her out as lower class (she is 'the unfortunate victim of circumstances that dictated she be only-just-pretty and only-just-wealthy, and possessed of a terrible propensity for wearing extremely silly hats').[46] The series lavishes descriptions on Ivy's outlandish attire, but only to mark her out as demonstrating poor taste, associating her with a nouveau riche aesthetic of conspicuous consumption and excessive display: 'Ivy reappeared in a walking dress of orange taffeta ruffled to within an inch of its life, and a champagne brocade overjacket, paired with a particularly noteworthy flowerpot hat. The hat was, not unexpectedly, decorated with a herd of silk mums and here and there a tiny feather bee on the end of a piece of wire'.[47] This episode not only underscores the post-feminist alignment of femininity and commodity, but it also represents a circumvention of sorority. Rather than emphasizing a close female friendship, the narrative seems to focus on Alexia's acerbic comments related to Ivy's style.

Humour aside, Alexia's relationship to commodity and especially food is not a gesture which *subverts* normative ideas of the body, as much as it *inverts* these discourses.[48] Alexia is extraordinary because she seemingly doesn't care about managing her 'generous curves'.[49]

However, this is compromised by other statements which emphasize some very stereotypical (if strategic) ideas about femininity: 'Miss Tarabotti knew full well her own feminine appeal. The kindest compliment her face could ever hope to garner was "exotic", never "lovely"'.[50] Whilst identifying these discourses of female physical beauty, the text does very little to challenge them (it inverts rather than subverts). We are not left questioning ideas of femininity or gendered aesthetics, as much as we are shown they exist. Indeed, in post-feminist fiction, the heroine is often 'presented as having been transformed from "ugly duckling", in order to rebut readers' potential envy or hostility (and also in consonance with the makeover paradigm that has dominated contemporary popular culture)'.[51] This is very much the case in Carriger's writing and perhaps is influenced by Charlotte Brontë's own 'ugly duckling' in this respect, the Victorian governess, *Jane Eyre* (1847). By the end of the novel, however, the emphasis is on Alexia's desirability to the opposite sex:

> 'This has got to stop', she insisted. 'We are in danger, remember? … '
> 'All the more reason to grasp the opportunity', he insisted, leaning in and pressing her lower body against her.[52]

The text also carries the burden of some distinctly racialized overtones. The reason why Alexia is 'exotic' is because of her ancestry: she is graced with 'the complexion of one of those "heathen Italians," as her mother said, who never colored, gracefully or otherwise. (Convincing her mother that Christianity had, to all intents and purposes, originated with the Italians, thus making them the exact opposite of heathen, was a waste of time and breath)'.[53] The text neatly circumvents criticism of racialized otherness (essentially Alexia is not attractive because she is too dark) and instead offers a very Eurocentric justification. Italians cannot be heathens because of their Christianity, which leaves the discourse of dark complexion equals uncivilized unfortunately intact. The text doesn't challenge these binaries or

fixed identities as much as it locates Otherness very conventionally 'elsewhere' than Europe. The final novel in the series, *Timeless* (2012), has Alexia travel to Egypt, a source of mystery and Otherness:

> Alexia absorbed the quality of the place: the subdued tranquillity of *exotic* buildings, broken only occasionally by the white marble turrets of mosques or the sharp knitting-needle austerity of an obelisk. She thought she could make out ruins in the background. It was mostly sand colored, lit up orange by the sun – a city craved out of the desert indeed, utterly *alien* in every way. The thing it most resembled was a sculpture made of shortbread.[54]

The incommensurability of East and West is emphasized through the absurdity of comparing the city to a biscuit (Alexia cannot comprehend the country), whilst the East provides little more than an exciting background to the adventure narrative.

However, any radicalism in the text is dissipated, as the first novel of the series concludes with Alexia's marriage to Lord Maccon the werewolf. This accords with Rosalind Gill analysis of 'Western culture's obsession with heterosexual romance as a discourse' where she explains, 'Romance is one of the key narratives by which we are interpellated or inscribed as subjects'.[55] Similarly, the foreclosure of any non-normative potential suggests the pressures on the romance genre to conform to a traditional stereotype of romance and heterosexuality. As Stacey and Pearce have observed: 'Despite the fact that classic romances are centred on heterosexual relationships in which male and female partners exact very clearly delineated roles, Western culture continues to naturalise and essentialize such conventions and thus make visible the *gendering* of those roles and the power dynamics involved.'[56] We might note that the 'Parasol Protectorate Series', in which Alexia is the heroine, engages with such romantic conventions quite closely. As a spinster, Alexia is admittedly at odds with the more typically young and naïve heroine, but she nonetheless represents

traditional inexperience in terms of relationships, and towards the end of the first novel, there is a definite sense that her husband will be 'taming' her. In a scene just after their marriage, Alexia and her husband are travelling in a carriage, during which point he opens the front of his breeches and says 'Now sit'. Alexia's response is 'there were destined to be some arguments in their relationship that she could not hope to win. This was one of them.'[57] More worrying is the rhetoric of no-means-yes in this scene: Alexia registers some distaste at her new husband attempting to seduce her in a carriage. Lord Maccon continues the seduction:

> Something extremely odd and tingly was beginning to occur in her nether regions. 'I shall take that as a no', said her husband, and began to move, rocking with the motion of the carriage. What happened after that was all sweat, and moans, and pulsing sensation to which Alexia decided, after about one second of deep deliberation, she was not averse.[58]

As many commentators have noted, the romance genre flirts dangerously with rape in such scenes: 'In rape the intention to dominate, humiliate and degrade is often disguised as sexual desire. In romances this is reversed: sexual desire is disguised as hostility and dominance … As readers, we are forced to collude with the idea that the hero knows better than the woman herself what she really wants.'[59]

Similarly, Alexia is accused of an infidelity of which she is entirely innocent (the offspring of a woman without a soul and a werewolf was thought to be impossible in this alternative world), but alongside accusations of treachery lurk a very familiar romance trope: violence. The narrator notes, 'Conall had committed many a violent act around Alexia during their association, not the least of which was [to] savage a woman … at the supper table, but Alexia had never been actually afraid of him before. She was afraid of him now.'[60] The emphasis on his brutality and animalistic passions accord very closely with the stereotype of male romance narratives articulated by Pearce

and Stacey: 'One standard Mills and Boon formula, for example, is precisely the taming of the male "boor" and the heroine's eventual love for the civilized beast.'[61] Alexia, in common with countless romance stereotypes before her, meets her future partner an 'initial unpleasant encounter with an aristocratic or otherwise powerful man (whose behaviour is misunderstood)'.[62] During this time, his wild otherness is emphasized: '[His] voice was low and tinged with a hint of Scotland' and 'brooks no refusal', whilst he is also described as follows: 'His dark hair was a bit too long and shaggy to be de mode, and his face was not entirely clean-shaven, but he possessed enough hauteur to carry this lower-class roughness off without seeming scruffy. He probably preferred to wander about bare-chested at home. This idea made her shiver oddly.'[63] Of course Carriger is working with the paradigm of the romantic hero here, who represents a masculinity expressed in brutality, curtness and rudeness (we need only think of Heathcliff in Emily Brontë's *Wuthering Heights* (1847) or her sister Charlotte Brontë's novel *Jane Eyre* (1847) with Mr Rochester as brooding hero in order to recognize the pattern).

Carriger's appropriation of literary convention also marks the foreclosure of revolutionary potential and relates to the representation of non-normative sexualities in the series. Alexia encounters a Frenchwoman called Madame Lefoux, who is a scientist, a lesbian and a cross-dresser:

Alexia thought, without envy, that this was quite possibly the most beautiful female she had ever seen. She had a lovely small mouth, large green eyes, prominent cheekbones, and dimples when she smiled, which she was doing now … the woman was also dressed head to shiny boots in perfect and impeccable style – for a man. Jacket, pants, and waistcoat were all to the height of fashion. A top hat perched upon that scandalously short hair, and her burgundy cravat was tied into a silken waterfall. Still, there was no pretence at hiding her femininity. Her voice, when she spoke, was low and melodic, but definitely that of a woman.[64]

So again we might note the focus on fashion which features in romance fiction, but it is also a hallmark of post-feminism, in which women are interpellated as consumers and neoliberal subjects. Madame Lefoux is dressed in trousers, scandalous in the Victorian period proper. The novel flags up not the romance and elegance of traditional female attire but also the utter impracticalities associated with such apparel: '[Alexia] envied Madame Lefoux the masculine attire. Her own skirts were getting caught about her legs.'[65] As a woman and a scientist, Madame Lefoux appears to resist the very traditional notions of femininity in the Victorian period: she is not only unmarried and a lesbian, but she is an inventor whose secret room behind a hat shop reveals a workspace full of cogs and gears, as well as research books and diagrams. In short, she has assumed a masculine role in all areas of her life, rejecting the convention of the fireside and nurturing a husband. However, she is also very much a stereotypical lesbian. Rosalind Gill has observed that post-feminist fiction attempts to engage with homosexual relationships, but that these tend to be one-dimensional, homophobic or employed in order to naturalize heterosexuality: 'homosexuality is made "contingently visible."'[66] Madame Lefoux's status as lesbian is predicated on her appearance, her masculine fashion choices, her rejection of femininity, her *difference* to other women, which essentially leaves heterosexuality untouched as the status quo. Her homosexuality conforms to stereotype, rather than subverts it. Indeed, whilst the visibility of Lefoux's scientific pursuits accords with the recuperation of submerged narratives which we associate with steampunk practice (and women in science, as discussed earlier in this chapter), it is also important to note that any sexual radicalism is entirely dispelled.[67] Despite Alexia's marriage, there are repeated hints of her curious sexual frisson with Madame Lefoux: 'Green eyes met her brown ones for a long moment. Two sets of goggles were no impediment, but Lady Maccon could not interpret that expression. Then the inventor

reached up and stroked the back of her hand down the side of Alexia's face. Alexia wondered why the French were so much more physically affectionate than the English.'[68] Indeed, Madame Lefoux was originally designed by the author to be Alexia's love interest. Carriger has explained as follows:

> Inside information into the authors [*sic*] head ... I had originally intended Madame Lefoux to be a [*sic*] alternate love interest. And she is definitely interested in Alexia. But any escalation of romance between them felt forced, and I realized that it was too out of character for Alexia. Unfortunately, poor Madame Lefoux is left rather lovelorn as a result.[69]

This heteronormativity is also apparent in the final novel of the series, where Alexia and Madame Lefoux discuss their first meeting:

> Madame Lefoux took Lady Maccon's hand, becoming serious in a way that made Alexia nervous. Her green eyes were troubled. 'You never even gave me a chance. To determine if you liked it.'
> Alexia was surprised. 'What? Oh.' She felt her body flush under the constriction of stays. 'But I was married when we met.'
> 'I suppose that is something. At least you saw me as competition.'
> Alexia spluttered, 'I ... I am very *happily* married.'[70]

Lefoux therefore is constructed as a threat to the traditional love and marriage plot. Interestingly, but problematically, the queer narrative is foreclosed by the pressures of heteronormativity, so only a spark of potential remains behind the traditionalism of the marriage plot.

A similar trajectory in terms of homosexual representation can be noted in the character of Lord Akeldama, who is obviously drawn from late Victorian discourses on homosexuality, established during Oscar Wilde's trial for gross indecency in 1895.[71] Carriger has identified Lord Akeldama as Alexander the Great (which aligns his queerness with the Greek tradition in terms of male relationships,

which Wilde drew from extensively in his alignment of Hellenism
and aestheticism).[72] However, Akeldama's address on Russell Square
is crucial, as it is in that very location (31 Russell Square) that Wilde
spent his final night in London on 19 May 1897 before his exile to
France.[73]

Lord Akeldama is introduced to the reader in the following
description:

> *Outrageous* was a very good way of describing Lord Akeldama.
> Alexia was not afraid of outrageousness any more than she was
> afraid of vampires, which was good because Lord Akeldama was
> both.
>
> He minced into the room, teetering about on three-inch heels
> with ruby and gold buckles. 'My darling, *darling* Alexia.' Lord
> Akeldama had adopted use of her given name within minutes of
> their first meeting. He had said that he just knew they would be
> friends, and there was no point in prevaricating. '*Darling!*' He
> also seemed to speak predominantly in italics. 'How perfectly,
> deliciously, *delightful* of you to invite *me* to dinner. *Darling.*'
>
> Miss Tarabotti smiled at him. It was impossible not to grin at
> Lord Akeldama; his attire was so consistently absurd. In addition
> to the heels, he wore yellow checked gaiters, gold satin breeches, an
> orange and lemon striped waistcoat, and an evening jacket of sunny
> pink brocade. His cravat was a frothy flowing waterfall of orange,
> yellow, and pink Chinese silk, barely contained by a magnificently
> huge ruby pin. His ethereal face was powdered quite unnecessarily,
> for he was already completely pale, a predilection of his kind. He
> sported round spots of pink blush on each cheek like a Punch and
> Judy puppet. He also affected a gold monocle, although, like all
> vampires, he had perfect vision.[74]

Notably, this description of Akeldama identifies itself as Wildean
in a number of ways. As well as the studied display of a leisured
and upper-class gentleman, both Wilde and Akeldama are
quite anachronistic in their dress: Akeldama's clothing reveals

the influence of Rococo, whilst Wilde praised the fashion of the eighteenth-century in England, which he explained was 'peculiarly gracious and graceful. There is nothing bizarre or strange about it, but it is full of harmony and beauty'.[75] Wilde opted for pseudo-medieval garb in his American lecture tour of 1882, where he designed his own suits. He explained he wanted 'Francis I coats of "tight velvet doublet, with large flowered sleeves and little ruffs of cambric coming up from under collar" and "two pair of grey silk stockings to suit grey mouse-coloured velvet". Wilde thought that sleeves "stamped with large pattern" would "excite a great sensation"'.[76] Wilde's understanding of spectacle and performance, as well as his use of classical/historical apparel, has clear parallels with Akeldama. The other discernible feature in Akeldama's description is the use of colour: Akeldama uses yellow, orange, gold, pink and lemon as part of his colour palate, whilst Wilde suggests, 'There would be more joy in like if we were to accustom ourselves to use all the beautiful colors we can in fashioning our own clothes. The dress of the future … will abound with joyous color'.[77] As an advocate of the Dress Reform movement (his wife, Constance Wilde, was also a vocal member), writer in *The Pall Mall Gazette*, and editor of *The Woman's World* (1887–1889), Wilde emphasized the need for comfortable clothes for men and women, influenced by classical models of dress design. Such clothes were also infused with beauty and careful design, including attention to embroidery, colour schemes and drapery which flattered the body.[78]

In common with Wilde, Akeldama is intelligent, witty, affected, flamboyant. As the description above indicates, his fashion sense is gaudy but well crafted, and his effeminacy is a key component of his identity (he wears heels, he minces, he wears make-up). He is ascribed 'foppishness in spades' and given to 'limp' wrists.[79] Indeed, his penchant for extravagant interior decoration and dress, his affected speech, alongside his affection for Biffy, his

'drone' or companion (whose relationship with Lord Akeldama is foreclosed as Biffy dies in the series) mark him as feminine, and the text uses these feminine signifiers as markers of Akeldama's gay identity. For instance, in *Timeless*, Lord Akeldama is described as being 'very motherly'.[80] One way in which we might critically appraise this characterization is through the notion of camp. Susan Sontag has described camp as 'love of the unnatural: of artifice and exaggeration ... it incarnates a victory of "style" over "content," "aesthetics" over "morality," of irony over tragedy ... Camp introduces a new standard: artifice as an ideal, theatricality'.[81] Clearly Lord Akeldama's affectation and love of artificiality (in attire, speech patterns and mannerisms) suggest the camp male. Relatedly, Gregory W. Bredbeck has identified a correlation between camp, Oscar Wilde and Havelock Ellis's theory, *Sexual Inversion* (1897), suggesting that 'what is at stake here is ... the "new" invention of *fin de siècle* sexology that initiated the construction of the modern homosexual'.[82] The theory of the 'invert' sought to identify gay men as feminine and lesbians as masculine and might be located in such works as *The Well of Loneliness* by Radclyffe Hall (1928). This theory amalgamated camp sensibilities, gay masculinity and effeminacy: 'Wilde's mythical status as the origin of modern gay Camp has been constantly reinscribed'.[83] Indeed, Bredbeck notes that many critics have taken for granted the alignment of Wilde, gay identity, femininity and camp, and that this is frequently located as a resistant gesture, but that it can also imitate assumptions about gay masculinity.

This notion of the effeminate male actually has much in common with aestheticism of the late nineteenth century (the correlation with gay identity emerged later). As Talia Schaffer notes,

> The male Aesthetes, especially Oscar Wilde, were often condemned
> for effeminacy, both because they worked in fields traditionally

associated with women and because they borrowed elements of woman's attire. In the Aesthete's desires to beautify everyday life, they moved into areas that had historically been associated with women: the decoration of homes and bodies.[84]

Alan Sinfield's work on Oscar Wilde has carefully explained that the modern identity of the homosexual, as being correlated with femininity, had little currency in the nineteenth century.[85] Daniel Orrels asserts that 'there was no such thing as a classic homosexual trait in the 1890s … the traits are in fact familiar characteristics of the dandy-aesthete'.[86] Indeed, as Talia Schaffer explains in her work on aestheticism and male sartorial codes, 'the conjunction of effeminacy and homosexuality was in fact produced by the visual spectacle of Wilde's trial in 1895, where the effete dandy was proven identical with the "somdomite," as Queensberry called him'.[87] In fact, scholars of Wilde's fiction, such as Sinfield in his reading of 'The Portrait of Mr W. H.', suggest the notion of artistic forgery in the story actually points to 'Wilde's interest in discovering a homosexual identity, but also his scepticism about how that might be achieved'.[88] Sinfield also notes that such queer fiction might be a way of claiming homoeroticism without 'accepting the terms and conditions, social and psychological, of being "gay"'.[89] The steampunk appropriation of this Victorian model of queerness, therefore, might be seen as somewhat problematic in Carriger's work, implicated as it is in a stereotypical alignment of male homosexuality and effeminacy, as well as replicating the stigmas derived from the Wilde trial in 1895.[90]

Lord Akeldama is not only homosexual, he is also a vampire, and the juxtaposition of queer and this familiar gothic entity has a number of interesting effects. Tanya Krzywinska has remarked that 'the vampire, throughout its history, functions as a means of articulating what is epistemologically constructed as both "unnatural" and unspeakable'.[91] Whilst the cornerstone of Wilde's trial was the 'unspeakable' love

that dare not speak its name (from Lord Alfred Douglas's poem 'Two Loves'), the idea of the 'unnatural' emerges in the figure of the vampire himself. Interestingly, whilst Lord Akeldama is clearly intended to be a sympathetic character for the reader, in positioning the feminized vampire against hypermasculine images of the romantic ideal (Lord Maccon), the text seems to register a partiality for normative and desirable masculinity, through the heterosexual male love interest. In his discussion of *Interview with the Vampire* (1994), Harry Benshoff has noted that whilst the film is sympathetic to the figures of Lestat and Louis, the queer Otherness of the vampire is also monstrous: 'The overall social effect of such images and discourses – even when couched within a queer theoretical paradigm – has been and continues to be the ongoing monsterization of homosexuality.'[92] Indeed, George E. Haggerty suggests that 'the vampire also fulfils the needs of the straight world that attempts to repudiate the lure of darkness'.[93] Haggerty's argument is predicated on reading the homosexual vampire as late twentieth-century's fetish, which is also foreclosed in the service of normative values – so what is feared is also that which is desirable. Additionally, whilst the character of Lord Akeldama might attempt to represent gay identity positively, in fact, it merely buys into commonly vaunted tropes about male homosexuality: femininity, foppishness, effete masculinity. By the very same token, Madame Lefoux appears as a masculinized woman. In each instance, the text insists that the characters bear the burden of *visual* markers of homosexuality, as markers of difference, with the result that heterosexual sexuality is ultimately invisible and rendered the norm.

Conclusion

Through investigating the ways in which the conventions of romance coalesces with steampunk, this chapter has demonstrated the

intersection of these genres can provoke dialogues about history, sexuality and narrative. Whilst the emancipated post-feminist heroine in these stories can introduce different career trajectories, interests and practices for women, these are also frequently overturned by the recourse to a traditional narrative of heterosexual marriage. At the same time, the positivity of representing alternative forms of sexuality can be undercut by a recourse to stereotype and visual signifiers, such as clothing and fashion, to render 'gay identity' observable and detectible. Steampunk fictions can be interpreted as both conservative and revolutionary in these contexts, subjecting the sexualized subject to visibility, but also stereotype and ultimately critical surveillance.

Notes

1 M-L Kohlke, 'Into history through the Back Door: The "Past Historic" in *Nights at the Circus* and *Affinity*', *Women: A Cultural Review* 15:2 (2004), 153–66, 153.

2 Janice A. Radway, *Reading the Romance: Women, Patriarchy and Popular Literature* (Chapel Hill: University of North Carolina, 1991), p. 11.

3 Radway, *Reading the Romance*, 213. See Dana Wilson-Kovacs, 'Some Texts Do It Better: Women, Sexually Explicit Texts, and the Everyday', in *Mainstreaming Sex: The Sexualisation of Western Culture*, ed. Feona Attwood (London: I. B. Tauris, 2010), p. 160. See also Tania Modleski, *Loving with a Vengeance: Mass-Produced Fantasies for Women* (London: Routledge, 1982) and Mary M. Talbot, *Fictions at Work: Language and Social Practice in Fiction* (London: Longman, 1995).

4 See Stéphanie Genz and Benjamin A. Brabon, *Postfeminism: Cultural Texts and Theories* (Edinburgh: Edinburgh University Press, 2009), p. 132.

5 Jackie Stacey and Lynne Pearce, 'The Heart of the Matter: Feminists Revisit Romance', *Romance Revisited* (London: Lawrence & Wishart, 1995), p. 18.

6 Radway, *Reading the Romance*, 193.

7 Katie MacAlister, *Steamed* (New York: Signet, 2010), p. 40.

8 Laura Mulvey, 'Visual Pleasure and Narrative Cinema' (1975), in *Visual and Other Pleasures*, ed. Laura Mulvey (Basingstoke: Palgrave, 2009, 2nd ed), p. 19.

9 Rosalind Gill, *Gender and the Media* (London: Polity, 2007), p. 223.

10 Julie Anne Taddeo, 'Corsets of Steel: Steampunk's Reimagining of Victoria Femininity', in *Steaming into a Victoria Future: A Steampunk Anthology*, p. 45.

11 MacAlister, *Steamed*, 178.

12 MacAlister, *Steamed*, 178.

13 As a corollary, Whelehan comments that the Wonderbra is the style statement of the ladette. See Imelda Whelehan, *Overloaded: Popular Culture and the Future of Feminism* (London: The Women's Press, 2000), p. 9.

14 Gill, *Gender and the Media*, 224, references the navigation of the gendered gaze in romance fiction.

15 Talbot, *Fictions at Work*, 82.

16 Radway, *Reading the Romance*, 213. She also argues that readers claim 'change is being generated' as a consequence of romance fiction.

18 Radway, *Reading the Romance*, 15.

19 MacAlister, *Steamed*, 15.

20 MacAlister, *Steamed*, 7.

21 MacAlister, *Steamed*, 2.

22 MacAlister, *Steamed*, 6.

23 MacAlister, *Steamed*, 12.

24 Evelyn Fox Keller, 'Gender and Science: Origin, History, and Politics', *Osiris* Second Series, 10 (1995), 26–38, 29. See also 'Romancing the Helix: Nature and Scientific Discovery' by Sarah Franklin, in *Romance Revisited*, ed. Lynn Pearce and Jackie Stacey (London: Lawrence and Wishart, 1995).

25 See Donna Haraway, *The Haraway Reader* (London: Routledge, 2004).

26 Sally Gregory Kohlstedt, 'Women in the History of Science: An Ambiguous Place', *Osiris* Second Series, 10 (1995), 39–58, 41.

27 Phil and Kaja Foglio, *Girl Genius*, vol 1, 'Agatha Heterodyne and the Beetleburg Clank' (Seattle: Airship Entertainment, 2006), pp. 75–76.

28 See Autumn Stanley, *Mothers and Daughters of Invention: Notes for a Revised History of Technology* (Rutgers University Press, 1993). Only a tiny percentage of patents were ever issued to women, even in the twentieth century and this trend continues today. In the nineteenth century, this was partly because women were unable to apply for patents in their own name, as technically all their property belonged to their husbands.

29 MacAlister, *Steamed*, 68.

30 MacAlister, *Steamed*, 164.

31 MacAlister, *Steamed*, 175.

32 MacAlister, *Steamed*, 176.

33 MacAlister, *Steamed*, 173–174.

34 Diane Negra, *What a Girl Wants: Fantasizing the Reclamation of the Self in Postfeminism* (Abingdon: Routledge, 2009), p. 51.

35 Gill, *Gender and the Media*, 269.

36 Gill, *Gender and the Media*, 269.

37 See Mike Perschon, 'Useful Troublemakers: Social Retrofuturism in the Steampunk Novels of Gail Carriger and Cherie Priest', *Steaming into a Victorian Future*, for further discussion of Alexia as fallen woman.

38 Perschon, 'Useful Troublemakers', 30.

39 Gill, *Gender and the Media*, 243. See also Genz and Brabon, *Postfeminism*, 14, and Angela McRobbie, *The Aftermath of Feminism: Gender, Culture and Social Change* (London: Sage, 2009), pp. 59–60.

40 'Steampunk Powers Female Characters Forward', 16 November 2011. http://geekout.blogs.cnn.com/2011/11/16/steampunk-powers-female-characters-forward/ [accessed 23 August 2017].

41 Gail Carriger, *Soulless* (London: Orbit Books, 2009), p. 18.

42 Carriger, *Soulless*, 26.

43 Carriger, *Soulless*, 26.

44 Carriger, *Soulless*, 13.

45 Gill, *Gender and the Media*, 246–247. Also see Pierre Bourdieu, 'The Social Space and the Genesis of Groups', *Theory and Society* 14:6 (1985), 723–744, 724.

46 Carriger, *Soulless*, 27.

47 Gail Carriger, *Changeless* (London: Orbit Books, 2010), p. 18.

48 See Amanda DiGioia and Charlotte Naylor Davis, 'Cursed Is the Fruit of thy Womb: Inversion/Subversion and the Inscribing of Morality on Women's Bodies in Heavy Metal', in *Subcultures, Bodies and Spaces*, ed. Holland and Spracklen, 27–42.

49 Carriger, *Soulless*, 13.

50 Carriger, *Soulless*, 4.

51 Gill, *Gender and the Media*, 239.

52 Carriger, *Soulless*, 239.

53 Carriger, *Soulless*, 9.

54 Gail Carriger, *Timeless* (London: Orbit Books, 2012), p. 157. My italics.

55 Gill, *Gender and the Media*, 218.

56 Stacey and Pearce, 'The Heart of the Matter', 19.

57 Carriger, *Soulless*, 288.

58 Carriger, *Soulless*, 290.

59 Gill, *Gender and the Media*, 221–222.

60 Carriger, *Changeless,* 298.

61 Stacey and Pearce, 'The Heart of the Matter', p. 16.

62 Stacey and Pearce, 'The Heart of the Matter', p. 16.

63 Carriger, *Soulless*, 6, 11.

64 Carriger, *Changeless*, 64.

65 Carriger, *Changeless*, 135.

66 Gill, *Gender and the Media*, 233.

67 Lefoux has been given her own romance narrative in Carriger's *Romancing the Inventor* (2016).

68 Carriger, *Changeless*, 123–124.

69 'Character Study: Madame Genevieve Lefoux', 9 August 2011, http://gailcarriger.com/2011/08/09/character-study-madame-genevieve-lefoux/ [accessed 22 August 2017].

70 Carriger, *Timeless*, 111.

71 The fandom has also identified the issues with Madame Lefoux and Lord Akeldama. See http://www.fangsforthefantasy.com/2012/09/gblt-characters-in-parasol-protectorate.html [accessed 24 August 2017].

72 http://gailcarriger.wikia.com/wiki/Akeldama,_Lord#cite_note-7 [accessed 24 August 2017]. However, Carriger's character study

identifies the Wilde as an influence on the character, using a photograph of Wilde, *c.* 1894. http://gailcarriger.com/2010/12/15/lord-akeldama-character-study/ [accessed 24 August 2017]. See also Stephano Evangelista, *British Aestheticism and Ancient Greece: Hellenism, Reception, Gods in Exile* (Basingstoke: Palgrave, 2009). For Hellenism and homosexuality, see Richard Ellmann, *Oscar Wilde* (London: Penguin, 1998), pp. 27–28.

73 For details of Wilde's final day in England, see Ellmann, *Oscar Wilde*, 495–496.

74 Carriger, *Soulless*, 37–38.

75 John Cooper, *Oscar Wilde on Dress* (Philadelphia, PA: CSM Press, 2013), E-book, location 378.

76 Cooper, *Oscar Wilde on Dress*, location 270–276.

77 Cooper, *Oscar Wilde on Dress*, location 369.

78 For further on Wilde and dress reform, see Isobel Hurst, 'Ancient and Modern Women in the *Woman's World*', *Victorian Studies* 52:1 (2009), 42–51, 47–48. See also John Strachan and Claire Nally, *Advertising, Literature and Print Culture in Ireland, 1891–1922* (Basingstoke: Palgrave, 2012), Chapter 6, 'Oscar Wilde as Editor and Writer: Aesthetic Interventions in Fashion and Material Culture', pp. 137–155, and Paul Fortunato, *Modernist Aesthetics and Consumer Culture in the Writings of Oscar Wilde* (London and New York: Routledge, 2007).

79 Carriger, *Soulless*, 44.

80 Carriger, *Timeless*, 110.

81 Susan Sontag, 'Notes on Camp', from Susan Sontag, *Against Interpretation* (London: Vintage, 2001), pp. 275–288.

82 Gregory W. Bredbeck, 'Narcissus in the Wilde: Textual Cathexis and the Historical Origins of Queer Camp', in *The Politics and Poetics of Camp*, ed. Moe Meyer (London: Routledge, 1994), p. 55.

83 Bredbeck, 'Narcissus in the Wilde', 51.

84 Talia Schaffer, 'Fashioning Aestheticism by Aestheticizing Fashion: Wilde, Beerbohm, and the Male Aesthete's Sartorial Codes', *Victorian Literature and Culture* 28:1 (2000), 39–54, 39–40.

85 Alan Sinfield, *The Wilde Century: Effeminacy, Wilde and the Queer Moment* (London: Cassell, 1994), pp. 25–26.

86 Daniel Orrels, *Classical Culture and Modern Masculinity* (Oxford: Oxford University Press, 2011), p. 105.

87 Schaffer, 'Fashioning Aestheticism by Aestheticising Fashion', 39.

88 Sinfield, *The Wilde Century*, 19.

89 Sinfield, *The Wilde Century*, 20. See also Orrels, *Classical Culture and Modern Masculinity*, 189.

90 For a useful discussion of queerness, race and the dandy in steampunk fandom and cosplay, see Roger Whitson, *Steampunk and Nineteenth-Century Digital Humanities: Literary Retrofuturisms, Media Archaeologies, Alternate Histories* (London: Routledge, 2017), pp. 164–169.

91 Tanya Krzywinska, 'La Belle Dame Sans Merci?', in *A Queer Romance: Lesbians, Gay Men and Popular Culture*, ed. Paul Burtson and Colin Richardson (London: Routledge, 2005), p. 118.

92 Harry M. Benshoff, *Monsters in the Closet: Homosexuality and the Horror Film* (Manchester: Manchester University Press, 1997), p. 274.

93 George E. Haggerty, *Queer Gothic* (Urbana: University of Illinois Press, 2006), p. 167.

Conclusion

I opened this book with an anecdote about my own experiences of a steampunk festival, and I will close my analysis in a related way. In 2018, one of the largest steampunk festivals, the Steampunk World's Fair, demonstrated that some elements of the steampunk subculture still have much to learn about equality. The festival's organizer, Jeff Mach, stepped down in January following a wave of accusations taking their impetus from the #MeToo movement and the Harvey Weinstein sexual misconduct scandal in Hollywood. The festival has drawn up to 7000 steampunk attendees and was billed as 'the largest steampunk event in the world'.[1] Mach subsequently resigned from the festival, which has placed the future of the event very much in jeopardy.[2] Anonymous reports from men and women have implicated Mach in a series of sexual harassment accusations:

> I was 16 or 17 I think, from when I first started volunteering for JME [Jeff Mach Events]. Jeff took me aside, asked to do a favo[u]r for him, something about helping with a performer or something. Unthinkingly I was like, 'Okay, sure.' So he leads me to some clearly much older dude in the lobby, says, 'Hey, this is *Black Widow*. She's a Volunteer, and has to do anything I say. Her job is to keep you entertained and happy while we sort things out for you.' 'Anything?' asks the guy in a creepy tone. 'Yeah, it's her job to make you happy. She'll do anything.' … It didn't hit me until now just what he was implying. It wasn't the first, or the last time. I'm not the only one.[3]

These accusations have clear implications for any claim to steampunk being an exclusively radical movement. This case rehearses a very

traditional perspective of women as sexual objects, and whilst men have also come forward with stories of a comparative kind, it is clear that men wielding power in the subculture have some very unreconstructed notions about women and ownership, gender, sexuality and the body. It is also apparent, as Foucault argued in *The History of Sexuality*, that we are not as distant from the Victorian period (and its inequalities) as we might like to suggest. As I argued in the Introduction, and throughout this book, steampunk, like many subcultures, is fundamentally a politically ambiguous discourse, and this extends to its articulation of gender. In the preceding account of steampunk as a cultural, literary and artistic practice, I noted that steampunk can also be a challenging and radical form.

There are many instances of steampunk art, culture and literature which contest a correlation between steampunk and sexism, and steampunk and conservatism. Additionally, whilst 'steampunk' originated as a tongue-in-cheek term in the 1980s, it was still centre stage in the early part of the twenty-first century. The opening event of the Olympic Games in London (2012), directed by Danny Boyle, was 'spectacular, literate and often irreverent … [and] dramatized more than three centuries of British history, with a bucolic agrarian society giving way to Industrial Revolution and ultimately the digital age'.[4] Its use of steampunk motifs is especially discernible in its revival of themes and icons from Industrial Revolution. Jeff Vandermeer has suggested that steampunk can 'serve as a catch-all for the Industrial Revolution'.[5] Boyle deployed similar steampunk themes in Nick Dear's adaptation of *Frankenstein* at the National Theatre in 2011 (with Jonny Lee Miller and Benedict Cumberbatch), though this production's constructions of gender (including the introduction of a rape scene with the Creature and Elizabeth) might also be read as gratuitous and therefore problematic.

Steampunk takes its departure from Mary Shelley's 1818 novel, *Frankenstein*, among other ur-texts. Under Boyle's direction in the

play, we witness a spectacular staging of a huge locomotive engine readily identifiable as steampunk. Jenny McDonnell correlates this performance with the 2012 Olympic opening ceremony where Boyle symbolized the Industrial Revolution with heavy industry and machinery akin to the 2011 production of *Frankenstein*.[6] What is especially noteworthy about Boyle's Olympic vision is the foregrounding of steampunk imagery: nineteenth-century technology looms large here, with seven chimneys rising from a rural landscape, alongside five beam engines, six looms, a crucible and a waterwheel. Kenneth Branagh performs as Isambard Kingdom Brunel (reading Caliban's speech, 'Be not afeared. The isle is full of noises' from Shakespeare's *The Tempest*) and acts as a herald to the Industrial Revolution. Underlying this celebratory message, however, is a covert critique. Boyle dubs this part of the Olympic performance 'Pandemonium', the capital city of hell in John Milton's *Paradise Lost*. This is also a place of work and toil, with steaming foundries and armies of men (in goggles) working to produce this modern vision. Women of the Suffragette Movement counter the groups of men in top hats and tailcoats who assemble in this industrialized landscape. 'Votes for Women' sashes and N.U.W.S. (National Union for Women's Suffrage) signs contend with the self-congratulation of Brunel's address. Rick Smith of the British electronic duo Underworld (who also scored *Frankenstein*) composed the music to accompany the ceremony, a partnership which Boyle has fostered due to the 'radical' nature of the band.[7] Ann Heilmann and Mark Llewellyn have argued that the Olympic ceremony was an exercise in 'nostalgic performativity', and they especially emphasize the anachronistic nature of the chronology: 'The collapse of cultural signifiers (Romantic landscape, Shakespearean text, the Victorian voice) into a single heritage history nevertheless prioritises the actions and acting out of the nineteenth century as key to the birth of modern Britain and its complex position in the world.'[8] However,

this perspective is not without its complexity. Catherine Spooner suggests that the ceremony was 'explicitly celebratory' in tone, 'a vehicle for a piece of teasing political protest that was readily decoded by commentators. Its tone was playful, nostalgic, irreverent and sentimental'.[9] References to the NHS, suffrage, the Windrush years and West Indian immigration all suggest a counter to that other vision of Victorian Britain, Margaret Thatcher's, with which I introduced this book.

Boyle's radicalism in terms of stage design, and message, is shared by other practitioners. It is a radicalism which extends to the *Steampunk Magazine*, 'Steampunk Emma Goldman', bands like The Men That Will Not Be Blamed for Nothing in their recovery of nineteenth-century women's experiences of contraception, artists like Doctor Geof and his reflections on alternative sexualities, and graphic novelists like Bryan Talbot, who offers a critique of post-9/11 political rhetoric. However, it is clear that elements of steampunk also draw on some very conventional notions of gender and sexuality. Whilst Emilie Autumn is attempting to showcase the diversity of sexuality and gender dynamics, she nonetheless becomes implicated in some highly sensational ideas common to aspects of Neo-Victorianism more generally. Similarly, the space which romance may afford women in texts like Gail Carriger's book series is undercut by some very traditional messages about women, gender, sexuality. This is despite its engagement with women of science and the 'female adventurer' who is so prominent in steampunk fiction.

Steampunk's reflections on sexuality, and women's engagement with sex, are similarly Janus-faced. Sarah Hunter (aka Lady Clankington) is a useful case study here. She produced a series of steampunk vibrators and has appeared in *Penthouse* and *Hustler* magazines as a steampunk pin-up. Hunter's articulate exploration of steampunk's navigation of sex reveals a very retrogressive notion of feminine behaviour in the wider community. She comments:

I've personally seen knock-down, honest-to-goodness flame wars in more than one online steampunk forum in which several members said not only that they had to *protect their women* from any possibility of becoming the new 'Goth girls are easy', but also that any prospective steampunk models should think twice and *consider the consequences* before even entertaining the possibility of documenting their sexy personas.[10]

However, Hunter's sex-positive statement (along with her justifiable outrage at some of the more outmoded ideas of masculinity and femininity espoused here) seems a part of the more general cultural move towards certain strands of post-feminism, where 'sexuality/femininity ... undergoes a process of resignification whereby it comes to be associated with feminist ideas of female emancipation and self-determination rather than its previous connotations of patriarchal oppression and subjugation'.[11] Notably, in Hunter's comment, 'patriarchal oppression and subjugation' are framed around those who censure the sexualized steampunk woman. Her corrective to those who view the Victorian period akin to Margaret Thatcher's notion of puritanical 'Victorian values' is forthright: 'They were not all the stuffy, repressed people that we've been taught to believe them to be.'[12] Alongside this post-feminist rhetoric, Hunter's work as an erotic model, sex toy purveyor and pornographic actress also registers some of the ways in which steampunk is a contested terrain for gender and sexuality – on the one hand, it seeks to embrace the past and thereby attracts a conservatism very much at ease with 'Victorian values', whilst on the other hand, it is a futuristic and uchronic discourse which challenges the status quo and is espoused by many participants keen to revise hegemonic narratives. As we have seen with the Steampunk World's Fair, the subculture is not immune to accusations of sexual misconduct and very traditional forms of gendered behaviour. On 16 October 2017, Hunter's post on Twitter read simply '#MeToo' (adding her voice to thousands of women who

have experienced sexual harassment) and on 27 November her post
on Facebook announced she had suspended her twelve-year career,
stating that 'I mostly got into entertainment because I was looking
for validation and attention and [had] a mindset of insecurity and
poor body image'. I use Hunter as an example here to demonstrate
how even up to the point of writing, steampunk iconography is
extremely ambivalent about its relationship to gender and sexuality.
What is also debated here is the status of our (fictional) memory
of the Victorians – as exemplars of moral fortitude, strict gender
boundaries and stern regulation of sexual habits, or by contrast,
the mass pornographers and the sexual experimentalists. In many
instances throughout this book, this vision of the Victorians is also
navigated through steampunk texts.

I have employed a Neo-Victorian lens in order to explore some
of these issues. Like steampunk, Neo-Victorianism is an equivocal
discourse advocating both conservatism and radicalism. It reflects
upon our relationship to the Victorians in an attempt to understand
their visibility in the contemporary moment:

> In literature, visual arts, material culture, adaptation and – to
> a degree – political discourse the Victorians have dominated
> understandings of 'the past' in the UK. Questions of memory and
> modern identity have been investigated through contemporary
> culture's 'heritagisation' of the Victorian and wider nineteenth-
> century past, most recently examining how its haunting presence
> underpins the sense of the 'now'.[13]

Steampunk texts and practices also explore the implications of the
rise of the far right in contemporary discussions on the world's
stage. In a political climate where Donald Trump is US President,
and Brexit articulates broader concerns about multiculturalism and
immigration in the UK, it is compelling to think that steampunk's
science fiction credentials and its utopian endeavours might prove to

be especially attractive – a fantastical way out of the contemporary quagmire in which we find ourselves. However, in the texts analysed in this book, steampunk is used to confront these very issues, rather than escape them. In Doctor Geof's wry analysis of Brexit as an historic moment, we are offered a mirror up to our own absurdity. This is also discernible in Bryan Talbot's *Grandville* series, which takes the racialized discourses of post-9/11 media as its target. In both instances, however, we can also witness the way in which a toxic masculinity has underpinned much of this rhetoric.

Steampunk's currency as a literary genre attests to its importance as a space to revise, reflect on and regenerate the Victorians and their technological advancement, as well as our own relationship to Victorian icons. Ada Lovelace (1815–1852) until very recently was forgotten in the annals of history and stood in the shadow of Charles Babbage, the engineer and mathematician who is often considered the father of modern computing, designing the Difference Engine and the Analytical Engine. Lovelace's recent visibility, fostered through various campaigns for Women in STEM, is now represented by Ada Lovelace Day (held in October each year), which seeks to give more women and girls role models in science, technology, engineering and maths subjects. Her seminal paper from 1843 expanded on the Analytical Engine, but it was highly unusual that a woman should author such a piece: 'Women rarely wrote papers for scientific journals … The few women who wrote about scientific subjects … did so only on the basis that they were making ideas discovered by men available to a mostly female lay readership.'[14] Lovelace's trailblazing career is a touchstone in steampunk culture. Not only does she feature in one of the most iconic texts of the genre, William Gibson and Bruce Sterling's *The Difference Engine* (1990), but she also takes centre stage in Sydney Padua's *The Thrilling Adventures of Lovelace and Babbage* (2015) – note the order of characters in the title – a text which is self-consciously aware of its steampunk subject matter.[15] Ultimately, this

recovery of historical women in science is foundational to broader social issues of equality in science-based subjects. This repossession of occluded narratives is also one of the ways in which women as writers, makers and creators of steampunk texts are offering their voices as equals to men in the field.

As I conclude this study, I find myself wondering where steampunk will head from here. We have various subgenres, including whalepunk and dieselpunk (both of which were sadly beyond the scope of this book). Whalepunk is best defined by Arcane Studio's game *Dishonored*: whale oil (rather than steam) powers machinery, colour schemes are often greyscale and the sea, ports and whaling culture generally inform much of the narrative. Dieselpunk is very close to steampunk, but with interwar technology and twentieth-century stylings (such as Art Deco) rather than those associated with the nineteenth century. Larry Amyett Jr explains that the term 'Decodence' (a portmanteau word combining decadence and deco) is central to dieselpunk:

> Decodence is the essence that surrounds everything of the time of the 1920s through the 1940s, which is a period that dieselpunks call the Diesel Era. Decodence includes, but isn't limited to, gangsters, big band and swing music, the Great Depression, G-men, art deco, noir, prohibition, fedoras, flappers, zoot suits, hardboiled detectives, tommy guns, Nazis, zeppelins, World War II, and all of the other historical and cultural elements that distinguished the era.[16]

Amyett also emphasizes the importance of punk in this context (as in steam*punk*). Otherwise, it is historical re-enactment without a challenge to the history and politics of the period: 'It's something that's non-conformist and not part of the establishment. To be punk is to be an outsider.'[17] A useful example of dieselpunk is Greg Broadmore's *Doctor Grordbort's Contrapulatronic Dingus Directory* (2008). However, steampunk doesn't need to adhere to the fixed

chronology of Victoria's reign (1837–1901). The world didn't suddenly shift perspective with the death of Queen Victoria, and historical demarcations are ultimately constructions: as Martin Hewitt explains, 'historical boundaries are permeable, and questioning the nature and positioning of chronological markers helps to avoid closing off fruitful lines of enquiry'.[18]

More recently, as noted above, steampunk has found its ways into gaming (think *Fable 3* or *Bioshock Infinite*), whilst Lego's 'Monster Fighters' feature, as Spooner remarks, 'a band of Steampunk-style adventurers pursuing zombies, vampires, werewolves, Frankenstein's Creature and the monster from the Black Lagoon through a variety of spooky sets'.[19] This also attests to an overlap with goth and gothic, a common ground which is registered by the subcultural indeterminacy of a figure like Emilie Autumn. Like many other subcultures through their varied life cycles, steampunk has experienced an explosion in popular culture: we need only think of the TV show *Steampunk'd*, the Steampunk Bar in Prague, Boyle's 2012 Olympic ceremony (watched by 26.9 million viewers in the UK alone) or the ubiquity of fashionistas commenting on steampunk style hitting the high street.[20] This commercial popularity is comparable to the resurrection of goth (pun intended) and other related subcultures, such as punk. Most crucially, steampunk provides an artistic, literary and cultural terrain in which we can explore pressing issues of the present day.

Notes

1 The Steampunk World's Fair, http://steampunkworldsfair.com/about/ [accessed 6 April 2018].

2 See Trae Dorn, 'Steampunk World's Fair Cancelled … Sort of. Mostly. This is Confusing', *Nerd and Tie*, http://www.nerdandtie. com/2018/03/14/steampunk-worlds-fair-cancelled-sort-of-mostly-

this-is-confusing/, for an account of the status of the festival to date [accessed 6 April 2018].

3 Bess Goden, 'Why Did Jeff Mach Events Become Just Magical Events?', *The Steampunk Journal*, https://www.steampunkjournal. org/2018/02/05/jeff-mach-events-become-just-magical-events/, 5 February 2018 [accessed 6 February 2018].

4 Catherine Spooner, *Post-Millennial Gothic: Comedy, Romance and the Rise of Happy Gothic* (London: Bloomsbury, 2017), p. 183.

5 Jeff Vandermeer, *The Steampunk Bible* (2011), 9.

6 Jenny McDonnell, 'National Theatre Live: Frankenstein Encore Screening', *The Irish Journal of Gothic and Horror Studies* 13 (2014), 152–155, 154.

7 For Danny Boyle's comments on Underworld, see *Frankenstein: The Making of a Myth* (Lone Star Productions/National Theatre, 2011). It is important to note that Underworld situate themselves in the dance/industrial scene, but it is clear Boyle was attracted to their underground/rave culture status for the *Frankenstein* production, and later, the Olympic ceremony. They also feature on the soundtrack for *Trainspotting* (1996) with the 'Born Slippy.NUXX' remix.

8 Mark Llewellyn and Ann Heilmann, 'The Victorians Now: Global Reflections on Neo-Victorianism', *Critical Quarterly* 55:1 (2013), 24–42, 29.

9 Spooner, *Post-Millennial Gothic*, 183–184.

10 Sarah Hunter, 'The People vs. Lady C: Steampunks and Pornography', in *A Steampunk's Guide to Sex*, ed. Anon (New York: Combustion Books, 2012), p. 55, author's italics.

11 Stephanie Genz and Benjamin Brabon, *Postfeminism: Cultural Texts and Theories* (Edinburgh: Edinburgh University Press, 2009), p. 93.

12 Hunter, 'The People vs. Lady C', 55.

13 Llewellyn and Heilmann, 'The Victorians Now', 26.

14 Benjamin Woolley, *Bride of Science: Romance, Reason and Byron's Daughter* (London: Pan Macmillan, 1999), p. 260.

15 For further on Ada Lovelace in the contemporary moment, see Robert Hammerman and Andrew L. Russell (eds), *Ada's Legacy: Cultures of*

Computing from the Victorian to the Digital Age (New York: ACM Books, 2015), especially Part II, 'Ada's Legacy in Literature'. For Ada Lovelace Day, see https://findingada.com/ [accessed 7 April 2018]. See also Sydney Padua, *The Thrilling Adventures of Lovelace and Babbage* (2015), p. 32: 'Lovelace, Babbage and the Difference Engine, though thwarted in their own time, in ours play a large part in the alternate-history cosmos/geek subculture/fabulous design aesthetic known as Steampunk.'

16 Larry Amyett Jr, 'A Dieselpunk Primer', *The Steampunk Magazine*, Issue 8 (n.d.), 64–5, 64.

17 Amyett, 'A Dieselpunk Primer', 65.

18 Hewitt, Martin, 'Why the Notion of Victorian Britain *Does* Make Sense', *Victorian Studies* 43:3 (Spring 2006), 395–438, 395.

19 Spooner, *Post-Millennial Gothic*, 1–2.

20 For one example, see www.asos.com, 'Steampunk Hits High Street', http://fashionfinder.asos.com/womens-outfits/steampunk-hits-highstreet-86926 [accessed 6 April 2018].

Bibliography

Artwork and Art

Datamancer, https://datamancer.com/ [accessed 10 August 2017].

Doctor Geof, http://islandofdoctorgeof.co.uk/iodg/ [accessed 26 May 2016].

Dürer, Albrecht, *The Rhinoceros* (1515), Woodcut, 23.5 cm × 29.8 cm (9.3 in × 11.7 in), National Gallery of Art, Washington, DC.

Egg, Auguste Leopold, *The Travelling Companions* (1862), oil on canvas, Birmingham Museums and Art Gallery.

Leech, John, 'Enthusiasm of Paterfamilias, On Reading the Report of the Grand Charge of the British Cavalry on the 25th', *Punch*, 27 (25 November 1854), 213.

Manet, Édouard, *A Bar at the Folies-Bergère* (1882), oil on canvas, The Courtauld Gallery, London.

Simpson, Nick, http://www.bumforthmanor.com/ [accessed 26 May 2016].

Discography

TMTWNBBFN, *This May Be the Reason Why The Men That Will Not Be Blamed for Nothing Cannot Be Killed by Conventional Weapons*, Leather Apron Recordings (2012).

TMTWNBBFN, *Now That's What I Call Steampunk Volume 1*, Leather Apron Recordings (2010).

TMTWNBBFN, *Not Your Typical Victorians*, Leather Apron Recordings (2015).

TMTWNBBFN, *Double Negative*, Leather Apron Recordings (2018).

Filmography

Frankenstein: The Making of a Myth (Lone Star Productions/National Theatre, 2011).

The League of Extraordinary Gentlemen, dir. Stephen Norrington (20th Century Fox, 2003).

Interviews

Doctor Geof, Personal Interview, 9 July 2017.

Margaret Killjoy, Personal Interview, 31 July 2017.

Miriam Roček (Steampunk Emma Goldman), Personal Interview, 16 August 2012.

Nick Simpson, Personal Interview, 28 November 2017.

Texts and Critical Works

Ackroyd, Peter, *Thames: Sacred River* (London: Chatto & Windus, 2007).

Addison, Paul, *Churchill: The Unexpected Hero* (Oxford: Oxford University Press, 2006).

Aldington, Richard, *Death of a Hero* (1929: London, Penguin, 2013).

Allen, Robert C., *Horrible Prettiness: Burlesque and American Culture* (Chapel Hill: University of North Carolina Press, 1991).

Amato, Sarah, *Beastly Possessions: Animals in Victorian Consumer Culture* (Toronto: University of Toronto Press, 2015).

Anderson, Benedict, *Imagined Communities: Reflections on the Origin and Spread of Nationalism* (London: Verso, 1991, rev. ed.).

Anon, 'Cosplaying the Good Fight: Emma Goldman and Voltairine DeCleyre: Steampunk's Own Anarcho-Anarcho-Feminists', *The Steampunk Magazine*, Issue 8 (n.d.), 75–77.

Anon, 'The Execution of Mary Ann Cotton at Auckland County Durham Who Was Accused of a Long Seiries [*sic*] of Murders by Poison', Bodleian Library, Oxford, Firth *c.* 17(98). http://ballads.bodleian.ox.ac.uk/view/sheet/12876 [accessed 21 March 2018].

Anon, 'GBLT Characters in the Parasol Protectorate Series', http://www.fangsforthefantasy.com/2012/09/gblt-characters-in-parasol-protectorate.html, 28 September, 2012 [accessed 24 August 2017].

Anon, 'Less Brass Goggles, More Brass Knuckles: An Interview with The Men That Will Not Be Blamed for Nothing', *The Steampunk Magazine*, Issue 7, 73–76.

Anon, 'Rees Mogg Launches Steampunk Revolution', http://www.thedailymash.co.uk/politics/politics-headlines/rees-mogg-launches-

steampunk-revolution-20180126143249, 26 January 2018 [accessed 26 January 2018].

Anon, 'Steampunk Powers Female Characters Forward', 16 November 2011. http://geekout.blogs.cnn.com/2011/11/16/steampunk-powers-female-characters-forward/ [accessed 23 August 2017].

Anon, 'The Steampunk's Guide to Body Hair', *The Steampunk Magazine*, Issue 2 (n.d.), 48–49.

Anon, *A Steampunk's Guide to Sex* (New York: Combustion Books, 2012).

Anon, 'Tech Know: A Journey into Sound', 27 May 2010, http://www.bbc.co.uk/news/10171206 [accessed 14 March 2018].

Anon, 'The Trial, Sentence, & Condemnation of Mary Ann Cotton, the West Auckland Poisoner', Bodleian Library, Oxford, Harding B 12(184). http://ballads.bodleian.ox.ac.uk/view/sheet/18273 [accessed 21 March 2018].

Appignanesi, Lisa, *Mad, Bad and Sad: A History of Women and the Mind Doctors from 1800 to the Present* (London: Virago, 2008).

'The Art of Steampunk' (blog) http://artofsteampunk.blogspot.co.uk/2012/02/emilie-autumn-steampunk-goth-style.html [accessed 8 August 2017].

Ashworth, Dave, 'Anachronism in Context – The Men That Will Not Be Blamed for Nothing', *Pure Rawk*, 22 October 2011, http://www.purerawk.com/2011/10/anachronism-context-men-blamed/#more-8010 [accessed 14 March 2018].

Attridge, Steve, *Nationalism, Imperialism and Identity in Late Victorian Culture: Civil and Military Worlds* (Basingstoke: Palgrave Macmillan, 2003).

Attwood, Feona, 'Sexed Up: Theorizing the Sexualization of Culture', *Sexualities* 8:5 (2006), 77–94.

Autumn, Emilie, *The Asylum for Wayward Girls* (The Asylum Emporium, 2009).

Autumn, Emilie, *The Asylum for Wayward Victorian Girls* (ebook, 4th edition, 2017).

Bakhtin, M. M. *Rabelais and His World*, trans Hélène Iswolsky (Bloomington: Indiana University Press, 1985).

Bates, Laura, *Everyday Sexism* (London: Simon and Schuster, 2014).

Bennett, Andy and Kahn-Harris, Keith, *After Subculture: Critical Studies in Contemporary Youth Culture* (Basingstoke: Palgrave, 2004).

Benshoff, Harry M., *Monsters in the Closet: Homosexuality and the Horror Film* (Manchester: Manchester University Press, 1997).

Benwell, Bethan, 'Ironic Discourses: Evasive Masculinity in Men's Lifestyle Magazines', *Men and Masculinities* 7:1 (2004), 3–21.

Boehmer, Elleke, 'The Worlding of the Jingo Poem', *The Yearbook of English Studies* 41:2 (2011), 41–57.

Boehm-Schnitker, Nadine, and Gruss, Susanne (eds), *Neo-Victorian Literature and Culture: Immersions and Revisitations* (Abingdon: Routledge, 2014).

Bouchoucha, Léa, 'In France, Marine Le Pen Pushes Abortion Politics into View', *Women's News*, 4 January 2016, http://womensenews.org/2016/01/in-france-marine-le-pen-pushes-abortion-politics-into-view/ [accessed 26 September 2017].

Bourdieu, Pierre, 'The Social Space and the Genesis of Groups', *Theory and Society* 14:6 (1985), 723–744.

Bowser, Rachel A., and Croxall, Brian (eds), *Like Clockwork: Steampunk Pasts, Presents and Futures* (Minneapolis: University of Minnesota Press, 2016).

Brownmiller, Susan, *Against Our Will: Men, Women and Rape* (New York: Open Road, 2014, new ed.).

Brummet, Barry (ed.), *Clockwork Rhetoric: The Language and Style of Steampunk* (Jackson: University Press of Mississippi, 2014).

'Buns and Roses', http://www.bunsandroses.co.uk/ [accessed 25 August 2017].

Burke, Edmund, *A Philosophical Enquiry into the Origins of Our Ideas of the Sublime and Beautiful* (1757) (Oxford: Oxford University Press, 1990).

Burstein, Miriam ('The Little Professor'), 'Rules for Writing Neo-Victorian Novels', 15 March 2006, http://littleprofessor.typepad.com/the_little_professor/2006/03/rules_for_writi.html [accessed 3 October 2017].

Burtson, Paul and Richardson, Colin (eds), *A Queer Romance: Lesbians, Gay Men and Popular Culture* (London: Routledge, 2005).

Buszek, Maria Elena, *Pin-Up Grrrls: Feminism, Sexuality and Popular Culture* (Durham and London: Duke University Press, 2006).

Carriger, Gail, *Changeless* (London: Orbit Books, 2010).

Carriger, Gail, *Soulless* (London: Orbit Books, 2009).

Carriger, Gail, *Timeless* (London: Orbit Books, 2012).

Carroll, Noël, *Humour: A Very Short Introduction* (Oxford: Oxford University Press, 2014).

The Catastrophone Orchestra and Arts Collective (NYC), 'What then, Is Steampunk?', *Steampunk Magazine*, Issue 1, pp. 4–5.

Chapman, Rowena, and Rutherford, Jonathan (eds), *Male Order: Unwrapping Masculinity* (London: Lawrence and Wishart, 1988).

'Character Study: Madame Genevieve Lefoux', 9 August 2011, http://gailcarriger.com/2011/08/09/character-study-madame-genevieve-lefoux/ [accessed 22 August 2017].

Clarke, Harold D., Goodwin, Matthew, and Whiteley, Paul, *Brexit: Why Britain Voted to Leave the European Union* (Cambridge: Cambridge University Press, 2017).

Combustion Books, http://www.combustionbooks.org/about/ [accessed 15 April 2018].

Conley, Carolyn A., 'Rape and Justice in Victorian England', *Victorian Studies* 29:4 (Summer 1986), 519–536.

Cooper, John, *Oscar Wilde on Dress* (Philadelphia: CSM Press, 2013), E-book, location 378.

Crenshaw, Kimberlé, 'Demarginalizing the Intersection of Race and Sex: A Black Feminist Critique of Antidiscrimination Doctrine, Feminist Theory and Antiracist Politics', *University of Chicago Legal Forum*, Issue 1, Article 8 (1989), http://chicagounbound.uchicago.edu/uclf/vol1989/iss1/8.

Crenshaw, Kimberlé, 'Mapping the Margins: Intersectionality, Identity Politics, and Violence against Women of Color', *Stanford Law Review* 43:6 (1991), 1241–1299.

CY Press, 'EA Live Show Promo Text', www.cypress-agentur.de/fileadmin/pdf/mod_press/EmilieAutumnInfo.pdf [accessed 8 August 2017].

Danahay, Martin, 'Steampunk as a Postindustrial Aesthetic: "All That Is Solid Melts in Air"', *Neo-Victorian Studies* 8:2 (2016), 123–150.

Darwin, Charles, *On the Origin of Species* (1859: London: Penguin, 2009).

Davies, Helen, *Neo-Victorian Freakery* (London: Palgrave, 2015).

Davies, Shaun and Stilinovich, Milly, 'How Return of Kings Used Outrage to Sell Extreme Ideas', BBC News (Australia), 4 February 2016, http://www.bbc.co.uk/news/world-australia-35490223 [accessed 10 April 2018].

de Groot, Jerome, *Consuming History: Historians and Heritage in Contemporary Popular Culture* (Abingdon, Routledge, 2008).

Di Liddo, Annalisa, *Alan Moore: Comics as Performance, Fiction as Scalpel* (Jackson: University Press of Mississippi, 2009).

Doctor Geof, *The Fetishman Filthology: The Collected Early Adventures of Fetishman* (Leeds: Doctor Geof, 2016).

Doctor Geof, *The Steampunk Literary Review*, Volume I, Series B, Issue 1, n.d.

Doctor Geof, *The Steampunk Literary Review*, Volume I, Series B, Issue 2, n.d.

Dodsworth, Karen, '[Re]presenting the Nineteenth Century: Victorian Gender in Contemporary Adaptations', Leeds Beckett University, September 2017, unpublished PhD thesis.

Donovan, Art, *The Art of Steampunk* (East Petersburg: Fox Chapel, 2011).

Dorn, Trae, 'Steampunk World's Fair Cancelled … Sort of. Mostly. This Is Confusing', *Nerd and Tie*, http://www.nerdandtie.com/2018/03/14/steampunk-worlds-fair-cancelled-sort-of-mostly-this-is-confusing/ [accessed 6 April 2018].

Dudink, Stefan, Hagemann, Karen, and Tosh, John (eds), *Masculinities in Politics and War* (Manchester: Manchester University Press, 2004).

Duncombe, Stephen, *Notes from Underground: Zines and the Politics of Alternative Culture* (Bloomington: Microcosm, 2008, 2nd edition).

Dunt, Ian, *Brexit: What the Hell Happens Now?* (Kingston upon Thames: Canbury Press, 2017, rev. ed.).

Edwards, Elaine, 'Tuam Babies: "Significant" Quantities of Human Remains Found at Former Home', *Irish Times*, 3 March 2017, https://www.irishtimes.com/news/social-affairs/tuam-babies-significant-quantities-of-human-remains-found-at-former-home-1.2996599 [accessed 10 April 2018].

Edwards, Justin and Soltysik, Agnieszka Monnet (eds), *The Gothic in Contemporary Literature and Popular Culture* (Abingdon: Taylor and Francis, 2013).

Einhaus, Ann-Marie, and Baxter, Katherine (eds), *The Edinburgh Companion to the First World War in the Arts* (Edinburgh: Edinburgh University Press, 2017).

Elgot, Jessica, 'Jacob Rees-Mogg Opposed to Gay Marriage and Abortion – Even after Rape', *The Guardian*, 6 September 2017, https://www. theguardian.com/politics/2017/sep/06/jacob-rees-mogg-opposed-to-gay-marriage-and-abortion-even-after [accessed 10 November 2017].

Ellis, Katie, *Disability and Popular Culture: Focusing Passion, Creating Community and Expressing Defiance* (Abingdon: Routledge, 2016).

Ellmann, Richard, *Oscar Wilde* (London: Penguin, 1998).

Evangelista, Stephano, *British Aestheticism and Ancient Greece: Hellenism, Reception, Gods in Exile* (Basingstoke: Palgrave, 2009).

Evans, Geoffrey, and Menon, Anan, *Brexit and British Politics* (Cambridge: Polity Press, 2017).

Fairclough, Norman, *Language and Power* (London: Longman, 1989).

Faludi, Susan, *Backlash: The Undeclared War against Feminism* (London: Vintage, 1993, new ed.).

Ferguson, Christine, 'Surface Tensions: Steampunk, Subculture and the Ideology of Style', *Neo-Victorian Studies* 4:2 (2011), 66–90.

Finch-Field, Ian (SkinzNhydez), https://www.etsy.com/uk/shop/SkinzNhydez [accessed 9 August 2017].

Flanders, Judith, *The Invention of Murder: How the Victorians Revelled in Death and Detection, and Created Modern Crime* (London: HarperCollins, 2011).

Foglio, Phil, and Foglio, Kaja, *Girl Genius*, vol. 1, 'Agatha Heterodyne and the Beetleburg Clank' (Seattle: Airship Entertainment, 2006).

Fortunato, Paul, *Modernist Aesthetics and Consumer Culture in the Writings of Oscar Wilde* (London and New York: Routledge, 2007).

Foucault, Michel, *The History of Sexuality*, vol. 1, 'The Will to Knowledge', trans. Robert Hurley (Harmondsworth: Penguin, 1998).

Foucault, Michel, *Madness and Civilization: A History of Insanity in the Age of Reason*, trans. Richard Howard (New York: Vintage, 1988).

Foulds, Adam, *The Quickening Maze* (London: Jonathan Cape, 2010).

Garvey, Ellen Gruber, *The Adman in the Parlor: Magazines and the Gendering of Consumer Culture, 1880s–1910s* (New York: Oxford University Press, 1996).

Gauntlett, David, *Making Is Connecting: The Social Meaning of Creativity, from DIY and Knitting to YouTube and Web 2.0* (London: Polity, 2011).

Genette, Gerard, *Paratexts: Thresholds of Interpretation* (Cambridge: Cambridge University Press, 1997).

Genz, Stéphanie, and Brabon, Benjamin A., *Postfeminism: Cultural Texts and Theories* (Edinburgh: Edinburgh University Press, 2009).

Gilbert, Sandra M., and Gubar, Susan, *The Madwoman in the Attic: The Woman Writer and the Nineteenth-Century Literary Imagination* (New Haven, CT: Yale University Press, 1979).

Gill, Rosalind, *Gender and the Media* (London: Polity, 2007).

Goden, Bess, 'Why Did Jeff Mach Events Become Just Magical Events?', *The Steampunk Journal*, 5 February 2018, https://www.steampunkjournal. org/2018/02/05/jeff-mach-events-become-just-magical-events/ [accessed 6 February 2018].

Goh, Jaymee, 'Silver Goggles' blog, http://silver-goggles.blogspot.com/ [accessed 18 September 2018].

Goldman, Emma, *Living My Life* (London: Penguin, 2006).

Goldman, Emma, 'A New Declaration of Independence', *Mother Earth*, vol. IV, no. 5 (July 1909), available at The Anarchist Library, https:// theanarchistlibrary.org/library/emma-goldman-a-new-declaration-of-independence [accessed 17 April 2018].

Green, Michael J. A. (ed.), *Alan Moore and the Gothic Tradition* (Manchester: Manchester University Press, 2013).

Greer, Germaine, *The Female Eunuch* (1970, repr. London: HarperCollins, 2006).

Groth, Helen, 'Technological Mediations and the Public Sphere: Roger Fenton's Crimea Exhibition and "the Charge of the Light Brigade"', *Victorian Literature and Culture* 30 (2002), 553–570, 561–562.

Gunew, Sneja, *Framing Marginality: Multicultural Literary Studies* (Carlton, Victoria: Melbourne University Press, 1994).

Haggerty, George E., *Queer Gothic* (Urbana: University of Illinois Press, 2006).

Hague, Ian, and Ayaka, Carolene (eds), *Representing Multiculturalism in Comics and Graphic Novels* (Abingdon: Routledge, 2015).

Halberstam, J., *Female Masculinity* (Durham, NC: Duke University Press, 2000).

Halsall, Alison, "'A Parade of Curiosities: Alan Moore's *The League of Extraordinary Gentlemen* and *Lost Girls* as Neo-Victorian Pastiches'", *The Journal of Popular Culture* 48:2 (2015), 252–268, 252.

Hammerman, Robert, and Russell, Andrew L. (eds), *Ada's Legacy: Cultures of Computing from the Victorian to the Digital Age* (New York: ACM Books, 2015).

Hannan, Daniel, 'If the EU turn hostile on Brexit and see us leaving as an act of aggression — it's time to turn to trade deals and the open seas', *The Sun*, 25 July 2018, https://www.thesun.co.uk/news/6857039/hostile-eu-uk-daniel-hannan-opinion/ [accessed 7 September 2018].

Haraway, Donna, *The Haraway Reader* (London: Routledge, 2004).

Harwood, John, *The Asylum* (London: Jonathan Cape, 2013).

Hawthorne, Melanie, 'Bryan Talbot's *Grandville* and French Steampunk', *Contemporary French Civilization* 38:1 (2013), 47–71.

Hebdige, Dick, *Subculture: The Meaning of Style* (London: Routledge, 1979).

Heilmann, Ann and Llewellyn, Mark, 'Introduction: To a Lesser Extent? Neo-Victorian Masculinities', *Victoriographies* 5:2 (2015), 97–104.

Heilmann, Ann and Llewellyn, Mark, *Neo-Victorianism: The Victorians in the Twenty-First Century* (Basingstoke: Palgrave, 2010).

Hewitt, Jema, and Ladybird, Emily, *Steampunk Tea Party* (Cincinnati, OH: David and Charles, 2013).

Hewitt, Martin (ed.), *Victorian World* (Abingdon: Routledge, 2012).

Hewitt, Martin, 'Why the Notion of Victorian Britain *Does* Make Sense', *Victorian Studies* 43:3 (Spring 2006), 395–438.

Hill Collins, Patricia, and Bilge, Sirma, *Intersectionality* (Cambridge: Polity, 2016).

Hirschkop, Ken, and Shepherd, David (eds), *Bakhtin and Cultural Theory* (Manchester: Manchester University Press, 2001, 2nd ed.).

Ho, Elizabeth, *Neo-Victorianism and the Memory of Empire* (London: Bloomsbury, 2012).

Hodkinson, Paul, 'Ageing in a Spectacular "Youth Culture": Continuity, Change and Community amongst Older Goths', *The British Journal of Sociology* 62.2 (2011), 262–282.

Hodkinson, Paul, *Goth: Identity, Style and Subculture* (Oxford: Berg, 2002).

Holland, Samantha, and Spracklen, Karl (eds), *Subcultures, Bodies and Spaces: Essays on Alternativity and Marginalization* (Bingley: Emerald, 2018).

Holmes, Mark, Interview with Emilie Autumn for *Metal Discovery*, 9th March 2010, http://www.metal-discovery.com/Interviews/emilieautumn_interview_sheffield_2010_pt2.htm [accessed 8 August 2017].

Hunter, Sarah (Lady Clankington), '#MeToo', Twitter post, 16 October 2017.

Hunter, Sarah (Lady Clankington), Facebook announcement, 27 November 2017.

Hurst, Isobel, 'Ancient and Modern Women in the *Woman's World*', *Victorian Studies* 52:1 (2009), 42–51.

Hutcheon, Linda, 'Irony, Nostalgia and the Postmodern', http://www.library.utoronto.ca/utel/criticism/hutchinp.html (1998) [accessed 13 April 2018].

Hutcheon, Linda and Valdés, Mario J., 'Irony, Nostalgia, and the Postmodern: A Dialogue', *Poligrafías* 3 (1998–2000), 18–41, 23.

Jagose, Annamarie, *Orgasmology* (Durham, NC and London: Duke University Press, 2013).

Jameson, Fredric, *Archaeologies of the Future: The Desire Called Utopia and Other Science Fictions* (London: Verso, 2007).

The Jewish Women's Archive, https://jwa.org/media/steampunk-lgbt-equality-rally-flyer [accessed: 23 April 2018].

Jones, Jason B., 'Betrayed by Time: Steampunk & the Neo-Victorian in Alan Moore's *Lost Girls* and *The League of Extraordinary Gentlemen*', *Neo-Victorian Studies* 3:1 (2010), 99–126.

Joyce, Simon, *The Victorians in the Rearview Mirror* (Athens: Ohio University Press, 2007).

Kaplan, Cora, *Victoriana: Histories, Fictions, Criticism* (Edinburgh: Edinburgh University Press, 2007).

'Kimberlé Crenshaw on Intersectionality', http://www.law.columbia.edu/news/2017/06/kimberle-crenshaw-intersectionality [accessed 16 April 2018].

Kirchknopf, Andrea, *Rewriting the Victorians: Modes of Literary Engagement with the 19th Century* (Jefferson, NC: McFarland, 2013).

Knelman, Judith, *Twisting in the Wind: The Murderess and the English Press* (Toronto: University of Toronto Press, 1998).

Kohlke Marie-Luise, 'Into History through the Back Door: The "Past Historic" in *Nights at the Circus* and *Affinity*', *Women: A Cultural Review* 15:2 (2004), 153–166.

Kohlke, Marie-Luise, and Gutleben, Christian (eds), *Neo-Victorian Humour: Comic Subversions and Unlaughter in Contemporary Historical Re-Visions* (Leiden and Boston: Brill-Rodopi, 2017).

Kohlke, Marie-Luise, and Gutleben, Christian (eds), *Neo-Victorian Tropes of Trauma: The Politics of Bearing After-Witness to Nineteenth-Century Suffering* (Amsterdam: Rodopi, 2010).

Kohlke, Marie-Luise, and Orza, Luisa (eds), *Probing the Problematics: Sex and Sexuality* (Oxford: Interdisciplinary Press, 2008).

Kohlstedt, Sally Gregory, 'Women in the History of Science: An Ambiguous Place', *Osiris* Second Series 10 (1995), 39–58.

Köttig, Michaela, Bitzan, Renate, and Petö, Andrea (eds), *Gender and Far Right Politics in Europe* (Basingstoke: Palgrave, 2017).

Kronsell, Annica, and Svedberg, Erika (eds), *Making Gender, Making War: Violence, Military and Peacekeeping Practices* (London: Routledge, 2012).

Ledger, Sally, *The New Woman: Fiction and Feminism at the Fin de Siècle* (Manchester: Manchester University Press, 1997).

'Legendary Comics Writer Alan Moore on Superheroes, *The League*, and Making Magic', 23 February 2009, https://www.wired.com/2009/02/ff-moore-qa/ [accessed 18 September 2017].

Leonard, Garry, 'Joyce and Advertising: Advertising and Commodity Culture in Joyce's Fiction', *James Joyce Quarterly* 30:4–31 (1993), 1.

Levi, Ariel, *Female Chauvinist Pigs: Women and the Rise of Raunch Culture* (London: Simon & Schuster, 2005).

Liming, Sheila, 'Of Anarchy and Amateurism: Zine Publication and Print Dissent', *The Journal of the Midwest Modern Language Association* 43:2 (2010), 121–145.

Llewellyn, Mark, 'What Is Neo-Victorian Studies?', *Neo-Victorian Studies* 1:1 (2008), 164–185.

Llewellyn, Mark, and Heillmann, Ann, 'The Victorians Now: Global Reflections on Neo-Victorianism', *Critical Quarterly* 55:1 (2013), 24–42.

Lord Akeldama Character Study, http://gailcarriger.com/2010/12/15/lord-akeldama-character-study/ [accessed 24 August 2017].

Loutitt, Chris, 'The Novelistic Afterlife of Henry Mayhew', *Philological Quarterly* 85:3/4 (2006), 315–341.

MacAlister, Katie, *Steamed* (New York: Signet, 2010).

MacKenzie, John M., *The Empire of Nature: Hunting, Conservation and British Imperialism* (Manchester: Manchester University Press, 1997).

Marcus, Steven, *The Other Victorians: A Study of Sexuality and Pornography in Mid-Nineteenth-Century England* (New Brunswick: Transaction Publishers, 2009, new edition).

Markovits, Stefanie, 'Giving Voice to the Crimean War: Tennyson's "Charge" and Maud's Battle-song', *Victorian Poetry* 47:3 (2009), 481–503.

Mason, Rowena, Elliott, Larry, and Boffey, Daniel, 'Brexit War of Words Heats Up as "Enemy" EU Tells Britain to Pay Up', 13 October 2017, https://www.theguardian.com/politics/2017/oct/13/brexit-war-of-words-heats-up-as-enemy-eu-tells-britain-to-pay-up [accessed 16 January 2018].

McCloud, Scott, *Understanding Comics: The Invisible Art* (New York: HarperCollins, 1994).

McCormick, Joseph Patrick, 'Margaret Thatcher, a Controversial Figure on Gay Issues, Dies Aged 87', 8 April 2013, https://www.pinknews.co.uk/2013/04/08/margaret-thatcher-a-controversial-figure-in-gay-rights-dies-aged-87/ [accessed 11 September 2018].

McDonnell, Jenny, 'National Theatre Live: Frankenstein Encore Screening', *The Irish Journal of Gothic and Horror Studies* 13 (2014), 152–55, 154.

McNair, Brian, *Striptease Culture: Sex, Media and the Democratization of Desire* (London: Routledge, 2002).

McRobbie, Angela, *Feminism and Youth Culture* (Basingstoke: Macmillan: 1991)

McRobbie, Angela, *The Aftermath of Feminism: Gender, Culture and Social Change* (London: Sage, 2009).

Meyer, Jessica, *Men of War: Masculinity and the First World War in Britain* (Basingstoke: Palgrave Macmillan, 2009).

Meyer, Moe, *The Politics and Poetics of Camp* (London: Routledge, 1994).

Millner, Jacqueline, and Moore, Catriona, 'Performing Oneself Badly?' Neo-Burlesque and Contemporary Feminist Performance Art, *Australian and New Zealand Journal of Art* 15:1 (2015), 20–36.

Mitchell, Kate, *History and Cultural Memory in Neo-Victorian Fiction: Victorian Afterimages* (London: Palgrave, 2010).

Modleski, Tania, *Loving with a Vengeance: Mass-Produced Fantasies for Women* (London: Routledge, 1982).

Moore, Alan, *The League of Extraordinary Gentlemen*, vol. 2 (London: Titan Books, 2011).

Moore, Alan, and O'Neill, Kevin et al., *The League of Extraordinary Gentlemen*, vol. 1 (London: Titan Books, 1999).

Muggleton, David, *Inside Subculture: The Postmodern Meaning of Style* (Oxford: Berg, 2000).

Muggleton, David, and Weinzierl, Rupert (eds), *The Post-Subcultures Reader* (London: Berg, 2003).

Mulvey, Laura, *Visual and Other Pleasures* (Basingstoke: Palgrave, 2009, 2nd edition).

Munro, Stephanie, 'A Moment That Changed Me: Turning My Back on Monogamy', https://www.theguardian.com/commentisfree/2017/sep/15/moment-that-changed-me-monogamy-polyamory-jealousy [accessed 14 March 2018].

Murdock, Jason, 'Ukip Declares it's "Ready for War" over Second Brexit Referendum, Twitter Responds with Memes', 15 January 2018, http://www.ibtimes.co.uk/ukip-declares-its-ready-war-over-second-brexit-referendum-twitter-responds-memes-1655201 [accessed 16 January 2018].

Murphy, Margi, 'Steampunk! Introducing Britain's Latest Fashion Craze', *The Independent*, 20 January 2013, http://www.independent.co.uk/life-style/fashion/news/steampunk-introducing-britains-latest-fashion-craze-8458861.html [accessed 9 August 2017].

Nally, Claire, 'Grrrly Hurly Burly: Neo-burlesque and the Performance of Gender', *Textual Practice*, 23:4 (2009), 621–643.

Negra, Diane, *What a Girl Wants: Fantasizing the Reclamation of the Self in Postfeminism* (Abingdon: Routledge, 2009).

Nevins, Jess, *A Blazing World: The Unofficial Companion to The League of Extraordinary Gentlemen Volume 2* (London: Titan Books, 2003).

Nevins, Jess, *The Encyclopaedia of Fantastic Victoriana* (Austin: Monkey Brain, 2005).

Nevins, Jess, *Heroes and Monsters: The Unofficial Companion to The League of Extraordinary Gentlemen Volume 1* (London: Titan Books, 2003).

O'Connor, Alison, 'How the Death of Savita Halappanavar Changed the Abortion Debate', *Irish Examiner*, 28 October 2017, https://www.irishexaminer.com/viewpoints/analysis/how-the-death-of-savita-halappanavar-changed-the-abortion-debate-461787.html [accessed 10 April 2018].

Onion, Rebecca, 'Reclaiming the Machine: A Look at Steampunk in Everyday Practice', *Neo-Victorian Studies* 1:1 (2008), 138–163.

Orrels, Daniel, *Classical Culture and Modern Masculinity* (Oxford: Oxford University Press, 2011).

Padua, Sydney, *The Thrilling Adventures of Lovelace and Babbage* (London: Penguin, 2015).

Paglia, Camille, *Sexual Personae: Art and Decadence from Nefertiti to Emily Dickinson* (New Haven, CT: Yale University Press, 2001).

The Parasol Protectorate Wiki, http://gailcarriger.wikia.com/ [accessed 24 August 2017].

Pearce, Lynn, and Stacey, Jackie (eds), *Romance Revisited* (London: Lawrence and Wishart, 1995).

Peck, Tom, 'Only Two Days after Vote for Brexit and Already the Broken Promises Are Mounting', http://www.independent.co.uk/news/uk/politics/brexit-lave-campaign-broken-promises-mounting-live-updates-polls-7103076.html [accessed 3 January 2018].

Perry, Gillian, *Femininity and Masculinity in Eighteenth-Century Art and Culture* (Manchester: Manchester University Press, 1994).

Pho, Diana M., 'Beyond Victoriana' blog, https://beyondvictoriana.com/ [accessed 18 September 2018].

Piepmeier, Alison, 'Why Zines Matter: Materiality and the Creation of Embodied Community', *American Periodicals: A Journal of History and Criticism* 18:2 (2008), 213–238.

Poliquin, Rachel, *The Breathless Zoo: Taxidermy and the Cultures of Longing* (Pennsylvania, PA: Penn State University Press, 2012).

Porter, Lynette (ed.), *Sherlock Holmes for the 21st Century*, ed. Lynette Porter (Jefferson, NC: McFarland & Co., 2012).

Primorac, Antonija, 'The Naked Truth: The Postfeminist Afterlives of Irene Adler', *Neo-Victorian Studies* 6:2 (2013), 89–113.

Purvis, June, 'Remembering Emily Wilding Davison (1872–1913)', *Women's History Review* 22:3 (2013), 353–362.

Radway, Janice A., *Reading the Romance: Women, Patriarchy and Popular Literature* (Chapel Hill: University of North Carolina, 1991).

Rafey, Kate, 'JWA's Greatest Hits: Meet Steampunk Emma Goldman', *Jewish Women's Archive*, https://jwa.org/blog/meet-steampunk-emma-goldman, 3 October 2011 [accessed 23 April 2018].

Rappaport, Erika, *A Thirst for Empire: How Tea Shaped the Modern World* (Princeton, NJ: Princeton University Press, 2017).

The Rat Game, https://www.youtube.com/watch?v=4ApFvVobL4Q, from The Key Tour (Berlin 2010) [accessed 13 April 2013].

Rattle, Alison, and Vale, Allison, *The Woman Who Murdered Babies for Money* (London: Andre Deutsch, 2011).

'The Reading Child Murders', *Morning Post* (London), 20 April 1896, p. 6.

'Remarks by the President upon Arrival', South Lawn, 16 September 2001, https://georgewbush-whitehouse.archives.gov/news/releases/2001/09/20010916-2.html [accessed 25 September 2017].

Ritchie, Graeme, 'Developing the Incongruity-Resolution Theory' (2000), https://www.era.lib.ed.ac.uk/bitstream/handle/1842/3397/0007.pdf?sequence=1&isAllowed=y [accessed 7 February 2018].

Ritchie, Graeme, *The Linguistic Analysis of Jokes* (London: Routledge, 2004).

Robida, Albert, *Le Vingtième Siècle*, [*The Twentieth Century*], trans. Philippe Willems, ed. Arthur B. Evans (1883: Middletown, Wesleyan University Press, 2004).

Roček, Miriam, 'A Healthy Alternative to Fascism in Fashion', *The Steampunk Magazine*, Issue 9, pp. 96–101.

Ruiz, Maria Isabel Romero, 'Detective Fiction and Neo-Victorian Sexploitation: Violence, Morality and Rescue Work in Lee Jackson's *The Last Pleasure Garden* (2007) and *Ripper Street*'s "I Need Light" (2012–16)', *Neo-Victorian Studies*, 9:2(2017), 41–69.

Rutherford, Lara, 'Victorian Genres at Play: Juvenile Fiction and *The League of Extraordinary Gentlemen*', *Neo-Victorian Studies* 5:1 (2012), 125–151.

Samuel, Raphael, 'Mrs Thatcher's Return to Victorian Values', *Proceedings of the British Academy* 78 (1992), 9–29.

Sanger, Carol, *About Abortion: Terminating Pregnancy in Twenty-First Century America* (Cambridge, MA: Harvard University Press, 2017).

Schaffer, Talia, 'Fashioning Aestheticism by Aestheticizing Fashion: Wilde, Beerbohm, and the Male Aesthete's Sartorial Codes', *Victorian Literature and Culture* 28:1 (2000), 39–54.

Schechter, Harold, *Fatal: The Poisonous Life of a Female Serial Killer* (New York and London: Simon and Schuster, 2003).

Schrager Lang, Amy, and Lang/Levitsky, Daniel (eds), *Dreaming in Public: Building the Occupy Movement* (East Peoria, IL: Versa Press, 2012).

Sh! Women's Erotic Emporium, https://www.sh-womenstore.com/ [accessed 12 February 2018].

Showalter, Elaine, *The Female Malady: Women, Madness and English Culture, 1830–1980* (London: Virago, 1985).

Siebers, Tobin, 'Disability as Masquerade', *Literature and Medicine* 23:1 (2004), 1–22.

Siebler, Kay, 'What's So Feminist about Garters and Bustiers? Neo-burlesque as Post-feminist Sexual Liberation', *Journal of Gender Studies* 24:5 (2015), 561–573.

Simpson, Nick, https://www.artsyshark.com/2015/09/14/featured-artist-nick-simpson/ [accessed 19 February 2018].

Sinfield, Alan, *The Wilde Century: Effeminacy, Wilde and the Queer Moment* (London: Cassell, 1994).

Skeate, Sarah and Tedman, Nicola, *Steampunk Softies: Scientifically-Minded Dolls from a Past That Never Was* (Lewes: Ivy Press, 2011).

Smith, Matthew J., 'Strands in the Web: Community-Building Strategies in Online Fanzines', *Journal of Popular Culture* 33:2 (1999), 87–99.

Solicari, Sonia (ed.), *Victoriana: A Miscellany* (London: Guildhall Art Gallery, 2013).

Sontag, Susan, *Against Interpretation* (London: Vintage, 2001).

Spooner, Catherine, *Post-Millennial Gothic: Comedy, Romance and the Rise of Happy Gothic* (London: Bloomsbury, 2017).

Stanley, Autumn, *Mothers and Daughters of Invention: Notes for a Revised History of Technology* (New Brunswick, NJ: Rutgers University Press, 1993).

'Steamgoth in a Nutshell', http://www.decimononic.com/blog/steamgoth-in-a-nutshell-1-of-6-intro [accessed 8 August 2017].

The Steampunk Bar, Prague, http://steampunkprague.cz/ [accessed 10 August 2017].

'Steampunk Hits High Street', http://fashionfinder.asos.com/womens-outfits/steampunk-hits-highstreet-86926 [accessed 6 April 2018].

The Steampunk Magazine, http://www.steampunkmagazine.com/ [accessed 15 April 2018].

The Steampunk Magazine, 'SPM Contributor Miriam Roček Arrested at #OWS Again', http://www.steampunkmagazine.com/2012/03/spm-contributor-miriam-rocek-arrested-agai/ [accessed 17 April 2018].

The Steampunk World's Fair, http://steampunkworldsfair.com/about/ [accessed 6 April 2018].

Steele, Valerie, *The Corset: A Cultural History* (New Haven, CT: Yale University Press, 2001).

Steele, Valerie, *Fetish: Fashion, Sex and Power* (Oxford: Oxford University Press, 1996).

Sterling, Bruce, 'The User's Guide to Steampunk', *The Steampunk Magazine*, Issue 5 (n.d.), 32–33.

Stetz, Margaret D., 'The Late-Victorian "New Man" and the Neo-Victorian "Neo-Man"', *Victoriographies* 5:2 (2015), 105–121.

Stewart, Heather, and Mason, Rowena, 'Nigel Farage's Anti-migrant Poster Reported to Police', 16 June 2016, https://www.theguardian.com/politics/2016/jun/16/nigel-farage-defends-ukip-breaking-point-poster-queue-of-migrants [accessed 8 February 2018].

Stoker, Bram, *Dracula*, ed. Maurice Hindle (1897: Harmondsworth: Penguin, 1993).

Strachan, John and Nally, Claire, *Advertising, Literature and Print Culture in Ireland, 1891–1922* (London: Palgrave, 2012).

The Subcultures Network, *Fight Back: Punk, Politics and Resistance* (Manchester: Manchester University Press, 2014).

Summers, Leigh, *Bound to Please: A History of the Victorian Corset* (Oxford: Berg, 2001).

Sundén, Jenny, 'Clockwork Corsets: Pressed against the Past', *International Journal of Cultural Studies*, 18:3 (2015), 379–383.

'Supporting Women in Science', http://www.womeninstem.co.uk/women-in-science/interviews [accessed 13 February 2018].

Sweet, Matthew, *Inventing the Victorians* (London: Faber and Faber, 2001).

Taddeo, Julie Anne, and Miller, Cynthia J. (eds), *Steaming into a Victorian Future: A Steampunk Anthology* (Lanham, MD: Scarecrow Press, 2013).

Talbot, Bryan, 'The Anthropomorphic Tradition', Lecture at The Lakes International Comic Arts Festival, Kendal, 18 October 2013.

Talbot, Bryan, *Grandville*, vol. 1 (London: Jonathan Cape, 2009).

Talbot, Bryan, *Grandville: Bête Noire*, vol. 3 (London: Jonathan Cape, 2012).

Talbot, Bryan, *Grandville: Force Majeure*, vol. 5 (London: Jonathan Cape, 2017).

Talbot, Bryan, *Grandville: Mon Amour*, vol. 2 (London: Jonathan Cape, 2010).

Talbot, Bryan, *Grandville: Noël*, vol. 4 (London: Jonathan Cape, 2014).

Talbot, Mary M., *Fictions at Work: Language and Social Practice in Fiction* (London: Longman, 1995).

Tanguay, Liane, *Hijacking History: American Culture and the War on Terror* (Montreal: McGill-Queen's University Press, 2013).

Tatalovich, Warren, *The Politics of Abortion in the United States and Canada: A Comparative Study* (Abingdon: Routledge, 2015).

Taylor, James, '*Your Country Needs You*': *The Secret History of the Propaganda Poster* (Glasgow: Saraband, 2013).

Tempest, Matthew, 'Immigrants to Face Language and Citizenship Tests', *The Guardian*, 7 February 2002, https://www.theguardian.com/politics/2002/feb/07/immigrationpolicy.immigration [accessed 5 October 2017].

Tennyson, Alfred Lord, *Selected Poems*, ed. Aidan Day (Harmondsworth: Penguin, 1991).

Teukolsky, Rachael, 'Novels, Newspapers, and Global War: New Realisms in the 1850s', *NOVEL: A Forum on Fiction*, 45:1 (2012), 31–55.

Thomson, Rosemarie Garland (ed.), *Freakery: Cultural Spectacles of the Extraordinary Body* (New York: NYU Press, 1996).

Thoss, Jeff, 'From Penny Dreadful to Graphic Novel: Alan Moore and Kevin O'Neill's Genealogy of Comics in *The League of Extraordinary Gentlemen*', *Belphégor* 13:1(2015), [online], http://belphegor.revues.org/624 [accessed 15 August 2017].

Tomaiuolo, Saverio, 'The Aesthetic of Filth in *Sweet Thames, The Great Stink,* and *The Crimson Petal and the White*', *Neo-Victorian Studies* 8:2 (2016), 106–135.

Tosh, John, *Manliness and Masculinities in Nineteenth-Century Britain* (Harlow: Longman, 2005).

The Trial of Amelia Dyer, May 1896, Old Bailey Proceedings Online, https://www.oldbaileyonline.org/print.jsp?div=t18960518-451 [accessed 9 March 2018].

Triggs, Teal, *Fanzines* (London: Thames & Hudson, 2010).

Trimm, Ryan, *Heritage and the Legacy of the Past in Contemporary Britain* (New York and Abingdon: Routledge, 2018).

Valente, Joseph, *The Myth of Manliness in Irish National* Culture, *1880–1922* (Champaign, IL: University of Illinois Press, 2010).

Vanacker, Sabine and Wynne, Catherine (eds), *Sherlock Holmes and Conan Doyle: Multi-Media Afterlives* (Basingstoke: Palgrave, 2013).

Vandermeer, Jeff, *The Steampunk Bible* (New York: Abrams, 2011).

Vandermeer, Jeff and Boskovich, Desirina, *The Steampunk User's Manual: An Illustrated Practical and Whimsical Guide to Creating Retro-Futurist Dreams* (New York: Abrams, 2014).

Vice, Sue, *Introducing Bakhtin* (Manchester: Manchester University Press, 1997).

Victoriocity (podcast), https://www.victoriocity.com/ [accessed 2 December 2017].

Voights, Eckhart, '"Victoriana's Secret": Emilie Autumn's Burlesque Performance of Subcultural Neo-Victorianism', *Neo-Victorian Studies* 6:2 (2013), 15–39.

Voights-Virchow, Eckhart, 'In-yer-Victorian-face: A Subcultural Hermeneutics of Neo-Victorianism', *Literature Interpretation Theory* 20:1 (2009), 108–125.

von Slatt's, Jake, Introduction, *The Steampunk Magazine, Issues #1–7* (New York: Combustion Books, 2012).

Walkowitz, Judith R., 'Jack the Ripper and the Myth of Male Violence', *Feminist Studies* 8:3 (Autumn 1982), 542–574.

Walkowitz, Judith R., *Prostitution and Victorian Society: Women, Class, and the State* (Cambridge: Cambridge University Press, 1980).

Waller, Reed, and Worley, Kate, *Omaha the Cat Dancer*, see http://www.omahathecatdancer.com/ [accessed 18 September 2017].

Walter, Natasha, *Living Dolls: The Return of Sexism* (London: Virago, 2010).

Warner, Marina, *Monuments and Maidens: The Allegory of the Female Form* (London: Vintage, 1996).

Waters, Sarah, *Fingersmith* (London: Virago, 2002).

Wayward Victorian Confessions (Tumblr), http://waywardvictorianconfessions.tumblr.com/search/Rat+game [accessed 7 August 2017].

Wertham, Fredric, *The World of Fanzines* (Carbondale, IL: Illinois University Press, 1972).

Whelehan, Imelda, *Overloaded: Popular Culture and the Future of Feminism* (London: The Women's Press, 2000).

Whitson, Roger, *Steampunk and Nineteenth-Century Digital Humanities: Literary Retrofuturisms, Media Archaeologies, Alternate Histories* (London: Routledge, 2017).

Willson, Jacki, *The Happy Stripper: The Pleasure and Politics of New Burlesque* (London: I. B. Tauris, 2007).

Wilson, David, *Mary Ann Cotton: Britain's First Female Serial Killer* (Hampshire: Waterside Press, 2013), p. 157.

Wilson-Kovacs, Dana, 'Some Texts Do It Better: Women, Sexually Explicit Texts, and the Everyday', in *Mainstreaming Sex: The Sexualisation of Western Culture*, ed. Feona Attwood (London: I. B. Tauris, 2010).

Wintle, Sarah, 'Horses, Bikes and Automobiles: New Women on the Move', in *The New Woman in Fiction and in Fact: Fin-de-Siècle Feminisms*, ed. Angelique Richardson and Chris Willis (Basingstoke, Palgrave, 2002).

Wise, Sarah, *Inconvenient People: Lunacy, Liberty and the Mad-Doctors in Victorian England* (London: Vintage, 2013).

Wolf, Naomi, *The Beauty Myth: How Images of Beauty Are Used against Women* (London: Vintage, 1991).

Wolf, Naomi, *Fire with Fire* (London: Vintage, 1994).

Wong, J. Y., *Deadly Dreams: Opium and the Arrow War (1856–1860) in China* (Cambridge: Cambridge University Press, 2002).

Woolf, Virginia, *Mrs Dalloway* (1925: Harmondsworth: Penguin, 1992).

Woolf, Virginia, *A Room of One's Own/Three Guineas* (Harmondsworth: Penguin, 1993).

Woolley, Benjamin, *Bride of Science: Romance, Reason and Byron's Daughter* (London: Pan Macmillan, 1999).

'The World according to Emilie Autumn', *The Worst Fanzine*, Issue 8 (Spring 2007).

Index

on 9/11 and the War on Terror
175–6, 181, 183–6
racism and intolerance 181, 185
Pegasus, representation of 194
self-consciousness, notion of
178–9
technology, use of 195–7
on 'Weapons of Mass Destruction'
183, 185
Talbot, Mary 241 n.3
Tanguay, Liane 183, 210 n.31
Tatalovich, Warren 211 n.52
Taylor, James 92, 133 n.33
tea drinking. *See also* Tea
Referendum
Brexit and 98–9
dueling and 6
English obsession 94, 97–9
Mugs, image on 87, 94
'Tea and Country' (journal) 97
Tea Referendum 24, 102. *See also*
Doctor Geof
technological developments
inventor-hero models 119–30
steam, use in 120
Tedman, Nicola, *Steampunk Softies*
17
Tempest, Matthew 215 n.127
Tennyson, Alfred, Lord 115
Charge of the Light Brigade
113–14
Tesla, Nikola 113, 119, 205
Teukolsky, Rachael 94, 133 n.34
Thatcher, Margaret 9–11, 100, 207,
250, 251
The Men That Will Not Be Blamed
for Nothing (TMTWNBBFN)
33, 35, 52–4, 58–60, 62, 65,
67, 71
'A Traditional Victorian
Gentlemen's Boasting Song'
58
'Baby Farmer' 60, 65
'Brunel' 59
'Doing it for the Whigs' 53

'Free Spirit' 56–8, 60
'I'm in Love with Marie Lloyd' 58
'Inheritor's Powder' 60–1, 63–5
'Miner' 52
Not Your Typical Victorians 58
*Now That's What I Call
Steampunk Volume 1* 54
*Steampunk Album That Cannot Be
Named for Legal Reasons* 126
Steph(v)enson 126
'Third Class Coffin' 52
on women's role 60–2
Thoss, Jeff 209 n.3
Tomaiuolo, Saverio 139 n.114
Tosh, John 91, 126, 132 n.26, 138
n.90
Trans, transsexual 36, 42–3
Trial of Amelia Dyer, May 1896 80
n.117
Triggs, Teal 38, 74 n.26
Trimm, Ryan 8, 27 n.11
Trump, Donald 101, 252

UKIP (UK Independence Party)
100–1, 135 n.55
Unwoman 35
US (United States)
alliance between church and state
50
Comstock Act 50
Donald Trump's Presidency 101,
252
9/11 responses to 186
social justice movements 45
women's rights, right-wing policy
on 61

Vale, Allison 80 n.116
Valente, Joseph 187, 211 n.54
Valizadeh, Roosh, 'The Return of
Kings' 70
Vandermeer, Jeff 52, 248
Steampunk Bible, The 130, 149
Steampunk User's Manual, The
142

steampunk 55, 108, 220, 251
 in STEM departments 108–9
Wong, J. Y. 133 n.38
Woolf, Virginia
 Mrs Dalloway (novel) 117, 138
 n.95
 'Three Guineas' 202
Woolley, Benjamin 256 n.14

Worley, Kate, *Omaha the Cat Dancer*
 179

Yeats, W. B., *On Baile's Strand* 187

zine culture 24, 33, 36–42. *See also*
 e-zines